MW01062001

BEING

AND OTHER REALITIES

BEING

AND OTHER REALITIES

PAUL WEISS

OPEN COURT

CHICAGO AND LA SALLE, ILLINOIS

OPEN COURT and the above logo are registered in the U.S. Patent and
Trademark Office.

© 1995 by Open Court Publishing Company

First printing 1995

All rights reserved. No part of this publication may be reproduced,
stored in a retrieval system, or transmitted, in any form or by any
means, electronic, mechanical, photocopying, recording, or otherwise,
without the prior written permission of the publisher, Open Court
Publishing Company, 315 Fifth Street, P.O. Box 599, Peru, Illinois 61354-
0599.

Printed and bound in the United States of America.

Library of Congress Cataloging-in-Publication Data

Weiss, Paul, 1901-
 Being and other realities / Paul Weiss.
 p. cm.
 Includes bibliographical references and index.
 ISBN 0-8126-9293-4 (paper)
 1. Metaphysics. I. Title.
B945.W396B45 1995 95-32762
191—dc20 CIP

To Constance Rothschild Pitchell

Contents

Preface

This work has been revised many times. It could surely benefit from many additional rewritings. I am not confident, though, that if I spent more time clarifying, elaborating, illustrating, and restating what is now presented, the view would be easier to understand and accept. After all, it is not just to be read but to be thought through.

I have not looked at most of my previous works in many years. That fact and a poor memory have made it possible for me to write this book with a becoming innocence. No reference to those other studies is needed, though some of the themes here dealt with had been there examined at length and from different angles. The present account should make it possible to note strengths and weaknesses in them that I may have overlooked, and they in turn could help clarify what might here be too dense to allow in much light. It is best read as a proposed map of all reality, and is best tested by seeing how well it meets the challenges: does it squarely face and answer the questions that a claimed comprehensive account of reality raises? Could it be lived?

Those who are well acquainted with the major turns in the history of speculative thought may find it more congenial to begin with the fifth chapter, go on to the sixth, and then turn to the first four. In the end, though, it will not matter whether one follows the present sequence of discussions or begins elsewhere. The way up to what necessarily is and is presupposed by all else, and the way down to where one had begun, supplement one another.

I am greatly indebted to Lewis Hahn, Kevin Kennedy, Tom Krettek, George Lucas, Robert C. Neville, Constance Rothschild Pitchell, and Jonathan A. Weiss for their supportive assessments, sharp criticisms, helpful suggestions, and excellent advice.

April 1994

A Recapitulative
Introduction

1

It does not take long before an infant becomes aware that it has to act in different ways on different occasions. New insistent demands, the responses of others, and its failure to obtain satisfactions cut short its inclination to act along the lines it had previously followed with some success. Not all that it seeks or that it is required to do is benign; nor does it always focus on what is best for it. The most desirable outcomes and the best of habits are not always produced. On the whole, an infant will be content to have its needs satisfied, to be left undisturbed, free from pain or threat, with its major urges quieted. Later, it may fare better, but rarely as well as it could and should. The young cast long shadows on the promise they may realize.

Only some acts are in the best interests of those who perform them. Restraint must be exercised, and what is irrelevant or counterproductive must be altered or avoided. Much has to be done to enable one to live on one's own terms, or even to fit in well with others. New demands push forward, requiring fresh ways of acting. With time, old habits are modified and others carried out, more or less in consonance with common, established practices.

Since there are many individuals, obdurate and insistent, together able to use considerable power, it is expedient for each to plan, speak, and act in considerable consonance with what is prescribed and with what is usually done. At the same time, each both assesses and adjusts himself to the natures and activities of what is confronted, as well as to what is expected. In consequence, what is done will be a complex outcome of

not entirely predictable efforts, qualified by and qualifying one's acts. By tailoring inclinations and expressions so as to produce something not radically or conspicuously in disaccord with what others demand and do, it will usually be possible to function quite successfully for a time in a limited part of the world.

While planning, communicating, and acting in large part as others require or insist on, each person continues to be and act in distinctive ways. There may not be much deviation from what others do or permit, but what is done will usually reveal one to be both free and constrained. Thinking, inventing, creating, and speculating are usually carried out within limits set by other realities, other occurrences, and the group within which one lives. Each of us freely expresses himself, sometimes in order to reach objectives that others neither endorse nor limit, even when pressed to conform or to do what these demand. Usually, a person is effective only over a small area. Some acts were initially infantile, apparently random, and surely unfocussed. Later when an attempt is made to quiet a hunger, slake a thirst, escape from burdensome encumbrances, or oppose established practices, one will still continue to conform, by and large. To increase both the efficacy and range of what is done, acts must be controlled.

Desirable as well as undesirable effects are the outcome of efforts freely carried out. Whatever the occasion, the cause, the pressures, or the controls, each of us acts independently, working to realize outcomes not yet fully determinate. No matter how free the acts, each will still be subject to necessitating causes, and arrive at necessitated effects. Like good inferences, causation moves freely to formally required outcomes.

2

Granted that I am now dreaming or being deceived, and even that I may always have been and always will be dreaming or deceived, I am still distinct from the dream or the deception. If I dream or imagine that I am doing this or that, I must be one who is able to dream or imagine. Nor can I maintain that I am not sure whether or not I am dreaming or being deceived, unless I am, so far, different from the dream or the deception.

I may not know how to describe or say just who or what I am, but my existence does not wait upon my having that knowledge. If I ask myself whether or not I am dreaming or being deceived, I ask as one who has learned a language, has a past, and sets the question in a context. Like other questions that I may put to myself, this is freighted with accumulated meanings. When I abstract from these, I do so as one who has

acquired some understanding of what is being abstracted from, and, as a consequence, as one who is able to ask the right questions.

A dreamer who asks 'Am I dreaming?' sets himself apart from his dream. The question might be part of a larger dream; questions may follow questions, without apparent end. Evidently, at the root of the initial question is an uncertainty as to what could not possibly or reasonably be dreamt or doubted. All the while, questioner and that which is questioned will continue to be distinct from one another. A dream that embraces both is necessarily different from each of them.

What is tacitly asked in the question 'Am I dreaming?' is whether or not there is anything other than what is merely imagined. That question, presumably, is being asked by someone who is real. Were the question extended to include the questioner as well, it would presuppose another reality, and so on, endlessly. The real can always be caught, but can never be captured. Itself beyond all questioning, it escapes whatever boundaries a question imposes. By putting a question mark before and after their questions, Spanish writers make evident that they know the difference between what is and what is not in question.

What is true of dreams is true of appearances. Appearances are appearances of what are not appearances. If we bring to the fore what is not an appearance, we leave behind what is not yet an appearance. The question 'Are there only appearances?' evidently already contains its needed answer: appearances cannot be unless there is something that is both different from and sustains them. The 'red' I now focus on is the red-of-an-apple, not an airy red belonging to nothing. When I attend to that red, I am already involved with what sustains it.

We reach the real by moving intensively from an appearance to what appears, adumbrating this when and as we attend to it as manifested and available. It would, therefore, be more correct to reverse the usual claims, and say that we are initially involved with what is beyond all appearances and are able to attend just to an appearance only with great effort. Not until then are we in a position to bedevil ourselves with the question as to whether or not something is real. What, instead, should have been asked is how we could get a better knowledge of reality, not if we can know it at all.

Sometimes we are urged to turn away from experience and attend to formulae and categories. These are usually preferred because of their clarity, their use of the grammar of a common language, their value for a formal logic of apparently unlimited application, or the guidance they provide for some favored discipline. Each presumably exhibits the essentials of what is, could be, or could be known. Nevertheless, we do, we

must, we should initially accept whatever items are available, if only in order to begin to have a knowledge of what is privately done, the ethical, the social, the expedient, the surprising, and the recalcitrant. Users of formulae and categories are not able to account for the presence of that to which they apply, nor for volitions, assessments, idiosyncrasies, love, faith, action, creativity, or evil. These could be squeezed into formulae or put under categories, but only if their distinctive natures and functionings or their involvements with other things are ignored. What is needed in order to know what is real is a study that acknowledges factors whose existence and operation are evidenced everywhere, both in what can and in what cannot be formally stated, investigated, or understood. Account should be taken of the private as well as the public, of the trivial as well as the splendid. Nothing less than a wide-ranging, sinuous, defensible account could provide what is needed.

What is sought is a justified, all-inclusive view that neither denies nor precludes, neither overlooks nor minimizes the existence either of contingencies or necessities, the role of ideals, or the fact that errors haunt every endeavor. The primary, essential task of philosophy is to provide an account of whatever primary realities there be, and to make evident their primary preconditions, interrelations, and consequences. Since it will not be of much value if it does not provide more than an outline, a philosophic study will, at the very least, also take note of the distinctive ways in which individuals both privately act and make use of their bodies, how they can and do interplay with others, and what is then presupposed. Beginning anywhere, and with anything in the world in which we daily live, it will seek and use evidences of what accounts for them, without compromising their reality. Ideally, nothing will be sacrificed in order to keep the system coherent; nothing will be orphaned by one's procedures. Arbitrary suppositions or hopes will have no place in it. Nor will anything be affirmed or denied in order to make the whole more persuasive or acceptable. Like everything else done by a human, the work will be flawed. But instead of discouraging, what is achieved should make both writer and reader exert themselves in strenuous self-critical efforts to produce an even more complete, articulate, illuminating, justified, systematic view of all reality, and to make evident the ways it can be known.

Men are born free to accept, loosen, modify, or add to their chains. They must look for what will enable them to act with greater freedom, assurance, and success, both where they are most constrained and where they are not. Each freely acts on what is insistent on itself, accommodating and using this as well as he can. Humans live and act together in a world that is neither altogether alien nor congenial.

We are at our best when we know who we are, and what we can and

should do. Of primary importance for the success of that endeavor is an understanding of the different kinds of reality there are, as well as of their distinctive ways of functioning, their constituents, and their relationships. The whole will be badly skewed if made to fit into a prepared frame, or reshaped to satisfy the demands of some method, singularly appropriate to another type of investigation. The task is stupendous, requiring as it does the consideration of whatever basic kinds of things there are, their interplays, their presuppositions, and what these may themselves presuppose. What is finally reached must, in turn, be understood both as it is apart from, and as it is in relation to what else there be.

If there be a final reality beyond which it is not possible to go, it should enable all else both to be, and to be better mastered. To know that reality, we need to carry out an inquiry that is more comprehensive and sounder than any presently available. Well-articulated, it should explain what is now obscure or unjustified, and, at the very least, provide an occasion for the production of another, more comprehensive and illuminating view.

Philosophy is a cooperative enterprise carried out seriatim, accepting, discarding, modifying, and sometimes going counter to what others have stressed as pivotal and important. It strives to be systematic, in part because it will thereby encourage daring advances, doubts, and criticisms, particularly with reference to central issues, primary factors, and important interinvolvements. While avoiding the pretense of being the expression of omniscience, those who occupy themselves with it will not pretend to a modesty that is unbecoming in anyone who seeks to understand reality as it must be, is, and can become.

3

Particular objects—'actualities' I have termed them—are of at least four distinct types, each with a different constitution, and engaged in distinctive types of activities. We are most familiar with those in the humanized world, the world in which we daily live. There, humans live apart from one another, as well as in groups. There, they carry out social and political roles. Far richer and more variegated than a socially-oriented view usually acknowledges, individuals and groups are there affected by traditions, myths, customs, language, economics, and brute forces, as well as by separate and common memories, beliefs, intentions, and expectations. Every one of us combines privately-initiated contributions with natural or cosmic realities, or what was already humanized.

Expectations and other privately-initiated expressions have singular forms. Quite quickly they are caught up in habits, or are interlocked with contributions provided by other realities. They are also qualified by what

originated in nature or the cosmos, or by what had already found a place in the humanized world. The familiar, commonsense world, in which we more or less unreflectingly live every day, is a limited, specialized form of that world. It, too, is usually accepted without hesitation, qualifications, or refinements. A good understanding of that world can be achieved only if one stands away from it and, at the very least, then recognizes that some realities there are combinations of individual persons and natural beings.

In the humanized world, our hopes, fears, expectations, beliefs, intentions, misconceptions, and plans acquire public roles. Despite our singular privacies, all of us fit more or less together, sustaining and modifying common traditions, practices, adventures, and expectations, and qualifying separate demands. A common language, cooperative action, and conventions help stabilize and sometimes modify what is individually accepted and done. All are limited by intrusions from nature and by what has already found a place in the humanized world.

Pragmatism is the self-appointed but still good defender of the humanized world. It is, though, unable to account for the existence of that world. It is not enough to claim that raw experience and hypotheses are to be so joined that they enable humans to act well, separately or together; what is said about their existence, nature, and roles must be justified. Its principles, moreover, should not preclude it from knowing the raw experiences that supposedly provide it with its needed content and base. Those principles must also allow for an acknowledgment of mathematical and other fixed truths, particularly since these may help one deal well with whatever exists. Since pragmatism does not allow for realities that are not related to humans, not only formal logic and mathematics but nature, the cosmos, and Being will be beyond its reach. At best, it can do no more than take them to be limits for or distillates of what is in the humanized world.

Were pragmatism right, the stars and the sun, milk and mice would at best be potentialities, for as actualities they presumably originate and vanish with the coming to be and passing away of humans. Even now, the very existence of these as independently existing realities would be questionable, were pragmatism a tenable view. Offering an illuminating criticism of an occupation with idle formulae, and rejecting dogmatic claims, it shows how one might live successfully in the humanized world, all the while continuing to presuppose the existence of other domains that do but also do not contribute to the existence and nature of what is the humanized world. Incomplete, pragmatism presupposes what it can neither know nor allow. Its claim, that it is hard-headed and interested only in what is experiential or verifiable, leaves it incapable of knowing what has no pragmatic value. What it maintains must be justified, shown to be both better based and more fruitful than other views. It is questionable

that it does or could provide as good an understanding of art or religion as other views do. Only fitfully and partially does it justify the view that what is to be accepted is what is most fruitful. Individuals, nature, the cosmos, and transcendents, as well as Being, are all beyond its capacity either to acknowledge or to understand.

Nothing prevents one from being immersed in the humanized world, adjusting as well as one can to what, for the moment, is supposed to be commonly accepted or most acceptable. If it is added that this is all that should be or could be done, one will be left with unexamined assumptions about the irreducible finality of humanized objects. At the same time, each individual will be asked to accept the view, as though it did or could embrace him and all that was or could be real or known.

The language of philosophy is not freed from all humanizing factors. It could not be, since it builds on a language that is pertinent to sharply limited areas in the humanized world. Its terms, nevertheless, can be given different weights on different occasions, so as to become more appropriate to what occurs in other domains, and to what is outside all of them. Some of those terms will be newly forged; others will be given new meanings. If pragmatism were not part of the humanized world, nor subject to what this presupposes, other views could also be taken to be independent of the domains to which they apply. If those others could be no more than privately entertained views, pragmatism would be similarly flawed. If it could do no more than call our attention to the distinctive kinds of activities that are effective in the humanized world, other, nonpragmatic approaches would be needed to enable us to deal well with what occurs in other areas.

Customs and laws dictate how publicly acknowledged persons are to be understood and treated, but, since we know a good deal about what humans are as apart from such determinations, we can also know both that the range of those customs and laws is limited, and that some of them need to be changed if they are to comport well with what individuals are and intend.

Nothing less than the recognition of the independence and existence of real objects stands in the way of their ruinous, imagined reduction to daily expressions and uses. We might take what is said as though it were just a floating raft of words, or we might be prompted to make incorrect references to what is real. There is no sure way to prevent this. The hope of a philosopher, like that of a poet, is that the uses of other terms, and, finally, the entire work as more than an aggregate of words, will help rectify initial misunderstandings, particularly those based on attempts to read different parts as though they had nothing to do with the rest. Pragmatism keeps one alert to the danger.

Analysts often concentrate, not on realities, but on the words used in daily life or in some special area, such as logic or science. Their enterprise is best carried out when divided into two branches, one trying to separate out the contributions of both individual persons and other realities from what occurs in the humanized world, the other trying to isolate what is presupposed. Both branches can be properly pursued only if one allows for a movement to the sources of the objects analyzed.

Thoughtless speech is to be condemned because it ignores the accepted referential role of the terms used. Learned ignorance is to be feared because it uses technical terms in wooden ways. What individuals say and do have meanings that are never exhausted by noting what the body does, or by attending to common uses of words. The license that some take to be granted to them when they make philosophical claims is checked by following up the references and understanding what is presupposed.

Acknowledgments of what is in the humanized world are made by men existing outside that world. In stark contrast with those who think humans are hopelessly trapped in the humanized world, it might therefore be maintained that they are hopelessly trapped in themselves. One will then overlook the fact that whatever is initially acknowledged is two-sided, one side related to the knower and the other to the object known. An overemphasis on the first may prove harmless for a while if it is remembered that the second has a reality and status of its own. An overemphasis on the second may prove equally harmless if it is just remembered that it is individuals, not just minds, and surely not brains, that think and know.

When we wish to speak about what occurs in domains other than the humanized, our humanized language must be qualified. References to individual persons are value-laden; those pertinent to natural objects take account of indivisible extensional spans; the cosmos contains unit bodies. Ideals, ultimates, and Being can be referred to by giving our terms an exalted import, charged with such emotions as awe, respect, and admiration. Treated as though they did not refer to distinctive kinds of realities, references to these would be little more than oddities, to be rejected by those who allow only for a use of a common language in commonplace ways.

Just as it is a mistake to deal with biological occurrences in purely physical terms, or conversely, or to use biologically pertinent terms to express what is in the cosmos, so it is a mistake to speak of individual persons in humanized ways, or conversely. Few today are disturbed by the fact that scientists give special meanings to 'body', 'energy', 'light', 'star', 'evidence', and other focal terms, particularly when they are trying to refer to what is outside the humanized world. Their popularizers, by

restating scientific views and claims in humanized terms, distort what is scientifically known, for this cannot be wholly separated from the realities scientists know.

Sometimes humans do intelligent things. Some of their work may be duplicated by machines. If those machines act swiftly and accurately, they are sometimes said to be intelligent. It is not then asked if they might also be pious or superstitious, thoughtful, or considerate. A machine's 'intelligence' is disconnected from motives, objectives, concerns, and fears; a human's is not. The intelligence that is attributed to a machine abstracts from the fact that the intelligence of a living being is possessed, not just expressed.

Words are more than parts of speech, and more than so many bodily vocalizations. They are both possessed and affected by other human acts. When one deals with words as though they were just humanized occurrences, one still tacitly takes many of them to produce warranted condemnations or praise of the individuals who expressed them. No robot expresses anything, none possesses anything; none acts to continue a custom or tradition; none speculates or imagines. Creatures of habit, subject to communal pressures, making use of a common language and acceptable techniques, humans are often occupied with routine matters, or with trying to find quick answers to pressing and common problems, but no one of us ever succeeds in fully escaping from the humanized world—or is wholly trapped inside it.

When common expressions are interchanged, we qualify what we say by what we intend. When we exchange banalities, we do so as indifferent, friendly, or thoughtless humans. Sometimes, we might express emotions beyond our capacity to convey through the use of words. The claim that there can be no private language is made by individuals who so express their concerns, intentions, emotions, and beliefs in the humanized world that others may sometimes be induced to change their attitudes or acts.

There are some who would like to retreat within themselves so as to be better able to attend to what they believe, or to be in a position where they can express themselves more effectively. Since no one ever succeeds in retreating more than part of the way, and then only for a short while, and since the body's demands are often imperious, the intrusions of others unrelenting, and the established humanized world insistent and limiting, no one ever entirely escapes from all external influences. While existing by ourselves, each of us is inescapably involved in the humanized world, interplaying there with other humanized realities. That world is not a single-toned, all-encompassing whole. It is differentiated and subdivided in many ways. Combinations are formed, many with fragile or fluctuating borders. Dominating figures, local customs, pressing needs, and limited

opportunities, make a difference to what is and what could be done there. When statistics are taken to report what occurs in the humanized world, one glides over what produced and sustains the figures and classifications.

Those who urge that one conform to common practices, or work to better the world, appeal to one who is outside the humanized world, to contribute to the result. Socially-grounded accounts covertly appeal to individuals to do what they alone can do—express themselves in such a way that they help constitute occurrences in a different domain. Every one of us acts in some accord with what occurs in the humanized world. If we did not, we would not be able to provide what is required if what is there is to be judged, modified, used, or rejected. Although we must express ourselves in the humanized world if we are to move, eat, drink, or otherwise use what is available, what we do or undergo is initiated apart from the humanized world, and could end in a private satisfaction not otherwise possible. Most of us speak and act in acceptable ways, but not always in full accord with what others say, or with what occurs. We are able to function with considerable success because we separately qualify common expectations and acts. We also separately utilize what has already been established or accepted, usually because it proves useful or congenial, thereby enabling us to determine what it is reasonable to expect and do.

There are two distinct stresses in the humanized world, one reflecting common acceptances and interests, the other what is of interest to individuals. The two are not easily distinguished, though they do not always fit well together. Either the singular or the common may be unduly emphasized. An effort to achieve private satisfactions may give undue weight to an individual's hopes and fears, while an effort to function well with others may be overdetermined by what is in accord with common trends. Everyone passes back and forth from one emphasis to the other, without taking particular note of the fact. What is prepared for and done is usually the outcome of a wobbling course carried out between singular and common expectations and insistencies.

We cannot understand what humans are and do if we ignore the common language, customs, standards, and expectations, or the ways these are diversely qualified. Still, if we existed wholly in the humanized world we would never have private views or make private assessments. While anyone may set himself in opposition to all the rest, or reject the accountability that the humanized world attributes to him, he is not able to keep to himself for long, or make his own way without encountering limits set by others.

There was a time when it was thought that the humanized world was progressing in an almost straight line toward some ideal stage—a democ-

racy of practical men, a community where all use the same language and have similar interests, or an economic moral paradise in which there would be no inequality or discrimination, and where differences would be welcome as long as they did no more than promote diversity in a splendid whole. All the while, an appeal was made to persons as existing apart from the humanized world, where they might be occupied with other issues, and not be much concerned with fitting in with the rest. The idea that everyone is a social unit or product is offered by individuals who are not themselves in good accord with most of the others. To flourish in the humanized world, we must have recourse to inductions, expressing a common confidence that what had been accepted and justified can be relied on to define what it is then reasonable to expect and do. All of us live in a part of the humanized world and must do our best to live in it successfully, both separately and together. We should use a common language, follow common practices, challenge common constraints, if we are to enrich our lives. We should also recognize that we exist outside the humanized world as well, and that we can and do contribute to its constitution and perhaps to its enrichment. When emphasis is placed on the activities of groups, the course of the humanized world will be viewed in terms of what they do and need. When, instead, emphasis is placed on leaders or statesmen, we usually attend to those who presumably could enrich some members of the humanized world.

Were there no power able to qualify and be qualified by that with which one begins and that at which one ends, there would be no way to get from one to the other. References to hypotheses need support from what enables one to reach what is apart from oneself and one's hypotheses. No matter what the view and where we start, one needs the help of what is distinct from both the beginning and end.

Some try to meet this demand by referring to a God, a self-causation, a rush of time, laws of nature, practice, or custom. It is not enough to refer to these; one must make evident how any of them could take one from what is at the beginning to what is at the end. One must show if, how, and to what extent what is initially supposed is able to be accommodated, rejected, or modified by what is different from it. Good practice is a precipitate of good arrivals at what is other than what one has in mind. Try as we may, we cannot escape a reference to effective agencies distinct from that which is initially entertained as well as from that at which one ends. These agencies are acceptive of and are affected by what is at one end, and are to some degree able to terminate at what is accommodated or rejected at the other end. Once the nature and operation of such mediators are understood, a host of baffling issues are not only opened up, but can be mastered.

The most characteristic feature of humanized objects is that they are both primarily constituted and primarily subject to the Affiliator, an effective, permanent condition, for which they provide limited beginnings and endings. That Affiliator subordinates and limits the effective operation of other mediators, giving them a different effectiveness and import from what they have when they are themselves dominant in other domains.

<div align="center">4</div>

From the first to the last moment of our lives, we are helped to fit into settings and forced to conform. Always free and always constrained, each of us is more or less a part of the humanized world, as lived in and qualified by the practices and aspirations of the groups to which we belong. Yet, even when we there carry out the most routine of acts, we reveal something of our private natures, intentions, beliefs, fears, and hopes. Usually, to obtain a knowledge of them, we must pull ourselves away from common practices, modify or abandon common assumptions, and focus on what had not been focussed on before. That does not mean that we never initiate and carry out acts dealing with what is outside the humanized world. If we could not do that, we would not only be unable to reach what we presuppose when we know and act, but we would not get from or to the humanized world, to or from ourselves, as realities apart from all others.

Each of us is a unique source of what is publicly done. Whether acting voluntarily or involuntarily, with or apart from others, every individual remains apart from all else. Comatose, some may be unable to deliberate or to decide to do this or that, but what is done will be their acts. Even when they are unable to do more than live, they are still irreducible realities, making some use of their characters, privacies, and bodies. The so-called vegetative state into which some unfortunates fall, is that of a human who is unable to make his body act in desirable humanized ways.

Occasionally, an individual may be discerned with sympathy by those who approach him. They then pass beyond his appearances toward him, not only as a distinct person outside the humanized world, but even beyond this. The adumbrative move that takes one from appearances into the depth of things is here far outraced by the more penetrating discernment. Usually, though, we are content to stop short of this at a man's privacy, character, or person, as these together, and never as wholly sundered from him as a unique being.

A person is a locus of inextinguishable rights. A discernment of that person is to be filled out with a knowledge of what is insisted on through his body. Never entirely known to himself or others, he can be known to

be more than and different from what he publicly is and does. The fact has puzzled thinkers everywhere over the ages—those who carry out scientific investigations, those who reflect on what is daily known, as well as sages, theologians, and analysts.

How is it possible to know another? Do we speak and observe, attend to and use only what is in a common public world? How could we possibly know ourselves or anything else? These perplexities turn into antecedently defined defeats when it is held that the questions make no sense, or that no answer is possible. Such rejections rest on presuppositions not themselves examined. Who provides those rejections? To whom are they addressed? Are they justified? Are there alternatives to them? Let it be granted that what most maintain is overrun with unexamined presuppositions. Is the acknowledgment, criticism, and replacement of what is affirmed not itself open to questioning?

The bleakest sceptic takes a stand somewhere, but does not take note of it. Under no circumstances will he allow it to be scrutinized. Were he more self-critical, more of a sceptic, he would find that he had no time left to attend to the supposed faults of others. He would stand stupefied before his first utterance of 'this', 'that', 'I', and, of course, 'text'. Faults, particularly the faults of those who have seriously carried out an inquiry, should be exposed, but if the judgments are to have strength or validity, they must be from a position that is itself tenable. Placing question marks and exclamation marks after the remarks of others is not beyond the power of a child. The fear and trembling, the doubts and fears, the retreats, and even the discomfort and defenses aroused in those who claim to have learned something from great thinkers in the past, or from the sciences, arts, mathematics, and logic, make evident that they have not learned enough. It is right to remark on the serious flaws found in even the greatest of works; the work is still eminently worthwhile. Failures and faults should be exposed and corrected, but that cannot be well done until one arrives at an unassailable place from which everything else can be judged. The arrival at that place is beset with multiple hazards; every step needs to be tested by seeing how it is warranted by that which had preceded it and by that which follows. Denials that some inquiry can be carried out are willfully *a priori,* no matter how many previous failures can be cited, unless they can be shown to be precluded by what is known to be beyond the reach of doubt. The fact that faults can be found with every inquiry and every answer no more proves that all inquiries are futile than does the existence of flawed great plays, paintings, poems, and dances show that no others should ever be produced.

Radical sceptics frighten the faint-hearted. The right response to them is to adventure again and again, checking oneself at every crucial point,

and incidently exposing every dogmatism, including the resolute sceptics. After all, he offers no more defense of his position than the observation that no one has yet succeeded in producing a perfect work. Could he produce one, even one compacted only of denials, doubts, erasures? Why are so many cowed by the undefended claim that only this or that could or should be done?

Knowledge does not stop at surfaces; appearances do not exist wholly in a public world. Perception is intensive, penetrative, rarely stopping short at or with what is faced. A farmer does not see a red color and then infer that a ripe apple might be found there. What he sees is a reddened ripened apple, adumbratively reached by passing beyond the red apple, encountering this at greater and greater depths, depending on the way he carries out the act. What he does we all do. We often act in more penetrating ways when we attend to one another. What most of us do so readily and often is claimed by some also to be done when they attend to subhumans. Unfortunately, we have no good way to determine whether they are right or wrong, since subhumans cannot back up their responses with a flexible language, or a revealing range of expressions. When they respond in evident anger, we do not know how much of this is reactive and how much is expressive of them as existing apart from their bodies.

Sometimes we end at what is just accepted and not noted. When we try to say what it is we reached, we tend to ignore what we had adumbrated or discerned, particularly since our language, though remarkably pliable, is primarily used in public interchanges, to refer to what is publicly available.

Cadets, underlings, and messengers are trained to absent themselves when they carry out their duties or follow commands. All contact with them as distinct persons need not then be lost. Unfortunately, that will not assure a treatment of them as though they were more than reactive and unfeeling bodies. Sometimes we speak at others, commanding, demanding, threatening them as though they were just depersonalized objects. Even then, we are involved with them as more than surfaces, and surely as different from things or animals. At times faintly, at other times more evidently, we discern and thereupon speak to and interplay with other humans as individual persons. Even when we focus on their public acts or appearances, we usually pass intensively beyond these, toward them as unique realities. When we converse, and more evidently, when we sympathize, we move intensively and insistently toward them as individual persons, occasionally noting this or that revelatory feature along the way. We never completely obscure that fact, even when we make a great effort to keep to the surface.

When humans converse, they discern one another as persons, usually

expressing the fact in their emphases. Fitted inside the steady frames of a common grammar, and using an established language, their expressions are flattened. An effort to communicate with them may encourage that tendency. In a conversation, discerning persons express themselves in public terms, offered to and accepted by one another in distinctive ways. The acknowledged failures of those who say that they are unable to get to anyone, even to themselves, in depth, show that they misstate or hide from themselves what they know. When they tell us what they are searching for, they report what they have already reached, while trying to understand it as though it were some kind of public object. Most use terms and categories that are appropriate, not to privacies, characters, or individuals, but to public occurrences or to subhumans. Whatever made them think of looking into themselves? How did they know how and where to attend? One wishes that Hume and Kant had addressed these questions to themselves.

The discernment of other persons is possible only to one who then and there also discerns something of himself for, when moving into others, one also moves back into oneself. In daily encounters we usually muse, without changing our adumbrations or discernments, whether these are of oneself, of others, or both. Usually we let what is predominately humanized usurp our attention, without ever fully succeeding in keeping out all that is outside the humanized world.

Humans are individuals with characters and privacies from birth to death. During that interval, a number of private powers are acquired in sequence, in a rather constant order. Sensitivity to pain and pleasure usually precede a sensibility to aesthetic differences, with these followed by desire, mind, will, and responsibility. An individual grounds and expresses himself in and through them. Little more than a preference for a particular use of terms is exhibited when we take 'person' to refer to a distinctive subdivision of the privacy (of which the mind and self are others) or, instead, as we usually do, take 'person' to refer primarily to the entire inwardness of a human being, and secondarily to a locus of publicly-acknowledged and defensible rights. The language used, in any case, is mainly that which had been established in a part of the humanized world. What is meant by those who use it will always be more than what is contained in what is written or said. A supposed common public language is at best a distillate of the outcome of an interplay of limited, diverse languages, each expressed in some corner of a common humanized world.

What prophets, mystics, poets and metaphysicians say, when they speak about what is not in the public, common world, is often dismissed as being willful or vague. It need not be. Nor is it right to criticize them for making use of metaphors. Every utterance has a metaphorical tinge. 'This

cat' yokes two quite disparate expressions, a 'this' and a 'cat' to point up the single fact that there is a real cat that can be adumbrated with the help of a depth reference made with the help of an 'is'. Common use has hidden from us the fact that 'this cat' is a powerful metaphor taking us past an experience toward a reality underlying it.

Most of the metaphors we daily employ are not noticed. Those anxious to make evident unnoted features and realities forge new metaphors, shocking those who are at home only with the metaphors that are widely used. We try to break the back of metaphors by focussing on one component and then taking the other to do no more than qualify it. It is doubtful that this can be successfully done. Still, that is what we try to do when we say that machines are intelligent, though they do no more than yield right answers faster than humans can.

A common language is a constant, abstracted from a used language. All of us make some use of it as a frame into which our expressions are to fit, with their metaphors minimized or ignored. The terms and combinations of that common language can be used to speak of persons and of their essential subdivisions. References to intention, obligation, or speculation, as well as to the awesome, the exalted, the novel, and the created, make use of that language while qualifying it in the course of an individual use. What we say may also be charged with emotion, and may be modified by our yieldings and acceptances, affecting its rhythm and import. There are many ways in which one may say 'Good morning' and be well understood to mean different things. We qualify what we say by the way we express ourselves. We qualify what is written by the way we read, adding stresses, acceptances, and rejections to what we may have wished to let pass without qualification.

A language in use is a language not reducible to fixated terms, grammatically ordered. It expresses a user, affects those who are addressed, mediates the two, and directs both to a common reference. When in use, it is no longer the language that was available for use. We take account of the latter mainly to guide us in our engagement with the former. Both are used in the humanized world, the latter as a more or less constant residue of what once served as an effective, cohesive agent. Making possible a meeting of beings who continue to remain apart, a language is best used, not by trying to imitate the monotonous presentation of a machine, but by turning it into a flexible agent enabling one to express oneself, or to probe and ferret out what may not be of much interest to those engaged in familiar, routine activities. Even when what is said is banal and uninteresting, language is inevitably qualified by its users and referents. The result reveals something of the speaker, of one who listens, and of what is distinct from both.

Each individual modifies what is being expressed. Sometimes this is done by shifting attention, by an insistence or a withdrawal, by a joining or a separating, without explicitly using a language. If we take account only of what is expressly said about what occurs in the humanized world, we will never be able to convey much of the knowledge that we have about someone in pain, who is appreciative, committed, or obligated, or who remembers, believes, hopes, or fears. As long as we refuse to attend to what is behind the established practices of the humanized world, we will not speak appropriately to anyone. Nor will we be able to know much more than what we could learn by studying bodies in a common arena. There would then be no one to credit with a mind, a memory, or unalienatable rights. Nor would there be anyone to know that there was a humanized world, or that humans were more than publicly evident, encountered beings. At best, humans would be taken to be just one type of public object, credited with publicly-defined accountabilities. What was private would then have to be taken to be an unknown source of public occurrences, located perhaps in the brain, or in some other part of a publicly-available anatomy. Prescriptions would be identified with commands, lies with misleading statements or errors, and memories with the outcome of present movements of brain cells. Who would make these identifications? Would they express more than movements in the claimant's own brain? Implicitly, and sometimes explicitly, each one of us evaluates some of the others. Since each usually concentrates on what can be accomplished by using a possessed body, each may fail to take adequate account of others as persons. All may act at cross-purposes. Occasionally someone may take himself to stand alone, to be inferior to or above the rest, and, in any event, to be quite unlike them. Then, as well as at other times, only part of him will be manifested.

Each of us needs and often seeks public acknowledgment, and some reassurance. Since we are also members of the humanized world, it will evidently not be possible for any of us to achieve a good understanding of others unless these are in that world, and are attended to by what is outside it. Since every one of us has a humanized body within which there are subordinated natural and cosmic bodies, an adequate understanding of any awaits a knowledge of what exists in other domains. That knowledge, in turn, requires a grounding in what enables all the domains to be dealt with in common, neutral terms. How this could be done becomes most evident after the humanized beings, persons, natural occurrences, and cosmic units have been understood, and the nature of the passage from one domain to another squarely faced. It will then be found that each actuality and relation is constituted by all the ultimates, themselves presupposing a final reality, Being. A knowledge of this will enable one to

reverse direction, and thereupon be able to account for that with which one had begun.

Though differing in ability, virtue, achievements, and maturity, all persons are equal in worth. All are to be assessed as units having the same rank. Other kinds of actualities are more or less valuable to the degree that they approximate humans, or to the extent that they promote human continuance, effectiveness, and prosperity. Since those other kinds of actualities are constituted by all the ultimates, but with the Assessor in a recessive position, they will not have the values humans have as so many unique beings in a domain of their own.

Each of us makes some use of other humans as occasions, agents, or means, though only a few of these are expressly focussed on, and then not for long. The fact that public treatments fall short of what is reached by means of discernments carries a tacit assessment that a person has a dignity not possible to other kinds of actualities. A king looks at a cat in a way no cat can look at a king. If the king speaks or acts as though other humans had less value than a cat, that will be because the king is stupid, brutal, unfeeling, or evil, usually one whose insistence on himself makes him override what even he discerns.

It would be an error to try to carry out a systematic study of what there is by initially attending to characters, privacies, or possessed bodies, though these are preconditions for and contributors to what one knows or does in the humanized world. Even when individual use is made of a language, shaped and qualified by intentions, hopes, and fears, the result will be contoured and rather tightly confined within the humanized world. An unusual effort must be made if one seeks to refer to individuals, their characters, their privacies, or the possession of their bodies, and thereupon be in a position to do justice to them as persons.

We must be alerted to what should be done if we are to be effective in a common humanized world. Clinging together is not the best way for us to prepare for what is to be done either severally or jointly—we might have readied ourselves to be destroyed together. Some private determinations of public acts are, of course, ineffective or undesirable. One might benefit more by trying to keep in better accord with what others are doing. In any case, whatever is publicly done exhibits some determinations originating in the humanized world, as well as others originating in us as outside it.

5

We evaluate and accommodate both what intrudes on, and what interests us. All the while, each of us possesses and uses a distinct body. This interplays with a distinct privacy, with its thoughts, desires, memories,

feelings, appreciations, and obligations. Both the privacy and body are individually possessed; our emotions are the products of their fluctuating interinvolvements. Used as agents, our bodies enable our characters, as well as our thoughts, desires, and other private occurrences, to be both lived through and publicly expressed.

No matter what the body does, it, like the privacy, is individually possessed. Each of us is so involved with his body that it is possible for him to take private note of what the body undergoes, and sometimes even to be alert to what the body needs. Each privately experiences as hunger a bodily need for food; each feels dryness as thirst. Hungry, each looks for food and makes bodily use of it; thirsty, each looks for something to drink. Whether one emphasizes the private or the bodily side, the two are here joined to constitue an emotion of want. This varies in intensity and emphasis over the course of its expression, with either the private or the bodily side more insistent for a while, usually in an inconstant way.

None of us jumps out of a hidden world to attend to what his body undergoes. Instead, each insists on himself in and through it. Nor is what is grasped of it concentrated in the brain and there transmogrified into private thoughts and feelings. Nor does anyone move close to his own or another's mind, or other subdivision of the privacy, by attending to some part of the body. One's mind, and other epitomizations of the privacy, are where the body is, but they are not bodies inside or alongside a larger. A privacy is but one subdivision of a single reality existing in a domain in which there are no bodies, and is also united with a body emotionally—as well as by the character, and by an individual, possessing and using both.

I feel my body privately, and privately credit what I feel to my body. When I deal with my body as in the humanized world, I carry out an individual act in which I express myself in and through my privacy, at the same time that I possess my body. When I point to my body, I do so as an individual who circles about in the humanized world to carry out a discerning act moving toward myself as the source of that act.

I feel a pain in my toe. I do not feel it in my brain and somehow project it into my toe. The pain continues to be privately felt; it is both private and in my toe. Instead of supposing that my pain is in my brain—where it is never felt—it would, therefore, be more correct to say that I am privately present wherever my pain is felt. If I lost a toe, I might nevertheless feel a pain that I take to be a pain in that toe. Instead of claiming, with Descartes, that there is an occurrence in a nerve that had once continued into the toe, and that this is changed into a pain by a gland, the mislocation of the bodily place where my pain is taken to occur should be understood to reflect a more or less successful practice of locating the occasion for the pain at some identifiable part of my publicly available body. A pain is an

occurrence in a privately-felt, possessed body. The fact is not compromised when the pain is taken to be occasioned by what happens to the body in the humanized world.

Neurons and other particles may take a while to go from one place in my body to another, but when I feel something in my body, I feel, not those neurons or other particles, but an accentuated part of my body. I am not caged within that body. Nor does my privacy ever become a body. My privacy continues to be a privacy even when I take what it undergoes to have initially occurred at this or that part of my publicly available body. Able to concentrate on what is happening in and to my body, I continue to be apart from it, able to impress myself on and express myself through it. I would never know that I had a body did I not privately experience it in a domain other than the humanized world, where it is related to and interplays with other humanized publicly-interrelated bodies.

When I am conscious of my emotions, my consciousness underlies and permeates them. Although both the emotions and the consciousness are partly dependent on my lived body, all three are possessed by me, an individual who is other than his privacy, his body, or the two together. These are my possessions, mediated by my character. Taken altogether, I am an individual, inwardly free but publicly limited. As the latter, I may be held to be accountable for some of the things that are taken to be due to me, as just an identified, public body.

I form habits of observation and acceptance, and convey in common ways what I am, and what I acknowledge. My expressions are channelized and subjected to private qualifications and bodily determinations. While being insisted on against the constraints expressed by what I confront and may try to know, and perhaps by what I act on or with, I again and again retreat from my body so as to be able to express myself there, as well as through it in more appropriate ways. The freedom is natively mine, but limited by what I yield to, by what I accept, and by what obdurately stands in the way. With others, I am limited by what is encountered; with them I impose myself on what exists independently of me. Were that not so, or were the fact not known, there would be no warrant for my claiming that there was anything that was or could be subjected to my individually determined, privately produced qualifications. We know that there are such qualifications, because we know that what we insist on is blocked, modified, and may be sustained by what is terminated in or at.

My body, no matter how individually qualified by my privacy, is together with other bodies in the humanized world. It is clothed, moves about, and is credited with viable rights. With other human bodies, it is also encompassed by and subject to a group, union, society, and sometimes a state. Custom, tradition, and morality define what it is permissible

for me to do there, without any decision being made as to whether or not my body is individually possessed, controlled, or guided.

The object of publicly-accredited rights, my body is sometimes required or forced to act in ways that go counter to what I privately endorse. Often enough, I am held accountable for what my body is credited with being or doing, whether or not I or it has in fact initiated anything. Sometimes I am held accountable for something simply because that is the outcome of usual ways for determining accountability. I need not have initiated anything; it is often enough that I have been identified as an appropriate terminus for impersonal, established procedures for distributing punishments and rewards. Generals get medals for battles won while they were asleep.

While never able to dictate all the ways the body functions, each one of us lives his as a distinct, possessed body, and helps determine how this will contribute to and help constitute what occurs in the humanized world. Each of us tries to get his body to fit more or less well in that world. Without losing the qualifications to which it is individually subjected, his body will continue to act in ways that are determined by what it contains, and by the humanizing constraints to which it is also subject. Each of us is expected to act in ways that may not comport well with what could be justified, or with what may have been insisted on privately.

One's body is one's own. Because it is also subject to more or less imperious demands in the humanized world, it is also a socialized body. Few ever make a detectable difference to it as a member of that world. Some, though full members of that world, may be ignored because they do not fit in well with the rest, are not conspicuous, or not threatening; some may be made the object of constraints simply because they speak in an unapproved way, have an unacceptable ancestry, follow strange customs, carry out odd religious practices, or have an unacceptable appearance. There are no interchangeable commonsense men, always doing the same things, speaking a common language in exactly the same way. Conformists conform more or less; deviants deviate only here and there, at certain times and places.

Human bodies are agents of individuals. They are partly controlled by the individuals' characters and are interinvolved with the privacies of those individuals. All those bodies are thereby qualified, with much in them minimized or ignored, some parts or aspects concentrated on, and a few greatly affected. When a reference is made to a humanized body in speech, in the courts, or in the arts, it is quickly overlaid with qualifications, but rarely so completely that one cannot recognize that a body is possessed and used by an individual, making use of a character and privacy.

Freedom in the humanized world is limited in its expression and duration. A body there has many roles, usually carried out with little or no regard for what may be privately envisaged or endorsed. What that body contains, when its involvement with an individual is abstracted from, exists in nature, and, in still another way, in the cosmos. Individual persons, natural objects, and irreducible cosmic units are all presupposed by and utilized in the humanized world. All deserve to be understood as also existing outside it. That claim is inseparable from the acceptance of a plurality of distinct domains. That is an outcome from which thinkers past and present try to withdraw, or at the least to mitigate by placing different kinds of realities in a hierarchy, relating them as more or less good, intelligible, comprehensive, and the like. Yet, from the very beginning, in their distinguishing of mind, person, will, and the like, from what occurs in the humanized world, they have assumed a pluralism with themselves in one domain and humanized objects in another. A major difference between the present account and theirs is that the pluralism is acknowledged, its problems faced, and the pluralism recognized to contain members other than persons and humanized objects.

6

There were living beings with their ecosystems before there were humans, but we know almost nothing about what the first humans were like. If they existed in nature, they were, so far, beings in it. The status of individual persons, that they might then or later attain, and the humanized world into which they then or later fit, preclude their full presence in a world where they are together with other natural beings. Humans and some subhumans face the same breaking of dawn; they and other beings drink from the same stream; rain falls on all alike; the same boulders and canyons block the paths of all. Still, humans alone make these part of the humanized world. Since it is impossible for anyone today to take himself to be a part of nature, were in the way his remote ancestors did, we will never fully know who man is if we misconstrue when and where he is.

A common language is privately qualified and used within a part of the humanized world. If we take our stand with it, we will be able to talk about nature from a position outside it, but without thereby being able to enter it. Natural objects have their own distinctive spaces, times, and causal connections. Since nature is a domain into which we cannot enter, no one of us is able to observe anything in it, free from all subjectifications and humanizations. We could, though, still know that time, space, and causal processes have distinctive ways of functioning there. We could also come to understand what is in nature by seeing how what we observe in

the humanized world could be so transformed that it could be in nature. If we not only know what the transformations are and do, but can also participate in them, we can terminate in nature with what it accepts of the transformed content.

Were a single purposiveness, an outcome in nature toward which all activities tend without aim or desire, to be operative, what happens there would be geared to the production of something likely to occur. Were humans in nature, they too would be subject to such a purposiveness. Were there an overall evolutionary course or a power of natural selection operative there, the humans would then be subject to it, if only to reach the stage where they might finally escape from it. Any purposes they might then express, in which prospective outcomes dictate what is to be done, would not necessarily cancel or interfere with any purposiveness nature might exhibit. Before there were humans, there were just prospective futures, likely, perhaps alluring, but still impotent, none a purpose.

We initially become aware of natural beings when, in the humanized world, we analyze objects there, and distinguish factors due to humans from others that resist and interplay with these. We all took a while before we became aware that we were alive, with appetites and modes of action not reducible to what would be characteristic of beings in nature. No one of us lives the kind of life that spiders, flies, or tigers do, or prehistoric humanoids did. Separately and together, we—but not they—live in a distinct domain, not subject to the purposiveness governing natural beings, no matter how like them we seem to be.

Some cosmologists suppose that a cosmic singular time, a special cosmic space, and a distinctive kind of causality alone occur. Pragmatists allow only for those extensions that are operative in the humanized world. Subjectivists insist on them as occurring only in privacies. None can do justice to the kinds of extensions that are present in nature. In this, there is a primal voluminosity with different specialized spatial, temporal, and causal forms, each with distinctive unit magnitudes. One should not need poetry, story, music, dance, or other arts to alert us to the fact. Still, it is hard to know and hard to understand what in fact exists in nature.

There is nothing particularly daring in the affirmation that there are undivided extensions of various lengths in the humanized world. The writing of a letter takes up one such extension, cooking a dinner another, a war a third. Other, quite different, undivided extensions occur in nature. Budding, nesting, bonding, and hibernating need no humans to set their beginnings and endings; nor do evolutionary changes, species continuance, interplays with ecosystems, or protections against the elements. All allow for smaller spans to occur within larger ones. We have, though, no good warrant for supposing that there is a single span embracing the

whole of nature, any more than we have for supposing that there are only tiny unit ones, or aggregations of them. Nor do we have a warrant for supposing that there are extensions in nature that have no conceivable subdivisions. Yet from Democritus on, it has often been assumed that time is a sequence of distinct units of equal length, space a collection of unit places, and causality a series of little, equal steps. In any case, no matter how small the accepted units of extension, they have termini that are distanced from one another, and that function as constraining limits.

Recognition of the reality of different kinds of undivided spans is part of the understanding that there is a nature distinct from other domains. Purposed actions are grounded in individual humans, who give distinctive weights to accepted prospects. The course of a natural being, in contrast, may not only have limits further apart from those characteristic of a human purpose, but its prospective terminus lacks the fixity and insistence characteristic of prospects that terminate purposes.

Unlike purposes, which have prescribing futures, a purposiveness defines a direction it does nothing to promote. Kant knew this, and made the fact evident in his usual brilliant, original way. Yet he not only failed to deal clearly with the distinctive spaces, times, and causality that occur in nature, but did not take adequate account of the fact that there are different spans there, appropriate to different kinds of natural occurrences. Nature is the locus of the tendential. Not itself purposive, not carrying out any purpose, it provides frames within which various purposive activities can occur.

If one were to deny that temporal, spatial, and causal limits in nature have any efficacy, one could do no better perhaps than to follow Whitehead's lead and suppose that there is a cosmic pivot that makes it possible for the future to be in some accord with what has just been achieved. His was a backward-looking world, with a God who presented, to whatever occurs, a possible future it otherwise would not have. To be, for Whitehead, was to perish, though not without providing the supposed God with promptings, making it possible for there to be new realities that inherit the old, in some accord with divine, benign suggestions. Obligation, misery, evil, bad habits, confusion, have no place in that account. The beatifically innocent, at last, have a philosophy.

Nature exhibits many spans, leaving much room not only for conflicts, irrelevancies, and discontinuities, but for organisms, the inorganic, and groups to live within their own spans on their own terms. To understand it, we need make no reference to a powerful, two-faced God who sees to it that the future will be in some accord with the past, any more than we need to suppose that there is a powerful final prospect pulling everything toward it. Extensions in nature have limits, enabling what is within those

limits to act in accord with others that are also there. They preclude neither spontaneity nor occurrences monotonously following one another.

We are tempted, again and again, to deal with what occurs in nature as though it were a variant of an occurrence in the humanized world. Again and again, we also take ourselves to be just natural beings, clearly or obscurely doing nothing more than preserving our species within an apparent or innocuous culture, history, or political organization. At times we take ourselves alone to be truly humanized, and treat all else as affected by us culturally, historically, or politically. Without the contributions of humans, natural beings could not be part of the humanized world; it is no less true that without them, neither would we. Humanized realities are the joint products of humans and non-humans, both existing in domains of their own. Some of those humanized objects are then overlaid with new humanizations, due to the humans alone.

Dewey, despite some slippages here and there, seemed determined to hold that there were only humanized objects, denying that these were the products of contributions from humans and objects existing in separate domains. Such a position ends in a contextualism, in which there are terms but nothing terminated at. Inevitably, it has those terms pulled into the relation that was supposed to connect them, while they continued to remain apart from it. Once it is recognized that the members of the humanized world are themselves separate from and interconnected with one another, it is but a step to recognize that those members are themselves the outcome of a joining of other kinds of realities. As components of humanized beings, those realities are irreducible; it is only as existing in domains of their own that they are irreducibles, able to be combined to form more complex realities there.

Sexual urges, changing seasons, the different needs of the young and old, male and female, the strong and the weak, the diverse circumstances faced by those who live in the North and those who live in the South, in the plains or on the mountains, by the sea and in the desert, all make a difference. The fact can be known, of course, only if what is entertained can be brought to bear on what exists apart from any such entertainment, and therefore if there are effective agencies that connect what occurs in one domain with what occurs in another.

To know what is a part of nature we must be able to know what it is as apart from all humanizing conditions. When and as we do this, we are in a position to know ourselves as we too are, apart from the humanized objects to which we and natural objects contribute. Nature at times plays such a great role in the constitution of humanized occurrences that humans are readily credited with making only minor contributions to it.

We open our umbrellas, but the rain still keeps coming down. As members of the humanized world, we remain dry, all the while that the rain falls, indifferent to our concerns and efforts. Even when we humanize the rain's natural course, the rain continues to be in nature. Like ourselves, the rain is in two domains, one in which it is together with other realities all subject to the same dominant natural conditions, and the other in which it is together with us in a distinct, humanized world.

We have good reason to believe that something like humans was once a part of nature. Humans were then not able to engage in any humanized or private activities. Unfortunately, it is not now possible to determine just when some such human-like beings escaped the tight grip that nature had on them and others. Whether accompanied or caused by their use of tools, attachment to prospects, ability to speak, a concern for others, acceptance of ideals, participation in religious rites, or their formation of societies— the first humans were not involved with these in the ways in which we now are. In the end, we have to be content to speak of the origin of humans at some arbitrary time, identifying as our ancestors only those who were human. So far, they will, with us, be understood to be part of a single, ongoing humanized world. Any prior humanoid beings would be wholly in nature. The only past living beings who were humans were members of a humanized world.

Occurrences in nature are extended temporally, spatially, and causally, with the two ends of the extensions referring to one another with varying degrees of insistency in different situations. Different kinds of occurrences there have different ranges. Birds produce eggs that may become birds in one type of extension; oaks produce acorns that grow into oaks in another. When we privately qualify either of them, or subject them to humanizations, we add new determinations, while more or less neglecting the natural ranges.

The fact that various kinds of occurrences occupy different extensional spans in nature does not preclude their being contemporaries, subject to different kinds and degrees of constraint, and needing to fill out different extensional blocks, in order fully to be. A contemporaneity, expressed by a line cutting across the different, temporal extensions characteristic of particular occurrences, is an abstraction, only imaginatively slicing through different, extensional spans. Each span is an undivided extension, within which such lines—or more precisely, an endless number of them—provide impotent cross sections.

The sequence of butterfly/caterpillar/butterfly is different from the sequence of oak/acorn/oak, both in space and length. Each sequence has its own distinctive beginning and ending, intruding on what occurs in between. Each stretch is a singular, allowing no subdivision to have a

separate status. Longer stretches may provide effective termini, but they need not then deny full, independent status to the stretches they encompass. A butterfly and an oak may be in their different spans at the same time. A reference to that common time, or to other different times, is made from outside both spans, expressing nothing more than the fact that both can be crossed by the same lines. Just as there is no need to suppose that there are common, unit intervals of time, setting limits to the existence of all actualities, so there is no need to suppose that there is a single stretch beginning at some first and ending at some last moment. The longest stretch is provided by nature in the form of a distinctive tendency marking out a singular epoch.

What holds for undivided spans of time, holds also for undivided spatial and causal spans. The locale of one group of living beings occurs within the compass of an enclosing space where those beings interplay with one another, their food, and their enemies; a purely neutral space in nature is an abstraction indifferent to the spaces that are actually occupied. Similarly, the causality over which common demands are expressed is a singular. It can be subdivided only by abstracting from its involvement with different natural beings, having futures affected by their pasts, as well as from pasts that continue to play a role in the present. As a game makes evident, one can apply the idea of single, undivided extensions to occurrences in the humanized world. In that world, though, limits are set by humans; in nature, they fit inside long-ranged tendencies. Time, space, and causality are not detached from one another. They occur together. It is when and as realities occupy a spatial region that they carry out acts over stretches of time. Were there an operative species to which all beings of a certain kind were subject, these would still act out their own lives on their own terms.

Might not nature be only a part of the humanized world, arbitrarily supposed to exist apart from this? If it were, nature could not exist before there were humans, and there might be nothing to be humanized. Objects could be known as they are in nature if they could be separated out of what is of the mind or what is in the humanized world, or if what is in neither could be transformed into what is in nature. The Kantian system ends frustratingly staring at such a prospect, since it confessedly cannot know what exists apart from our knowing and, therefore, what could contribute to it. It could have escaped that impasse had it taken account of both adumbrative and discerning acts, that intensively reach more and more into richer and richer depths of confronted actualities, as well as of mediators that make it possible to pass from one domain to another.

Are there not bodies within us, having their own courses? Yes. Do not all complex bodies contain units, cosmic ones? Yes, but so far as anything

exists as part of some other, it is subject to qualifications by what contains it. It may still have an existence and boundaries of its own; its rate or type of movement may not be altered. It will nevertheless be qualified by what encompasses it. This may impose constraints on its place, time, action, and import.

One day, when my children and I went shopping together, a friend joined us. When we turned in at the store, he did not. He had been strolling. Although his stroll coincided with our walk for a while, it had its own beginning and end. My children and I, while living our own independent lives, walked together in a way that coincided for a while with the stroll of our friend. He fitted the walk to the store within a single undivided time, while my children and I, severally and together, filled out another, smaller, undivided time. The terminus of our walk to the store coincided with an abstracted part of our friend's stroll. He and we were contemporaries during the entire walk, but when my children and I arrived at the store, our contemporaneity with him was seen to be no more than an abstraction from different acts. He turned that terminus into an idle line across his stroll. There would, of course, be nothing amiss if, instead of referring to such a line, reference were made to a short extension, perhaps one encompassing our leave-taking, just as long as this was seen to be a common, abstracted part of our different spans. The illustration offers a faint, humanized counterpart of the ways in which different natural spans are related.

Why should we not, instead of making these distinctions, just follow Wittgenstein and suppose that there is nothing other than a humanized world in which we might live, but which we cannot understand or justifiably dissect? Might not all uses of 'I' or 'we' be vain attempts to point beyond our language? If so, no one could properly claim to know the fact, since such knowledge requires one to stand apart from the language. While able to use a common language, we would not yet be able to say anything intelligible about our uses of it, about ourselves, or about what might exist apart from us. Nothing would be known that was able to resist or affect us, or anything about us, who used the language. There would be no long-range tendencies, or astronomical bodies yet to be discovered. There might be rituals, but no acts of faith. Nothing would be hidden; instead, everything would be an actual or readied item in, but never for, a language.

Some of the more developed animals are sometimes said to realize purposes when they attack, hide, or retreat. If they did have purposes, they would still be in a subdivision of nature, and those purposes could qualify a natural purposiveness. Humans, in contrast, are known to have purposes, but there is no evidence that they are subject to a common

purposiveness. The human young often are among the most neglected of living beings; those who are able to be reproductive are sent off to the wars. Hormones play a role, but individual persons often decide whether or not they are to have successors. A descent of humans from non-humans does not necessitate that the purposiveness, that may have operated in the latter, will continue to operate in the former, even in an altered form.

Although purposes, a purposiveness, and tendencies are causal, spatial, and temporal, they differ in their emphases on these. Purposes are primarily causal, with actions geared to realize an objective; a purposiveness is primarily temporal, with a prospective future serving as a guide; tendencies are often spatial, emphasizing the area within which prospects are to be realized. In all, extensions function as conditions within whose compass particular activities are ordered. When any actuality in any domain dictates to its parts, we have a variant of the kind of purposiveness that characterizes the way in which some of them act over extended stretches in nature. The parts are not then deprived of their ability to act on their own. Although the dominance of a whole may make it easier to complete an act, it cannot assure that this will occur. The proper functioning of bodily organs and the actions of cosmic particles limit what an organic body can do, but that body has its own ways of functioning, with its contained bodies both qualified and qualifying, limited by and limiting it.

7

Before there was a domain of natural beings, there was a domain containing unit bodies—a cosmos. This undoubtedly will continue to exist long after nature—and the humanized world, and humans—is no longer. Speculative scientists try to understand that cosmos by building on occurrences which evidence and theory enable them to focus on, preliminary to the formulation of a justified account of what unit bodies are and how they act together. Their theories sometimes are tested in crucial experiments, with special attention being paid to unexpected results, and to indications of the shortcomings of prevailing views. These, though, are not major matters, it being the primary intent of the investigations to point up occurrences requiring a new understanding of all unit bodies, as separate and together. The needed alterations may sometimes require such radical changes in the dominant outlook that it would be right to speak of the result as initiating a revolution, beginning a new era. Arresting and well-focussed outcomes, certifying as well as requiring fresh ways of speaking of what occurs, offer certificates of respectability for new cosmological views. New accounts of the nature of space, time, and

causality, separately and together, may then have to be produced, so as to accommodate the kind of coordinations that the new understanding requires.

Some philosophies try to do maximum justice to what is supposedly known by scientists of occurences in the cosmos, so far as this has been evidenced by what experiments reveal, and what a coordination of unit bodies requires. Their accounts build on the latest deliverances of the sciences. Had it been their primary concern to understand what is in other domains, they would have had to do something different, for no cosmology can do justice to persons, to what occurs in nature, or to what is in the humanized world. Before one can use what is in the cosmos, one must first get to it, and then reverse the move, in such a way that one comes back to oneself as apart from it. No experiments reach bodies as they exist in the cosmos; all are carried out in the humanized world, and end with what is necessarily humanized.

Cosmic units, though existing apart from and prior to what occurs in other domains, also exist within complex bodies in other domains. Those units are qualified by what contains them. Each is a body. Not being in nature, it could not have the same kind of career that a natural object has, or be subject to the purposiveness that operates there. We will not be able to justify the claim that a cosmic body resists and insists, interacting with other unit bodies, not until we learn how to reach it as it exists in the cosmos. Dependent as we are on instruments, theories, and perhaps recondite mathematical creations, and subjecting what we confront to multiple, unnoted humanizing and privately controlled determinations, we can do no more than produce theories of what unit bodies are and do, and then try to terminate at them, with the help of agents bridging the gap between what we entertain and what exists in the cosmos. Crucial experiments will again and again require the formulation of new characterizations of the unit bodies and the ways they are together.

Since the cosmos could exist before all other domains do, and since every body in the other domains contains and is affected by cosmic bodies, it is easy to see why astronomers and physicists take the cosmos to be the primary, or even the only domain. What is surprising is to find philosophers accepting that view, and then trying to build comprehensive systems on it. Whether or not what scientists affirm is just accepted or modified, too little is known about the cosmos to justify saying much more about what is always true of it than that it existed before other domains did, that it contains coordinated unit bodies and that its bodies contribute to the complex bodies that exist in nature and in the humanized world. We would gain nothing and lose much if we took a different

tack, and treated the cosmos as though it were merely imagined, or was only an abstraction from the humanized world, since, among other things, we would then be unable to provide an adequate explanation of the fall of bodies, or of the changing positions of the sun or the stars. If all that we were seeking to understand were the cosmos as a domain with its own distinctive units, able to contribute to the bodies in nature, the humanized world, and individual persons, we would need to consider nothing more than what it might contain, and what it might control. Did we wish to account for the members of the cosmos, we must go further, and attend to what is outside this, just as surely as we must when we seek to understand the members of other domains.

When I walk to the door, I make the cosmic unit bodies within my body move in a direction and at a pace they otherwise would not. When cosmic bodies are in complex bodies in other domains, their acts are also qualified by what contains them. It is only as members of the cosmos that all unit bodies are able to act in the same ways under the governance of the same ultimate Coordinator, which dominates over the other ultimates in every cosmic unit. The others are dominant in other domains. All are beyond the reach of categories or formulae. To know any, one must begin with it as instantiated with other ultimates, in a distinct order in some domain, and end at all of them as not instantiated but alongside one another. One will then have carried out an act of evidencing.

Were there only unit cosmic bodies, it would, of course, be improper to say that there was a sun, moon, or stars. Instead, we would have to say that these were made up of unit bodies, so joined that they seemed to be on fire, millions of miles away. At the very least, we must take astronomical observed realities to be in nature, containing cosmic unit bodies in great agitation. Might not some unit bodies be so affiliated with others that they constitute complex cosmic bodies? If they could, such complex bodies would not only encompass unit bodies but would be so subject to other conditions that what had been just aggregated units might be radically qualified. Unit bodies might then be members of a single cosmic aggregation, with pockets here and there containing assessed, affiliated, or extensionalized units. The sun, moon, and stars would then, as aggregations of cosmic bodies, be subjected to conditions other than the Coordinator.

Our machines act in accord with physical laws, at the same time that they have the status of property in the humanized world. As merely physical, they are aggregates of unit, cosmic bodies; as in the machines, they may also be subject to what is done to or by the machines. Since the machines are humanized, the units in them will also be subject to

determinations that cannot be accounted for by knowing only what they are and do in the cosmos. We buy, sell, and use machines, not bundles of cosmic bodies.

The currently agitated question, whether or not complicated machines, such as computers, can think, refers to them as members of the humanized world. As existing there, those machines can be characterized in any way we find agreeable. We can say, if we so wish, that they feel or hope, just as some now say that they think, for a supposed thinking is no more evident than a supposed feeling or hoping is. If a machine's operations end with the same results that arithmetic operations do, we may say, if we wish, that the machine can add, subtract, and so on. If it were geared to present the words of an oration or a prayer, we could, with equal warrant, say that it orates or prays. All the while, it would be in the humanized world and contain cosmic units. We grant the humanized world too much power, though, if we assume that it plucks out some cosmic units, and then subjects them to humanizing qualifications. Cosmic units continue to be in the cosmos, even while they are subject to other conditions in other domains.

8

Actualities, no matter what the domain, are constituted by specializations or irreducible factors. These meet at their nuances, and thereupon produce what exhibits all of them, with some one in a dominant position. 'Ultimates,' I term them. In the past, I have referred to them as 'modes of being'. More recently, I have spoken of them as so many transcendents, while distinguishing them sharply from the ideals of the good, the true, and the beautiful, with which some medievals confused them. The changes in terminology reflect gains in insight and understanding.

The ultimates are realities; ideals are prospects. The first are instantiated together; the second are the first as converging at a common terminus, able to be separately filled out, enriched, given content, on being made present and determinate. The ultimates do not overlay or organize a passive matter. Ordered in a distinctive way, they jointly constitute confining natures in a domain, and are there possessed by singular beings.

There are two ultimates—the Rational and the Dunamis (from the Greek for potentiality, power, and dynamism)—that are always submerged in the constituting natures of every actuality. They alone, though, have dominant roles in the evidencing of all the ultimates—and therefore of themselves—as well as in all passages from members of one domain to

those in another. They cannot, therefore, be known in the same way other ultimates are, by attending to the dominant contributor to the nature of actualities in a particular domain.

The Rational is intelligible and structuralizing; the Dunamis is pulsative and vitalizing. In the absence of the one, there would be nothing intelligible; in the absence of the other, there would be no ongoings. Their submergence in every actuality makes evident that both formal and dynamic accounts of actualities presuppose an inversion of the order of constituting ultimates in other domains. The two are properly to the fore only in references to evidencings, and passages from one domain to another.

Where most Westerners are inclined to overlook the role of the Dunamis, most Easterners are inclined to minimize the role of the Rational. Transience baffles the one, intelligibility the other. They agree only in their neglect of the other ultimates, with the consequence that they are equally unable to understand the distinctive natures of the members of different domains. Rational structures are dunamically quickened; dunamic moves fit inside steady intelligible settings. Stability and fluidity benefit one another to produce what is both meaningful and ongoing, intelligible, and in process. Because they also constitute primary mediators, they make it possible both to evidence all the ultimates and to move from one domain to any other.

Hegel boldly took the Rational and the Dunamis together to constitute powerful negations. He should also have distinguished the two, and recognized that sometimes the one and sometimes the other may have a dominant role. He also supposed that there was an Absolute Mind or Spirit that so expressed itself that the history of mankind was necessarily displayed—a view that required him to ignore stagnations, backtracks, and mixtures. Sometimes, too, he seemed to take the dunamic side of things to be produced by and eventually to end in the Rational. Yet the Dunamis, as a distinct ultimate, is needed, if there is to be anything produced or arrived at. Since Hegel had no place for contingent occurrences, he also had no place for what might instantiate his categories in ways those categories could not determine.

There are four ultimates in addition to the Rational and the Dunamis—the Affiliator, the Assessor, Voluminosity, and the Coordinator. The Affiliator is dominant in the humanized world, the Assessor in individual persons, Voluminosity in nature, and the Coordinator in the cosmos. These, and the Rational and the Dunamis, are presupposed and evidenced by every actuality, no matter what the domain. We come to know them by moving intensively from the essential constituents of actualities to them as

existing apart from those actualities. We will then find it possible to return to the actualities and understand them in a way they could not have been understood before.

That there was not only an upward movement to what necessarily is, but a downward one as well, to where we had begun the first, was long ago recognized by Plotinus. Later thought replaced his three-step downward passage from a primal reality with the idea of a creation for whose operation it could not account. It was easy then for those who did not care for mysteries to neglect the downward movement altogether, and thereupon find no reason to carry out the upward movement. Both Plato and Hegel began with an upward movement, but ended with what was not shown to be able to begin, or carry out a downward movement to where the upward movement had begun. Peirce took some account of the issue in his theory of abduction, the process by which one reached a hypothesis about what might be encountered, but he overlooked the fact that hypotheses could never terminate in anything distinct from them, unless there were some agency that carried the hypotheses toward what in fact occurs independently of them. Whitehead is one of the few in modern times who recognized that there was both an upward and a downward movement to and from what he called 'God', but he failed to show how these were connected, or how one could come to know that God. If there is an intelligible termination in a final reality, there should be another intelligible termination in that with which one had begun. The different beginnings and terminations need to be distinguished. They are complementary.

A good understanding of the passage to and from a final reality requires an understanding of the ultimates. These have at least four roles: (a) All are presupposed by each actuality, no matter what the domain; (b) all are sources of the essential constituents of every actuality; (c) all are together; and (d) all presuppose a single, common source.

(a) Each actuality is constituted by all the ultimates in diminished forms. Each of the actualities exists because the ultimates have come together to constitute specialized, limited versions of themselves, with a distinctive ultimate dominant in all the members of each domain. We reach those ultimates through a dunamic, rational, intensive, evidencing act, more and more controlled by that at which it arrives. The move does not traverse a space, arrive at what is past or future, or produce what it terminates at.

(b) The ultimates are realities. Evidencing reaches them from what they had constituted, ending at them as so many distinctive powers able to combine in many ways. Joined, they together constitute actualities; as singulars, they constitute fields in which those actualities are together;

converging at a common point, they constitute ideals grounding the more limited, specialized prospects to which creators commit themselves and which they try to realize. Possibilities are abstract versions of them.

(c) Logic, for Aristotle, was an agent for making discoveries, providing means for improving our knowledge of nature. His view must be modified if it is to be appropriate to what occurs in other domains. However, no set of rules relating variables that are able to govern any value whatsoever could do justice to what occurs in different domains. What is supposedly appropriate to whatever happens anywhere requires that some ultimate be dominant in all domains. Though all ultimates are present everywhere, they are all subordinated and qualified in distinctive ways in various domains.

(d) Presupposed, part of a single eternal set, no one ultimate, or any number or kinds of them, is necessary in itself. Just as actualities are the outcomes of the joinings of all the ultimates, so the ultimates themselves depend for their reality on a final Being beyond all of them.

[This, for me, is a belated discovery. I was once (in *Modes of Being*) content to stop with an account of the ultimates (there, badly misnamed), to leave unanswered the question of whether or not they had some common source or ground. The attempt made there to solve the problem of the one and many, moreover, was not well-joined to the rest of the work.]

No account can be complete if it does not deal with the source of all the ultimates. Only then can it make evident the essential constituents of every actuality. Only then can it show why there are actualities, and how they can be in different domains and yet be related to one another.

<div align="center">9</div>

Being is the immediate source of the ultimates and the mediated source of actualities. Beyond it, understanding cannot go. Sometimes it is said that Being—often beatified as God—is the necessary outcome of a singular possibility, the possibility of that which cannot be. But if a mere possibility, no matter how splendid, could necessitate what cannot not be, something necessary in itself would be dependent on what was at best devoid of power.

Being could not be dependent on anything, unless itself provided this. It could be possible only if it produced that possibility, and whatever is needed to sustain and refer this to Being. That is why Being produces the ultimates, when and as it is. In their absence, there would be no possibility *for* Being, maintained apart from and referred to it. In the absence of the ultimates, Being would not be possible. Being enables itself to be possible,

when it is, i.e., always. It can be known because it makes itself to be known.

Being produces the ultimates to act as its agents. This they could do only if they were given a distinct status and, so far, could act on their own. Contingency necessarily enters into the scheme of things because Being requires the ultimates to exist in contradistinction to it. Those ultimates might have had different natures and could have been more or less than six in number. Necessitated to be by Being, they nevertheless might have been other than they now are. Able to constitute actualities, they might not have done so.

How is it possible for what is necessary in and of itself, and does only what it must, to produce what could have been otherwise, and nonetheless carry out other acts? Until that question is well answered, the existence of actualities that need not have been, and the number and kinds of ultimates that might have been otherwise, will stand in the way of our knowing primary truths, presupposed by all others.

Were the possibility for Being a floating, pallid, abstract version of Being, it would not be apart from Being and be able to be referred to Being. Being necessitates that there be ultimates, so that there be what both sustains Being's possibility and has this referred to Being. Since those ultimates are necessarily granted a status of their own, they are able to act in other ways as well.

Having necessarily produced them to act on its behalf, Being continues to treat the ultimates as perfect agents, doing what Being requires. When the ultimates jointly constitute actualities, those ultimates necessarily convey Being beyond what they constitute, and thereupon enable Being, in a limited form, to possess, use, and act independently of those ultimates. If they could not convey Being within the confines of their joint instantiations, they would not function as Being's perfect agents.

Were there no perfect agents that always and necessarily, yet freely acted on behalf of Being, Being would not even be possible. Since the ultimates are not only produced by but function as perfect agents for Being, they will do what Being requires them to do, when they independently constitute actualities.

The ultimates need never have produced anything. Having produced actualities, they might cease to do so. Since they are Being's perfect agents, when and as they act independently of Being, they will necessarily enable Being to achieve a position within the confines of whatever those ultimates might jointly constitute. As a consequence, the independence that the ultimates exhibit when they constitute actualities and fields is matched by the possessors of those ultimates, by Being conveyed to the actualities within the limits constituted by the ultimates.

10

Being has an intensive substantiality, as surely as actualities do, but it does not express itself through appearances. One with a mystical vision, or one who has a justified faith, may claim that God is the inwardness of Being, able to express Himself through Being and, thereupon, produce not only the possibility of Being, but the ultimates, and all else as well. No one can demonstrate that this does nor does not occur. Nor can anyone prove or disprove what is accepted on faith. No one, not even the greatest of philosophers, knows whether or not a religious man's faith just satisfies him, or is in fact satisfied. Where there is no reason to affirm or deny, one should remain silent. No theology is able to help a philosopher, for it presupposes deliverances and assurances whose warrant and reception is beyond the reach of his study. Theological claims about what a faith does or does not do, or the way it is received by a God, articulate a hope or a fear, usually by so tailoring philosophic truths that a subjectively acceptable clarification of the nature of the supposed God is achieved. Theologians tend to dress their God in ill-fitting clothes, sometimes borrowed, and sometimes stolen from philosophers.

Were there a God within Being, He would express Himself in and through it on His own terms. He would add, to what we know or could know of Being, a possible rewarding acceptance of a faith in Him. There might well be such a God, but we will not be able to know there is one, unless He breaks through Being to act in His own way on what else there be, or unless we can somehow break through Being and make some contact with a richer, more powerful, independent reality, more than Being itself, and therefore more than what can be known. To be able to get to it one needs a faith, but if one has a faith one does not yet know what is arrived at.

11

If we are to benefit maximally from other actualities, these must be both subjected to our determinations and be accommodated by us. Did we wish to become most fully enriched by Being, we would have to be acceptive of it, as actualities who had already managed to fit in well with other actualities. If, instead, what was sought was a maximization of our status relative to other actualities, their distinctiveness would have to be respected while Being was accommodated. Over the course of a life, sometimes the one and sometimes the other needs to be stressed.

A fanatic and a romantic are both inclined to forget that a full involvement with Being entails a neglect of other actualities. As a

consequence, actualities will not be adequately controlled, beneficially used, or properly helped. Evil-doers, instead, concentrate on achieving a mastery of other actualities, but at the price of denying them integrities of their own. They are unwitting slaves of Being, overwhelmingly obligated the more surely they insist on a supposed right to use all else as they wish, while those who try to keep focussed on Being have to depend on others to keep them alive. Both are in disequilibrium, often believing that they are well-focussed because they are blind to the fact that they have unreflectingly and overwhelmingly obligated themselves.

A Nietzschean superman frees himself from unnecessary and often debilitating limitations, but forgets the obligation this entails. Such a superman is an oriental sage disgusted with the ways men behave, but unwilling to pay the price their improvement demands. The freedom at his center is just like ours, able to be used in biased ways. Like the rest of us, he should overcome what unduly hinders, but then, like us, he must pay the price of being obligated to make good whatever losses he produces.

12

The present work begins with an examination of the humanized world, and then moves on to consider individual persons, natural beings, and cosmic units, each in a domain of its own. It then faces the problem of how one can pass from one domain to another, attends to the ultimates that all actualities presuppose, and arrives at the Being that necessarily is. It then takes account of the fact that Being necessarily produces the ultimates, and how these can jointly produce the actualities at which one had begun, as well as others existing in other domains. At its end, it opens up the question of whether or not it could be lived.

I hope that this work will prompt other inquiries and that these, at the very least, will provide checks on and clarifications of what is here maintained. Best of all, I hope it will prompt others to move further along the road to a comprehensive view that is able to be enriched and subtilized beyond any pre-assignable limit.

1

The Humanized World

1. Common Acceptances

We come naked into the world, without ideas, remembering little, if anything, and expecting nothing. Some habits were acquired during our embryonic lives, but we then had not yet learned how to make clear or effective distinctions. Initially doing little more than living through a darkness and a sudden light, felt silences and heard sounds, pressures and pulls, we began to form some other habits, felt some new pains, enjoyed some new pleasures, and experienced some of the consequences from our overcoming of unnoted tensions and our meeting some pressing needs. At the beginning of our lives with others, a figure or two soon loomed out of an inchoate background, overcoming some of our vaguely located distresses and satisfying many of our demands. Unless we were seriously disadvantaged, we slowly but surely acquired a better control over our limbs, mouth, and eyes, and soon after achieved some mastery over some bodily functions. As a consequence, we began to act with increased independence, accompanied by a growing awareness of ourselves as having distinctive bodies and privacies. Through the use of fragments of a common language, we were soon able to make evident what interested us, accompanied by a growing awareness of ourselves as distinctive and apart, while also occupying a place alongside, and carrying out roles together with others. Again and again, we were frustrated, challenged, and defeated, unable to do exactly what was required by circumstance or by others, within areas that were neither well-mastered nor well-understood. Those of us who were well-guided were soon able to continue and prosper without much guidance, though the familiar was constantly intersected and intruded on by the unfamiliar. All the while, we acted somewhat like

accepted aliens in a realm where others seemed to fit in very well, and which they apparently controlled. We got to know our way about in a limited but not well-bounded part of a larger world, containing many objects and exhibiting many turns we neither understood nor mastered. Most of us were normally treated as alongside others, usually to the degree that we managed to fit well within a common context. There, too, the stable and the usable were mixed in with the transient and frustrating. Usually, we sorted them out, occasionally discovering that some had been qualified by the practices of those who preceded us, as well as by those who were in controlling, pivotal positions.

We do not often think about the world in which we live, use a common language, accept established customs, and ready ourselves to realize a common future. Usually, we are content to live in consonance with others, and particularly those with whom we constantly interplay. Most of our lives are spent in a rough-hewn, commonsense area of the humanized world that becomes better known and better lived in, the more mature we become. Some of us are prompted to reflect on life's nature and course, particularly when we are blocked, baffled, or otherwise made aware that we, and perhaps others as well, have allowed beliefs, hopes, desires, and needs, as well as what had been and what is expected, to distort what is present or prospective. Defeats and frustrations prompt most of us to move back for a while from a participation in that world, to prepare for a better mastery of a part of it. Uses of common terms, and other established practices will then be modified. Quite soon, we will tend to act as rough-shod Aristotelians, distinguishing the obstinate presence of things from their intelligible, communicable natures.

Experience, tradition, myths, customs, beliefs, hopes, and fears qualify what we confront. Many try to distinguish the different contributions these make to what seem to be impersonal, independent occurrences, but most of us, most of the time, are content to accept as correct what is established, or what others insist on. As time goes on, we will add our own qualifications, without ceasing to credit what is faced as obdurate and external with a status demanding understanding, and often, some respect. Defeats and frustrations prompt most of us to move back from a full participation in the world about, sometimes to enable us to act more effectively than we otherwise could. Use of common terms and other established practices will then be modified, usually in little, hardly noticeable ways. It does not take long for most to note signal differences between humans, animals, other living beings, and what is not alive, but many will be content to attend mainly to what satisfies, invites, frustrates, endangers, or even goes its own way, if this seems to have some relevance

to our continuing welfare. The commonsense world, nevertheless, is too overrun with superstitions, unexamined assumptions, and special interests to allow anyone to accept it without question. Everyone adds refinements, usually in good accord with prevailing views and approved practices. Few know what these are, unreflectingly allowing custom, approvals, disapprovals, admonitions, habits, beliefs, and experiences to guide them.

Again and again, everyone finds himself somewhat at odds with others. Without altogether abandoning the acceptance and activities that allow them to fit well with some, particularly those nearby and familiar, reflection will compel most to stop every once in a while, to consider what would occur were they to act in other ways. No recourse to a common tradition, language, or morality will enable them to do much more than to fit a little better into some limited segment of the humanized world, and then only fitfully and for limited times. What is in that world is constituted by what originates in nature and the cosmos, joined to what humans produce. The product is soon overlaid with other qualifications, and that outcome with still others. It is not easy to get back to the original joining of human and non-human contributions; it is still harder to see just what these were as apart from one another.

All our studies begin inside the humanized world, or in the rough-hewn commonsense world, of which the humanized is a refinement. The two are not well marked off from one another, or well-defined. In both, we separately and jointly define the nature and import of what is encountered and surmised. Not well defined, or always clearly marked off from one another, we and other members of the humanized world are all irreducible realities, though containing what originated elsewhere. In that world, the sun moves from East to West, shines bright at noon, and sometimes ends in the explosion of a glorious red. It is there that we come to see that there must be other domains, having their own distinctive members, particularly when we realize that what is in the humanized world is the product of a meeting of contributions from man and what exists in nature and the cosmos.

Thanks to Peirce and Dewey, many have come to see how important it is to think, speak, and act in accord with what occurs in the humanized world. The limitations of the view do not become apparent until one tries to account for private decisions, creativity and its products, inviting ideals, what is always presupposed, and what exists before there are any humans. Pragmatism does less than justice to what has been preserved but which does neither much harm nor good. Yet what does not contribute to a better mastery of the humanized world is not necessarily meaningless, idle, or distortive.

Allowing for no transcendentals, pragmatism precludes all knowledge of the essential constituents of every actuality. Nor does it know what to say about a God that some take to be concerned with more than humans and their affairs. It takes pleasures to be surplus values, or gratuitous gifts. For it, tragedies are grave disappointments, and comedies no more than occasions for refreshment. Noble but futile sacrifices baffle it. What does not promote success, harmony, democracy, or peace, it takes to be just stimuli prompting one to do better than one had. Speculation and a search for what is final and always presupposed are rejected as futile, unless perchance the pursuit happens to enrich daily life. Acutely aware that a philosophy should be lived, it has little time for, or interest in, providing a sound comprehensive view, and then trying to live it. If a number of men act well together to overcome obstacles, it is assumed that they will enrich what occurs in the humanized world, and thereupon enable all to live well, and perhaps splendidly.

Pragmatism has laudable aims; it is also utopian and quite limited, failing to take account of what must be added in order to correct what practice inevitably omits or distorts. It would be more reasonable were it more modest. In its present form, it risks sacrificing the rational for the efficacious, preconditions for the conditioned, the languages that people actually use for a language of mankind that no one speaks. Priding itself on its catholicity and flexibility, its this-worldly attitude, and its rejection of academicism, abstractions, the imaginary, the futile, and the speculative, it is singularly obstinate in its rejection of realities that humanized objects presuppose, and in its attempt to translate knowledge about what is in other domains into variants of what occurs only in the humanized world. It has no interest in learning about what necessarily is, or in knowing whether or not this would justify other views to the same or perhaps even to a greater degree than it justifies the pragmatic.

The world in which humanized objects are is neither well-knit nor steady. Overrun with novelties and singular occurrences, it easily escapes the grip of views that are concerned with realities only so far as they promise desirable outcomes. Only if we attend to what is outside the humanized world, will we be able to come back to it with a good understanding of both its wealth and its poverty. The best form of pragmatism will encourage the pursuit of non-pragmatic objectives, if only to enable it to become more at home in, and be able to master, crucial turns in the humanized world. Inevitably, it too will both fail to do justice to what is in other domains and be unable to explain how there could be an occupied, humanized world, containing much that is useless, banal, mechanical, and trivial. Since these often provide needed resting points between the impersonal and the personal, it is as wise to ignore

them as it is to ignore commas in writings, rests in music, or pauses in replies to challenges. Since a view that is occupied only with what is in the humanized world can never be more than a fragment of a complete account, pragmatism compromises whatever plausibility it has when it pretends to be all-comprehensive.

Whether initially humanized, or overlaid with multiple other humanizations, what occurs is an undivided occurrence, with its own distinctive nature and course. When new humanizations are added, they become integral parts of what was already humanized. They will then, of course, affect a different kind of content from what the original humanizations did. Where the original individual contributions used natural and cosmic bodies, it is usually the outcome of the union of these that is subsequently united with what individuals may then provide.

A sealed-off, humanized world allows only for humanized beings, some of whom may make the humanized remark that only what is in that world exists. To know that what they maintain is true, they must be able to stand outside that world. Otherwise they would just say something there that would be no more warranted than was its denial. When we speak of all there is, our reference will, unavoidably, include a reference to us, as existing beyond what is being terminated at. No one of us could ever successfully maintain that only humanized beings existed without getting in his own way. The only intelligible form such claims could have is one that requires the acknowledgment of oneself as existing outside as well as inside the humanized world. Radical deconstructionists and other sceptics join pragmatists in quietly ignoring the self-annihilation contained in their claims.

We can escape the limitations of the humanized world only if we know what exists apart from it. Since studies carried out in that world involve an interplay of privately entertained concepts and already humanized objects, instead of enabling one to know the constituents of humanized objects, they put barriers in the way. Pragmatists and the others should be bolder than they have been. Instead of precluding a knowledge of what they and their objects presuppose, they should take both to be realities and then try to understand them. They would stop too soon if they rested with supposed items existing nowhere except in a language or a method. Gardens cannot be well understood if one treats them as places where one can plant only artificial flowers.

Did we wish to know why and what humanized objects are, we must, sooner or later, know what individuals, natural objects, and cosmic units are, and how they are joined. If we could not know that, individuals with their characters, privacies, and used bodies, as well as natural and cosmic beings, would be known by no one. There might then be nobody who

could be committed to carrying out an inquiry. Nor would there be any known natural beings or cosmic realities in domains of their own.

So far as a dog is treated as though it were just a natural being, it would be dealt with in abstraction from what it is as a pet, and therefore as humanized. As a pet, it has a primarily humanized status. So far, it will be affiliated with other humanized beings. The dog, of course, will not then be multiplied or divided. It is a natural being, just as surely as its ancestors were. While in the humanized world, it will continue to be a natural being, for it is only through the agency of another component that it has a place in the humanized world. Because the dog's a pet, it has relations to humans that it does not have as just a natural being. While primarily natural, it is nevertheless so interinvolved with humans that it also exists in the humanized world. In nature, it is in a span extending beyond itself, interplaying with other natural realities existing in their own spans. When the dog's existence is involved with other factors, stemming from individuals or from humanized realities, its natural state may be able to be exercised only within limits imposed by the humanized world. Conceivably, it could escape the humanization, and return to its natural state, but it will then continue to bear the marks of having been humanized. It would, as a consequence, be a little like one who decided to imitate Thoreau only if he were supplied with a beeper.

A good knowledge of anything in the humanized world allies it with other items, and attends to the resulting interplays. It identifies a dominant Affiliator, and the effective presence of natural and cosmic bodies in every member. Although we cannot reach unhumanized content just by stripping away supposed overlays without thereby introducing others, we can still know what is essential to it. If we know that something is a bird or a river, we know what is more or less central and what is more or less peripheral in them and, as a consequence, are in a position to focus on, distinguish, or abstract from humanizations of them. The result will not usually be free of irrelevancies or blurs, but these, like many of the defects in any work, need not get in the way of a sound grasp of the whole, and many of the details.

We live in the humanized world. While there, we can also take a stand outside it and note that it contains contributions from nature and the cosmos. The joinings of these with what was contributed by us as so many individuals, or by what had already been humanized, is dependent on the Affiliator. This is instantiated in the joinings, as the most dominant of all the ultimates instantiated there. Both those who depend on and those who decry an immersion in that world are individuals, existing apart from it. There they make use of their privacies and bodies to provide what the

Affiliator, as dominant over the other ultimates, joins to contributions from nature and the cosmos. We can know that what is true of the members of the humanized world has counterparts in other domains, because we are able to evidence all the ultimates, and understand how they can be jointly instantiated in various other orders of dominant and dominated. To know what in fact occurs in another domain, we must know how to get to those occurences by using a mediator that begins in one domain and terminates in another.

We do not live in the humanized world in a steady way. The most conventional of us is occasionally deviant just as the most deviant of us often acts in good accord with its major demands, if only in order to be able to communicate a dissent. All of us slip into and out of the humanized world again and again, no matter how routinized we are, or how insistent its demands. When inside the humanized world, while expressing ourselves along well-established lines, we punctuate our acts with hesitations, sudden turns, confusions, and miscues. As apart from that world, we may, of course, still think and intend along lines the humanized world had made evident, as well as in ways it had not.

As in the humanized world, humans define what is moral, mainly by treating well-established practices as canonical. Like our established language, the morality could be specialized in many ways, to leave it an ill-defined, shifting core of established permissions and preclusions, endorsements and rejections. Its 'ought' is hardened 'should'. It can be absolutized. So can an economy, a history, or religious practices and affirmations. Aspects of the humanized world will then be set over against others, and used as though they were warranted determinants of them.

A morality is a summation of what is acceptable to humans in a part of the humanized world. It never completely coincides with what an ethics endorses. The product of humans together, it is used to prescribe to them severally. Many of its prescriptions are acceptable just because they have been long accepted. Since each morality is occupied with what occurs in some part of the humanized world, and since humans also exist apart from this, they sometimes do and always should use other ways of determining what they are to do.

Our knowledge of privacies, nature, and the cosmos, as well as of what is beyond all of them, is sustained by that to which it refers. Usually it will be only the most luminous part of what we confront that will be explicitly acknowledged. What had once been known may then become more and more submerged, and what had been faintly noted may become more and more prominent.

Everything, be it thought or fact, a simple or a compound, is subject to

dominant and subordinate conditions. Focussed on, these help one to know what can exist in other domains. Every one of us takes account of that fact, usually without reflection. As a consequence, we submit to and use much that we do not well understand. Once we are aware of the dominance of some ultimate, e.g., the Affiliator in the humanized world, we can learn about the natures of the actualities in other domains by noting that ultimates, in a subordinated position in the humanized world, could either be in a dominant position in other domains, or could connect what are in different domains.

We readily speak of slippery rocks and refreshing breezes, though the adjectives refer to their effects on us and tell us little about them. Some men are now on the verge of saying that machines play games, even though the games are humanized activities resulting from the imposition of privately envisaged plans and objectives on well-ordered aggregates of already humanized occurrences. There is no evident harm in speaking in this way, provided only that it be recognized that the terms are being used primarily as occasions for enabling humans to extend the range of their usual references, so as to indicate some interesting effects they may have on those who experience them. No one, it is to be expected, will ever claim that a machine is devout, even if so constructed that the words it prints or the sounds it produces are used by one who prays. No machine is a hypocrite, sincere, afraid, brave, or self-conscious. Successful actions are eminently desirable, but they surely fall short of showing that what exhibits these is intelligent. Otherwise, we should have warrant enough for taking the most primitive water wheel to be intelligent, and for supposing that some day we will be able to make a machine that is able to assume responsibility, to hope, fear, and feel pain.

Wild animals live in our absence. Some kinds existed well before any humanizations occurred. We humanize them when we take them to be exotic, fearsome, or even wild. One of the great difficulties in the way of knowing whether or not animals have a language is that we frame what they do inside humanized contexts. There is no question but that they use signs referring to what concerns them, but it is dubious that they can be shown to think by being trained to use humanly relevant ways of communicating. Although naturalists note occurrences that others overlook or misconstrue, it is not possible even for them to avoid all humanizations in their observations and reports. Once, though, they take account of the distinctive, affiliative condition that plays a dominant role in the humanized objects, and of the spanned occurrences that could occur only in nature, they need have no great difficulty in knowing what part of their observations and accounts ground good moves into it.

Humans often act thoughtlessly, sometimes almost mechanically, without much reflection or without making any special efforts to guide or control themselves. Less often, they try to realize purposes by so acting that they enable an envisaged prospect to be realized. We have no warrant for holding that subhumans carry out similar acts. If prospects simply guided acts that realized those prospects, it would be reasonable to suppose that there were purposive acts carried out in nature, for these, unlike purposed ones, promote the realization of prospects without these dictating what is to be done.

Following Kant, a purpose can be treated as a projected final cause, guiding what will realize it. A purposiveness, instead, refers to a sequence of activities so ordered that some outcome is promoted. Because it is my purpose to write, I sit at the typewriter, take off the cover, and so on; were my acts just purposive, those acts might fit within a tendency to do something with my hands. The first is governed by a prospective act of typing; the second refers to steps so aligned that some prospect might be realized. When typing out what I am thinking I may help clarify what I have in mind, but may not act with the purpose of achieving that clarification. If, though, I type to express my thoughts, I will act with a purpose.

We overhumanize natural beings when we take them to have purposes. We dehumanize them so far as we take them to be subject to a purposiveness. Where animals may be swept along by an overwhelming purposiveness, such as the preservation of their kind, humans sometimes carry out purposes that preclude the realization of such a purposiveness. They sometimes sterilize themselves, live alone, commit suicide, with prospective outcomes guiding and controlling their acts. Unless we are able to provide warrants for the claim that there is a terminus to human history, perhaps one that lures everyone, the question whether or not humans act in accord with that prospect must be left unanswered. If, instead, we take humans to be in nature, we may warrantedly assume that they are subject to a purposiveness operative always and everywhere.

Purposiveness refers to a prospect that may not be known or accepted by what acts in ways that may promote its realization. A purposed outcome, in contrast, uses a prospect to control what is done to realize it. Purposiveness is usually a large-scale prospective outcome. A purpose, instead, guides and controls what a man does. The first could occur in the humanized world, but we have no evidence that it does; the second sometimes makes a great difference to what would otherwise occur, but we are never sure whether or not we can realize it, needing as it does some support and supplementation from what we do not control.

In the humanized world, actions may be carried out to realize purposes. To do this, use has to be made of what is both available and able to be so used that an objective is realized. Sometimes individuals make it their purpose to realize a group objective; sometimes, a group promotes the realization of an objective that a leader insists on. Each defines what is acceptable to it; sometimes it accommodates the demands of the other. When the two supplement one another, a purposed purposiveness is produced, with a trend helping define a prospect to whose realization one commits oneself.

In his *Origin of Species*, Darwin tried to attend to occurrences in nature. In his *Descent of Man*, he unknowingly took his stand in the humanized world. Although he there tried to show that natural beings carried out acts that differed only in degree from what humans did, he took humans as his measure, and thereupon envisaged some natural beings carrying out pale versions of what humans do. One cannot show that humans are just natural beings by remarking that subhumans have humanized natures, or that they act in what seem to be humanized ways. If one tried to do this, one would, with Darwin, do no more than hold that natural beings are rough-hewn humanized ones. To view humans as natural beings, one must take their purposes to be inside a purposiveness. Neither the reduction of humans to natural beings, nor the enhancement of natural beings to the status of variants of humans, does justice to either. There is no need to choose between the two approaches, for both neglect a great gap separating humans from subhumans.

Although it is marginally plausible to say that our pets are fully humanized, and while there is some warrant for maintaining that humans have an inescapable natural side, there are good reasons for saying that there was a time when our predecessors were completely immersed in nature. Once this is recognized, we can go on to understand how humans could contribute to the existence of themselves as humanized beings. While they could then continue to have many of the abilities that their predecessors had when these were in nature, their abilities would be subordinated to, and modified by, others that reflect the humans' distinctive reality and needs.

What is humanized is in the humanized world; what is not there is not humanized. What is humanized may cease to be so; what is not humanized may be subjected to a humanization. We must avoid dealing with what is subhuman in human terms, or dealing with humans in terms appropriate to natural beings, but nothing less than a vigorous separation of the two kinds of beings, as existing in distinct domains, will enable us to escape the biases characteristic of approaches that deal with both as though they were members only of the humanized world or of some other domain.

2. Self-Correction

There is much amiss in the humanized world. Crime, war, prejudice, superstition, corruption, ignorance, illiteracy, famine, and poverty are everywhere. Apparently, they always will be, though signal advances have been made here and there in medicine, sanitation, hygiene, attitudes toward children, women, employees, and minorities, as well as in the health and rights of the disadvantaged and the aged. Philosophies and religions have, for the most part, followed rather than led the way in the effort to overcome, reduce, or compensate for major horrors. It was late in the history of 'civilization' before fault was found with the treatment of those who were not dominant or prominent, who did not accept the received morality or religion, or who had the 'wrong' color or gender. Many have claimed that they focussed on what transcends daily judgments and practices, and looked at things from the position of eternity; others held that they made clear, objective, dispassionate, sound judgments, and that they really knew that obedience, kindness, or charity was what was mainly needed. All the while, they dismissed multitudes as not being truly, purely, or fully human. Although it was said again and again that each person was the equal of every other, most found little amiss in the debasement of some. The little progress that has been made over the centuries, though occasionally guided by enlightened leaders, and sometimes backed by enforced laws, has been achieved mainly after a series of quite aimless corrections, adjustments, shifts in interest, wars, and threatened uses of power. Societies and states, their rules and their practices, usually change without preparation, suddenly congealing into effective agencies after disabling conflicts have spluttered to inconclusive outcomes.

The 'should' of morality is at its best when it supports the 'ought' of ethics. This demands, but cannot compel. So far as we are immersed in the humanized world, we can do little better than try to live morally, within the broad limits defined by an ethics. The claims of those who think that they have a right to admonish, guide, and lead others usually testify more to an optimism or an arrogance than to the value of what they aim to achieve. We not only live in the humanized world, but make our most effective corrections there, usually using what had been established to help bring about what is needed if we are to live there as we should.

The strength of established practices, and the ways these limit and control, can rarely be counteracted by a reference to truths holding always, or by threats and promises made about what will happen when one's life is over. A good life, like a sound inquiry, depends on our ability to use the past to help us master the future. That will usually require us to

be alert to what is most likely to occur. Self-corrections are also needed; these, though, will fall short of what is required if they are not guided by worthy objectives, while keeping close to courses that have proved to be reliable. This is not the method followed by those who create, but it does encapsulate the practical wisdom of those who function well and for longer times than others do, before being faced with likely disasters.

Leaders sometimes help a number to attend to and make use of what will enable them to become enhanced together. Many who claim to speak on behalf of the divine are occupied with making a part of the humanized world—'their people'—act to realize supposedly enhancing common objectives. Self-corrections, too, are carried out inside the humanized world. If they are to become redirections, they will require a preliminary retreat from the humanized world back to individual persons. The retreat may range from a mere move back in order better to spring forward, to the attainment of a position where one can achieve a better focus on an ideal that can be realized.

Corrections in course need the guidance of what deserves to be achieved through a fresh use of constant factors. If the assessment that things are not as they should be is to be more than part of a reaction to what produces pain or other discomforts, one should act in the light of what the assessment underwrites, even with respect to what will not necessarily benefit oneself. Occasionally, this is done. Slave holders have acted to abolish slavery; men have enfranchised women; the rich have sometimes eased the burdens of the poor.

Changes in the humanized world may depend on the use of what is not in that world. One acts to realize ideals not exhibited there, or that are not evidently pertinent to what is there occurring. Again and again, individuals act so that what would perhaps not otherwise be noted or realized is promoted. Activities carried out on behalf of some social or political policy, or to satisfy the demands of some ruler, are not always variants of what had been done before; they may be newly constituted and could promote the realization of excellent outcomes. A number may be forced to do this or that and, thereupon, made to promote some objective. A desirable outcome might then be realized. If a leader determines the nature of a common objective and what is to be done to realize it, the result might benefit a people, usually, however, with the people's help. The people might then live in better circumstances, but if they had not made the objective pertinent to themselves, they would be benefitted but not enhanced, living more pleasantly but not necessarily as they should.

We believe, fear, expect, and hope. Sometimes we see clearly; at other times we are clearly confused. The nature of the humanized world and what it could become cannot be well grasped until we know what

contributions we and others could, do, and should make to it. In the absence of that knowledge, and of the control needed so that the knowledge will prove of benefit, one can do little more than act as well as one can to fit within an already existing humanized world. Numbers of men are able to forge private languages neatly cut to their separate desires, but they would then pay the price of not being able to communicate very well. Each intrudes thoughts, choices, memories, expectations, and beliefs into what is shared, both when thoughtful and when heedless, brutal, or blindly reactive to pressures and obstacles. Privately grounded acts are publicly qualified, and framed within limits others impose.

A body's demands must be met, more or less. Desires make a difference to what the body does. No one, consequently, can live a completely private or public life. When we conform and adhere to common ways, we add stresses, qualifications, and tonalities, reflecting our interests. We may add emphasis to or may minimize what already exists; what is common may be modified by the way it is individually insisted on.

The lead of a Dewey or a Wittgenstein is well worth following, if all that were sought were the achievement of a mobile, sinuous grasp of what can be mastered in the humanized world. The first, unfortunately, will most likely prompt one to emphasize the technological, the satisfying, the solving of practical problems, while the second will encourage a dextrous use of an established language. The bias of each should clarify what the other obscures. Both presuppose, but also neglect, the contributions made by individuals, natural beings, cosmic bodies, the ultimates, and ideals. Other realities usually act in their own distinctive ways, no matter what humans desire, do, or say. Camels cannot now be made to walk backwards, cows to fly, or roses to sing.

A complete description of any particular in the humanized world is impossible. There are too many details and influences to allow a reference to anything there to be more than schematic, filled out with changing details, some important, some trivial. What is constant for any is usually no more than a piece cut out of a slowly changing pattern, where what is supposed to be common is often no more than an abstraction from a miscellany of singulars. Like a thrown stone skipping over the water, each of us makes some slight difference here and there, while remaining affected by the way we had begun, what we had encountered, and where we had aimed.

Reformers, like the rest of humans, speak and act in the humanized world. To do this best, they must make some use of whatever agencies had been successfully used in the past. They must also add to their claims about the splendor of what they would have all eventually share in, an appeal that will prompt each to back the common aim with private

commitments and public acts. Societies and states may support a reformer's admonitions by providing constraints, guidance, and stimuli, but the rest must, in addition, help promote what promises to produce a better humanized world. We should so act that we support, while qualifying, what promises to strengthen and perhaps enrich others, our group, and ourselves.

3. Induction

The dominant determinant operative in the humanized world is the Affiliator. This is but one of a number of ultimates that jointly constitute and relate actualities. In each domain one ultimate is dominant over the others, warranting the use of a distinctive method of inquiry. The presence of the other ultimates, in subordinate positions, introduces qualifications in the dominant, and conversely. The ultimate that is characteristically dominant in a domain is dominant in each actuality there, as well as in the relations that these have to one another, both those that are contemporaneous and those that are not.

Past occurrences make a difference to the present in which they are. Although they exert no power, they qualify what is present, giving it an import it otherwise would lack. A dead tyrant is as impotent as those he destroyed, but what he and they were is retained as subordinated qualifications in what follows. Those who exist long after the tyrant has died can come to know him only by envisaging a determinate past from which that present could be derived in accord with known processes of succession and causation.

The full understanding of the past depends on the acknowledgment that the past is determinate, fixated, and unalterable. We come to know it by using present content as the beginning of an inference to the past as that from which the present would follow if some type of sequence had occurred. What succeeded what was present would be understood to be what forced that past to become a determinate, sunken part of that new present. The past is and could be nowhere else but in the present. It is there, but not as it was when it was present, for it was then in the process of becoming fully determinate. That process began in the present as related to an indeterminate future; it ended with that future made present, and thereupon related to a new future.

The past, as it had been when it was present, ongoing, and not altogether determinate, is not recoverable. All that remains of it is determinate content in the present. It does not exist in some place into which we cannot enter; it remains where it had been, but in a determinate, recessive state. To know it as it had been when it was present, we have to

envisage it as in relation to the prospective future that had replaced it as a present, when and as that prospective future became present. What had been present is no longer operative; it is the past as subordinated in a new present. A 'time machine' would have to travel inside present realities if it is to reach what had been, and would find this both to be what in fact qualifies what is present, and what cannot be separated from it.

What is in the present is no *causa sui,* a self-contradictory cause of itself. It may have a short or long career, it may continue to exist for an indefinite period. It is also projective, qualifying what it is helping become determinate, and which will thereupon replace it. The past is wholly determinate, the future is maximally indeterminate. The present, in contrast, is partly indeterminate in relation to the past, and partly determinate in relation to the future, becoming more and more determinate as it is replaced by what had been future.

What had been, what is, and what will be are affiliated over undivided stretches having no antecedently prescribed length. To live most successfully in the humanized world, it is necessary to keep in good accord with its general course. We are properly expectant so far as we take future occurrences to continue along the path that is now being traversed, particularly if this had been previously followed successfully. Usually, our inquiries are desultory, unfocussed, not well-sustained. Suspected and actual dangers, confusions, injuries, pains, and, occasionally, a curiosity tinged with fear or desire, prompt many to try to become better adjusted, as well as to be better equipped to achieve what is intended. A concern with what deserves to be realized in art, mathematics, science, society, politics, or oneself, an involvement in religion, or an interest in reaching what always is, and is always presupposed, help one's acts and preparations to be well-directed.

Induction is a method by which what had been is used to enable one to anticipate what is likely to occur. Each inductive move expresses expectations that are in good accord with what had previously occurred. Rarely needing to be concentrated on, its use is easily ignored, particularly by those who use it confidently and well. The supposed God of process philosophy, who adjusts Himself so as to make what was grasped of the completed past affect what He will do in the future, is induction divinized.

We may, and indeed often do, misconstrue what had happened or what is now happening. Nor will the future necessarily and precisely continue along lines previously laid down. We can do no better than to expect that it will do so, and then try to express that fact in preparations and acts. Although some deliberately try to replace their inductive acts with formulae, in the attempt to express precisely what is supposedly essential to them, others more properly and effectively build on what had occurred

again and again over long stretches. They carry out their inductions unreflectingly, but often successfully, by expectantly continuing into the future practices that had been successfully carried out in the past. Although our expectations may turn out to be irrelevant because of a sudden change in the way things happened, induction would still be the best method to use, expressing as it does that what is reasonable to expect in the humanized world will in fact occur. Its route and outcome must be worked through then and there, spelling out the expectations that carry into the future what had been learned in the past.

As simply expressing an expectation, an induction is no more than a hypothesis confined within the privacy of one who entertains it. Embedded in a time ending in a prospective future, an induction adds a qualification that will be more or less accommodated, as answering to the way time is sustaining the pattern of the events that had occurred. Depending on the degree to which an induction meshes with the course of the passage of the sustaining time, an induction will be a component in a more or less effective mediator between what had occurred and what will occur. Since, in the absence of the induction, the antecedent and the consequent will nevertheless be mediated by time, a successful induction will be identical with an anticipation of the future that is in fact satisfied.

We live in the humanized world, projectively and expectatively, tacitly supposing that what will be will follow along the lines laid down by what had been. We may misconstrue what is happening; our expectations may be unwarranted. Cataclysms and passions, the neglected and the unexpected, may sometimes play crucial roles. Since there is nothing in the humanized world that warrants the supposition that the future will always and precisely continue along lines previously laid down, we can do no better than to expect that it will do so, and then try to express that fact in preparations and acts.

An induction turns what otherwise would be a guess, a surmise, a baseless hope or fear, into a prediction. By continuing the present into the future, along lines already followed, it enables one to remain in consonance with the Affiliator's operation as it had already been and presumably will continue to be manifested. When other methods are used in the humanized world, they serve mainly to support or supplement the inductive. Although inductions never yield certainties, they give us more reliable leads for acting successfully in the humanized world than we otherwise could obtain.

There is usually little point in starting an inductive move by attaching it to a supposed remote past, and then trying to act as if what then occurred continued unaltered. A good induction will usually project into the near future what occurred recently, adding modifications enabling the result to

be in considerable accord with what is unfolding. It is not wise either to forget the past or to suppose that it will be repeated. If it is to be used as part of an induction, it should be qualified by a cautious expectation that what is in the process of occurring will in fact occur. One should remain alert to the likelihood that there will be novelties and deviations, even in what had previously proved to be reliable and steady. Poor generals fight old wars on new terrains; great ones know that what is new could continue along the lines of the old only in wars that were stripped of many of their relevant details.

We are properly expectant so far as we inductively take the future to continue what is occurring. What is then expected might not occur. Rules for making good inductions, the use of statistics, deductions, and reassessments of what had occurred over long periods may help one avoid some pitfalls, while making others likely. Our habits incorporate inductions germane to what we unreflectingly do, but those inductions fall quite short of providing what is needed if we are to enter the future as well prepared as we could be.

Nothing guarantees that if we have a sure knowledge of what is necessitated, we will in fact reach this quickly, or at all. No inference is contained in a rule. Nothing guarantees that if one follows good rules, one will be able to anticipate what in fact occurs. Inductive rules mark out beginnings and endings to be filled out in acts that move at their own pace and in their own ways. One big difference between them and deductions is that the latter end with what is necessitated, while the former do no more than point to what seems likely to occur. Deductive rules provide tests and checks for inferences; inductive rules define what, on the basis of what occurred, can be reasonably expected to occur. To carry out good inductions is to be reasonable—and conversely.

The humanized world is well lived in, not by formal logicians, but by reasonable men. In no induction are the past and future lined up one after the other, separate and bounded. An induction points to what is likely to occur if one continues along a path that has so far been successfully followed. When what an induction projects does occur, it may still be qualified in new ways by factors that were subordinated in the relating of the past and present to the future. A justifiable induction does not warrant one to conclude from seeing a car that rain is likely, or, indeed, that there is much more to be expected than that the car will continue to be somewhat as it had been. If rain was expected, one perhaps was looking at the car on some day in April. That expectation would be inductively reached if it took its start, not from a seen car, but from a seen gathering of dark clouds.

We live together in a humanized, shifting world, where nothing is

certain, though a good deal can be counted on. Hope and fear deflect and color the inductions we make as we ready ourselves to act there with reference to what we expect to occur. Some of those inductions will terminate in what we then await, others will refer to what will likely occur with the passing of a longer time. We use longer-range inductions to allow us to live confidently for a while; we ready ourselves to make adjustments for likely failures of inductions having shorter ranges.

An induction may end with the prospect of the sun rising tomorrow. We will not, as Mill thought, then have taken account of the number of times the sun rose in the past, but will expect it to rise, simply because we had become habituated to seeing it rise. That habit is a lived-through induction, built up over a period in which the sun was seen to rise—for most of us today, because we often saw it at different positions in a circuit in a westward direction. However formed, the habit is expressed in the present as an expectation that there will likely be a repetition of what had previously occurred.

We live together in the humanized world in accord with the deliverances of common inductions. Some of these are embodied in the routines we carry out unreflectingly. When we become aware of the uselessness of inductions that had been previously made—even with considerable success—by those in the distant past, we bound off the period in which they were successful, somewhat as we bound off familiar surroundings from those that are alien and threatening. Sometimes we may find ourselves in a situation so strange that the only induction we could then reasonably venture is that we are about to be surprised.

It would be foolish to use changes in rules governing chess as a guide to the times and ways in which politicians will alter their policies or practicies. It would be no less foolish to reverse the procedure. Women's skirts rise and fall; most men grow beards at one time, and most are clean-shaven at another. At those times the stock market might have risen or fallen, sunspots might have grown larger or smaller, and the like. Some take such concurrences to justify inductions that start with one of these changes and end at some one of the others. It is not reasonable to do this, for there is no ascertainable connection between these different events. Though it is we who produce the inductions, they do require us to follow paths usually followed successfully from similar acknowledged beginnings. It is not helpful to remark on the concurrence of periods when men were clean-shaven and the stock market rose; good inductions start and end with affiliated, not with just concurrent, items.

Were humans the sole source of what was or could be known, what they took to be objective, independent, and external would be misconstrued. There would be nothing actually obstinate, dangerous, or desir-

able. Nor would there be obstacles to overcome or agencies to use. Each individual might have beliefs, and these might be shared, but there would be nothing that would warrant those beliefs, or show them to be mistaken. Sometimes what enables something to be encountered dominates over the human contributions. Sometimes the reverse occurs. If the former, there will be little more to do than to try to express its import in theories, language, and actions. If the latter, the encountered will be overlaid with expressions of memory, intent, need, fear, and hope. A violent realism, allowing for no contributions by humans to what they confront, is evidently at the forefront of a covert subjectivism.

Probability theory shows what might be expected were items to occur at random. Rarely does anything conform to its rigid requirements. If it did, there would still be no assurance that the theory's mathematically determined results would continue to be exhibited in any set of actual occurrences. The theory in fact tells us only what would occur, for example, were a perfect coin thrown randomly over a 'long' run, i.e., a run having no specifiable end. It allows for either a head or a tail of a randomly thrown, unbiased coin—though there may never be any such coin to throw. It would not be jeopardized were a series of such throws to yield nothing but heads, or heads followed by tails by heads . . . forever.

All sequences of heads and tails of a perfect coin, randomly thrown, are equally probable. Were all the sequences set alongside one another, there would be only one that contained just heads, and only one that contained just tails, but there would be many more in which there were many heads and tails. There is nothing amiss in a perfect coin, thrown at random, turning up the same face from now until doomsday, the probability of that or any other sequence occurring being $1/n$, where n represents the totality of sequences. We blunder, therefore, if we replace the question of the probability of having one of a number of sequences occur, by the question of the probability of what occurs in some one sequence. Conceivable sequences form a disjunctive set, each with the same formal probability value. Whatever the sequence, each occurrence therein will have a distinctive probability value. In a sequence of all heads, the probability of a head is one, and the probability of a tail is zero. That sequence is theoretically as probable as one in which a head is followed by a tail, and this by a sequence of heads, tails, heads, tails, and nothing else—or by a sequence of tail, tail. . . . There is nothing in the nature of perfect coins that requires truly random throws to make each side turn up with equal frequency, in any run, no matter how long.

Gamblers demand that what has a high mathematical probability value be realized within a limited time. They do not care whether seven comes up as six and one, five and two, four and three, two and five, or one and

six; they are content to note that there are more ways for a seven rather than a twelve to come up. A failure of some combinations of the dice, adding to seven, to appear more frequently than combinations adding to twelve—combinations in a finite time—is explained by gamblers as being due to extraneous causes—most likely cheating or 'bad luck.' They usually have a good reason to suspect that they are being cheated, since they live in that part of the humanized world where this is not an uncommon occurrence. When their mistaken suppositions about probability are not upheld, they make shrewd judgments about the intrusion of unpermitted controls. Carrying out no careful mathematical calculations before deciding that cheating is the most likely cause of the unexpected results, they make their decisions without entertaining the likelihood that all alternatives will turn up 'in the long run.' Most of the rest of us allow that cheating might occur, but we have insufficient experience to support the induction that, after such and such a run, it is most likely that the result is due to a willful manipulation of the dice. If the dice added to twelve on every throw, that would not show that the dice were imperfect or that the throws were not random. What is true of a coin is true of the dice: an endless sequence of twelves is one of many sequences; there are many more sequences in which some other combinations adding to seven occur. Unless there were an opportunity to select some one sequence from among all the others, whatever sequence did occur would be no more likely than that in which there were only twelves. The supposition that sevens will more likely occur if the dice are not 'fixed' and the throws are indeed random is based on the mistaken supposition that a sequence has a high probability value of occurring if it is one among the many in which various sequences of the same combinations occur. Not only is there no selecting of any one sequence out of a multitude, but whatever sequence does occur is no more probable than any other. Did one care about the order in which sevens occur, it would become evident that a sequence of sevens, in some particular order of pairs of six and one, five and two, and three and four, has no greater probability than a sequence of twelves.

A community, with some effect on more limited groups, sometimes takes serious failures in inductions to be due to some power, perhaps one that is divine or demonic. It tacitly assumes that common inductions can usually or perhaps always be depended on, did not some power get in the way. By taking an untoward outcome to express some great power, the result is cosmologized. If, instead, an induction were confused with a hazardous deduction, it would be supposed that good inductions would end in what could have been deduced, had one but known the natures of all the operative factors. Yet no adequate knowledge of a future that will in

fact follow the present is possible. What will be present later will become appropriately determinate only when it is in fact present.

Unless there could be completely random occurrences, inductions have to be relied on to point us in a direction in which a continuation of what had been could be reasonably expected. The best inductions will express what it is reasonable to expect within the humanized world. When we find that we had been mistaken about the course of events there, we must grant that our expectations were not properly grounded, that we had been mistaken about the warrant for the accepted inductive outcome or that the course of events has taken an unpredictable turn. Sound inductions depend on our knowing what it is reasonable to assume is a good sample and a dominant trend.

Formal logic is occupied with expressing precisely what follows necessarily from what is accepted. In practice, its necessitations will usually be accompanied by the induction that what is formally derivable will in fact occur. Sound inferential moves will then be tacitly supposed to be those that end with what logical consequents endorse; if they do not, the humanized world's course will be taken not to be entirely rational. Still, what occurs need not be supposed to have required a defiance of formally expressed necessitations, since the occurrence may have been reached in ways that take no account of what is formally sanctioned.

What occurs in the humanized world is a product of all the ultimates, under the dominance of the Affiliator. One might overlook its role and still be exemplarily rational, but the more insistent one is on remaining rational, the more surely will one be unreasonable—not because the reasonable is irrational, but because effective qualifications of the rational were overlooked. Few know the formal laws of logic. Fewer attend to them when they reason. Formal contradictions and irrelevancies are usually dismissed as misstatements or confusions, or as momentary aberrations in the otherwise consonant activities and discourses of reasonable members of the humanized world. Logic remains an important study, but its formalities should be, and are in fact, usually qualified when they are used in the course of reasoning.

In the humanized world, hunger, terror, illness, and death, leavened by an acceptance of a prospective common fulfillment and a supposed incomparable past, play a strong part in what is acknowledged by a group. If its members are to prosper in both body and spirit, an effort must be made to provide for inductions that have good warrants. No numerical value, though, can rightly be placed on the likelihood that some inductively reached outcome will be realized, since it reflects the nature of a reasonable readiness and a supposed trend more than it does a necessitation or a prescription.

Most inductions are not formally expressed. Usually they are incorpo-
rated in habits of expectation, some rightly and some wrongly taking
various types of occurrences to be more likely to recur than others will or
can. What has often occurred in the humanized world may not occur
again, or might appear in a radically altered form. Brokers and bankers find
this hard to believe until ruin makes the truth of little worth to them. Still,
one should be able to benefit from what was learned about the success of
some inductions previously carried out, since inductions also help one to
understand what had once occurred. There is no circle here. An induction
to what is past follows in reverse the route along which the present
presumably had been arrived at in fact. Defining the present as the
reasonable outcome of what had previously occurred, a historian here
makes an inductive move to a supposed past from which that present
could reasonably be said to follow.

Historians are reasonable men, *par excellence,* since the past for them
is what can be reasonably expected to eventuate in the present. Unfortu-
nately, if we expect the future to be what is reached from the present, in
the way the historians take the present to be reached from the past, we
will rarely, if ever, be able to find the supposed path leading from the
present to the future. Inductions start with what is in the lived present,
not with what is in a present supposedly arrived at, beginning from a
supposed past. The past for a historian is a past that must end in the known
present, but the expected future for him, as it is for everyone else, is at
best what is only likely to occur. He could be said to deduce the present
from the past, though it never was so arrived at in fact. Such a deduction is
possible because the past that he acknowledges is precisely that from
which the present is an inevitable outcome. He does, to be sure, often
enough speak of coincidents, accidents, and chance, but these are
understood by him to occur in the past that is acknowledged to be that
which inevitably ends in the initially acknowledged present. If he said that
the present is an adventitious, inexplicable successor to what had previ-
ously occurred, he had evidently not completed his work.

The best use of statistics builds on inductions that had proved to be
helpful or dependable. Although some uses of statistics have made various
inductions more acceptable, there can be no assurance that they will help
one achieve a better result than could be otherwise. Nor can there be any
certainty that any particular induction will end at what had occurred, or
will in fact occur. Still, though the humanized world is a world of
contingencies, one will be most reasonable there if one expects that the
near past and the near future are reachable along lines that had previously
been successfully followed. Historians are plausibly omniscient after the
fact.

The most familiar inductions use temporal referents to promote a better mastery of what occurs in various spatial regions and causal processes. We live in enclaves with inductively reached, fluctuating borders, marking out where the familiar and controlled give way to the alien and threatening. We are also inductively prepared to act in ways that have proved to be efficacious before. Were we to live in a place that had no interest for us, our inductions would at best offer ways for testing and perhaps improving our understanding or grasp. Were we to carry out practices monotonously, perhaps by just following established courses, our uses of inductions would reflect our understanding of the efficacy of our activities and those with which we are most familiar. Usually, we use spatially and causally toned inductions to bolster others that apparently are relevant to our welfare. Although such indifferently reached prospects may add something, this will rarely be enough to make a significant difference to what is inductively reached. What we lose in leaving rough-hewn commonsense behind, so as to live well in the humanized world, will not usually be recovered. It will, though, be at least partly compensated for by the successes made possible by carrying out good inductions since we thereupon will be able to live in considerable accord with what else there is in the humanized world, and particularly with what is nearby and familiar.

Inductions offer structures connecting not only temporal, but also spatial and causal stretches. All the while, the users may be readied to act, but may not necessarily do anything relevant. When they act, they will usually follow a course charged with expectations and, so far, will inductively terminate at what it is reasonable to suppose will occur. Those inductions will enable them to move beyond the ostensible limits of the present, the here, and the confronted. The fact that an induction is not formulated, or consciously made, matters little if it is sound. Humans unreflectively live inductively-governed lives.

We may credit subhumans with the ability to make inductions, in part because we read into them the humanizations within which we initially attend to them. The justification for doing this depends in good part on our knowing whether or not, how, and to what extent subhumans face the future in the light of what they have learned from their experiences. Whatever inductions they carry out are apparently confined to what might occur in their environment. Some of their habits could be treated as coiled inductions. The most cautious claim to be made about them, perhaps, is that they make possible unreflective inductions within limits, exhibiting the presence of the Affiliator in a subordinated role.

The temptation to deal with humans as though they were natural beings, or with natural beings as though they were types of humans, must

be resisted. Otherwise, we would have to take subhumans to be miniaturized humans, or humans to be glorified animals. There is no need to ignore evolutionary theory, to deny that humans had non-human ancestors, or to suppose that some subhumans are not similar to humans in appearance and act, in order to maintain that humans alone are individual persons, able to commit themselves and to be responsible. Both humans and subhumans provide components for humanized objects, but only humans are able to assess those objects objectively. They are primarily governed by the Affiliator, even when they are joined to what existed in nature or in the cosmos, and then subjected to inductions reflecting traditionally warranted expectations.

Paradoxically stated, whatever inductions subhumans make are based on their several experiences embedded in their different habits, while the inductions that humans usually make are those acceptable to a group. Different men, of course, do make their own inductions, and these may not be in good accord with the inductions made by others. Still, it is what occurs in the humanized world that grounds their best inductions, particularly those that are pertinent to their common welfare and concerns. Individual persons add qualifications to the common course, or, at their peril, follow their own bent.

4. Contemporaneity

'Contemporaneity' has a number of distinct meanings, each singularly relevant to what occurs in a particular domain. In a domain occupied by individual persons, it refers to their copresence. In nature, where different kinds of beings exist over distinctive spans of different lengths, the reference is to actualities in abstraction from their spans, or to what is crossed by imaginary lines making no reference to any actuality. In the cosmos, contemporaneity refers to coordinate bodies. In the humanized world, the reference is to humanized actualities and to what is present with or for them.

The supposition that we hear only what had been said at a previous time, and that we then reply to someone who conceivably might not exist later, or who might be quite different from the original speaker, is not only arbitrary but untenable. No one can attend to what is occurring in the past, no matter how short the interval be between it and the present. Distant seen stars, thunder claps heard after lightning is seen, and tiny humanlike figures noted at a distance are all contemporary with those who perceive them. We could not possibly perceive what is at any other time than the present.

References to supposed passages of time, traversed spaces, and causal

processes offer different ways by which we try to account for our separations from what is confronted as contemporary. They all fall short of explaining the brute fact that I am now larger or smaller than, or equal in size with every other body in the humanized world, no matter where it is. Since the appearance of something small may be of something that is large, I evidently am contemporary in different ways with appearances and with what appears.

I cannot enter the past any more than I can the future, but were I just the recipient of what comes from the past, and a projector of what will be in the future, I could conceivably be all alone, attending to what might no longer be, and address what might never be present. References to photons, or to sound and light waves, require one to attend to what is known of occurrences in the cosmos, and not to what is in the humanized world. Photons and waves, in any case, do not carry reports telling us where they had originated. None could enable us to discover what occurred elsewhere, unless at the end of its journey it could tell us about what might no longer be. No matter from what angle or with what speed a photon or wave might hit one in the eye, or how the brain might thereupon act, it could never enable us to confront what is in the past, even the past of a micro-second ago. Although what is now perceived may have been caused by what is long gone, what is perceived is copresent with the perceiver. It is not in the perceiver; if it were, he might be affected by it, but that would not mean that it was perceived by him.

All measures of a distance between past and present are in the present, unable to bridge the distance between them. To know what existed in the past of the humanized world, we must carry out inferences. These may allow us to come to conclusions about the past, but they will not enable us to enter it, or to pull what is there into the present. Since we cannot move out of the present and measure or traverse the distance that separates what is in the present from what is in the past, we could not know whether the supposed interval were large or small.

An examination of the humanized world is carried out by persons existing apart from that world. The result would be no more than a fantasy, were it not possible for what they have in mind also to occur in the humanized world. The means for doing this could not be just a projection, a supposition, an induction, an abduction, or a hypothesis. All leave one referring to what conceivably might not exist. If anything is to be known of what is other than ourselves and our knowing, what we entertain must be at the beginning of a transformation terminating in what has a reality of its own. The transformer could not just be in us, without its beginning and ending being there as well. Nor could it be in the humanized world, without thereby ceasing to be what is individually entertained. Were it not

intelligible, it would not provide a connection that could be understood. Were it not effective, it would not provide a passage from a beginning to an end.

We individually come to know what is in the humanized world—and in nature, the cosmos, the past or the future, and what is presupposed—only when we are subjected to dunamic-rational power, enabling what we have in mind to be located elsewhere as well. When that power operates in the humanized world, it is subject to an affiliative condition, relating it to what else is there. (The issue will be faced again in Section 6.)

A passage from what one entertains to what is externally sustained takes no time, covers no space, exhibits no causality. When we have something in mind, or when we are desirous, expectative, fearful, and the like, we remain in ourselves. To get to ourselves as we are in such states by starting from what we are in the humanized world, we must participate in what can take us from the one to the other.

Hume drew the right conclusion from his supposition of the status of what is subjectively undergone. Although his references to *im*pressions belied his gentle scepticism, what he supposed was in his mind was taken by him to be so detached from anything else that he could not possibly know anything. He did suppose that repetitions made (caused?) associations to appear to be causally related; it is also true that, on his own theory, he was trapped inside his own mind. Why then did he think that he could communicate with anyone else, and tell him about the theory? If Hume could associate ideas, in any case, something other than his ideas enabled him to do so. Could this not also relate what he had in mind to what was outside it?

Without getting in our own way, we cannot deny that there are both separate individual persons and a number of humans existing together with other actualities in the humanized world—and passages from the one to the other. All of us are able to pass from what we entertain to what is sustained by other realities, and conversely, through the help of agencies that have powers of their own. These are versions of all the ultimates, joined in a distinctive order. In the humanized world, the dominant ultimate is the Affiliator; in a domain of individual persons, it is the Assessor. In a passage from and to that world to and from oneself as a separate individual person, the dominant ultimate is the Dunamic-Rational, a combination of the ultimates, the Dunamis and the Rational.

To be in the humanized world is to be affiliated with others there, in various degrees and ways. The knowledge that all the members of the humanized world are so related underscores the fact that they are contemporaries. The view is faced with some hard questions. One of them: a man makes a will that is read after his death. Perhaps some money

is left for a grandchild if there should be one. Evidently, the testator is not contemporary with the reading of the will, or with the grandchild not yet born. The will, when drawn, was contemporary with whatever else there then was. When the grandchild is born, the document will be contemporary with whatever else there then is. What had been present evidently will have given way to a present where the document and grandchild are contemporaries. The will, of course, as an actual document, underwent changes over time. As contemporary with the testator it is in one state; as contemporary with the grandchild it is in another. When we later speak of it as the will that was originally signed, we intend to say that it expresses the same intent at both times. No study of the document, and no overcoming of changes in the use of words, would get us to the document as it was when it was signed. So-called deconstructions that free one from the supposed overlays are reconstructions achieved by an imaginary reversal of changes introduced over time.

We plan, we set goals before us, we carry out projects that take weeks to complete. We act in terms of what we remember and that are in some consonance with habits formed over extended periods of time. We also act in terms of what we expect, and of what lures and guides us. Still, at each moment of time, no matter how this be construed, we are in the present, together with a multitude of other realities in the humanized world, no matter how far away. We do not, of course, know most of them. The pear I now have is riper than pears still on the tree. That does not affect the fact that the latter, too, are my contemporaries.

A message is contemporary with different realities at different times— or, more precisely, as in such and such a place and condition, a message is contemporary with all the other members of the humanized world. Some of these may have originated at an earlier time; others may have come into existence when the message did, or after the message had arrived at some particular place. In every case, the message will be contemporary with whatever exists in the humanized world. At different times, it will be contemporary with different humanized objects.

Though contemporaries may be far apart from one another, there could be no passage of time relating them to one another. That truth is evident, and yet shocking and disturbing, but its rejection would leave one with nothing. If whatever is seen, heard, touched, or attended to in any other way is in the past of ourselves who confront it, we will not only not know if there is anything that is together with us now, but will somehow have managed to reach what may no longer be. Starkly alone, we would not be able to speak to, or act on, anything.

Although contemporaries are at various distances from one another, there can be no passage of time from one to another. Not only is there no

passing time connecting them, there is no passing time connecting perceiver and perceived. What we perceive is what is contemporary with us in a common humanized world. Those contemporaries can be viewed either as being possessions of, or as existing apart from, their sources. A seen star now is one of a number of appearances of a real star that co-exists in an intelligible, vibrant relation to other realities. There is no passage of time involved in the relating of these realities, or in the relating of the perceiver to what he perceives, but there is a passing of time in the coming-to-be of what is perceived and a passing time in the coming-to-be of a perceiver of it.

Were nothing perceived, there would still be rationally related realities, but were there no realities, there would be nothing perceivable and no one who could perceive. Both the perceiver and the perceived are in the humanized world, but the being who is able to perceive and the being that is able to be perceived are in different domains, the one in a domain of individual persons or a domain of subhumans, the other in nature or the cosmos.

Perceiver and perceived are contemporaries. A reality whose appearances are perceived may be intelligibly related to other realities. Passing time is involved in the relation of an appearance to the reality that appears; it is also involved in the achievement of the state of being a perceiver. The source of this is a being that is related to another, the source of what is perceived. The perceiver and what is perceived are both produced by realities. Although there is no passing time involved in the connection between the reality that appears and the reality that provides a perceiver for that appearance, there is a temporal passage in the appearing of what is perceived, as well as in the co-production of a perceiver of this.

The space, time, and causality in the humanized world provide different types of connection there. That the connections allow for sequential orderings in them does not mean that the items there are in a passing time, any more than the fact that our living in a passing time means that, as perceivers, we are not contemporaneous with what we perceive, no matter how distant. The time connecting realities contains no changes; it is a fixed sequence. Although I have come late into the world, I am as real as all that had preceded me, my lateness expressing nothing more than my place in that fixed sequence. That does not mean that I am immortal, but only that I have a fixed position in a sequence of realities.

Neither the seen nor the real star acts on me. The seen star is just the terminus of my perceiving it; the real star cannot act on me, nor I on it. The remark seems perverse, or at best paradoxical. I am alerted by the sudden sound of a fire engine; I await a thrown ball and prepare to catch it. Still, the sound that disturbs me is heard here and now; the awaiting of

the ball is also here and now. One thing is sure; try as I may, I cannot look backward in time, hear what is now soundless, or locate what I now experience, in a world where such experiences could not occur. To know a reality in the past I must understand it as a predecessor of a reality in the present; to perceive anything I must face it as a contemporary. Time passes in the production of perceivers and what is perceived, but not in the connection of their sources, or in the relating of perceiver and perceived.

This view of passing time and temporal sequence is not too apart from the view expressed by some contemporary physicists—but only if it is differentiated from the account of time that is singularly pertinent to what occurs in the humanized world, for there, time is subject to the Affiliator, joining contemporaries and defining as past and future what these contemporaries define to be conditions and prospects for one another.

When we attend to time as though it had the same import in every domain, we deal with it in abstraction from the different qualifications to which it is subject in each domain. Such questions as to whether or not time has a distinctive past, present, and future, what relations it has to space and causality, the difference it makes to assessments, affiliations, coordinations, rationality, and vitalizations, cannot be well dealt with except when understood to refer to what is operative in some domain. It is only as operative in nature that time has a dominating role over the other ultimates. There, other ultimates affect it to a degree and in a manner that it does not affect them. The observation raises a difficulty for those who deal with time as though it had to do only or primarily with individual persons, with their knowledge of realities, or with what occurs in the cosmos or the humanized world.

What we initially know is primarily subject to the conditions characteristic of the humanized world. In that world, actualities are primarily affiliated contemporaries; in the cosmos, they are coordinated contemporaries; in nature, their contemporaneity is extensionalized; in a domain of persons, it is assessed. Were one to accept what physicists understand by space, time, and causality as definitive of the meaning of contemporaneity in all domains, one would consequently treat a subordinated relation in the cosmos as though it were dominant everywhere.

What is true of their contemporaneity is also true of other relations connecting the members of a domain. When a man and potatoes are balanced, their weights are treated as though they were only aggregations of the unit bodies that are present in both the man and the potatoes. While the man is said to be thin or fat, and the potatoes are said to be few or many, they are balanced in the humanized world as having an equal weight. Measured by cosmic units, or collections of them, the man and potatoes are dealt with as though they were in the cosmos, though the

weighing evidently occurs in the humanized world, and is understood by humans in humanized terms.

The shock that is produced when one is first confronted with the fact that contemporaneity of actualities in the humanized world is different both from the contemporaneity involved in perceptions and from that which is characteristic of some other domains, reflects the strong hold that the contemporaneity characteristic of what occurs in those others has on us in the humanized world, and thereupon obscures what holds there. It should alert those who would like to consider only what occurs in that world to the fact that we do know other kinds of actualities. Subordinated, qualifying factors are sometimes isolated and made prominent when we try to free ourselves from the emphases characteristic of the humanized world. Sometimes the outcome is said to be 'objective', as if one somehow had already subjectified what is confronted. The characterizations that are singularly appropriate to what occurs in some domain must always be understood to refer to what is subordinated in other domains.

Though cosmos, nature, and humans precede the existence of humanized beings, each has its own integrity. If we know what cosmic bodies are, and therefore that affiliation plays only a subordinate, but still qualifying role in the cosmos, we would not yet be in a position to know a member of the humanized world. The difference made by a dominant factor in any domain could not be known just by imagining what would occur were it to be dominated by some other. The effect of one ultimate on others is determined when and as they are jointly instantiated. Knowing the order in which the ultimates are instantiated together falls short of knowing the effect they have on one another. That fact, in a specialized, limited form, is not unknown to those who are engaged in politics. When new heads of state take over, the vices and virtues they had expressed in limited contexts are sometimes newly exhibited in startling, often overwhelming ways. Forgetting that fact, great generals are sometimes elected to high office.

The sun in the humanized world passes from East to West, changes in color and in distance over the course of the day; it warms, is clouded over, and may have its passage recorded by the movements of flowers, birds, and fish, by chronometers, or even by a sundial. These, as providing such recordings, are in the humanized world, just as surely as we and the perceived sun are. What we see there is no more the sun known by astronomers than it is something in our minds, somehow projected outwards. Neither the humanized past nor future has a magnitude.

There is no region of exhausted events trailing behind us, nor future activities awaiting an entry into the present. The past and future of actualities in the humanized world are relevant to what is in the present.

Each, while contemporary with others, also conditions and prescribes to them. The sun in the humanized world is a contemporary of whatever else is there. Starting from the determinations it imposes on us, we can speak of it as being in our past; starting from the possibilities it makes relevant to us, we can speak of it as making such and such prospects available. We, reciprocally, provide a past and future for it. Comparisons among humanized actualities are to be understood in a similar way. I am smaller than you, not because you act on me or I on you, but because you and I have different sizes, now related to one another as determinations and as prescriptions. It is because of you that I am smaller and will measure less than you. It is because of me that you are larger and will measure more than I. Your six-feet-three does not act on my five-foot-three, but it does make me be in a relation of smaller to larger. Were you to sit on or push me, I would be affected by you in a different way.

There seems to be no limit to the number of possible ways you and I could affect one another. The differences in what we mutually determine and mutually prescribe usually reflect differences that are often viewed only from one side or other. In one way, my clothes are closer to me than is my friend across the street; in another, he is closer. The two affect me in different ways and degrees, and may do so at the same time. The determinations and prospects that any one humanized reality produces in and for others are accepted by each in its own way.

To be in the present with others in the humanized world is one with being affected by and prescribed to by them, and conversely. The past and present of no one is exactly like that of the others, dependent as each is on different determinations. What mediates contemporaries remains between them. To know what had once occurred in the humanized world, we must know what determinations the contemporaries had imposed on one another. To know their common future, we must know what they mutually prescribe. We could not, though, have such knowledge unless we knew that members of the humanized world exist together. While in that world, we know a common past and future only by and large, and then only so far as we abstract from the differences that those members make to one another.

Our common account of time understands it to have a dominant role in the constitution of actualities and fields. This it has only in nature, where, as one component in a dominant, conditioning Voluminosity, it qualifies and is qualified by instantiations of all the other ultimates. In the humanized world, time is subordinated to the Affiliator. This requires that contemporaneity be understood to be subject to limitations in the humanized world that it does not have in other domains. In the humanized world, the contemporaries, x and y, provide determinations for one

another. The assertion that the sun overhead now makes me a sun-conditioned being, while I make it a personally conditioned sun, at the same time that each of us helps determine what is possible to the other, will sound ridiculous, were we to forget that reference is being made to what is in the humanized world, and not to what is in some other domain. Only in that world do copresent realities mutually qualify one another. Whatever is contemporary with me there helps determine what I will do, while conversely, I help determine what it will do.

5. Humans and Language

All of us live in the humanized world, using its language, conforming to its customs, and, by and large, fitting in with what else is there. Almost every one of us acknowledges other domains. Some of those who make such acknowledgments, and even those who reject or trivialize what occurs in them, are ridiculed, while others are hailed as innovators or privileged, or as having special abilities. As the common acceptances of astronomical and other scientific affirmations, religious beliefs, and ethical demands show, they may also be taken to be reports about what occurs in other domains. The Roman Catholic Church once condemned Galileo because his Copernican account of the movement of the earth relative to a stationary sun conflicted with its humanized version of the relation of the sun and earth. Recently, it reversed its position and declared that Galileo's condemnation was wrong. It erred twice, or alternatively, it was right both times. Galileo did not report what occurred in the humanized world, but what was then astronomically warranted. The latter neither conflicts with nor replaces the former. In the humanized world, the sun goes round the earth; in nature, the earth goes round the sun. Astronomers today allow one to take any heavenly body to be fixed, with others to be dealt with as moving with reference to it. They, unlike those who think they are confirming what astronomers accept, leave over the question of what should be said to be fixed and what should be said to move relative to it.

Whether or not it fits in with what the rest accept, a claim about what is outside the humanized world may be justified and intelligible. Neither in fact nor in theory does the humanized world require the affirmation that it alone is real, or that we must avoid referring to what does not occur within it. When we use a common language, whatever is said about occurrences in other domains will, though, have to be freed from a subjugation to humanizations, before justice can be done to what occurs in those other domains. Speaking responsibly, individuals express themselves as realities existing apart from the humanized world; when they privately frame their

accounts of what is in other domains, they subject these to a dominant evaluative condition, appropriate to themselves as individual persons.

Were all references to what is outside the humanized world illegitimate—indeed, if one acknowledged only what is in that world—one would cling to errors and suppositions long ago known to distort and pervert what is well certified. The errors and the expressions of the suppositions, as well as their outcomes, are in the humanized world together with the expressions of justified claims about what is elsewhere. All of us live in that world, and are subject to its demands. Were no references to anything in it possible, there would be nothing to encounter, and no opportunity to check our surmises about what independently occurs there. To speak responsibly is to act not only as a humanized being, but also as an individual person who may then state, more or less adequately in humanized terms, what is intended.

That a cultivated plant does not grow exactly as a wild one is knowledge many have. It is humanized knowledge, with a distinguishable component referring to what is not humanized. The cultivated plant is a natural plant that has been subjected to humanizations reflecting the effectiveness of our interests, desires, customs, and appreciations. It is watered and grows because account has been taken of its natural needs, modified by our individual and social qualifications. Sometimes, those qualifications overwhelm the others. Price and taste will dictate the ways the plant will be dealt with by most. As in the humanized world, and there subject to distinctive determinations, the plant has a career that is only partly due to what it is in nature.

Since there is no telling in advance exactly what the outcome of the joining of the contributions from other domains will be, we always risk misconstruing what in fact occurs. The failure to see that no one can well understand what occurs in one domain in terms that are singularly appropriate to what occurs in others is characteristic of all reductionisms. Even when most flexible, these can do no more than imaginatively transform what is in other domains into the one that alone is thought to be, or to be worth considering. The understanding of their doing this, and good criticisms of their acts, evidently depend on the achievement of a position in terms of which what occurs in different domains can be understood. What language could then be used?

A language in use is the outcome of the interplay of at least seven factors: (a) It depends on the acts of individuals. Machines may make marks and produce sounds, but they neither do nor could use a language. Able to record and transmit marks and sounds, they are not able to speak, to listen, to communicate, or to attend. Evidently, they have nothing to

say, nothing to comprehend, nothing to learn. (b) What is said reflects something of the users' characters. Those who are careless, evasive, earnest, or concerned, give different weights to the same linguistic expressions. (c) What is said or written carries out an accepted, tacit, or actual desire, and usually some responsibility or accountability. Even cries and shouts suddenly elicited make use of a privacy as well as of a body, and often enough indicate a lack of control, or a failure to be properly prepared. (d) Since the human body must be utilized in order to express what is privately determined, one's linguistic expressions will be qualified by one's body. (e) What is written or said is about something. Even an idle remark or an inadvertent slip has a reference, usually to some private state. (f) When what is said or written is addressed to others, or to oneself as existing at a later date, what is expressed will involve a connection and perhaps an interplay with others in the present. One might mumble, talk to oneself, write in a secret diary. If use is made of a common language, there will be a reference implicitly made to something. If it were not, only marks would be set down, or noises produced; no language would be used. (g) Finally, a language usually serves a purpose. At the very least, it provides a means for recording, sharing, informing, directing, or making contact with others.

When some one of these contributions to the constitution of a used language alone is acknowledged, we get distortive accounts of what a language is and does. It is as much an error to take a language to be an accepted set of noises or marks, as it is to suppose that it is an impersonal, objective set of expressions that different public beings use in somewhat the same ways. Not only does it have a status apart from this or that individual and community, it has a history, a more or less settled vocabulary, and a grammar. Children, and the rest of us as well, usually use it without reflection, trying to keep in accord with what is acceptable in our group. As traditionalized and commonly used, it is like an established practice, a mode of dress, or a shared belief, more or less reflecting common customs and traditions.

Faced with a linguistic expression, one cannot get to it in its initial pristine form just by isolating what history and practice have presumably added, and then removing the overlay. Not only will such moves involve the introduction of other overlays, reflecting the attitudes and procedures carried out at a later time, but one will not know how to proceed unless one knows whether or not the work is a poem, a message, an exhortation, a historic record, or a story. Whatever else one might do in trying to understand a text, one must begin by taking it to be an expression of a certain kind, to be properly grasped only if dealt with in a way that is appropriate to that kind of expression. Poems are not to be read as though

they were cries, signals, or prose. A failure to produce a coherent outcome requires one to distinguish central and peripheral features, and to reconsider the assumptions that had been made about the nature of the text. Poems embrace a number of rhythms, meanings, and stresses, more or less well-joined. Should one's efforts end with ambiguities, incoherences, gaps, or blockages, it will be necessary to reconsider what one had done, before one supposes that one has at last uncovered a text in an unsullied form. It is the knowledge of the kind of work being examined that should direct one's inquiry into its meanings, with irrelevancies, failures, and intrusions determined by knowing what the central and essential factors are. Deconstructionists silently begin with a knowledge of the nature of what they want deconstructed. But then, like good grave diggers, they remove dirt in order to make place for a corpse in which they have little interest, and cover it up their own way. What is usually needed is an identified and presumably important poem, story, document, or message. Sometimes it is enough to note that a common language had there been used in unusual ways. Different emphases are to be put on one or more terms as they are daily employed and understood, so as to make them singularly relevant to the distinctive kinds of objects to which references are being made. This is surely eminently desirable, but it is also what has always been done by good readers. Changes in usage that have occurred over time need to be noted, just as surely as they must, when we try to know anything in the past. What is to be known is not a pure residium, but what can also account for what we now confront.

If we wish to use ordinary language well, when speaking of persons, we must know something about what persons are. The emphases then placed on such terms as 'individuals', 'privacies', 'characters', 'bodies', and 'freedom' will vary somewhat from the ways they are usually used. If, instead, we want to speak clearly and well about what is in other domains, we have to forge a technical language, and then try to keep it geared to what can and does occur there. That language, though produced and used in the humanized world, partly reflects the manner in which a mediator enables one to move outside that world.

It is as members of the humanized world that we forge languages referring to what occurs elsewhere or in other domains. The one that is appropriate to the use of numerals in the humanized world is not appropriate to numbers since these are not in any domain. There are many numerals called 'eight', each referring to a different collection of items, but there is only one number eight. While the numeral eight can be added to other numerals to end with numerals appropriate to larger collections, the number eight can be added to no other. We can add and subtract numerals, but we cannot add or subtract numbers. Numbers are singulars,

in fixed relations to one another. 'Eight and nine are seventeen' is an ambiguous statement. It may be used to refer to the outcome of a joining of the members of two different collections, or to the steps that must be taken to arrive at the number seventeen if one counts nine numbers beginning at the number eight. When a numeral is used to characterize a collection of particular items, its meaning is usually tinged by the natures of those things.

The numeral 'eight' applies to collections whose members can be placed in a one-to-one relation with the sequence of numerals beginning with 'one' and ending with 'eight', but unless the numerals can be sealed off from that to which they have one-to-one relations, the pairings will affect only the terminal points. The 'eight' in 'eight meals' is not identical with the 'eight' in 'eight wars'. That nominalistically tempered observation does not preclude the recognition of a constant core in all uses of the same numeral, reflecting the stability of a group's way of using it.

There are multitudes of collections of numbers to which the same numerals can be applied, as well as multitudes of collections of other kinds of entities. The numbers themselves apply to nothing, but it need not therefore be supposed that they exist in a Platonic heaven, or are the outcomes of deductions from axioms or logical truths. The products of mathematical creative acts, numbers provide beginnings for other mathematical creative acts, ending in still other outcomes. There is no evident end to what creative mathematicians can reach by building on what their predecessors had mastered. Since only numerals play a role inside a domain, it is easy to see why mathematics is a subject that pragmatists, existentialists, naturalists, and cosmologists cannot accommodate.

To obtain useful languages, appropriate to what is not in the humanized world, it is necessary to focus on the constituents of what occurs in it, and then learn what will enable one to know what is in other domains, as well as what is outside every one of them. Expressions of concern, accounts of what occurs in nature or the cosmos, and references to what all actualities presuppose depend on our ability to do this. That, almost everyone knows. Every day, again and again, references are made to what is outside the humanized world, even when the professed views of philosophers and scientists forbid or do not allow for them. Astronomy, chemistry, geology, and physics, the arts, metaphysics, and prophetic utterances all refer to what is not in that world, even when they expressly address themselves to others who exist there.

The language we speak in the humanized world does not just report; it lures and may pull one toward what is outside that world. Its ability to help us attend to what is outside that world is no more astonishing than its ability to help us attend to what is inside it. At both times, it helps us pass

to what exists independently of us. A language is a mediator between us, as individual persons existing outside the humanized world, no less than it is a mediator between us as fellow humanized beings. 'I hate you', 'I love you' make our attitudes evident to those who are the objects of the references.

Knowledge of persons, privacies, individuals, characters, possession and use of human bodies, freedom, natural objects, cosmic bodies, the ultimates, and Being is well conveyed in languages whose expressions and connections are not identifiable with those in the humanized world. The best philosophic language is humanized, but so used that others are not only prompted to reflect, but are readied to refine what is said, and prompted to continue the work on their own.

Ideally, there would be as many well-structured languages as there are subject matters. Linguistic theory tries to identify what is essential in each; a usable version of this focusses on what is common to them. Each domain should be taken to be the provenance of a distinctive paradigmatic language, to be specialized in different ways so as to be relevant to major subdivisions in that domain. The technical languages of the different sciences are partly successful products of attempts to meet that requirement.

To be able to refer to what is in every domain without being biased toward any one of them, one must have recourse to a language that is used in none. In effect it would be a vitalized logic joining variables whose values refer only to what occurs in one domain or another. Since a philosophy is primarily an inquiry, aiming to provide a justified, comprehensive account of reality, carried out by individuals living in the humanized world, it will gradually modify the daily language in the course of a progression toward the achievement of a final comprehensive account. Although the daily language will continue to be used, it will be more and more charged with new meanings.

6. Roles

Everyone of us utilizes what had been learned as infant and child. We make use of a common language, and carry out common practices, acceptances, and rejections in more or less the ways most of the others in our group do. Even those who are set apart, or who set themselves apart, believe, feel, and think by using the same kinds of powers that the rest do, though not necessarily in the same ways. To identify them as aberrational is to take them to be unable to fit well within a part of the daily world. If supposed to exist outside this, they will still be judged on terms used there. We need not refer to those whom we take to be mad, ridiculous, abstracted, or

deluded in order to make evident that humans do not live wholly in the humanized world. None of us does or could.

Humanized objects are constituted by contributions from what is not in that world. Persons, natural objects, and cosmic units exist in other domains, but are still able to contribute to the reality of what is humanized. The living of a human body would not be possible were there no beings who possess and could make use of it, or were there nothing that nature or the cosmos contributed to the human body as existing in contradistinction to its possessor—a person in a distinctive domain.

Abstracted, maladjusted, unable to fit in well with those who are fully at home in the humanized world—a Bruno, a Dickinson, a Kierkegaard, a Kafka, a Peirce, indeed, any one of too large a number—one may try to break away from the humanized world and its concerns, to attend mainly to what occurs in other domains, or to what all of them presuppose. The most despised continues to be in the humanized world, as surely as the most honored, conventional, or successful, and will, so far, never be entirely free from its determinations. While living in a society or state where there are no slaves, one can understand the nature of slavery, as involving the denigration, control, and reduction of some humans to the status of subhumans or things, by taking account of the nature of their persons, and thereupon seeing how attitudes and practices in the humanized world, at some stage or place, misconstrue in thought and act the humans who are there dealt with.

Once the nature of humans is known, one is in a position to begin to carry out deliberate, focussed acts condemning and promoting the abolishment of the horrendous practice. What will still be needed is a sound understanding of what is distorted, followed by a concerted effort to overcome the wrong. That means one must know what persons are, as outside the humanized world, but be able to make a difference there. An appropriate language will have major referents different from those of a language that refers exclusively or primarily to men as in the humanized world at a particular time. It is hard to believe today that the great Greeks, theologians for over a thousand years, outstanding statesmen, the saintly, intellectuals, and reformers, generation after generation, failed to condemn slavery.

Would any of us, had we lived in earlier times, have thought or acted differently? Yes—if we then did not fit as well as they did inside their humanized world. The claim that we would not think or act as they had, would be believable if we could avoid being too completely a part of our present humanized world. As a matter of fact, we all do live outside it. It is questionable, though, whether we impose on it what we know, or are apart from it as well as we can and should be.

When power is put behind the claim that the humanized world distorts the natures and hobbles the promise of some of the beings who contribute to it, a belligerent response may sometimes be provoked in those who are adversely affected. Passionate rejections of the views about what should prevail in the humanized world often enough exacerbate those views. When references are made to results achieved in investigations of what exists outside the humanized world, the terms used will have an import different from what they had in that world. Popularizations of mathematics, science, metaphysics, like recapitulations of poems, cannot tell us what is outside the reach of referents appropriate to the humanized world. To get to what is not there, one must make use of agencies that end at what is not confined to what occurs there.

Everyone has multiple roles to play in the humanized world. Each is required by some subdivision of that world to do distinctive kinds of things at different times. Too often some of the roles are dictated by the dress, privileges, proscriptions, and prescriptions that custom or power had entrenched. Before they know it, children are fitted into positions requiring certain acts and precluding others. Many of the roles they then have, and those they have later, are defined by and help strengthen a tradition. The armed forces, in an almost pure form, know how to turn young men and women into humans of a distinctive kind. A soldier learns how to be, or at least how to act like, a soldier.

Roles are assumed by actors. Instead of occupying positions and carrying out tasks prescribed by custom or by those with greater authority and power, actors so vitalize their roles that they convey the import that these have when carried out in the humanized world. A martinet fills out a role as though he had nothing to contribute to it; an actor portraying a martinet makes evident the martinet's petty thoughts and suppressed desires, even in situations where the martinet seems to behave like everyone else. When he sneezes, a king expresses himself as others do; an actor playing the part of a king, instead, tries to act like a king in every move. A king sneezes as a man; an actor portraying a king sneezes in ways that reveal a king. When a king tries to act as a king, he will rarely do so as well as an actor-king does. For the man who is a king, there are particular roles to play in various situations, leaving him to be like the rest of men in other circumstances. Bureaucrats identify themselves with their roles. Like actors, they disappear behind these; unlike actors, they do not give the roles an import revelatory of truths about themselves, both as they are in and as they are apart from the humanized world. An actor in the role of a king or bureaucrat reveals what a man is by so acting in a multitude of situations that the nature of man is penetrated in ways otherwise not possible.

When a machine does what no human could, it is not thereupon revealed to be a superior kind of human. Instead, it makes evident that it is both different from and inferior to one. The amazing accuracy and speed characteristic of the best machines is one of the sure marks of the fact that they are not only not human, but are inferior to humans, doing what humans cannot and should not even try to do. The women in California who pack oranges into crates with an efficiency no machines have yet been able to equal are pitiful workers who have subordinated themselves to producing machine-like bodily moves. The faster they move, the faster they make evident the difference between what a human should and should not do. Once a machine is made that can act in better ways than even those women could, it will become evident that the actions of such machines, and of the women who now partly duplicate them, are below the level at which humans could and should try to function. It may be desirable to know the answers to difficult technical problems very quickly and accurately, but men have more important things to do. One of these is to know the importance of what is being done.

Hesitations and errors could conceivably be exhibited by machines, but they still would lack the humanizations that human malfunctionings produce. When we are vexed by a machine's malfunctioning, we humanize it; in the absence of a vexation or some other human expression, there would be nothing more to say than that the machine failed because a part slipped or broke, or the like. Some people kick a cat when they, but not the cat, make an error. A kick is a petulant way by which a cat, already humanized as a pet, is humanized in still another way. When a machine is praised or blamed for doing or failing to do what it was made to do, it, too, is treated as a humanized object to which new humanizations are added, but its functioning will always be too predetermined to be equated with a human's, or even a subhuman's. Even randomized moves that it may be geared to perform will be different from those that humans could carry out. The humans' moves will be affected by habits and hardly noticed preferences; the machine's moves, precisely because the machine is so well engineered, suffer from no such qualifications. A machine could be made to throw a ball and have it be hit every time. A baseball player might let a ball pass because he might thereby benefit a runner, or because he had been told, rightly or wrongly, to do so. There are some who would like all advice to be good and successfully used, but then they cannot also reasonably want a game to be then and there produced by the players. Humans have roles that they are to carry out as well as they can; machines do what they must.

Some animals and other natural beings at certain times take on roles as producers, guides, protectors, or breeders. The roles are not adopted, nor

are they usually defined and distributed by a group following some rules or continuing established practices. Roles are definitory of them as distinctive kinds of members of a single group. When men participate in common rituals, they seem to approximate the behavior of some animals, but only because the effective operation of human choices, decisions, concerns, plans, hopes, and fears are ignored. A domesticated cat is still a cat; a serial killer is still a human. The one is only partly humanized; the other remains an individual, but the course he is running has taken a turn for the worse.

A role is defined by the kinds of comportment and acts one is expected to perform; it is a type of public habit. Fisherman, farmer, teacher, father, mother have different things to do or learn; the situations in which they are help determine how their roles are to be carried out. No consideration might then be given to the question whether or not they do this voluntarily. On behalf of some imagined ideal of fairness, or because of what is required by custom or convention, one might try to redress what is thought to be an unwarranted or unwanted distribution of rewards, punishments, aids, and demands. If successful, the effort may, but need not, result in a significant difference in the prevailing course and practices. There is a blunt obstinacy to what occurs, not often radically challenged. Sometimes great changes are brought about by a strong figure; for the most part, though, little can be done in a short time to affect a consensus about the rights and status of women, children, the ill, the disabled, the aged, and those who are powerful or feared. Much might be changed, but even when a great difference is made in humanized matters, little difference may be made in the lives of those involved. A slave yoked behind a plow yoked to a horse is still a slave, though perhaps in a better position than one behind a hoe.

Most humans have roles into which they easily slip because of the prevailing weight of identified origins, gender, or race, or because of their speech, dress, accent, or religious practices. What each is as an individual person will usually be ignored. We live in a world where most are held accountable for what can be traced back to them in established ways, as sources or occasions, though the acts may in fact have been deplored by those who are being held accountable for them. Law in its majestic impersonality holds accountable all those whom its impersonal application takes to be accountable. No one can be sure just what anyone privately desires, intends, or initiates. To know this, it is necessary to move from the humanized world to a domain of individual persons. From the standpoint of the humanized world, responsibility is no more than an accountability, credited to an unreachable source.

Each individual can initiate private acts, some of which make a considerable difference to what is publicly done. From the standpoint of

the humanized world, these initiations are unknowable. The members of the humanized world, or of some subdivision of it, can then be treated as no more than role-bearers who, in accord with established practices, are identified as the accountable origins of what occurs in that world.

Were it not that humans possess their bodies, express themselves through these, and use them to carry out public roles, it would be possible to accept the social, political, linguistic, and historical views that attend only to the ways roles are distinguished and executed. Because we know that individual persons exist apart from the humanized world even while they contribute to the existence of themselves and other members of it, all of us, again and again, resist the identification of an attributed accountability with a personal responsibility, and a preparation with an intention. The first members of these pairs are to be treated as beginnings, not origins; with endings, not completions.

Possessing and using their bodies, humans can make them act as agents. Because those bodies have parts, some of which originated in nature, and others in the cosmos, those bodies are more than what individuals possess—indeed, they are more than what could ever be completely possessed by them. Possession adds an individualized component to what continues to have a status of its own.

When a farmer buys a cow, he buys a humanized reality in the expectation that she will calve and produce milk, functions that she could also have carried out in nature. When she becomes his property, he may give her hormones to make her produce more milk than she otherwise might. He will confine and may later sell her. Whatever he does, he never turns her into just property in the humanized world, thereby wiping out what she is as a natural being. Joining humanized factors, as custom and law require, to the cow as already humanized, he adds to her status as a humanized object whose natural functionings will continue to have a large role to play in what she does. The farmer did not have to do anything special to make her be in the humanized world, for it was there that he initially encountered her. It is there, too, that he uses her.

Perhaps no one was more aware of such truths than Dewey. But instead of trying to understand the difference between what is in the humanized world and what is in nature, and how the former both contains contributions from the latter and interplays with others there to constitute new humanized beings, Dewey focussed primarily on the task of showing how men could fit well within the humanized world. He spent little time trying to understand how humanized beings were related to what was in other domains, or what they presupposed. Primarily occupied with showing how humans could become most at home in the humanized world, he

failed to do justice to ethics, religion, the objects of impersonal acts, or what was always true and was always operative. Not oblivious of the failure, toward the end of his life he affirmed that there were areas outside the reach of pragmatic agencies or concerns—mathematics, privacies, and metaphysics. At its best, pragmatism makes it possible to improve the ways one can fit inside the humanized world, but it then incidentally reveals that its understanding requires references to and uses of what exists and can act in ways having no pragmatic value. A pragmatic mastery of what is in the humanized world presupposes what must be known in other ways, for, at the very least, the process of knowing what is in the humanized world not only makes use of but makes possible a knowledge of what exists apart from that world.

Dewey and his self-appointed heirs overemphasize the reality of humans, focussing mainly on them as making use of what they terminate with. None knows how to acknowledge what exists independently of himself or his acknowledgments. Strictly speaking, allowance is made only for contexts in which a human is at the center of a multiplicity of termini, for which no separate grounding is or apparently can be given. Since, apart from a human, nothing can for them be known to be, whatever is acknowledged will inevitably be pulled into Being. With nothing to oppose it, that Being could have no other status than that of a black hole, sucking in all that it terminates at. A contextualism, allowing for no independent realities apart from what is at the center, ends by having a center-for-nothing and, therefore, has no distinguishable nature of its own. The humanized world is best defended by one who knows that in it men are no more and no less real than other items there. That will not preclude the recognition that men, and the other members of the humanized world, also have realities outside that world.

An individual can act in more than one domain; in each one it will have limited functions and be both apart from and together with different kinds of realities. Every one of us is three-faced: we are distinct from and together with other humanized realities; we are together in a domain occupied only by persons; and we have organic bodies all the while we exist apart from and possess the other two.

Dewey stressed the fact that the bodies humans have are more than organisms. What he did not see was that, as organisms alone, the bodies were in nature, and could be said to belong to men only so far as they were in the humanized world or were possessed by individuals who gave them a new import—without denying them roles in a nature that men did not constitute or control. Natural realities, no less than humanized beings and persons, must be understood to exist in distinctive domains, and there to

have realities maintained against others, before it will be possible to understand how they can be connected and therefore what individuals are and do.

The possession of such a body precludes it from being an organism in any other sense than that of an abstractable component that has a distinctive being and independent way of acting only in nature. The appearances and activities of the human body provide clues about its owner and the nature of its use. These are not bodily. Thus, a study devoted to the understanding of the human body will fall short of learning what it should; if, that is, it ignored the difference made to an organism by its individual possessor and user.

Illness and death defy the strongest wills and intentions, but even when the hold is weak or loose it reveals one to be more than a living body, and this body to be more than an organism. While no human is identifiable with his body, each insists on himself against and through himself. When the body is no longer owned, its owner might conceivably continue to exist, but while we can know that the possessor of a human body exists in a domain apart from that in which the body interplays with other bodies, we do not know if it could exist if it did not also possess a body.

A human's body is related to other bodies in the humanized world. The observation verges on a tautology. As present there, it is a living body, different from what it is as individually possessed and used, since it is not only affected by other members of the humanized world, but depends on contributions from nature and the cosmos as well.

A living organism is affected by a human's use of it. That use, and qualifications by others, operate in different ways. The one affects what had different origins, the other affects the ways the parts interplay. We must move away from an emphasis on an organism if we are to understand what an individual is. As in the humanized world, the body is one among a number of affiliated realities. As not in it, it is what is being owned and used by an individual.

Contributions from a person and from nature affect and are affected by the living body to make it only partially true to say either that one lifts one's arm or that the arm is lifted through the use of muscles and supplementary agents. When I decide to lift my arm, I must make use of bodily powers and parts. If I do not intend to raise it, I may be made to lift it and thereupon be made to use the same powers and parts I had used when I acted voluntarily. Sometimes my arm may move in ways beyond my control. If I am comatose, someone might lift it for me. At both times, it will be my arm. I am in the humanized world because, while existing apart from it, I express myself in and through my living body.

Since Descartes, the primary problem for many thinkers has been to understand how to pass from the mind or some other aspect of a person to what exists apart from him. The pragmatic insistence on the primacy of the humanized world marks a decided break from the Cartesian view. Since Descartes never doubted the truths of pure mathematics, while pragmatists are unable to acknowledge them, pragmatism, in the Deweyan sense, can never fully replace him. He must be replaced, not by a view that allows only retail doubts, elicited by blockages, but by a view that deliberately raises particular doubts in order to test the strength of what has been affirmed.

Were the Affiliator supposed to lie in wait for some combination of contributions from individuals and from other domains to be joined to it, and thereupon produce a humanized being, it would also be tacitly supposed that the Affiliator (and, therefore, any of the other ultimates) might characterize an entire domain, whether or not there were any actualities in it. One might then suppose that inanimate, natural, and humanized bodies, as well as those lived in by humans, were versions of one another. But, unlike all other bodies, a human's is both humanized and organic. As humanized, it can be injured; as organic, it can be hurt. It can be both injured and hurt because a person exists apart from, while joined to, an organic body.

It is one thing to live well inside the humanized world. It is quite another to understand what is in that world, and the conditions it fulfills. One might function well inside the humanized world, but still not know if there could have been a better way of being there, or what is presupposed, or what might continue to be and act, no matter what humans did. Or even if there were none other than a human being. Only because one exists outside the humanized world is one able to know, not only what one can do there, but why one should do it. To know what is best to do in the humanized world is to know what a morality should endorse. To know what ought to be done, and therefore what morality's limits are, one must turn to where intentions and responsibility have pivotal roles.

2
Humans, Persons, Individuals

1. Dreams and Doubts

All the while that roles are being mastered and carried out in the humanized world, each of us remains free to do something else. No matter how firmly we are caught in established ways, or kept at debilitating, mechanically performed tasks, we can still vary our emphases, pace, and directions. Computers are much steadier and more reliable than we are, not only because they are more tightly constructed bodies, but because they are not persons, able to use their bodies, and therefore to make a difference to their functionings. It takes some time before we can become so habituated that we remotely approximate the functioning of a machine. All the while, we will continue to act in less well-controlled ways, beyond a machine's power to duplicate. Since we personally can and do make a difference to what our bodies might do, a computer's excellent performance provides a good, strong reason for believing that it is not intelligent.

When I say 'I am a man', I presumably am saying that I am both a person in a domain with other persons, and that I have a living body and publicly manifested powers that are similar to those possessed and expressed by others with whom I am more or less affiliated. I may hate or fear them, but I still am one with them, discerning something of their characters and even of their individualities. If I attend to the expression 'I am a man', though, I find myself quickly caught up in difficulties long ago noted. I surely am not '*a* man', i.e. a man in general. I am no more and no less than 'this-man', unique, qualifying and limiting terminations at my person, my organism, and the two together—my living body, that is.

Nominalism rejects the expression 'I am a man' as self-contradictory,

or at best as vainly trying to join what is unduplicable with what is common. I am I, and a man is a man, it claims, and also that nothing could be both, at once unique and general. Yet it is surely true that there is something common to me and other actualities that are more or less shaped as I am and able to act more or less as I do—listen, speak, create, share in a universal tradition, use a common language, engage in organized sports and rituals, and carry out long-range plans to produce what has no practical value.

The same man is localized and specialized in each of us, grounded in an individual of which nothing more apparently can be said than that it might be more or less discerned. The two views are separated parts of a single whole. By itself, 'I' refers to an unduplicable person in a domain of persons; by itself, 'man' refers to an actuality in the humanized world; by itself, 'am' refers to an individual. The expression, 'I am a man' is to be so read that the 'am' is dealt with in three ways—as bringing the claims of the two extremes together from opposite positions, and as diversely expressing the same individual. 'Am' here enables the 'I' to singularize the 'man', the 'man' to accept the 'I', and both outcomes to have a common ground. 'I am a man' consequently, is to be read backwards and forwards, via an intensive move to and from an individual.

We come to know about ourselves as 'I's' who exist apart from the humanized world only after we have lived in it for a while. Until we reach a position where we can understand what we are as outside that domain, we will not be able to know the contributions both the 'I' and the organism can and do make to what occurs in the humanized world. As outside that world, we exist as individuals who independently determine what we are to do, both apart from and in that world.

The passage from ourselves, as in the humanized world, to ourselves, as apart from it, obviously cannot be achieved if we cannot escape from that world. The fact stands in the way of socially oriented accounts of man. Those who offer the accounts, like the rest of us, exist apart from all others and there suppose that everyone is interinvolved with everything else. The converse is also true. One cannot be completely cut off from all else without being unable to report what was privately entertained. Each of us is apart from and together with other humanized realities. Since, when and as we are in the humanized world, we continue to be persons not in that world. It would not have been improper to have begun this study with an examination of persons as they are in a domain of their own.

Each of us, as apart from the humanized world, thinks about it and initiates acts carried out there, but is also so involved with what occurs in the humanized world that each finds it difficult to speak of what exists apart from it. Somehow we must manage to say in flat prose what friends

and lovers, poets, dramatists, and novelists convey in other ways. As in a domain of our own, each of us is an unduplicable person. Must it not then be said that what each is and does is cut off from what else there is, leaving no more than self-enclosed egos, unable even to know there are any others? Could anyone, as so apart, do more than idly dream? Even if the dreams were expressions of an unconscious, local or cosmic, or were due to movements of physical bodies, they conceivably might tell us what was occurring inside or outside the humanized world, but we would have difficulty in reporting what we then knew. Were persons realities, sealed off from all other kinds, what went on in any one would be cut off from what occurred in the others. Supposed perceptions of external realities would then be indistinguishable from idle dreams. Writers of dream books do not hold such a view; they are radical realists who take dreams to be adequately reported and to refer to truths and realities otherwise inaccessible. A rejection of their claims does not, though, warrant the view that every private thought is a floating image, attended to by no one and referring to nothing.

When Descartes asked himself whether what he supposedly perceived was anything more than a misconception implanted in his mind by a devil, he imagined that there was a devil who, as able to put an effective question mark after every claim, existed outside Descartes' mind. An imagined devil could not deceive him; at most, it would be imagined to do so. That would not result in Descartes' being actually or even possibly deceived. Had Descartes imagined that the devil made him believe what was not so, that would not mean that what Descartes held to be true was false or even doubtful. Had Descartes imagined that the devil was eating him, his life would not be in jeopardy. As James and Peirce noted, an imaginary doubt is just a paper doubt, not operative, not affecting what is being entertained, experienced, or intruded on. Descartes himself recognized that his doubt left untouched his clear and distinct ideas, as well as his idea of a God who guaranteed that such ideas were true. Why did he suppose that the devil could not have misled him about what clear and distinct ideas were, or that their truth was guaranteed by God? Was the devil just an imagined being, but God not? Did Descartes have a clear and distinct idea of the devil? If he did not, why should his entertainment of the idea of a devil's deception disturb what he thought? A confused idea of a devil, deceiving Descartes about the validity of the claims of other confused ideas, surely has no more validity than those ideas have. An 'I' that thinks is an 'I' having thoughts. It could be deceived. Were a devil to provide it with content that was falsely assumed to be true, the devil would have a reality and a power greater than the deceived being had.

The devil, for Descartes, was no more than a metaphor for the power of a doubt to ruin confidence in the legitimacy or finality of any perceptual claim. A doubt does no more than that; it neither qualifies nor denies anything. Still, despite James and Peirce, one may doubt freely and doubt anything, though, as they rightly insisted, one should not doubt indiscriminately. A doubt can, indeed should, be raised at every crucial point, to test whether or not there might be a better answer than that already provided.

Doubting is a part of a single process of inquiry, a reflection rather than a purging, an occasion for reconsideration rather than a warrant for a dismissal. Although he used an ordinary perception as an illustration, Descartes initially spoke as though every idea but one—his idea of God—might have been tampered with. Only later did he make evident that thinking encompassed diverse 'mental' processes, and that a special place was being reserved by him for clear and distinct ideas. His reference to a devil was his way of conveying the view that, apart from clear and distinct ideas, every idea was questionable.

A thinking being is not identical with a being who thinks. Did one conclude from 'I think' to 'I am one who thinks', a reference would have been made to what might do something other than think. If 'I am' is logically deducible from 'I am a thinking being', it has a possibly larger scope than this. It might, therefore, be able to possess, or to be interinvolved with a body; it might be submissive or commit itself to preconditions exhibited in every actuality, even those without an 'I'.

It is not clear or distinct why one should have to look to God to warrant a sound idea. Descartes' reference to God does, though, point out an important fact: the removal from clear and distinct ideas of a possible taint of dubiety depends on a power that transforms them from being members of a class of questionable ideas to being members of a class of those that supposedly are always true. That power need not be divine, but it must be strong enough to enable one to start in one place and end in another.

One need not, with pragmatists, hold that only something dubious in what one confronts should make one raise legitimate questions about it. One may, and sometimes does and should, doubt what others take for granted. Questioning does not necessarily corrode what is true; nor does it have to await a confrontation with what is unclear or frustrating. Though it is right to say that Descartes' doubt is a paper doubt, it does not follow that a doubt should not be deliberately raised as an occasion for a more careful examination of what one had accepted without question.

Descartes' doubt pushed aside all perceptions indiscriminately. It never occurred to him to ask himself whether he was in fact doubting

anything. Since he held that only clear and distinct ideas were true, he had to hold that his idea of his doubt was clear and distinct. He was surely right against the pragmatists in knowing that he could doubt what he had taken for granted, but not right in assuming that a lack of certainty justified a dismissal of anything that was being entertained. One may have doubts about what something is or might do, and still know that it is. One cannot doubt that there is something other than oneself without granting a privileged position not only to oneself as a doubter and the doubt one provides—as Descartes did—but to the content that is being doubted. Descartes doubted only the supposed existence of what he perceived. He was right to do so, as long as he took no account of what could bridge the gap between what he had in mind and what existed apart from it. When he turned to God as the guarantee of the truth of his clear and distinct ideas, he took Him to be a mediator, enabling Descartes to pass from his clear and distinct ideas to what had an existence apart from himself. He never did show that there was such a mediating God. Apparently he never asked himself whether or not there were any mediators in addition to, or instead of, his supposed God. Since, on his view, only clear and distinct ideas were true, and then only because such ideas were guaranteed by God, he found a sanction for his clear and distinct ideas in that for which he had no sanctioned clear and distinct idea.

A mediator need not be divine or divinely sanctioned in order to be able to accommodate what is privately entertained, or to be accommodated by what exists apart from it. In the end, a major difference between a Cartesian and a pragmatist is primarily a difference in the choice of mediators. Where Descartes refers to God, the pragmatists refer to action, experiment, inferences, and problem-solving. Do the mediators they acknowledge only happen to exist? Might they have not existed, or might they later not exist? Is it enough to acknowledge those that end at what is useful? Might one not arrive at a desirable outcome in a disreputable way, or at an undesirable outcome in a well-established or usually successful way? Poor inferences can end at good conclusions; well-established ways of moving to desirable ends may not prove successful in every case. Inquiry, inference, experiment, and the like, need to be assessed as good or bad mediators, not solely in terms of their outcomes, but on their merits and warrants. An adroit, successful cheater may get the right answers more often than one who reaches them under the limitations of good rules or laws. Some of these have natures, ranges, and justifications quite different from those needed to govern good scientific inquiries. Not much is gained by substituting a divine mediator, of whose existence we are not sure, for a scientifically usable one that has a limited application. What is needed is a mediator that has a necessary existence, able to take us from any place to

any other intelligibly and surely, no matter where we start. Neither Descartes nor Dewey showed that they had understood what mediators are or how they operate.

If we begin our studies—as we should—with what is in the humanized world, we will need the help of a mediator so as to be able to arrive at ourselves as existing in a separate domain. Conversely, what is in us as persons needs the help of a mediator if there is to be an arrival at what is in the humanized world. We come to know who we are as persons by following the first course; we come to know who we are as interrelated, localized beings in the humanized world by following the second. Initially and unreflectingly, we pass back and forth from one of these procedures to the other until we find acceptable beginnings and accommodating ends.

We come to know ourselves as individuals and as members of the humanized world in a process that is worked out then and there, moving backwards and forwards in the course of a progress from one end to the other, under the guiding control of an irreducible powers. Sometimes we are insistent on and sometimes we are submissive to what connects us to something else. Sometimes what we end at is accommodated to some degree, sometimes it is rejected. What enables us to arrive at something that is distinct from us has its own nature and course; it is affected by and affects both that which it accepts at the beginning and that which brings it to an end.

Pragmatism and Cartesianism need one another, the one effectively reminding us of the irreducibility of what is in the humanized world, the other reminding us of the irreducibility of what is outside that world. Each stresses essential connections between ourselves as apart from and as in the humanized world; both fail to identify what in fact operates between them. Doubt and confidence are both to be brought to bear in varying degrees on what is confronted, without either being able to annihilate or adopt the other completely. We begin more or less confident that our intentions will be well served, and end with more or less of a doubt that they had been well met.

We come to know about ourselves after we have managed to distinguish our contributions to humanized objects from what is contributed by other realities. All the while, we can be aware that we are individuals with characters, able to use our persons, our living bodies, and our organisms. Although we may not then be fully aware of ourselves as contributing to what is humanized, we may become more and more aware that we had done so, perhaps in a form that is compatible with contributions made by nature and the cosmos, or by what had already been humanized.

Might not some entertained idea lack an objective, sustaining component? Yes. Like a feeling of pain or pleasure, might it not be undergone in

oneself as apart from all other realities? Yes. Is it not reasonable to dismiss an idea if it does not fit well with what had been previously affirmed, or with some already established truth? Perhaps. If one did, one would, at least tacitly, take something real to warrant the rejection. A fantasy is a fantasy, not just because it is imagined, but because it is rejected by what is real. We may not know what excludes it; that will not mean that it is not a fantasy, but only that we do not yet know that it is one. Although there are idly entertained ideas, neither believed nor disbelieved, affirmed nor denied, they may well comport with what is elsewhere. Even if we make no claims on their behalf, they may be related to what is apart from them. While primarily referring to what is elsewhere, they may incidentally depend on other persons for acceptance or confirmation, or may primarily depend on other persons, and incidentally refer to what is elsewhere.

Possessions are distinct from their possessors. What is not so distinct are aspects, neither claimed nor rejected, not true, not false, not dreamt, not doubted. We can think, or at least speak of, a wise potato, a sixty-foot woman, a singing horse, gryphons, and Greek gods. As thought of, they are the termini of thoughts. Were those thoughts not sustained by us, they would not even be entertained; were they not also sustained by what is distinct from us, if only through the agency of a negation, they would be no more than distinctions in our minds. There are claims that have no validity, intentions that are not carried out, delusions, misconceptions, and idle thoughts. If any of these required us to hold that the outcomes were confined within human privacies, no one would know that they had external sources.

Those who hold that there is nothing but what is in a mind are anxious to convince the rest of us, as existing apart from that mind. Confident that they cannot get outside their own minds, they are no less confident that there are others with minds of their own. How, if everything is imagined or sunk in one's mind, could one know that there were others who are to be convinced that this is so? How could the others be reached? If everything is projected from a mind, there is no place for anyone or anything to receive it. All the while, the possessor or projector would not be known, except by someone who projected that projector, and so on down an endless line of projectors.

No real advance is made when what is supposedly in a mind is taken to be an occurrence in the brain. Instead, the issue will be doubly confounded, since it will presumably be supposed that what was in the mind was also in the brain, and that this was somehow then transformed into what is in the mind. If what we know of the brain is known to be true of it as apart from our thinking of the brain, why is this not also true of the seen

sun, and the heard thunder? It makes no sense to say that we have a knowledge of what occurs in the brain but that there is no one who knows this or anything else. How is it possible for anyone to think that there are no thoughts? Each of us is a person, one epitomization of which is a mind. Each of us also has a character, as well as a body that can be used. To know of any of these and what it contains and does, we must be able to move from what is in the humanized world to what is apart from it.

We have brains and we have minds; we do bodily things, and we execute private acts. Doubts and dreams occur in us, who are not doubts or dreams but real beings. Whether or not our doubts and dreams agree with what occurs apart from them, the two are different. Might not all persons be merely imagined? Surely not, for then there would be nothing but imaginings belonging to no one. If everything were a dream, there would be no dreamers, but just detached mental occurrences, thought by no one.

We can doubt anything, but we cannot doubt everything. We can keep our thoughts to ourselves, but we cannot get ourselves into ourselves. When we doubt or dream, we pass from the humanized world to another domain, and back again. Indeed, we do this many times every day. What is difficult is to understand just how it is done. A long tradition says that there is a component in whatever there be that we isolate, and then hold apart from its involvement. Unless it were just idly present, the supposed abstracted item must have made a difference to that from which it was abstracted, and a return to its original place will make a difference to it.

A full understanding of the issue, and the resolution of the problems that have traditionally haunted it, depend on an understanding of what it is to be in a domain of persons. That in turn presupposes a knowledge of how it is possible to pass from oneself as in the humanized world to oneself as a person—and conversely, from oneself as a person to oneself as in the humanized world. We unreflectingly make such passages again and again. Thinking we are hungry, we eat; having eaten, we no longer feel hunger. Most of us solve the supposed mind-body problem at least three times a day.

2. Persons and Their Possessed Bodies

Each of us is an unduplicable individual who possesses and uses a more and more habituated character. That character may be committed to the realization of an ideal good. It may use a person having a plurality of such distinct epitomizations as sensitivity, sensibility, will, and mind; it may also use a possessed body that is never under full control. A person has

unalienatable rights; with other persons, he exists within a distinct domain. While having a reality different from others there, each is together with all of them, most of whom are unknown.

When I am in a domain of persons, and when I know that I am in that domain, I can also be and know that, as a living body, I am in a domain of humanized beings. I can feel a pain in my living body while knowing that it is being adversely acted on, for that body is both lived in and possessed by me, an unduplicable being who exists together with other persons, and who is affected by, imposes himself on, and acts through his living body and his organism.

Separately and together all of us are persons, primarily subject to an ultimate Assessor, but when we express ourselves through our bodies, we provide an occasion for the Affiliator to take over the Assessor's dominant position. As subject to the Assessor, the different powers in each of us are stratified as being relatively superior and inferior; as subject to the Affiliator, those same powers, as expressed with the help of the living body, are stratified as being comparatively more or less serviceable.

Every one of us, no matter what we are and do in the humanized world, exists apart from it. The observation is at once perplexing and evident. Conversations, communications, sympathy, and the awareness that humans are affiliated with other members of the humanized world continue, all the while each of us remains apart from that world. As a person, each of us is both apart from and able to become a member of the humanized world. Did we not exist in a domain of our own, we would not be able to intend, understand, or believe. There would be no one who could know that there was a humanized world of which he was a member. Sometimes we have to grope for words to express what we had surmised about what occurs in the humanized world, and elsewhere as well, but if we cannot find the words the surmise will not necessarily vanish.

Although every one of us many times during the day readily passes to and from the humanized world and a domain where we are both apart from and together with one another, it is not evident just how this is done. Must we not somehow beg the question when we ask ourselves how it is possible to pass from what is in the humanized world to a person, or conversely? Do we then simply make a humanized supposition about something that could not be known? Or do we remain by ourselves and vainly imagine that there are other realities?

It is not possible to move from one position to any other unless we are enabled to do so by what bridges the gap between them. Although it is an individual person who tries to understand what is in the humanized world, the act must, sooner or later, subordinate what is initially accepted to what enables him to arrive elsewhere. Wherever we begin, we can end

in a domain different from that in which we began. If we begin with an idea or a supposition, this must be enabled to terminate in what exists apart from it. If we think about something real, what we have in mind must be brought to bear on what is outside us. Obviously, this cannot be done by attaching it to something else in the mind or to some other part of ourselves, unless this is what is being referred to. No hypotheses, suppositions, intentions, hopes, or desires enable what is in us to get to what is elsewhere. Nor could we, without the help of a separately existing agent, lay hold of what is apart from us.

We come to know other realities only if we and they exist in contradistinction to one another, and are joined by what is acceptive of the one and accommodated by the other. Indeed, we know where we begin only so far as we had arrived at an accommodated end, and then returned to our beginning as accommodative of what had been ended at.

We know where we end when we make use of intermediaries that had begun elsewhere. The knowledge we now have of ourselves and of what else there is, is the result of multiple passages back and forth from beginnings that had been brought to an end, and from endings at which returns are begun. This does not mean that what provides a beginning for a connection, or what brings a connection to an end, becomes more and more real, or more and more determinate, but only that some characteristic insistencies become more and more evident. This pen and I are determinate, independently of one another, but we become more and more determinate as termini of passages from one to the other.

We never begin or end with what is completely determinate, for the possessor of those determinations always adds to them, primarily in the form of intensifying, possessive acts. To obtain the best knowledge of my character, I must be enabled to move to and from it and my expressions of myself, until both termini are determinate enough to exist in contradistinction to one another. The more determinate those termini become, the more will they be distinct from one another, and the more too will they make evident both the effectiveness of their connection, and the presence of what grounds each of them. What is finally arrived at as determinate termini are both separately and jointly dependent on different insistent grounds, not exhaustively expressed in that particular situation.

Both intent and character have their own distinctive natures and powers; both become more and more determinate termini through passages back and forth from one to the other; both are possessed by individual persons who can do other things as well. Each not only possesses the termini of passages from one facet or part to other facets or parts, but provides a possessive base for them. If we tried to move from that base to some other, we would have to depend on the acts of what was

different from both. References would then have to be made to what could express itself in a plurality of moves back and forth between those bases.

If we make use of what is in the humanized world, this will be governed by the Affiliator. If we end at an individual person, it will be at what is primarily governed by the Assessor. It is also possible to begin at a person, or with what he privately entertains, and arrive at what is in the humanized world. It would not be possible, though, to pass in either direction unless what was at the beginning and end of the connection both qualified and were qualified by what was different from both of them.

An individual person possesses his body. His possessive act begins in him and ends at his body, not as this is in the humanized world, but as his possession. That possession is quite different from the possession of his body by another. A slave holder, no less than his slave, is a humanized being, exhibiting a deficiency in value in himself that spoils both his humanized life and that of the enslaved, in good part because full weight is not given to the ways both are changed by the linkage. Hegel, in his brilliant examination of the relations of master and slave, did not take adequate account of the fact that in owning a slave, the master became an enslaved master, and the slave a mastered slave. They could never reach the stage where they were free of one another, except, as Hegel did see, by facing one another as persons. Hegel should not, though, have treated slavery as an early stage in a historic march to his Absolute, but as an occurrence in the humanized world, to which persons contributed without thereby ceasing to be equal persons outside the humanized domain. The Stoics knew that.

That one's living body is possessed by oneself as an individual is made most evident by one's pains, since these are both bodily occasioned and undergone. Expressions of need and desire, and acceptances and rejections of attributed accountabilities for what the body is taken to be and to have done in the humanized world, offer other instances. Sometimes a person's bodily acts are supposed to be unaffected by anything other than by some other body. Sometimes one may be assaulted by overwhelming noises and shocking sights. Often enough, these are taken to be no more than reactions of an organism, mainly because they are not or cannot be traced back to the person as possessing and using his body. All the while, that body will continue to be possessed and used by him as one who exists and acts apart from the humanized world.

When someone is credited with or denied public rights, his living body is dealt with as a public object of a publicly defined accountability. A distribution of rewards and punishments, even when carried out in good accord with publicly applied rules, stops short of that body as possessed by an individual person. The possession begins outside and ends in what is

inside the humanized world. When one is forced to submit to the control of others, one's body will continue to be individually possessed. Each man's possession of his body is distinct from his possession of another's. A resentment directed against one's own possessed body is not equatable with one directed against those who deal with that body on their own terms. The body that is possessed by an individual is assessed by him; so far, it is not affiliated with others, for it is not yet part of the humanized world. Evidently, the living body is two-directional, being oriented to its possessor and existing together with others in the humanized world. A bodily pain occurs neither in a disembodied person, nor in an unpossessed body; it is no more sunk in oneself as apart from the body than it is in the body as apart from from one who lives it. Possessing is an assessive act, insisting on itself against constraints. A felt bodily pain provides but one instance of an assessing person outside the humanized world.

Hunger and thirst transform what is primarily subject to the Affiliator into what is more and more subject to the Assessor. The first occurs when one is primarily receptive or passive; the second, when one is primarily insistent. Since neither the receptivity nor the insistence is easy to identify, we tend to speak indifferently of ourselves as hungry or in need of food, as thirsty or in need of drink. References to intentions, fears, and hopes are made mainly when a reference to a person is intended; references to hunger, thirst and pain, instead, are made mainly when the organism is stressed. Each produces an odd miscellany of occurrences. There was a time when some of these activities were assigned to specific faculties, and a time when they were taken to be bundled together in judgments, or treated as stimuli and reactions. One escapes these unhelpful suppositions with the recognition that all are dominated at the end by a factor that was not dominant at the beginning. The acknowledgment of that fact does not require one to abandon the familiar conventional terms, provided it be understood that they involve references to transitions from a person to a possessed individual body, or conversely. In neither case is the possessed body identifiable with the body that is a member of the humanized world, for this is subject to different conditions.

The transitions from a person to an organism, and from a humanized living body to an individual who possesses it, occur outside the humanized world. Both involve processes in which a beginning not only gives way to an ending, but carries over what is at the beginning into what qualifies it at the end. The fact helps clear up an ambiguity that pervades the use of the term 'privacy' in law. When lawyers speak of a right to privacy, they refer, not to a privacy enjoyed by an individual person outside the reach of the law, but to a human who is publicly recognized to

have a public being with a nature and rights that the law takes to be within its provenance. What is in other domains does not concern the law. Nor does its designation of some acts as 'private' refer to what is in a person. For it, 'private' means what is attributed to living bodies so far as they are taken to be outside the interest of the law. As governing the ordered behaviors of human members of the humanized world, the law may deny itself the right to intrude into the bedroom of adults, but it may still claim the right to remove a child from its home if it is in danger, has a communicable disease, or is denied an education, and so on.

'Privacy' for the law is a public area that it takes to be outside its concern, not because it is inaccessible, but because it defines it to be be so. A family is 'private' to whatever extent the legal system takes it to be outside 'provenance' of the law. What it does not define to be private, the law may later take to be so. All the while, the privacy of a person will not come into question, being outside its reach. Since laws have to do only with publicly determinable activities, the 'intentions' mentioned in laws could refer only to publicly ascertainable, relevant antecedents of public acts. Justice, from the position of those laws, means only that an impartial determination of public accountabilities is carried out.

From the position of governing laws, a person is a source of public acts or, at the very least, has the status of an object of impartially distributed rewards and punishments, privileges and disabilities. Laws may be taken to be applicable only to some; whoever they are, they are supposedly to be dealt with impersonally, as so many public units acting under various specifiable conditions. Despite references to inalienable rights, intentions, and character, the laws never acknowledge anything more than humanized beings who are subject to common demands, and who are to be held accountable for what is impartially determined to have begun at those beings, and whom it thereupon takes to deserve rewards and punishments. A punishable act may not have been initiated by one who is being held accountable for it, or even to have been begun through the use of his possessed body. It suffices if, when impartial determinations of publicly designated, warranted objects of rewards or punishments are carried out, they identify some publicly identifiable beings as the proper recipients.

A living body, while it is in the humanized world, is possessed by an individual, and referred to by his person in a domain different from that in which there are humanized beings. Although a living body is in a domain where other living bodies are, and is also in the humanized world, it cannot be fully understood if one attends to it as though it were only in or only outside that world. We could, of course, if we liked, refer to our bodies as transformational agents, enabling us to pass from the status of persons in a domain of our own to being members of the humanized

world, and conversely. To do that, though, we would have to take our living bodies to be both possessions of ourselves as individuals and to be members of the humanized world. Our living bodies continue to be individually possessed all the while that they are subjected to determinations by others in the humanized world, and conversely.

The act of possessing one's living body is begun apart from that body, and ends at it as the body-of-an-individual-person, inseparable from the body as in the humanized world. As terminating the act of possession, the body is different from itself as in the humanized world. The possessive act requires no deliberation or knowledge, occurring as it does when and as the individual person exists.

A person and the living body have their own careers. A person can carry out other acts, and the body can interplay with other bodies in the humanized world. All the while, the person and the living body will be mediated by what is neither. Both rational and dynamic, this is identifiable as the character, itself expressed in a possession and use of a living body, organism, and person. The possession and use are united by the individual to constitute a consciousness and its intensification, more or less, by the emotions. The character, the person, and the living body, the consciousness and the emotions, are distinguishable expressions of an individual.

An individually possessed body is a lived body, a body that is distinguishable but not cut off from the organism or the person. Because the body is possessed through the use of the character, it is an individually lived body.

When we are interested in what is to be made the object of an accountability, an emphasis is placed on what is done in the humanized world; when we are interested in what is done to the body by the person, reference instead is made to him as responsible. Were the individual alone considered, the individual's organism would be subject to a mysterious control. The gap between an individual as apart from the possession and use of his body, and the body as not possessed, is the character's spanned body.

A living body is always distinct from the individual, just as his person, his consciousness, his character. The possession of the body occurs at the beginning of life, well before there could be an intent to possess it. So far as the possession terminates in the organism, it gives it a status different from what it has as in nature. The possession is made inescapably manifest, not only in feelings of bodily pain and pleasure, but also in expressions of desire, will, persistence, and in the acceptance of accountability for what the living body does in the humanized world. Were the body alone considered, then hunger, thirst, and appetite would be no more than instances of a bodily disequilibrium.

The observation of one's living body by another does not reach the individual who possesses that body. Still, it is often possible to pass beyond the living body, as in the humanized world, toward it as possessed, and thereupon be able to discern the presence of the individual, as able to possess that body, and do other things as well. Sometimes the possessive act is so feeble that one can do little more than lament that the act had proved to be hardly distinguishable from a claim that had been overcome. At other times, the living body, even though it continues to be possessed and used, is so obdurate that it seems to provide a serious block in the way of what one seeks to express. When others approach that body in the humanized world, they may deny it food and drink, habituate it in the use of drugs, place it in dangerous positions, or make it the object of their desires. All the while, even if permission is given to those others to treat one's body on their terms, that body will continue to be possessed by oneself as an individual.

There are inadvertent moves, forces beyond one's control, tremblings and stumblings that one would have preferred not to have occurred. They point up the fact that one's organism or one's body is not well controlled, perhaps not even entirely controllable. Those unfortunates who are comatose, or who seem to be living in a vegetative state, continue to possess their organisms, though they are not able to express much in and through them. Their condition makes evident that the possession of an organism or body is not the outcome of a deliberate act. Short of death, it will continue to be possessed, no matter what is done to it or what ensues.

Each person has a permanent right to his living body. That right, sometimes called a 'right to life', and sometimes a 'right to liberty', is not extinguishable by what another might decree or do. It can, to be sure, be brought to an end, or have its exercise severely limited and punished. Apart from these, the effectiveness of the possession of one's body varies considerably. The body may be so debilitated that what is intended cannot be well-expressed through it, or it may be so dealt with that it provides no occasion for the possessor of it to continue to possess it. In any case, what is possessed may be made so subject to controls by others that its acts will mainly be functions of exteriorly imposed determinations.

As long as there is an individual who possesses a living body, or an organism, that body will be qualified in ways no examination can reveal. Every once in a while, though, the body will be found to act in ways that compel one to try to understand it as having been subject to an individual person's determinations. Since a prisoner may be shackled, beaten, forced to act in one way or another, all the while that he individually possesses his organism and the living body in which the organism and person are

merged, possession evidently does not entail mastery or control. It does, though, express a right.

Those who enjoy subjugating others would feel cheated if a body, on being beaten, were not possessed by the victim. Contempt and hatred can, of course, be expressed by mutilating a corpse, but that lacks the bite that would be expressed had the humiliation been carried out on one who was aware of what was being done to his organism and his living body. It would be in good accord with current practice and belief were a dead body taken to bear the marks of having been possessed, and the possessor of it supposed to be one who will forever possess it, perhaps in a sublimated form. No one knows whether or not such suppositions are warranted. In this life, in any case, we know no more than that our plans, intentions, and demands are sometimes expressed through our bodies. However those bodies are possessed, and whether or not they are then taken to be primarily agents, hindrances, prisons, or instruments, and despite the fact that they grow, mature, suffer, and prosper in ways that are like those characteristic of subhuman living bodies and organisms, they are distinctive because possessed and used by human individuals. Once we understand how it is possible to pass from one domain to any other, we will know the general case for which the possession and use of the living body, and the help and hindrance this provokes, provide specialized instances.

It is one of the self-chosen tasks of western theologians to provide good reasons for supposing that persons could continue to exist after they have been separated from organisms, or are no longer able to be with other persons in a common domain. Where the life sciences seek a certifiable answer to the question as to whether or not humans ever were, now are, or could ever be natural beings, the theologians are inclined to accept the assurances expressed in holy books, or to look to prophets for assurances. While the first know nothing of bodies possessed by individuals, the second end with dogmatic affirmations, not always shared by the members of other religions.

What we now know is that living bodies and organisms are possessed by individuals. Sometimes we are able to discern ourselves and others as existing together in a distinct domain, but no matter how well we do this or how well we might anticipate what someone will do in the humanized world, we never get into another as one who knows, intends, believes, hopes, fears, feels, is resisted and challenged. What hunger does in one way, and eating in another, living expressed through a character does in a third. An individual keeps the person both apart from and joined to an organism, each affecting the other in the living body.

Ownership is not to be identified with possession. One may own what one does not possess, and may possess what one does not own. A thief may take possession of my watch, but he will still not own it. My bank is in possession of some of my money. Although it does not own my money, it will act as if it did, though on my behalf—or so I hope. Were I to form a full partnership with another, I might not possess, but I will own as much as my partner does. Possessing refers to a particular kind of governance or control; ownership refers to a status one has, because of the determinations insisted on by the group to which one belongs. Did I do no more than possess my living body, it would be subject to my determinations, but it might also be so used by a group or others that I could do no more than lay claim to it. Yet as long as I am alive, they could not preclude my possession of it. Did I not own my body, its use by others or by a group would define it on their terms. From my position, my right to it is never compromised.

Darwin thought that an ape could be said to pray when it faced the setting sun in what seemed to be a reverential attitude, similar to that assumed by some humans when they worship. His occupation with public acts should have led him to a different conclusion. Instead of supposing that the ape was reverential, carrying out in a faint way something like a human act, Darwin would have been more justified, on the evidence, to suppose that humans never did more than engage in animal acts even when praying, mating, eating, and so on. The humans would then be viewed as doing nothing more than acting as animals do, perhaps adding minor variations to animal-like acts. This, apparently, was the conclusion that Darwin wanted to draw. Instead, his understanding of the ape's behavior led him to treat the ape as though it were a truncated human.

When humanized, a human's body remains subject to an individual's possessive acts at the same time that it is subject to limitations set by others and the wholes in which it is together with them. The acts are expressed in and through the living body, sometimes at designated times and places. Try as we may, we cannot find an individual person by examining parts of that body, or all of it. Nor will we find any subdivision of the person there—sensitivity, sensibility, mind, will, and so forth. Nor will we come upon a consciousness, emotions, or any other ways in which a person and body are joined. Neither the sharpest scrutiny, nor the most careful study of a burn or nerves, will tell us anything about a felt pain, though this may of course prompt one who suffers it to carry out public acts directed at the burned area. It is because of the two-sided nature of a living human's body that a burn is felt as pain.

Those who reject the idea that humans possess their bodies and can privately feel what is bodily undergone make an implicit exemption for themselves. They do not take themselves to be engaged in just bodily acts.

Instead, they use their bodies to express their separately maintained denials and affirmations in such a way that others might also privately accept what is being claimed. Their cries of pain offer effective ways in which others can know what is being privately undergone by them. If we shy away from references to minds, feelings, and the like, we will have to be content to refer to human bodies as just affecting and being affected by their parts and by other bodies, all the while that—at best—we possess and use our own bodies.

Each of us is radically alone and always together with others. I know myself as a 'me', and thus as one whom I approach from without. This will usually be done by my passing intensively from my body as in the humanized world—and therefore from myself as approachable by another—to myself as an individual person possessing the 'me' that others refer to as 'you'. Both the 'me' and 'you' are passed beyond, toward myself as an individual person. This possesses the body that sustains the 'me' and accommodates the 'you'. 'I am' is shorthand for 'I am a person who can confront and pass beyond my public me'. 'I know you' is shorthand for 'I know you to be the possessor of what I confront, and toward whom I move in a discernment'. I can talk to you as well as at you.

To be a person, apart from all channels and ways of acting, is to be a distinctive member of a distinctive domain, occupied only by persons. What I am as so apart is sometimes spoken of as an 'I', 'self', 'ego', or 'soul'. None of these adequately conveys the fact that I exist in contradistinction to other persons in a domain in which there are no other kinds of actualities. I am together with the others in that domain in a way I am not together with other beings in the humanized world. Still, I and others possess living bodies that continue to have distinctive ways of functioning apart from our possessive acts. Consciousness, emotions, sensitivity, self-control, and purposes are some of the ways through which a human body is possessed, sometimes with qualifications reflecting private demands, and sometimes with qualifications reflecting insistencies due that living body. One's awareness of another person may be encouraged, well-directed, and perhaps alerted by various clues, particularly by those exhibited in mistakes, inadvertencies, hesitations, asides, and darting glances. It may be expressed quite early and well, even by one who might otherwise be dismissed as stupid or self-involved. How strange it is that what is so well-known to novelists and dramatists, and so often carried out well by little children in the course of even the most casual conversations, should be so widely ignored by theorists.

A discernment is a single move, penetrating much further than an adumbration does. At its best, it terminates at another's character sometimes as this is expressed in or through the person or living body, but

sometimes also as this is used by the individual. When I listen to someone speaking, I need not hear just words, but may learn something about that person, both as existing apart from his body, and as related to me as existing apart from mine, all the while that both of us possess and use our bodies. The use may stop at the bodies, or it may pass through and beyond them. I hear you over there in the humanized world, but I listen to you as one who is related to me in a distinct, non-humanized domain in which we are together as persons.

The very expression of one's doubts shows that it is possible for what is not bodily to express itself through one. Some who acutely observe living human bodies claim that they cannot find warrants for acknowledging anything that is not in the humanized world; yet they too acknowledge and make use of such warrants when they chide themselves for misconceptions and carelessness. These may make no evident difference in the way the body acts.

The relations that an individual has to his living body vary in intensity throughout the day. Sometimes this body may act as though it were just an organism. Usually it is known quite early to be a member of the humanized world. Were it freed from all the humanizations to which it is there subject, it would still be unlike any other kind of body, charged as it is by an individualized act of possession. When a human body is viewed as though it were not possessed, it will seem to be a body somewhat like that of a subhuman, differing perhaps only in its ability to use a conventionalized language. Since that would still keep the unborn from being included among humans, we would have to confess that we could not know what the essential difference between humans and nonhumans was until we were able to discern persons and contrast them with other kinds of beings. Were a successful meeting of a human sperm and egg to produce a human then and there—only after three months, or at some time short of nine— we could not know if all we could do was to attend to it as an organism. Thomas Aquinas, who thought he knew what God did, held that God waited a while before he ensouled a male, and a little longer before he ensouled a female. His God apparently acted only after gender had been determined, while ignoring devastating bodily defects.

In the heat of the First World War, Santayana said that Schopenhauer was the only German philosopher who was a gentleman. It was not a gentlemanly thing to say, but he did point up the fact that Schopenhauer was a philosopher who had a genuine interest in the arts, and presumably had a sharp and sure ability to penetrate beyond surfaces. Schopenhauer's remarks about women, though, made it clear that the ability did not help him carry out good intensive moves when attending to one half of mankind.

The bodies of males and females today differ from those that belonged to their pre-human ancestors, as well as from the bodies of subhumans then and now. There is no surety that the differences are anything more than a matter of degree, until one takes account of the distinctive way that human bodies are possessed and used by individuals. In any case, to know another, one must begin with what is publicly available and then move intensively toward its source. Although everyone does this when conversing, caring, loving, sympathizing, or appreciating, as well as when suspicious, disdainful, or disgusted, it is not yet known just how the ability can be enhanced or be more effectively employed. Many are hindered by the claim that at root each individual person is infinitely precious. The acceptance of that claim should not force one to deny that some individuals have long-stabilized bad characters.

3. Subdivisions of the Person

'Person' is a familiar term, usually used to refer to a human in the humanized world—one who enjoys various rights and privileges, and required to act in some conformity to various public demands. To distinguish this idea of person from one referring to what is not in the humanized world, I refer to the latter at times as an 'individual person'. 'Person', in any case, is an accordion word, with a stress now on this and then on that component meaning. It is also a Janus word, directing one to attend both to what is and what is not subject to public determinations. The latter use is most evident in references to individual possessive acts, private ruminations, and character formation, usually accompanied by individual insistences and accommodations. The former use is prominent in references to the living human body as a means by which one is manifested in the humanized world. Despite the fact that each of us knows himself and others to be persons, unduplicable, and never identifiable with any of their subdivisions, it is nevertheless hard to say, in good, communicable terms, what is so surely known. Of course, nothing that is said ever adequately expresses what it refers to; referring is not an innocuous act.

The discernment of a person, or an individual, is one with the arrival at what has yet to reveal all that it is. We may know something of the person of another, even some of its subdivisions, e.g., its sensibility, sensitivity, desire, and will. It is one thing, though, to know that another is a person, or to discern in him what he may not have himself noted; it is another to discern what may not have been noted by the person himself, and it is quite another to know all his essential parts, and what these can and in fact do.

Hume wrote—and so did Kant—that he looked for his 'I' but could not find it. Were they in search of a subdivision of their persons, as able to engage in perceptual or cognitive acts? It would have helped had they told us who it was that looked, how and what they were looking for, the warrant for and the manner of the search, and how they would recognize what they sought if they came upon it. It would have helped, too, had they taken note of their tacit suppositions about the nature of a person, the diverse subdivisions of person, and the ways those subdivisions are related to one another.

When one speaks of oneself as a 'me', a beginning is made at what appears. One may immediately pass intensively through that 'me' toward the 'I', as representing the privacy, the character, or the individual. Both Hume and Kant ignored the 'me's' that their 'I's' confronted on their way back to themselves. Had the fact been noted, it would not have been difficult for them to note that they were persons attending to themselves.

An attempt to reach one's 'I' is carried out in moves toward the beginning of a use of one's body. A reference is made to one's 'I' when one wants to refer to the source and ground of the 'me'. A person is more than such a source or ground, for not everything a person does is expressed through the body, approachable through what the person makes available, uses, and possesses.

Consciousness, emotions, assumptions of responsibility, commitment, and speculation are more than bodily events. The fact can be known by attending to the body as that which is possessed by an individual person. To move toward the source of that possession, one must ignore the humanized determinations of the externally acknowledged body. Although the possessiveness is not prominent in the confronted body, it can be progressively distinguished and made evident in the course of a discerning move beyond that body.

Literary critics and biographers sometimes make great efforts to get behind public expressions of their subjects, in search of hardly noticeable evidences of character, intent, and desire. Psychoanalysts and interpreters of dreams, while sometimes indistinguishable from readers of entrails, coffee grounds, or the conjuncture of planets, do try and sometimes do get behind that with which they are presented. The attempts of these interpreters to account for deviations from a normal life presuppose that they and their subjects are more than bodies. The fact that the procedures are flawed, the conclusions overbold, and familiar observations often just restated in technical terms need not get in the way of the fact that references are being made, and made well, to individual persons who are possessors and users of publicly available bodies. Even astrologers, who try to correlate the time of a birth with the position of heavenly bodies and

are, so far, occupied with bodies as publicly known, end with references to their listeners as persons with hopes and fears. There is no need to defend any of these practices, or the thinking that is characteristic of these various readers of bodily acts, relations, and objects, in order to recognize that persons are not cut off from what publicly occurs. What is publicly available provides means for learning what is not public at all.

No use need be made of a language in order to distinguish a pain from an intent, a fear from an appreciation, a thought from a preference. Despite failures in our language, we have little difficulty in distinguishing an expression of character, a thought, an individual possessor and user of the body, a commitment, or any of these, from a publicly expressed bodily act. We carry out discernments even when we are unable to say how we do so, or what it is that we discern. Those discernments move from the object of a personal act to the individual person who both possesses the body and has an unalienatable right to use it. That right is assessively joined to another—the right to pass judgment on the rights that a state might credit to a member of the humanized world.

Although possessive acts end at one's body, that body as in the humanized world is able to provide a beginning for reversed acts that end at the individual's person, and, through this, at the individual. The individual is unduplicable. Whether or not it is reached in a discernment, the fact that one is dealing with a unique being is hard to convey, if for no other reason than that what is conceptualized is a universal, and that what we say is duplicable, necessarily falling short of what is radically singular.

Duns Scotus took an individual to be a universal of a distinctive kind, incapable of having any instances. Although this was able to be known because it was a universal, it nevertheless was supposed to be unique and therefore knowable as an individual. That unduplicable, though, does not have the depth and possessive power of a real individual. Scotus' ingenious answer to the problem of individuation does not show that there is an individual with a plurality of powers, possessing a body that plays a role in the humanized world.

Another answer, Thomistic, unknowingly adopted and restated by the positivist, Carnap, holds that, where there are no God-given souls, there are passive, inert, unduplicable places. Anything located at one of these places supposedly would thereupon become singularized. Carnap, unlike Thomas, did not have recourse to God; he also substituted points in space for positions, contending that each point was distinct from all the others, so that anything occupying a point or a collection of such points presumably became unduplicable as well. Those places and points were themselves either true individuals, and the question then was begged, or they were just differentiated from one another by us, and therefore failed

to do what was required. They also allow one to suppose that a stone is an individual in the same way a human is, for the same reasons.

Leibniz, more boldly than these others, took every actuality to be a sealed-off individual. Each was also supposed to have all the others in it, in a more or less blurred form. Leibniz himself, evidently, would then have had to be self-enclosed. Yet he thought he knew that there was a real God existing apart from him, who gave items within Himself another status outside Himself. Leibniz was supposedly self-enclosed, but apparently had an open roof allowing him to make contact with his God. Leibniz thus thought that he was able to know what was external to himself. God, however, produced more or less muddled versions of everything in each item, and even of Leibnez himself in other items. It is not evident whether or not the Leibniz who was in every item was or was not a confused Leibniz.

When we note that characters, privacies, and possessed bodies change over the course of our lives, we are tempted to suppose that a person is just an aggregate of activities or sources. The supposition conflicts with the fact that each human is an irreducible individual. As in the humanized world, each is a locus of publicly expressible rights; as a person, each exists outside that world. Nevertheless, no great harm would be done if one followed the common practice of speaking of a 'changed person', a 'reformed person', and the like, provided only that it was not forgotten that these characterizations report what occurs in some subdivision of a man, as outside the humanized world. When one is dealt with as the possessor of a body, an acknowledgment is made, not only of a character being used, but of an individual who possesses this. The character not only mediates the individual but also sustains a commitment to realize some prospect.

Once it is allowed that use can be made of different ways of functioning, without turning a human into an aggregate of powers, a person can be known to be at once a person, a living body, an organism, and an individual. No matter what kind of act is performed, the individual will be self-same, while his person will acquire a distinctive degree of value. No person ever becomes a possessed body; no character ever becomes a privacy or a body; no individual becomes anything other than a reality expressed as a person and the possessor of a body that also has a role in the humanized world.

When it is noted that a character, a person, and a body change over the course of a life, it is tempting to suppose that individuals change as well. An individual, though, is a constant. I remain self-same, while expressing myself in different ways at different times, through my character, my

person, and my body. Others, and I as well, come to know more and more about my person, as well as about myself as an individual who expresses himself through my person, in the living of my body and in my organism. Neither I nor others, though, ever come to know me completely. Not only do the various subdivisions of my person vary, not only do I as an individual change the ways and degrees in which I express myself through my character, person, living body, and organism, but each of these makes its own contribution to the result. Sometimes the various subdivisions act in good accord; at other times they do not. Never fully isolated, they still may not comport well with one another. Feelings of pain get in the way of other feelings and of the focus on ideal prospects; bodily needs get in the way of the performance of willed acts. Expressions of myself as an individual are qualified by my character, person, and body—through which the expressions are carried out.

'Person' is often treated as though it referred to no more than the locus of rights maintained against other persons and/or the groups in which one is. Yet, as Epictetus insisted, a slave is no less a person than any other human. He is, too, no less an individual than any other human. One should, of course, quickly add that his body is also a body in the humanized world, and that a slave there is denied rights that others are permitted to exercise. His organism functions as other human organisms do. Slave or not, each individual possesses and uses his living body and his organism. Each also partly expresses himself as a person with its privacy, and a consciousness more or less emotionally qualified. There are some who would identify person and individual, but then they must credit the person itself with the power to possess and perhaps express itself through the body. Were it maintained that an individual is always expressed in and through the character, and then in and through the person, organism, and living body, one must affirm that one ceases to exist as a distinct reality on death, unless one could continue to be without a character, body, and organism.

The subdivisions of a person act in considerable independence of one another, with the organism and living body, the person, and the character achieving stabilities of different degrees and kinds. Since the body usually, and sometimes emphatically, dictates the when, where, and the nature and degree of the pains and pleasures one undergoes, it is to be expected that the role of the body will usually be overemphasized. Attempts to understand humans as though they were just bodies are, however futile, not only because the investigator is different from his own body, but because the effort falls short of others as realities with characters, privacies, and distinctive possessed bodies. No knowledge is to be despised, no clues are

to be ignored, but to say that is not to claim or warrant the view that an examination of what occurs in the humanized world could tell us all we do and can know about ourselves and others as persons and as individuals.

Were there no individuals, making a difference to the ways other dimensions of a person act, no one would ever extend a hand in greeting or, despite aches and pains, make the body continue to act in ways it otherwise would not. Nor could anyone responsibly take himself to be accountable for what he did, or effectively dedicate himself to anything. The claim that, because one was fearful, one began to run, is not to be separated from the counterclaim that, because one runs, one becomes fearful. Sometimes we run mainly because we are afraid, and sometimes we are afraid mainly because we run. At neither time is either the fear or the running entirely cut off from the other. Emotions are the outcome of meetings of person and organism, with an emphasis sometimes on the one and sometimes on the other. A consciousness is a constant subtending the fluctuating ways in which the person and the organism affect one another, and, so far, constitute an emotion in a living body. A mere state of consciousness is approached to the degree that neither the contribution of the person or the organism dominates over the other. Since we are conscious when we are emotional, there evidently is a midpoint maintained even when we stress some contribution. It is hard, though, to be aware of this when we are caught up in a violent rage, or when terribly frightened. Every one of us has a relatively calm or an emotionally charged consciousness at different times. That this is usually thought to be essentially or primarily private is one of the consequences of an attempt to suppose that the person and the organism are radically apart from one another. They do act independently, but they do act in different ways. At the same time, they are possessed and joined, used by an individual in shifting ways throughout the day.

A person is not a distinct reality; neither is a human organism. Both are possessed by an individual making use of a more and more habituated character. The more central the character, the more effectively will it connect the individual with the person, the living body, and the organism. The presence and power of the Assessor become most evident when the character is directed toward an ideal that one had committed oneself to realizing.

The possession of the body is primarily a possession uniquely insisted on. The relation of the individual to the organism, the person, and the two together, expresses the character. This becomes more and more habituated the more frequently it is utilized. A weak or vacillating character is as much the product of a habituation as a strong, the two differing mainly in

the fact that in the strong an insistence by the individual is followed by others of a similar kind, increasing the character's effectiveness. What becomes habituated is the kind of connection that the individual has to the person, the living body, and the organism. The fact makes evident that a strong character is to be understood, not to relate an individual to some part of the person, but to provide a more stable connection between the organism and the person. A strong character is the residuum of an effective use of the character by an individual in a number of directions, thereby making it a locus of a plurality of quite stable interconnections among essential components. That character may be good or bad, just a good character can be weak or strong. While the strength of a character is the outcome of habituations that enrich one another, the excellence of a character is the outcome of a concentration on an ideal outcome.

An emphasis on either the person or the body does not preclude the use of the other. What one is habituated to do is done by and large, not always, and not in isolation from other actions. The most habituated character is still somewhat amorphous, a route rather than a knot or a stamp. More and more fixated, usually by the way of an individual's insistence, it is made to fit more and more inside habituated ways of acting on and through the person and the body. Not a hardening lump keeping an individual apart from the privacy or the body, nor a more and more fixed avenue through which the individual manifests itself, a character's habituation makes it easier and easier for an individual to be expressed in and through the person, towards the end of realizing a possible prospect.

There never was a time when an individual did not have a character, however weak and undeveloped. An individual always remains free to act in other ways, for no habit is ever so rigid that it cannot be modified or qualified. A man who is habitually brave or cowardly is to be distinguished from another who acts bravely or cowardly on some occasion. The character of the one will be used at times in ways similar to those used by the other; both may fail to act bravely or cowardly on some particular occasion. Habits are more or less rigidified inclinations, never completely fixated. A strong and a weak character differ in degree; a good and a bad character differ in aim. It is possible to have a strong character but not a good one, or to have a good character but not a strong one.

Aristotle provided a fine guide to how one could build a character that was both strong and good, mainly by learning how to find a position between acts that overstress or understress what is needed if one is to do what is most suitably done by a fine member of a non-democratic state. Quite arbitrarily, he took a good character to be strong if it were primarily occupied with making the body of one of the ruling class function in good

accord with what was required by the state. He did not take adequate account of the person that each man has, or of all its major epitomizations. He could not, therefore, show the ways anyone could habitually deal with both the person and body, or how these could best be used, separately and jointly. A good character, he knew, was ordered toward a desirable end, but his 'ethics' ignored and sometimes denigrated women, shopkeepers, workmen, and slaves, except perhaps when it was necessary for them to fit within the state that the privileged made and benefitted from. He also failed to note that there were ideals other than those of a splendid state, from which the privileged benefitted. There were ideals, other than that of a splendid state, that deserved to be realized. That neglect was compatible with his supposition that art is just a making, and that a society is an inchoate or incipient state.

When the person is overemphasized, one is likely to act more awkwardly or inappropriately than one might otherwise. When, instead, the living body or organism is overemphasized, impulse is likely to prevail. Usually, the emphasis on one or the other is not noticed or is not conspicuous, but it will still be present, giving an emotional tone to what is done. We become accustomed to living at a low emotional pitch, with the consequence that we speak of ourselves as being emotional only when deviations from that pitch are conspicuous.

A human with a strong and excellent character is able to realize an ideal good by utilizing his character to focus on that ideal, and to enable him so to act that the ideal is realized. Any important 'making' in which the human might engage will be guided by that or some other ideal, and will make this more and more determinate. One who had a good but weak character might be as well-directed as one who had a good, strong one, but he would not act as persistently in the face of obstacles and distractions as would the other. The possessor of a poor but strong character usually achieves more than does the possessor of a character that is weak, whether it be good or bad. One who has a good but weak character will, of course, be a better human than one who has a poor character, strong or weak. A tyrannical ruler with an iron will may make possible great achievements; that will still leave its possessor a man to be pitied.

Individuals possess and use their persons with the help of a more and more strengthened character. Habits enable them both to strengthen and make ready use of their characters, whether these are good or bad. Their persons can be made to press themselves on and to express themselves through their bodies and their organisms. With the help of their living bodies, all can attend to and pass beyond the appearance of other actualities, toward them as realities. Different subdivisions of a person are

conspicuous at different times, but they never lose their connections with what is recessive, nor preclude this from expressing itself, if only faintly. One with a strong, fine character is committed to realizing an ideal good. Actions promoting its realization, for oneself and others, may also be incidentally produced by one without such a character. Sometimes what should be done is carried out by a person who seeks fame or who wants his will to prevail. Sometimes, he may be occupied with the promotion of the welfare of others, but may not do much to become a better human being. It is also possible to have a good, strong character and not be well related to others. The best of humans is splendid both as a distinct person and as together with others, both in a domain of persons and in the humanized world. No one, apparently, has ever reached that state, though hagiographers claim exceptions for their chosen subjects. Usually a perfecting in one direction yields benefits in others, but not to the extent that a full involvement with them would. The best of lives is the outcome of a tacking first in one direction and then in another, with maximum justice being done only on the whole, and over a lifetime. The realization of an ideal ends in the production of an unduplicable excellence. Since no type of excellence is superior to other types, it would be, at all times, a mistake to take one kind of act to be preferable. The fact still allows one to find some to be more congenial than others.

Most biologists—and, unfortunately, some physicians—take humans to be just organisms, differing little from some other kinds of organisms in nature. Were they right, individuals, characters, persons, and lived human bodies would either not be, or would make no difference to the ways the bodies act, in the humanized world. On either alternative, there would be no willed acts and no feelings of bodily pleasure or pain. No one would be able to decide to go to a physician to find out why an arm could not be lifted. The arm should, of course, be examined as part of a living organism, but account should also be taken of its owner's fears, repressions, and reluctances, since all affect its use. A heart is part of an organism, but it beats faster when one has to make a critical decision.

A human body in the humanized world, where it is initially encountered by a physician, is as public as any other living body there, but it should not be forgotten that it is possessed and used by one who is able to make some difference to the way that body functions. Did an occurrence in a human's body match another in a subhuman being, it would still be possessed and used in a distinctive way by an unduplicable individual. If the subhuman is taken to be able to suffer a bodily pain, it too must be credited with the ability to express itself in a living body, but perhaps by making use of a personalized sensitivity. Not an untoward occurrence in an alien body, or what is just privately undergone, a pain is lived. Others

might be alerted, by the sufferer's screams and behavior, that a pain was being undergone, even while awareness of it was blocked by the effects of some drug.

Possessed and used by an individual, a person has a nature of its own, making its own contribution to the person and what is done. It can also interplay with what exists apart from itself. Most of its later epitomizations impinge on earlier ones, and conversely. Thinking may be disrupted by pains; pains may provoke thought. Even when some epitomization of the person is not evidently exercised, it may make a difference, affecting and being affected by other epitomizations, as well as by the possessed and used living body. Any could be taken to represent the individual. This is tacitly done when someone is treated as though he were just or mainly a mind, a character, or a living body. Each individual person remains singular and unduplicable, even when without a thought.

Every human has a career. A society has only a history. A society may express the will of some one person, but what is then done is the society's doing. Sometimes a society will force some of its members to take on roles beyond their powers to carry out. A living individual's effect on the parts of his body, in contrast, is a consequence of his possession of the body as a single complex. No human is a society, no society is a human.

Those who seek to account for the existence of humans—and perhaps other living beings—by supposing that a distinct, unduplicable soul is created for each, are usually more faithful to the facts than are their opponents, since they take each one to be both unique and able to act in non-bodily ways. They fall short, though, of an understanding of how a body could be individually possessed and used. Others generously credit every being with some kind of created soul or psyche, implicitly supposing that even non-living beings are individuals, and might also be persons.

Were no reference made to any individual, nothing could be known to be responsibly initiated or accepted, unless 'responsible' were irresponsibly identified with 'publicly accountable', or taken to be an epitomization of the person not individually insisted on. Only an individual is able to focus on a personally forged responsibility and insist that this be given an effective role. When someone talks to himself, even when making strange sounds, use will be made of a common language, though perhaps not in familiar ways. The grammar might be garbled, the words new, the speaker confused, but individual use will still be made of a common language. A kind of ur-language that the familiar language, in its usual use, embodies will also play a role. Poets are alert to that ur-language, using it to charge and change what is conventionally said and meant. Because it has no relation to that ur-language, the sounds that a machine might produce will always fall short of being the sounds of words. We, who hear the sounds,

make them serve as carriers of words. A language does not just fit words into a grammatical structure; it provides an agency by means of which individual persons may record or transmit what is said or heard. Were a common language entirely freed from individualized contributions, it would be turned into a code.

4. Assessments

A person exists in a domain occupied only by persons. Each is assessive, and is assessively joined to other persons. Most of those others will not be known. Usually, one is aware of other persons only after some contact has been made with them through references expressed in the humanized world. Were no contact made in that way, there would be no knowledge of others. Still, if we tried to restrict our knowledge to what is in the humanized world, no one of us could be sure there were any persons other than himself. The most lonesome man in the humanized world is together with other individuals in a domain occupied only by persons.

As public, humans are affiliated; as possessors and users of their bodies, they are assessing and assessed beings. As apart from all possessings and usings, they are in a domain of their own; as individuals, they subtend what they are in a domain of persons, as well as what they are as humanized. To know them as individuals, it is necessary to move beyond what they are in any domain. Individuals, as organisms and as realities, express themselves in three domains. It is not too great a distortion, though, to think of them as if they existed only as persons or only as living bodies in the humanized world. Nevertheless, it is a distortion, since each expresses himself and possesses what joins both. Though the moves are often carried out casually, that will, often enough, enable one to become aware of humans as unduplicable. What is then known is usually left to artists to present in a guise that is representative of all persons, or left to lovers, parents, friends, and sometimes psychiatrists to focus on. We are together with other persons in a domain occupied by us alone, and, as humanized realities, as living bodies, and as organisms, to be subject to nature while still possessed by us in individual ways.

Our knowledge of other persons may be the outcome of an adumbration, reflection, or speculation. We move closer to an individual person in an act of discernment. There is, therefore, no need to suppose that there is some unreachable, mysterious reality that is the source of appearances. One can pass, without stopping, beyond the humans encountered in the humanized world, toward them as existing in a domain of their own. We never arrive at them as simply there. As just occupants in a distinct domain, humans exist in contradistinction to themselves as in the huma-

nized world, even when occupied with knowing one another. Panpsy-chists are acutely aware of the fact, but tend to spoil what they know by forgetting that humans are also members of a humanized world.

A discernment, like an adumbration, is an insistent act, enabling one to pass from the surface into the depth of an individual person. We misconstrue it if we credit it entirely to the discerner or the discerned, for what is in or due to either is, so far, unrelated to the other. To know someone else, we must be enabled to get to it. Projections, suppositions, or hypotheses can never do this. Discernment of others, though dim and flickering, is a single act, penetrative, acquainting us with another's use of some such epitomization of the person as sensibility, sensitivity, will, mind, or of the character and the way it is individually possessed and used. All the while, one may be aware that one is already together with others as persons, and/or as humanized beings.

Those who deny that there could be any access to others are already interinvolved with them. No one is concerned only with appearances; no one who hates, tortures, fears, or loves comes to a complete stop at such appearances. It is one of the oddities of both subjectivism and of physiological accounts of humans that, despite their formal denials, their defenders are involved in penetrative acts into other individual persons, as surely as everyone else is. Sometimes they complain that they have neither the words nor the grammar that would permit them to say this. Yet they, too, make good use of needed words and grammar again and again.

The 'is' in 'this is a hand' does not just connect the 'this' and the 'hand'. It pulls them together in a passage to 'this-hand' and, beyond that, to 'this, your hand', all the while making contact with the possessor of the hand. Everyone, even the very young, 'is' in a way that linguists and logicians have yet to understand. All are aware of themselves as outside the reach of detached, indifferent observations, and of conventional uses of a common language.

The explicit acknowledgment of others begins at their appearances. These are not indifferent layers, hiding realities beneath them. They are so possessed and used, by what appears, that they allow one to glimpse something of the possessors and users. Appearances are of a something and for someone.

We are aware of ourselves both as persons existing in a domain of persons, and as individuals existing outside all domains. In all cases, we move beyond constitutive conditions to what is confined by and possesses them. Our articulations always fall short of what grounds them. Many therefore concentrate mainly on categories, formulae, classifications, the humanized, and the publicly available. A Potemkin village can fool a queen who sees it from a distance because there are real villages that have

similar appearances. We can be similarly deceived if we forget that quick penetrative acts are often not carried far.

If we were to take note of the kinds of realities and acts that could occur in nature and the cosmos, and then understood what is presupposed by them, our surmises about the nature of persons and their essential components could be checked and refined. We could check what we grasp of specific persons by our understanding of what persons are, both as existing apart from all else and as existing in relation to other realities. Success in the pursuit of knowledge, here as well as elsewhere, depends on a willingness not only to advance and retreat, but to attend to singulars as well as to generals, the limited, and the all-encompassing, separately and together. There is no isolated, reliable, steady, progressively illuminating grasp of what is inward and unduplicable any more than there is a steady progress toward some glorious end. In order to advance, it is often necessary to leap forward to a position from which to survey and correct what had initially been accepted. Formalisms offer no adequate guide here. Still, particular movements in depth do not provide a satisfactory substitute for them. Each needs support from the other. Otherwise one will not arrive at persons as existing in a domain occupied by nothing else.

We confront other humans in the humanized world. There we are together with one another as well as with other actualities. Some of those others are bodies within our own; others exist and act in considerable independence of us. All are qualified by our interests, acts, and uses. In that world, we do not just interchange signs or words, or just alter our relationships; at the very least, we deal with some adumbratively, ending somewhere deep inside them, particularly when we are interested in them as individuals making use of their characters. The adumbrations are undivided and intensified in discernments, thereby enabling us not only to make contact with what is beyond what is obtrusive, but to reach some epitomization of his person, his character, and the way he possesses and uses his living body.

The more we allow ourselves to be governed by formulaic expressions, the harder it is for us to accommodate the fact that we can move adumbratively beyond appearances to the realities that appear, and can even do this in a single discerning move to individuals as existing outside the humanized world. We should make a more flexible use of a language than we usually do, shattering commonplace usages with fresh metaphors, or finding new uses and designations for our common terms. It is arbitrary to suppose with some philosophers that only scientists are able to say what is true; lovers, parents, novelists, playwrights, and other artists also know realities and they convey what they know in unusually effective ways.

A related difficulty is faced when we try to deal with what all actualities

presuppose. Once it is recognized that we can do this successfully if we back our efforts with a distinctively changed attitude such as awe or wonder, it becomes somewhat easier to see how a good grasp of other persons can be achieved by recognizing that they, severally and together in a separate domain, are primarily subject to the same ultimate, the Assessor. Because each person is subject to this, each is able to be with others in a common domain.

Apart from their practices and affirmations as members of religious groups, those who are pious are sometimes acutely aware of the presence of the Assessor, but all too quickly they take this to express or serve a divine being, and suppose that this varies in its insistence in neat accord with the merits of different persons and their interinvolvements. The Assessor, like the Affiliator and the other ultimates, is instantiated in every domain and every actuality; unlike those others, it has a dominant role only in persons and what they insist on. Although we could not know a person and what it could do until we had completed a thorough examination of him, we do have some awareness of our own persons and of the persons of some others. Our acquaintance with a few, particularly those with whom we are intimate, checked by reflections on what we ourselves had undergone and done, and by our fellow-feeling as being together in a common domain, help keep our surmises about ourselves and others from becoming fantasies.

Many of the most obvious truths about ourselves are neglected or dismissed by many theorists because they do not fit into theories that are cherished, perhaps because of their importance in some other inquiry. The situation could obviously be reversed. Better, the two approaches should be understood to presuppose common truths that they specialize in diverse ways. Too often, when we speak of assessing others, it is supposed that we are engaging in wholly private acts, and therefore wrongly subjectify the truly objective and impersonal.

Together with other ultimates, the Assessor is possessed and used by the realities it helps constitute, and confine. Like other ultimates, it is dominant in but one domain, and recessive in all the rest. We know of ourselves as together as persons in a distinctive domain, not because we discern the others, but because we attend to them as being primarily assessed with us as so many separate persons. Discernments direct us toward them, but never reach them as entirely free of humanizations. We complete our knowledge of them by recognizing that they, with us, are persons subject to the Assessor. The more we view them from the position of the Assessor, more or less at the point where our discernment becomes blurred, the more we come to recognize them to be self-centered, coexisting with us. Our discernments introduce us to what is as real as we

are, in a domain occupied only by us. We know humanized beings before we know the dominant Affiliator in any one or that it is the primary constituent of all. What is in other domains is known by arriving at them as already primarily constituted by other ultimates. We do not, though, usually attend to that fact. As will become more and more evident, we can and do pass directly from what is in one domain to what is in another, by using a combination of the Rational and the Dunamis, without taking explicit account of the ways in which the members of the different domains are constituted.

Every one of us makes quick references to intentions, characters, and individuals as sources of what is manifested, but few try to know what these are or how they act. Although we may know that an individual makes use of his character, that this is habituated over time, and can be good or bad as well as strong or weak, and also that he feels, thinks, wills, and makes use of his living body and organism, we usually do not know or even try to know him as fully and precisely as we could. When we do try, we find that he is both constant and variable, polymorphous and self-same at one end of a connection in which he participates, and which he qualifies as surely as he is qualified by it.

Each of us is related by what has a reality distinct both from us and that at which it terminates, making it possible for what we entertain to be known as present elsewhere, but never without the mediator and that at which it begins and ends affecting and being affected by one another. If I know something, the knowing affects me and it, and operates between us. The knowing instantiates an ultimate that enables me as a knower, and what is being known, to be related. A knowing that remained in me can never end at something else. Hypotheses and theories that were not enabled to terminate at accommodating realities are, like hope or fear, undergone alone. The expression, 'I know this,' does not entirely convey the fact that knowing can connect what I have in mind to something else that is not in my mind only if it is not confined to the mind. It must, in fact, begin with what is in my mind and end at what is not there, or conversely, and therefore must rely on the action of what is different from both.

Epistemology keeps many philosophers occupied over a lifetime, vainly trying to solve a problem they antecedently define to be beyond solution. If one begins with something in one's mind and has no way of moving to anything outside that mind, one will obviously remain occupied with what is in the mind. If, instead, one begins with something real, external to oneself, but can find nothing that connects this with what is in one's mind, it will obviously not be possible to end with what is understood. If a beginning is made with categories, theories, desires, or prescriptions, or with something external to them, one will not be able to

get from the one to the other unless there is something that is able to transform what it initially accommodates into what is finally accommodated by something else.

Geniuses sometimes speak and act in tedious ways; clods arc quicksil ver not far from the surface. The one does not always surprise, nor is the other always predictable. Quite different in fact and even in promise, they are alike in being overly determined in some ways, but still free to show that they are unduplicable persons, expressing themselves as individuals. Whether we take others to be surprising or commonplace, our discernments of them carry us further along the same kind of intensive route that enables us to reach other actualities.

It takes considerable discipline before we are able to attend, without thought or effort, just to the appearances of another reality, and avoid making adumbrative moves beyond what is confronted toward the reality that is appearing. Usually we take what we end at to be a thicker, self-maintained, unitary ground for what appears. Sometimes we penetrate quite deeply when we converse with another, and sometimes much more when we attend to those with whom we are intimate. In passing from what is publicly available toward an individual or a person, we learn more about him than that he had been intensively reached from what had been surmised or confronted. The more insistent the intensive move, the more is the source of different available content made evident.

Adumbration moves in depth but a discernment goes further: it may focus on the character, some epitomization of the person, or move toward the individual source. Dislocating what is contextualized, tracing it back, usually via the person or the character, discernment is adumbration in spades, usually carried out when attending to another whose motives or motivations are of interest. Some, particularly in adolescence, utilize it when attending to themselves. A few do this quite well. Others are more adept at discerning the persons of others. The first are not self-conscious, if by that one means that they are aware of the way in which they fit into a public setting. They are, though, self-conscious in the sense of having some understanding of themselves, their intentions, or motives. To discern in better ways, one must learn how to read inadvertencies as betraying revelations, and allow oneself to be guided by the way persons, severally and together, are primarily assessed as existing in a domain of their own.

Courts, when occupied with determining what acts are deliberate, get no further than the attribution of accountabilities for what is taken to have publicly occurred. At times, they do seem interested in discovering the character, intent, or purpose of a perpetrator of some act. They never succeed. Their methods and controls keep them focussed on the publicly ascertainable, backed by surmises about a character, and perhaps an

intention, and an awareness that behind all appearances humans are equally human. Jurors, instead, and sometimes attorneys in criminal trials, do their best to discern well. Their efforts and difficulties are generalized in those philosophical accounts concerned with knowing, not this or that person, but the components, as separate or as together with others.

Except on special occasions, humans do not first attend to one another's appearances and then try to surmise what is behind them. While publicly interinvolved, each now and then and without effort discerns something of what is behind all of another's manifestations, and may even learn why it is exhibited in just that way. Starting with what is manifest, just as an adumbration does, a discernment makes contact with a person, or some aspect of him, in a distinctive way.

It seems reasonable to say that animals, particularly those that most closely resemble humans in their bodies or acts, have something like the persons and perhaps even the characters of humans. There are even some who say that they can discern the persons and characters of various subhumans as surely and as well, perhaps even better, than they can discern those of humans. There is no sure way to determine whether or not sentimentality and desire have here led to a misconstrual of an adumbration and what it ends with, but until it can be shown that subhumans can commit themselves to realize an ideal, are able to assume responsibility, are in principle able to know what all actualities presuppose, can find out what exists in other domains, and are assessed as equals in a domain of their own, they must be taken to be different from humans, and to be occupied with realities in a way that is different from that possible to humans, separately or together.

It is a human who makes use of a character, not only in order to act on his person, his organism, and his living body, but to commit himself to realize an ideal. Each is a person apart from and together with others. The most advanced of apes knows no mathematics, cannot paint, sculpt, act, dance, or produce a poem. Many of us do not do any of these, and apparently cannot do so with any appreciable success, but we not only can commit ourselves to try, but can also accept ourselves to be of value, both separately and as together with others. Conceivably, some subhumans might be able to discern one another. When made into pets, they might be able to become aware of something in the persons who attend to them. If they do, that would still not show that they discern persons, existing together with other persons in a common domain.

Lacking a language, subhumans are not able to make use of metaphors, give commonly used terms new weights, or so join them that they together explicate a reality. None is primarily assessive, or related to others by means of a common Assessor. Some pets, to be sure, behave in special

ways when they are with humans. Some may respond to expression of approval or disapproval, and even to changes in the moods of their owners, but they provide no indication that they discern any individuals, or persons, or subdivisions of these, even of those they have lived with for a long time. While newborn infants also seem to lack that ability, they soon give indications that they are able to discern other humans.

Subhumans are individuated and individualized, necessarily lacking a human's constant, insistent individuality. Similarities in their behavior and the behavior of subhumans do not wipe out their irreducible differences, particularly since humans exist, not only in the humanized world, but also apart from this, in a distinctive domain. Subhumans, as outside the humanized world, exist in nature in which a Voluminosity, not the Assessor or the Affiliator, has a dominant role.

Humans alone have a language. This is quite different from a set of well-used signals, for these latter have no grammar and provide no way for reaching anything in depth. A grammar presents one with the desiccated outcomes of a living language, hiding primarily adumbrative and discerning references by placing connections between the terms used at the beginnings of convergences on what is real apart from those terms. What is ended at cannot be known except by escaping from a set of terms alongside one another to them as beginnings of a convergence at a common terminus. One begins with terms joined in one way to end with them joined in another. The first may have been preceded by the terms as separate, and then changed into terms to be connected. If they had, there would be two different transformative acts carried out, one in which the separate terms are turned into a pair, and one in which the pair is turned into the beginning of a convergence on a single reality.

The banal mutterings of lovers fail every test of significant speech but one—the grasp by both of what is intended. While it requires the exercise of no great ingenuity by the lovers to understand what is being conveyed, others are content to address one another in more impersonal ways. Yet though all use and qualify the common language of the humanized world, the presence and distinctive nature of the result is usually slighted or overlooked, particularly in theoretical accounts. Daily language is a language of convenience. A living language is forged in the very act of adjusting expressions, and thereupon producing fresh communications with distinctive rhythms and meanings, forged anew on each occasion. By and large, it is no more than a flattened, fatigued poetry, a poetry shorn of much of the power it has to make one acquainted with what is behind the seen and heard.

We soon become accustomed in daily life to the randomly invoked discernments we had carried out as children; thereafter, we are likely to

content ourselves with taking most others to be just members of a common humanized world. Usually, it is when something untoward is done that we are likely to carry out a discerning. Rarely do we follow one such act with another. Often enough a discernment is elicited when or because something inadvertent occurred. When I look at the hand of another, I am more readily inclined to carry out an act of discernment than I am when I look at my own. I am too much at home in my person to look for much help from my publicly observable body. Sometimes even this seems somewhat alien, too public to help me discern anything in me that is of much interest. I then resort to memory, read what I had written, recall what I had said or done. I accept myself as one who is radically singular but also as one who does not fully or clearly make himself manifest. Rarely do I take myself to be a 'me', and then often only when what others say or do leads me to try to view myself with some objectivity. Usually I ignore the fact that they are discerning much of me, tacitly supposing that I am fairly well hidden, all the while that I confidently take myself and them to be persons who are outside the humanized world, both separately and together.

The instantiated ultimates jointly constitute what is in the public world, but this is possessed and used by what is not there. When someone is discerned, one comes close to what has a status beyond one's power to alter. Though a man dies with the destruction of his possessed and used body, while he lives he will be one who has rights that no one could bestow, take away, or limit. Those unalienatable rights are not to be confused with inalienable ones. The latter could be qualified, rightly or wrongly, particularly when regimes change or in times of crises.

The discernment of an individual or a person is accompanied by the implicit acknowledgment of his unalienatable rights, but just what these are will not be known by those who attend only to men as members of a society or state. If a discernment is not backed with acknowledgments justified by reflection and an understanding of the place humans have in the scheme of things, it will not penetrate as far as it could. Also, we learn to speak of men in appropriate ways only after we have expressed something of what we had already discerned of them, when we know that they exist apart from all that is discerned. Poetry is the mother of prose.

Hamlet's answer to Polonius' question as to what he was reading, "Words, words, words," was deliberately insolent, denying Polonius an entrance into a text. Hamlet here provided a literary instance of the fact that if an adumbration or discernment of what is confronted is cut off, one will be left with detached items. Even the Nazis discerned the persons of those they captured; otherwise, they would not know that these could be humiliated before and while they were being killed. What the Nazis

apparently did not believe was that their victims were, like themselves, fully human, not only in a humanized domain in which they were brutally debased, but in a domain with all other persons. What they revealed was that it was they, not their victim, who fell short of others in character and virtue. All humans are equally human, but not all are equally admirable. Sometimes, as the Nazis made evident, those who despised a multitude were more despicable than most of those others were.

To claim that some men are unknowable is, at the very least, to express oneself paradoxically. If the others are known to be unknowable, they surely are known, in some way. Sometimes the blocks and avoidances that these may put in the way of knowing them may provide unexpected and even excellent occasions for deeper and more certain discernments. At times, they prompt the awareness of them as persons existing together with other humans in a common domain, distinct from the humanized world where other kinds of actualities also are.

5. Humans Together

Humans are together in a number of ways: in a common domain of persons, joined primarily through the dominating presence of a primal Assessor; in small groups, where they may discern what is beyond the appearances of other humans; in a society, a state, and a common mankind, where they are usually content to accept others as individuals, without paying close attention to them as possessing and using their bodies. Few care to know how some expressions were produced by themselves or by others. Often enough, when they try, they do so without much success or profit. For the most part, most content themselves with knowing that something is an expression of a person, without trying to know much more. Though distinguished from the rest, those who create in unusual ways, may lead, inspire, or shock, but will rarely be well understood. Creators in the arts, mathematics, science, society, and state, along with those who are noble, heroic, or wise, and those who speak of truths and visions with which most others are not acquainted, will be seen to have gone somehow beyond where most of the others could. Just as quickly and as surely, references will be made to oddities in their public ways. They will not thereby be shown to be either more or less human than the rest; the powers they have, everyone else has, but they are not used for the same reasons or with the same insight, persistence, control, dexterity, or effectiveness. They may achieve what differs in kind and not just in degree from what others do and produce, without ceasing to coexist with them. Each, even when subject to the dominance of a society, continues to be a person.

Most carry out quick discerning acts, even while primarily occupied with fitting well together with others in some common situation. They also publicly exist together as members of societies and in the larger humanized world, sharing in common traditions and acting to produce common goods, all the while that each remains radically alone. Customs and laws stop short of them as individual persons, while granting rights to some to act in various ways within established frames. Did one stop with what satisfies a society or a state, one would neglect the beings who have those rights and who might insist on them. Full justice cannot be achieved if nothing more is done than to protect a man's right to be and function with others in a segment of the humanized world. A group may curtail or deny this or that human's defined publicly viable rights, or deny some an opportunity to act in ways others may act. The fact makes all the more evident the truth that each individual person has a nature and rights not dependent on the decrees or acts of any group. In the absence of such rights, societies and states would never act unjustly as long as their prescriptions and decrees were carried out impersonally and well; but were there no societies or states, there would be no rights having protected, public meanings.

Unlike the so-called classical species 'man' with its supposed counterparts in other 'species', mankind is distinctive and has no effect on its members. It could, though, be credited with a history, summarizing the kinds of adventures people had carried out together. In the humanized world, humans jointly do more than what is expressible as an aggregation of what they do severally. 'The history of mankind' primarily refers to the histories of different groups, with the members in them making a difference to the groups, and conversely, but with the persons who suffer, sustain, and evaluate what is done to them ignored.

In religious communities, usually, use is made of the bodies of individuals to carry out sanctioned and demanded activities. Their separate utilizations of common references help define them as religious persons. All the while, each may or may not be involved with what is supposedly divine, while continuing to be together as persons and as members of various groups. They may then be so interrelated that they are able to express in acceptable common forms what they separately cherish. Dewey, with his idea of common faith, and Whitehead, with his view that religion is primarily a private act, supplement one another. Together, they make evident that a religious community is one in which the common is individually sustained.

Particular religions usually require their practitioners to turn away from other religions, particularly in the ways they worship and what they are to take the object of their worship to be and do. In each, no matter

how much the participants act in consonance, they worship as individual persons. But no matter how alone anyone may take himself to be with the common object of worship, he will be subject to the common conditionings. Those who rebel against a prevailing religion, like all rebels, carry a negative sign whose referent clings to it. A truly non-religious person would neither affirm nor deny what the religious claim, instead, he may interest himself in something else that he takes to be fully satisfying. No one is ever so religious that all other interests are extinguished; if there were such a one, he would soon die of thirst. Mankind never worships; worship is primarily the act of individual persons, presumably so together that each is enabled to do what could not have been done had he acted alone. Each member of a religious community supposedly enables the rest to be related to the divine in ways they otherwise could not. The separate acts of each presumably enrich all, and their joint acts make each richer as apart. The better they are together, the more each is apart, and conversely. Their religious community may make use of a common language and keep in some consonance with what is happening outside it. It may also express an appreciation of what other religions claim and do, all the while that it closes itself off, follows its own established ways of addressing the singular object of a common worship, and relates the required acts of separate persons. They do this even when they hold that the object of their worship is concerned with everyone, and when it is firmly believed that those who ignore and perhaps even despise them and what they do, are cherished by a merciful God.

When humans are joined, as persons in the humanized world or in subdivisions of this, each still continues to be apart from all the others. Each comes to know a good deal about who he is by starting with what he knows of himself as together with others. Since our introspections, often enough, are no more than our public observations of ourselves projected back into ourselves, if we are really to find out who we are, we must, instead, reverse the transformation that had presumably brought us into the humanized world. It is there that we carry out distinct, accountable activities, all the while that we continue to be outside the humanized world. We are always apart from and together with other humans in ways we do not share in the humanized world. We are together as humanized, more or less well-affiliated beings, without compromising our separate existences.

This cascade of apparently paradoxical observations will perhaps suggest to some that each one of us points vainly to what is in the same domain with him, while suggesting to others that each one of us is always a part of the humanized world. Neither of these positions alone is tenable, since it does not allow for the other except perhaps as a stress or

qualification. A self-maintaining position accompanies effective interinvolvements; full participation in common ventures is the work of those who act independently of others.

When a body is used by an individual as a means for carrying out a public role, it may follow a fairly well-defined public course. Urged on by a feeble sense of humor, one might thereupon speak of a newborn as having the role of a baby, and then hold that this role is denied or perverted when the baby is neglected or unloved. While a baby does have a distinctive position in society, it has the role of a baby only in a play or similar setting. When used to produce some desired effects on relatives and others, the baby may be fitted into a role, but it will not then carry out the role assigned to it. Later, knowing what is expected of it, it may smile, smirk, make odd sounds and gestures, fit into, but still not carry out, a role, since all the while that it is acting in a scheduled way it remains detached from what it is doing. The assumption of a role requires an act by a person. The most routine of bureaucrats occasionally charges his acts with thoughts of self-importance.

To carry out a role, one must vitalize a series of acts. Were the acts ordered toward the achievement of some objective, they would contribute to the achievement of some result, but not necessarily what satisfies a prescription. A thief does the former, an actor in the role of a thief, the latter. The one has an aim, the other performs a task. A thief is a thief intermittently; an actor in the role of a thief exhibits a thief in every move. No one but an actor could be just a thief, a king, a sage, or a saint.

Because it is mainly one's society that determines what one's proper roles are and how they are to be carried out and when, the society's contribution to the nature and exercise of those roles will usually be greater than that provided by any man. Workers on a production line, people waiting to buy tickets, and an audience in a theatre are conditioned in common ways, with one or two here and there at times making a signal difference to what occurs.

It is one thing to be in a society, and another to be fitted within some mold, functioning in a monotonous way, contributing little more than energy to the performance of some predetermined way of acting. Bees are not members of a society and, in any case, do not carry out assigned roles. They are organisms in nature, with bodies so suited to the needs of the hive that they could be said to be oversocialized organic beings that had been turned into components in some enterprise into which they fit, but which they do not understand. Humans, unlike bees, have bodies they can use to carry out different roles, sometimes in ways that do not benefit themselves, their bodies, or their society. Neither a willing nor a reluctant sustaining and performance of a role is possible unless one is able to

express an intent, need, desire, preference, or responsibility, to do so. These are acts of individual persons able to make a difference to what is done. In their absence, one might fit into a public niche but would not yet be a rolebearer there or be well-joined to others. Humans may carry out their roles resentfully, heedlessly, or poorly and yet be in good accord with what others require.

It is one of the primary self-assumed concerns of philosophy to try to understand how it is possible for a human to know what exists, independently of its being known. The issue cannot be dealt with well until some understanding of what occurs is achieved. It will be beyond resolution if what individuals do when carrying out a role is not understood to do more than continue what is in a mind or some other subdivision of the person. To be together with others in the humanized world and, therefore, with what is encountered through perception or in other ways, one must pass from one situation to another. The act will be more than the expression of a habit, an experiment, or some trial-and-error procedure. Otherwise, commitments to ideal ends, speculative probings of what was presupposed by every occurrence, arrivals at oneself as a separate person together with other persons, and the understanding of Being would be necessarily precluded as worthless or impossible.

Pragmatism, after a brief occlusion by positivism, is today once again conspicuous, cherished principally by those who are interested in practical politics or social reform. One reason for this is that it seems to offer a plausible, wide-ranging answer to the question of how it is possible to pass from thoughts to what is in the humanized world. Unfortunately, it does not understand well what is involved in the process, or show how it is possible to know what is in some domain other than the humanized. More specifically, it does not make adequate provision for knowing what is presupposed when one begins with something privately entertained and tries to end at a reality that sustains this. If it were to take what is entertained to be only a hypothesis, it would, as others do, remain with something entertained, not with what could take one from this to what objectively sustains it. Were one to neglect or misconstrue what every occurrence evidences, what makes transitions and transformations possible, what enables one to understand the constitution of every item, and what is evidenced by every activity, one would needlessly preclude an understanding of what is successfully done by everyone, everyday. All carry out bodily acts that enable them to change what is in the humanized world, but without understanding what they do. Do they alone bridge the gap between what they have in mind and what occurs apart from this? How do they do it? No advance is made when references are instead of or in addition made to habit, judgment, language, inference, dialectic, inten-

tion, or hermeneutics, precisely because there are a number of different kinds of realities existing in different domains that none of these can reach. No genuine pluralism is mastered by using a method appropriate only to what occurs in one domain, or a few domains. What is in one domain is as real as what is in another, differing from it primarily in the dominance of a distinctive ultimate and, secondarily, in the roles that the other, subordinated ultimates there have. One can, of course, imagine the members of one domain to be variant forms of the members of some other, but there then would be no assurance that the imagined variants had any reality. Nothing less than the achievement of a position outside all domains, where the factors are together, could provide a base, making possible an understanding of the similarities and differences of the members of different domains. Well before that fact is noted, we are aware that humans often act to realize purposes.

6. Purposes

If we begin with persons, sooner or later we will have to recognize not only such signal acts as their uses of their bodies but also their desires, needs, appetites, intentions, wills, habits, and accommodations. Some of these seem to have counterparts. What is not in nature are beings with purposes. Only humans have these. Once purposes are acknowledged, other acts can be understood as being carried out by humans in ways that differ from apparently similar ones carried out by subhumans. Because only humans have purposes, moreover, only they could be creative, for the commitment that their creative work requires is in the service of a purpose, terminating in an ideal prospect. It is the self-accepted task of creators to realize such an objective. While those who do not create have purposes as surely as creators do, their purposes do not relate them so firmly to ideal prospects. Rarely, too, are those purposes well backed by acts that promote the realization of those prospects.

Kant, in his *Critique of Judgment,* gave a splendid and arresting account of the nature of purpose, and particularly of its difference from purposiveness. When his view is supplemented by what has here become manifest, a purpose can be identified as an intended objective guiding actions that enable it to be realized. It contrasts with the Aristotelian final cause in not being a necessary component in every causal process, and with purposiveness in being more than a natural tendency toward some possible terminus. To be effective, a purpose must be sustained by what exists apart from the person it guides and be able to affect what that person does. Though purpose is the outcome of a private act, it is distinguished from others in its ability to determine what is to be done.

Were it only an envisaged or even an intended outcome, it would be indistinguishable from something merely hoped for. It is more because it is oneself as primarily subject to a dunamic-rational conditioning, effectively taking one back to oneself as able so to act that the realization of the purpose is promoted. If it is denied a position in that conditioning, the purpose would be idle, not a true purpose.

A purpose makes evident that there is an impersonal transformative power that begins at an intended objective and effectively determines what one is to do. There is no strong reason for accepting the idea that there is a final cause operative in every transaction, or any reason for believing that all humans are subject to a common purposiveness, perhaps promoting their common survival or prosperity. Humans do not seem to be subject to a common tendency, or even to a plurality of them, though an assimilation of men in that part of nature where evolution holds sway tacitly makes that assumption. But one need not deny that humans did evolve, just because they are not now subject to the purposiveness that may have governed their ancestors when these were wholly in nature. If humans are governed by a common purposiveness, we do not know what this is or how it operates. Although natural beings engage in many self-preserving acts, they do not, as humans do, commit themselves to realizing ideal objectives.

Were humans just a species of animal, they would not be likely to engage in projects whose completion contributes little or nothing to their efforts to survive. Yet some of those projects might be eminently worthwhile. The achievements of artists and other creators may benefit a multitude, but that is not why creators carry out their onerous and often unappreciated work. They try to produce what is excellent, which is to say, they try to make an indeterminate ideal become determinate, filled out, realized, even though it may not promise or provide any evident benefit to themselves or others. One could, if one liked, maintain that a creator's purpose was to produce something excellent so as to have something for him or others to enjoy or possess, but one would then have to take account, not of the creator's purpose, but of his motive. A purposed end awaits the performance of appropriate acts; a motive quickens an act, perhaps one as mundane as the payment of rent.

The purpose that is operative in a created work is an excellence that deserves to be realized. Its realization is motivated by one who wants to give it a determinate form. There are many motives that suffice to elicit actions, even those required in a creation; the best are those that are directed at the realization of an ideal. Where artists are committed to realize beauty, and mathematicians truth, some others commit themselves to realize an ideal good. Some leaders of societies commit themselves to

realize an ideal glory, and some statesmen commit themselves to the realization of an ideal justice. All the while, both the committed and the uncommitted may be strongly motivated to act in ways that may or may not bring about the worthy outcome. The realization of an objective to which one is committed is promoted if one is motivated to realize it, for one will then act to fulfill the commitment and not remain merely oriented toward an objective. The fact that a commitment, its objective, its realization, and what is in fact achieved are not well-known to those who spend their lives at the task need not compromise the splendor of the outcome. One may have a fixed purpose but not be well aware of its nature, or know how it is to be best realized. It is the work at hand, the issues it raises, the desire to resolve difficult problems, that are usually in focus. As many critics have discovered, one learns less about creative work from interrogations addressed to great creators than from those addressed to their achievements.

A purpose is the outcome of a conversion of an object of interest into a guiding constraint. Absent that guidance, a purpose would be no more than a hoped-for end, akin to the mutterings of encouragement one sometimes addresses to oneself. To act without a purpose is to act without a terminus that enables one's efforts and actions to be well-ordered. Occasionally, one might allow an irrelevant objective to encroach on what beckons and should control, but then one will not be occupied with carrying out acts that serve to realize a guiding prospect. A guiding prospect turns the object of some interest—a desire, a hope, an endorsement, an appetite—into a control. Unlike a purposiveness that overarches an ordered multiplicity of activities, a purpose involves no controlling objective, and may promote only the continuance of a type of being, requiring a person to envisage what elicits the actions that promote its realization. The purpose does not assure that needed actions will be produced; appealing rather than prescribing, it usually guides, but rarely controls. Purposes are envisaged prospects functioning as prescribing guides. One committed to their realization makes them more and more determinate through work carried out under their aegis. Usually, one backs the work with an intention and a submission, and thereupon becomes a dedicated, and sometimes also an obligated person, readied so to act that the purposed end is achieved. Since there are long-ranged purposes, requiring considerable preparation, perhaps some training and experimentation, one often acts in ways that do not promote the realization of a purpose.

There are some who rehearse, over and over again, in apparent preparation for a career as concert violinists, but are never ready to begin. At some time, it will be decided by them or others that the purpose had

become no more than a hope. No one can be sure just when a purposed outcome becomes no more than a beguiling idea, making no demands, involving no joining of what is desired with what guides and may control. I had an uncle who had a strong desire to obtain a license to be a plumber. Despite much effort and some help, he and others finally decided that his purpose had become an unrealizable prospect. His story was no less poignant than one about another who had to give up a more widely endorsed objective.

A purpose is not projected into the future, where it serves as a lure. Nor does it pull anything toward itself. It is a controlling prospect, turning one into a purposive being, when and as it is used as a guide. Since a purpose is often taken to express an interest, 'purpose' may be and is frequently taken to refer to the way in which an insistence subordinates what guides and lures. The existence of common purposes and inviting ideas requires that a cautionary note be added to that common interpretation.

One who seeks to know what actualities presuppose, and what this in turn depends on for its existence and power, carries out a purpose in which what is sought is already possessed in a faint and anticipatory form. Here, even more evidently than when engaged in realizing an ideal in a creative act, one is governed by what one seeks to realize. If, then, when we speak of ourselves as carrying out a purpose to know the ultimates, or the Being that is beyond and presupposed by them, we claim that we had turned the object of our attempt to know preconditions into actual preconditions, we would paradoxically suppose that we produced what was being presupposed.

The realization of a purpose to know is one with the accommodation of the knowledge by something apart from that knowledge. It is therefore more accurate to say, not that we seek to know something, but that we seek to have our idea of something accommodated by it. If, instead of saying that there is something in mind for which an objective ground was sought, we hold that what we have in mind is already externally sustained, we would have to conclude that there were no idle thoughts, downright errors, vain imaginings, but only more or less successful acts of knowing. The situation would be similar to that in which we find ourselves when we continue to observe or investigate, for we then qualify a desire to know by what is already partly known. It does, though, sound paradoxical to say that we want to know something better, since we then assume we know that there is something waiting to be better known. It would perhaps be more illuminating to say that we already know something and want to know it better by carrying out others, controlled, intensive acts, or that we want to express in communicable terms what we had already noted. These

complications underscore rather than diminish the claim that a purpose both guides and limits what is done.

Some animals prepare nests, traps, and distractions to ready themselves to take advantage of the weaknesses of others, or to protect themselves from the ravages of others. They cannot be properly credited with purposes unless they had appetites and desires that not only terminate at sustained prospects, but are limited and guided by these. Some subhumans apparently anticipate what will be done by other members of their group, or by common enemies and prey. It is far from evident that they are aware of what outcomes their preparations are to serve, or that they envisage prospects and then order their acts so that these will be realized. If they did, their acts might still occur only within the compass of a purposiveness.

Were there purposes and purposiveness in persons, as well as in natural beings, the purposes in the persons would dominate over the purposiveness, while the reverse would occur in natural beings. Human purposes are not framed within a purposiveness. The absence of that purposiveness makes their purposes different in kind from any that animals might have. At the very least, it must be said that humans are primarily beings with purposes, and that subhumans are primarily subject to purposive trends. There is no evident purposiveness operative in the humanized world; if there were, our inductions would be more accurate and successful than they are. We can count on oaks producing acorns in a way we cannot count on what will be done in the humanized world. A blight might prevent the production of any acorns, and the likelihood of the blight could be made the object of a good, controlled induction by us. All the while, the oaks, acorns, and the blight may be subject to a single long-ranged purposiveness, one that perhaps is also affecting the soil and rivers.

Traditions, habits, and sometimes routines in the humanized world keep most humans within steady grooves, but lacking the rhythms, punctuation, and range of the purposely-controlled spans that character-ize different kinds of natural beings. Some of these are living organisms. Whatever characters they have are strong or weak, not good or bad, since they are not keyed to or directed at objectives that the organisms intend to realize. It is questionable whether even the most advanced of apes understands why it seeks to mate or to sleep. None knows that it has a grandparent or a grandchild, or that what has always occurred might not occur again. Such apes are best understood, not by viewing them as truncated humans or as wholly humanized, but as occupants of nature, living in a part of it not entirely separable from the rest.

Since no one really knows just when, after a sperm and egg have met, a

human comes to be, no one knows when occurrences in the humanized world give way to humans who exist in a domain of their own. When natural or humanized items are used, of course, they will be subjected to new determinations. What is in the humanized world may then be put to uses that may result in radical changes in import and act, and what has a natural origin may then be affected by what encompasses it. A fertilized egg need not be any more human than a woman's blood or bones. It may become a member of a domain of individual persons, though no one knows exactly when. It is not known just when it acquires a character that will be more and more strengthened or weakened or become good or bad. We do not know exactly when it has a privacy, a consciousness, and purposes. A decision as to just when to declare the body of an embryo to be the body of a human is arbitrary, a matter to be decided by making use of a reasonableness that reflects the sedimented wisdom of experienced, mature members of the humanized world.

Each of us is an individual person, primarily subject to the Assessor. Our living bodies are both individually possessed and in the humanized world, where they are constituted by instantiations of nuances of all of the ultimates, with the Affiliator in the dominant position. As in a domain of persons, each is constituted by the same ultimates, with the Assessor in the dominant position. The body is used by the living individual who possesses it, all the while that he remains distinct from it. When I speak to another, I speak to one who is together with me in the humanized world; at the same time, I move intensively toward him in a single move, as the possessor of a living body, character, and person. I do not then have a knowledge of him as a member of a domain of persons. To have that, I must refer to him as in a domain occupied only by persons. I would then be split into two were I not a living individual, possessing both what the ultimates constitute as a body and what they constitute apart from this. My approach to another as a human begins at his body and makes a single intensive move toward him as its user and possessor; my being with him as an individual person is carried out in a domain of such persons.

The classical Stoics and Epicureans divided a single truth between them, and thereupon misconstrued what they severally intended to maintain. The Stoics knew that they were persons who could and should exist apart from all else, no matter how they were acted on, but they did not seem to realize that they were together with others, both in the humanized world and in a domain of their own. The Epicureans knew that it was eminently desirable to be persons together, but took inadequate account of the fact that they were so in a domain distinct from the common humanized world. Both stopped short of an acknowledgment of

themselves as individuals who expressed themselves both as persons and as humanized beings, while remaining distinct from both.

Nietzsche's distinction between the Apollonian and the Dionysian neglects the different roles that are played by the alternates, the Rational and the Dunamis, culturally and in the humanized world. It is not clear whether or not he recognized that individuals were always more than either, or than the two combined. His view needs to be amalgamated with one maintained by those democrats who support the rights of humans as publicly together in a part of the humanized world.

Religions profess to be primarily concerned with persons, but differences in creeds and practices set them apart from one another in the humanized world and lead them to view individuals in somewhat divergent ways. When a state decrees that there is to be a separation of the state and religion, it refers to religions as providing particular ways of carrying out various public activities in ways that are not in conflict with practices endorsed by the state. So far as an established religion is occupied with having its creeds and practices endorsed by a state, it will slight or ignore its primary claim to be occupied with persons existing outside the humanized world. Its admonitions, advice, and demands are means for enabling some to become better aware of themselves, as existing in a domain of their own, and perhaps also as individuals having a presumed existence outside all domains.

Each of us is confined by combinations of instantiated ultimates. We are confined as persons, as members of the humanized world, and as individuals. As the first we are in one domain; as the second we are in other domains; as the third we are outside all domains, but able to express ourselves as members of the others. The fact cannot be well understood until we have learned about the ultimates that are dominant in domains other than those that embrace humanized beings or persons—and also learned of those ultimates that are dominant in none. These, it will be found, make possible a passage from one domain to another, or from the member of any domain to what is presupposed by the members of every one. Like the ultimates that are dominant in the different domains, the ultimates that are dominant in none—the Rational and the Dunamis—will be possessed by what they confine, the Habitat. The fact can be best understood only after we have made some progress in understanding nature and the cosmos. In the one, Voluminosity, in the other, the Coordinator dominates over all the other ultimates.

3
Nature

1. The Knowledge of Nature

The wind blows, the earth trembles, light fades, the seasons pass, flowers bloom, wild animals and thousands of other realities and occurrences come and go in nature, apparently without any regard for us. Isolated areas, with their singular inhabitants, make us confident that nature has a reality apart from us, while fossils and other remains have convinced most that there were natural beings where no humans ever were. There are ocean depths, arctic regions, and great forests still awaiting exploration. But whatever we observe is affected by our interests, attitudes, judgments, associations, and customary ways of experiencing and assessing.

It is we who distinguish the domain of nature from other domains; it is we who characterize it, inescapably humanizing whatever we take to exist and function there, independently of us. If we are to know what is not yet humanized, we must make a distinctive effort to escape the limitations to which humanized occurrences are subject. Although the moon does not await our arrival, and though we speak of it as being in a domain of which we are not a part, it is still a humanized moon that we see in a humanized sky. Its waxing and waning and its different positions are daily identified in terms relative to us as in the humanized world. Nothing in principle would be changed were it maintained that that moon is only in the cosmos, but if it were, it would be in a domain where there are no persons, or members of the humanized world. It is not the moon that is in nature or the cosmos that I see when I look up at the sky. Nor is the moon that I see the moon at which a dog barks, though it may bark at a time and place and in a way that can be related to the time and the place from where I see the moon.

How could humans know what there is in a domain of which they are not a part, either as persons or as members of the humanized world? We can take the components of bodies in the humanized world to be differently ordered in nature than they are in the humanized world, but though we might have imagined well, we would not yet know that there was any such domain nor know anything in it. Yet were we completely sealed off from what exists in nature or some other domains, we obviously could not know what is in any one of them. As a consequence, we would at best be world-makers, or more precisely, world-imaginers.

There is no knowledge of other realities unless what one has in mind is accepted by what is able to bring this to bear on that which is to be known. To know what can do this, one must begin, not just with an idea, but with it as available to a mediator as accommodated or rejected by that at which the mediator ends. Whether we attend to the fact or not, we constantly pass from one domain to another and therefore not only can begin with what is in our persons or the humanized world, but can end at what accepts or rejects this—and conversely. If we wish to know how this occurs, we must know instantiations of what is operative between domains.

Whatever we entertain—an idea, hypothesis, belief, fear, hope—is impotent, not identifiable with what enables us to terminate at what exists apart from us and which may, more or less, accommodate or reject what ends at it. The Dunamis and the Rational, the one pulsating and to be lived through, the other intelligible and necessitating, jointly make it possible to do what no other ultimates can, for those others, when dominant, are definitory of what occurs only in some one domain. The Dunamic-Rational provides the means for our reaching what is not in ourselves—the humanized world, nature, and the cosmos, as well as what we and all of them presuppose.

Wherever we begin in thought or act, we must be helped by the Dunamic-Rational if we are to terminate at what is distinct from that with which we begin. There would be no such terminations unless there were that which could more or less accept what the Dunamic-Rational ended with. Nevertheless, it is the belief of some naturalists that they can know what occurs in nature, as entirely apart from all humanizations and even as it might have existed before there could have been any. At the very least, that would require them to know nature as unaffected by the naturalists' own presence and judgments.

We cannot confront what is in an unsullied, unqualified natural state just by distinguishing the constant from the variable or transitory, or long-range occurrences from short ones. Every domain allows for such distinctions. To know what is in nature, we must escape the limits of our

individual persons as well as those characteristic of the humanized world. The dominant assessed and affiliated items that were identified as existing in persons and in the humanized world are subordinate, constitutive parts of what is in other domains. Were one just to think about that fact, nature would, so far, be something thought about, and perhaps nothing more. That truth provides both a summary and an anticipation of what must be said about our knowledge of what natural beings are, by themselves and in relation to one another.

Natural beings precede the existence of humans. Although we might come closer and closer to knowing what is in nature, we can never enter it. Whatever we try to introduce into it will be countered and qualified, and perhaps rejected by what is there. We could all agree on what we think nature is and contains, but that will still leave open the question whether or not what is agreed upon exists apart from us and in just that form. While we are usually sure that what we take to exist in nature is not in ourselves, we have no warrant for saying that this is in nature as it is, unqualified by our interests. Yet, were nature a completely sealed-off domain, naturalists and the rest of us would either be part of it or would be so separated from it that we could not know that it existed. By playing variations on our procedures, we might be able to reduce the differences between what is and what is not a natural occurrence. That, though, would not suffice to show that there is no uneliminable human contribution clinging to the result. To know this, we must first be able to arrive at what provides a lodgement for what we have in mind, or is able to be reached from the humanized world.

In order to observe what is in nature, it is necessary to carry out a three-part move. This is often done, without any notice being taken of its complexity and important distinctions:

A. Whether we move from what is in an individual person to what is beyond this, or conversely, from one personalized item to another, or just between non-personalized items, what is initially accepted must be subjected to an independent operating connection. Whether we imagine, theorize, or observe, we must submit to what enables us to arrive at what may accept, reject, or qualify what is ended with. Only then will it be possible to know what is both distinct from and more or less accommodative of that with which we begin. 'Truth', as applied to what we have in mind about matters of fact, is an achievement word.

B. A transformative act is qualified both by that at which it begins and by that at which it ends. The act can have the same nature and effectiveness in many situations, for it is constituted by the same ultimates. Kant, who took a transformer (called 'judgment') to operate between categories and content, was never sufficiently clear on this point. He could not, so

far, make evident how any independently existing object could be known. When one knows—or sympathizes, fears, loves, desires, intends—one begins in one's privacy, but ends elsewhere, with what is more or less receptive of what is presented to it.

Natural beings exist in spans shared with other realities. An oak occupies one span; it is also in a span that began with an acorn and ends with acorns or other oaks. It is arbitrary to say that a span begins with acorns and ends only with acorns, begins with only acorns and ends with oaks, begins only with an oak and ends with acorns, or begins and ends only with oaks. What we say or observe of acorns and oaks in some extended spatio-temporal-causal region can never be freed from human qualifications unless the observations end at what both exists apart from and qualifies those qualifications. The closest we can come to knowing anything in nature is by transforming what we conceive or otherwise entertain of it into what is caught in a distinctive span, at once temporal, spatial, and causal. Only then will our observations be relevant to what is in nature, as this is apart from us.

C. When one looks at trees in a northern winter, one can see them as so many valiantly struggling realities. Existing in spans, they have beings of their own and are reciprocally both individuated and individualized, i.e., oriented at the same time toward the ultimates and other actualities. What is in us when subjected to transformations may be accommodated more or less by what is in some span. The more surely we recognize that what we attend to is in a span, the more surely do we know it to be a natural object. Unless a span could be just temporal, account must also be taken of its spatiality and effectiveness.

We do not achieve a knowledge of what is in nature just by making careful observations, carrying out experiments, being attentive, or checking the one by the others. These are at best preliminaries for an arrival in nature as a locus of a multiplicity of spans. Although we have no warrant for supposing that there are purposes operative there, it is reasonable to suppose that a purposiveness is being exhibited, just so far as the end of a span helps determine and order what occurs before that end is reached. Unlike a purpose, such a purposiveness is not produced by the beings that may promote its realization.

Without effort or thought, we readily pass to what exists in nature from what we had personalized and humanized, but only if we are helped by what transforms what we provide into what nature more or less accommodates. I may continue to speak of a tree in a humanized way, but to know it as it is in nature, I need the help of what can begin with what I have in mind and arrive at what exists in a different domain. I can escape the limitations to which I conventionally subject what I have in mind, but only

if I am submissive rather than controlling, yielding to what is arrived at rather than subordinating it to my ideas or categories.

As in nature, a tree is always in an environment, where it is subjected to special causes; it there produces special effects within distinctive spatial, causal, and temporal spans. Since an oak is an acorn-bearing tree, just as an acorn is an oak's possible predecessor, to know an acorn as it is in nature it must be taken to be in a distinctive span with the oak that grows out of it, and perhaps with the oak that produced it or acorns that preceded this. Wherever a span be taken to begin and to end, one's knowledge of it will be qualified by personal and humanized factors. I know what something is, as wholly in nature, only if I know it as what effectively qualifies what terminates at it.

What is known of what is in nature is possessed by what is in nature. It there enjoys a status it had not had before, presenting new challenges. It also offers possible ways to begin a move to positions outside nature. That would not be possible, of course, were there nothing there. There is something known because there is that which accepts what is thought, on terms to which what is transmitted of the thought submits.

Pets, cows, chickens, caged animals, and others in zoos, as well as flowers in botanical and other gardens, are natural beings. They are also humanized in different ways and degrees, without ever being completely pulled away from nature. When we fix the broken leg of a dog, shoot a rabid squirrel, remove spilt oil from the feathers of a bird, we bring our humanized skills to bear, while that with which we are concerned continues to be in nature. What is then done is not unlike what is done when we mow a lawn, since we then also attend to what is in nature, within the compass of, and as qualified by what is in the humanized world.

Nature embraces the earth, oceans, air, heavenly bodies, and living organisms. Much in it is not alive. Most of the living beings there are unknown except in general terms, referring to their kinds, not to them as distinct realities. Reasons have here already been offered for rejecting the view that nature includes individual persons, though as members of the humanized world each unites individual contributions with those originating in nature. We have remote ancestors who were natural beings. Even now, each of us shares many features with them, all the while that we live in a domain other than that which they occupied. Much that we know of what is in nature is due to our being able to pass in thought in a reverse way over the distance that was once traversed in a passage from natural beings to humans.

Each of us comes to be after an egg and sperm are joined. Though the occurrence is similar to what is characteristic of some non-human organisms, it is in fact radically different, if not at the moment of the

meeting of sperm and egg, then soon after. Just when, no one knows. What we do know is that when and as there is a human, there is a person, and when and as there is a person, the Assessor dominates over the other constitutive ultimates. Even one who turns away from all others, who tries to live on fruit and nuts and has only a bird as a companion, is an individual person, existing in a domain with the rest of us.

Were land, water, oxygen, rocks, and trees not in nature, living beings there would not be able to take account of or be together with one another as they now are. The cave in which a bear is hibernating and the nest that a bird uses are in nature along with the bear and the bird. The sun that warms them is there too. Were it held that the sun is not in nature, it would have to be added that it then could not be seen by anything there. The knowledge we have of some things in nature is doubly oriented, at once possessed by us in one way and by what is there in another. Like other kinds of knowledge, it involves a sustaining, altering passage from what is qualified by us into what is qualified by what is being known. As long as we are in the process of knowing, what we provide will be affected by us; but also, if we know anything, what is being known will affect what it accommodates. Although we never enter nature, what we think or say about it can become more and more subject to what is there. The knowledge is still ours, ending at what takes possession of what is brought to it, by a power that begins at us and ends at it.

It is possible for us to know what is in nature, because we do not just conceptualize or articulate, but yield more and more to what is being known. From my position, what I know is continued into what is distinct from me and what I entertain. From the position of what is known, what I know is not fully accommodated. Could I not adumbrate anything, there could be a termination of my knowing, but I would not know anything. There is no stopping with sense data or at appearances; at the very least, we end with a 'knowing-of', a knowing that ends with more or less accommodated content.

When I form a hypothesis or theory, I do not escape into myself as apart from all else, but I also do not then make contact with other realities. To do that, I must yield to what will enable what I entertain to be presented for accommodation by what is apart from me, the knower, as well as from my act of knowing. The activity is not properly attributable to me, nor to something operating independently of me; it is distinct from me and from that at which I end, qualifying and qualified by both.

To know an object is to be involved in a progressive possession by the object of what is presented to it. Arriving at the object with the help of an effective mediator, what I entertain is more or less accepted. My adumbrations, though initiated by me, become more and more converted into

invitations and adoptions as they progress into objects encountered. They can be credited to me, a knower, or to the object known, though they are never entirely freed from qualifications by both. Those adumbrations continue mediations and a greater emphasis is placed on what is being encountered than by that with which one began.

The result of an accommodation by an object of what is being brought to bear on it can be understood only after it is recognized that we may add an adumbrative insistence to a transition from what we entertained to what is being accommodated. In the absence of an adumbration of natural beings—and a discernment of persons or of humans existing in the humanized world—we would end with what is being accommodated by what escapes us. Realistic-tempered epistemologists who seek only to predicate what they have in mind of what exists apart from themselves must show how they could begin with what they have in mind and end at what is outside it. If concerned with knowing what is in nature, they must, in addition, show that they can arrive at what accommodates what is adumbrated. If this cannot be done, what is in nature would be arrived at only through an unknown accommodation by what exists apart from us. Poets know this, with the rest of us occasionally following their lead for a short distance in acts of appreciation of nature's independence from ourselves as persons or as members of the humanized world.

H_2O does not refer to water, but to the proportions of hydrogyen and oxygen that will be needed if water is to be produced from these under certain conditions. Those gases are not present in water, except in small quantities. Nor is there any water in those gases. The units common to both the water and the gases are in nature, as well as in the humanized world and the cosmos, but they are subject in those to different dominant ultimates. In nature, they are primarily extensionalized; in the humanized world, they are primarily affiliated; in persons, they are primarily assessed; in the cosmos, they are primarily coordinated.

When we refer to someone walking eight miles in two hours and conclude that he walks at the rate of four miles an hour, we will have divided the eight by two and accompanied the fraction with a reference to miles-per-hour. The hour does not divide the miles. How could it? Nor is energy divided by mass in $E/M = C^2$. To carry out the divisions we must use, not numbers, but numerals. It took an Einstein to tell us about the cosmic relations that energy, mass, and the speed of light have to one another, but even children can carry out the permissible arithmetic operations.

Some naturalists disdain the use of sophisticated agencies in an attempt to make direct, untarnished observations of what occurs in nature. All the while, they use eyeglasses, hearing aids, recorders, and cameras, take

notes, and rely on what they had been taught or learned. Once what is natural has been identified, any number of other agencies could be used to guide, control, intensify, and carry out new observations. Acceptable accounts of what is in the natural world primarily depend on an accumulation of such observations. They would be strengthened were they backed by an understanding of how natural beings differ from those in other domains.

Although human bodies are always involved with what originated in nature, their individualities, characters, and privacies radically distinguish them from other kinds of living beings. They could be in nature only if they were not persons, could not commit themselves, and were without traditions, languages, ideals, and the ability to understand how nature is different from other domains. The fact is obscured when it is held that humans are the agents of some God or destiny; it is distorted when they are taken to love and mate so as to preserve their species, or when they are supposed to be governed by the stars, an economic force, or an irresistible historic trend. Subject to multiple determinations over which they have no control, humans still use these on distinctively human terms.

Realities in nature subject the cosmic units, which they encompass or utilize, to distinctive kinds of determinations, reflecting the controlling presence of natural spans. All are affected by, but are still different in nature and act from, other realities in nature. The rate of fall of a body in nature is not altogether determined by the rate at which cosmic units fall, since the being in which those units are set limits and sometimes qualifies the conditions under which those units act. The acts of those contained units are not exactly those of detached singulars. It is no more correct to take humans to be just natural beings, vainly trying to hide behind a supposed culture, than it is to suppose that they are just cosmic beings, vainly trying to avoid acting mechanically. Humans do not live in spans. Their purposes reveal them to be realities who can face themselves with objectives that they intend to realize.

Some trees live longer than humans do. Roaches and rodents survive where humans perish. The wind blows and the clouds pass, no matter what humans desire. Humans make a distinctive use of their characters, privacies, and bodies; they alone accept responsibilities and commit themselves. They alone increase a common knowledge, generation after generation. Only they have traditions and live through a history. They alone make private decisions and carry these out resolutely. Only they are primarily assessive. Only they can raise the question whether or not they are in nature. All the while, natural disasters will treat their cherished buildings, monuments, and creations, even the strongest and most isolated of them, as though they were no more than minor obstacles. Nature

intrudes on men, and they on nature, while remaining in different domains only if and when they are mediated by what is different from both.

It is sometimes said that nature is man's footstool, there for him to use as he wishes. It is of course often affected by what he does; he may cultivate, destroy, hinder, or enjoy parts of it by having them subjected to what initially are non-natural determinations. To know a human as one who makes a difference to nature is to know one who, without ceasing to be apart from it, provides what can be transformed into what can be accommodated by what is there. We often misuse and abuse, distort and destroy what is in nature, paying little attention to what is needed there or what it could become. When we misconstrue what nature is and does, we make use of agencies that connect us and what is in nature. When we deliberately or accidentally, knowingly or unknowingly, injure or benefit what is there, it still continues to be independent of us.

When teaching the young how a flickering fire, dry weather, wind, and dead wood can together produce regrettable outcomes, we refer to the kinds of things that occur when what humans begin are carried out in nature. What is taught offers one application of the general rule that what is begun by a human can be changed into what nature controls—and conversely, that what occurs in nature can have consequences in the humanized world and in the body that exists between and embraces what a human and a natural being separately possess.

Circus animals seem to be so completely humanized that they act in ways that contrast radically with those they might exhibit in nature. Yet they never cease to be natural beings, no matter how confined and modified they are. The humanizations imposed on them keep their natural moves in check, but they do not make the animals be other than natural beings subjected to effective humanizations. The animals are not two different types of reality tied together or momentarily kept in accord, any more than they are full members of the humanized world. Like the living bodies possessed by individuals in which the private and organic are constituents, the bodies of complexes have both humanized bodies and cosmic ones as constituents. Though protected, well-fed, and cherished, and treated as though they were solely in the humanized world, natural beings always remain in nature and possess bodies that are different from humanized or cosmic ones.

A tiger riding on the back of an elephant in a circus is part of the humanized world, but never fully humanized. Its young and the young of humans can be subjected to the same disciplining and training, but the tiger will end only with spanned habituations, while most humans will be able to assess the effort and the outcome. Neither humans nor animals are

ever completely humanized, animals because they are already subject to determinations as natural beings, men because they also exist in a distinctive domain occupied only by persons.

Even when living in the humanized world, we occasionally recognize that we sometimes take account of a time that is different from a common humanized one. The time divisions accepted in the humanized world, subdivided and paced by our conventional watches and clocks, may mark off the beginning and end of a concert or a play, but these events are lived through at a pace and with divisions that are pertinent to the grasp of what is pertinent to persons in a domain of their own, or to what is not confined to any domain.

Histories of events long past have a pace, subdivisions, and a directionality that are different from any time we now live through or may record. The histories are histories of what occurred in the humanized world but, unlike the time that men actually live through, their terminations rigidify the process by which they are arrived at.

It is hard to find anything that could be adequately described as occurring over a series of unit moments of time in the humanized world, in persons, in nature, and, as will become evident, even in the cosmos, while space in persons and, in another way, in nature reduces to co-determinations of distinguishable, independently acting items. Neither nature nor the cosmos pays attention to the punctuations of time that we use in the humanized world or live through as persons. Darwin was aware of the fact; Einstein has underscored it. The causality that interested the one is confined to nature; the time and space that interested the other is confined to the cosmos. Popularizations transpose what they should translate.

No humans live in nature. Subhumans do. In the humanized world contributions from both persons and natural beings are joined, with the first dominating over while being qualified by the second. Neither the bodies of humans nor of natural beings can be cut off from contributions having their source in the cosmos. If they could, they would not be subject to gravitational and other cosmic forces or from the effects that cosmic coordinations have on cosmic units. Needs, desires, fears, appetites, and the spans within which natural beings exist, preclude an understanding of them in terms appropriate solely to persons, humanized beings, or cosmic units.

These claims evidently presuppose that one has a knowledge of nature and the cosmos all the while that one exists outside them. Either the knowledge is obtained *a priori* and never confronted with anything real, thereby making accounts of nature and the cosmos indistinguishable from fictions widely agreed upon, or one is able to pass from oneself, as a

person, not only to the humanized world but to nature as well, and from the humanized world to either of them, and conversely. Nothing confined to a domain of persons or of humanized beings could enable one to do this. The acknowledgment of a nature, distinct from persons and the humanized world, depends on our ability to benefit from the presence and power of what is not confined to nature, persons, or the humanized world. It is in fact the very power that enables us to pass from the humanized world to persons, and back again, from nature to the cosmos, and from the cosmos to nature. As will become more and more evident, it is a distinctive ultimate—the Dunamic-Rational—recessive in every domain and consequently alone neutral enough to be able to connect what is in one domain to what is in another. We come to know what is in nature without ever entering into it in somewhat the way we know what is in the humanized world without our ceasing to be persons outside it—by sharing in the transformative power of the Dunamic-Rational, which never has a dominant role in any domain.

The price paid in the West when it takes whatever is to be an instantiation of the Rational is matched in the East when it takes whatever is to be an instantiation of the Dunamis. Not only does each tend to ignore what the other takes to be primary, but neither allows for the acknowledgment of distinct beings, in separate domains, that have natures and careers not reducible either to the Rational or the Dunamic, or combinations of them. No meeting of East and West that is content to deal only with the Rational as simply joined to the Dunamis will be sufficiently unified to do justice both to what is subordinated in each domain but is dominant in all relations confined to no domain. The recent recognition of the fact has led some to a despairing scepticism or a relativism, though all that is required is a distinction between what holds in some domain and what is needed if one is to pass from or to it from some other.

We come to know what is in nature the way we come to know what is in the humanized world or, starting in the humanized world, come to know what is in a person. The problem of knowing what occurs in nature is no more difficult to solve than is the problem of persons knowing what occurs in the humanized world. No one must pass through the humanized world in order to arrive at what is in nature.

The reason why so many think that they are or could be in nature is that they are so accustomed to passing into the humanized world, without attending to what enables them to do so, that they readily assume that nothing is needed to enable them to pass from themselves as persons or as in the humanized world to what is in nature. Were nature not differently constituted than the humanized world, we would not have to adjust our humanized practices again and again to what occurs in nature. No matter

what our calendar says, farming must be carried on nature's terms, or more precisely, must take account of its independent rhythms and course. What is humanized continues to have an independent nature and course, just as what is in nature does.

We enter into nature through thought or act, the one emphasizing the agency of the Rational, the other that of the Dunamis, all the while that we continue to exist both as persons and as members of the humanized world. We continue to exist in a domain of persons or humanized beings while, with the help of the Dunamic-Rational, we terminate at what is more or less accommodative of what is brought to bear on it. Our entrance into nature through knowledge is not an entrance in fact. When we know, we are not a part of it. What we have in mind or in some other part of our persons can be transmitted to what exists in nature, and there be more or less accommodated or even rejected. What we then know of nature will be in terms provided by us, modified by what brings this to bear on what is in nature and by the kind of reception it there receives.

Although we live in the humanized world, the problem of arriving at some other domain is in principle no different from what is faced when we begin in our persons and arrive at what is in nature. And, just as we enter into the humanized world through the agency of our living bodies, we conceivably could enter nature by preventing those bodies from submitting only to a humanization. That, though, would require us to avoid or overcome the humanizations that occur in the course of growing up and living together with other humans. To be in nature, it would not be enough to try to live like an animal; one would also have to feel, plan, and expect like one, and somehow avoid all speculation, assessment, creativity, imagination, commitment, and ambition. What we cannot do is be persons or humanized beings, and also be full members of nature, for the very time, space, and causality that operate in the one are different from those that are inseparable from us as existing apart from nature.

2. Nature's Spans

Evolutionary theory, while warranting the view that humans had predecessors who were wholly in nature, is unwarrantedly extended if it is taken to suppose that humans were ever in nature and, therefore, were subject to an evolutionary process that was operative there. Evolution apparently did once arrive at a point where proto-humans became humans, but there is no reason to believe that the process is repeated in the coming to be of each human today. Were a human embryo implanted and brought to term in an animal, and even raised by animals, it would be a natural, not a human, being unless its body was owned by an individual.

There are societies and states today that are larger, better organized, more equalitarian, less savage than many of those within which some humans once lived. The attitudes of some toward children, workmen, women, and races, economics, technology, culture, laws, and prospects are superior to those of our predecessors, even those who lived in the most advanced civilizations. There are not many today, as there once were, who would say with Thomas Aquinas that masturbation was a worse sin than rape, who would defend enslavement, think it wrong to earn interest on loans, or who would see no point in educating women. Before our time, there were persons like ourselves who, like us, were different in kind from anything that is or could be in nature.

Natural beings exist in spatio-temporal-causal spans; humans exist both apart from and in societies and states, with their traditions and moralities. They may be self-conscious and can commit themselves to realizing ideal prospects. An evolutionary theory that applied to humans would, at the very least, have such a different rhythm and course from one that applied to natural beings that it would promote clarity were it renamed, and its differences from a theory that applied to natural beings made evident. Even if men made great strides in knowledge, behavior, and continuance as persons or as members of the humanized world, one would have to strain one's vocabulary to identify the progress with the kind of evolution that marks the advance, from the kind of living beings that once existed in nature, to those that are now there, once we learn how to pass from what is in the humanized world to what is in nature.

Each domain differs from all the others in having an ultimate that is recessive in them play a dominant role in it. The recognition of the recessive presence of extensions in humanized beings and persons should therefore, alert one to the existence of a domain in which extensions play a major role. Although we cannot enter nature except by having what we entertain transformed into what accommodates it, we can understand what this essentially is.

The beings in nature are primarily subject to a primal Voluminosity, in which distinct end-points are sequentially, concurrently, and necessarily joined in spans of different kinds and magnitudes. Where, in the humanized world, different kinds of times, spaces, and causalities can be distinguished and even identified as pertinent to but not definitory of distinctive types of members of that world, in nature, different kinds of stretches of time, space, and causality in nature can serve to distinguish one kind of natural being from another. In any case, what occurs in nature must be dealt with in ways that are not appropriate to what occurs in any other domain.

Humans often change their courses because of what they have learned,

believed, surmised, or planned. This is usually done unreflectingly, but sometimes it is done deliberately. Unless we are to credit the beings in nature with purposes, commitments, and an ability to understand what occurs in domains of which they are not a part, we must recognize that they could not be persons and could not humanize anything. Since there is no known, sure method by which we can know exactly what is in nature, in the end, our characterizations of natural beings will be streaked with guess and be only partly defensible. That is why scientific accounts of what occurs in nature are being constantly revised. Could we neatly subtract our contributions, the residue would be rightly seen to contain contributions from nature and the cosmos, but we would not yet know how these functioned inside their own domains.

On one point speculative and scientific accounts of what occurs in nature supplement one another—what occurs in nature, both can maintain, fits into interinvolved temporal, spatial, and causal spans. In each of the three, there is an undivided stretch connecting a beginning and an end. No purpose, i.e., no objective is accepted in any as a guide and control of what is done. Even what appear to be preparations, snares, traps, and plans, competitions, deceptions, and lures, instead of being involved in the achievement of some purpose, are at most stresses in the course of a process of coming to the end of a span, or responses to a purposiveness luring what occurs within a span to progress in some particular direction.

Some subhumans travel great distances to feeding and breeding grounds. There is no reason to believe that they are trying to realize an objective to which they had committed themselves. No private decisions are first arrived at by them, as they are in humans, eliciting and promoting acts for a purpose that need not have been entertained. No private decisions, no setting of objectives for themselves to realize, need be attributed to them. Functioning within spans whose origins and outcomes they do not know, it need not be supposed that they speed up, slow down, change in direction again and again, to end at what they had not first envisaged and had used as guides.

Spans play distinctive roles in nature. Some remain undivided all the while that some occupants of them exist only within limited parts of them. Just how large a span is, is difficult to determine. Does the span of a tree encompass its entire life, a season, the production of seeds, or its struggle with competitors and predators? All could be allowed. A distinguishing of the temporality of a span from its spatiality and causality allows a tree to be identified as one entity while allowing it to be seen to be spatially together with others or as affecting and being affected by them.

The alien character of nature is perhaps nowhere more evident than in

the fact that the Voluminosity as realized there escapes a single precise formulation. With that caveat kept in mind, it is possible to offer a reasonable account of what occurs in nature. A span is an extension, having limits. A number of spans may be nested in a set of more and more inclusive ones. A tree can be taken to exist in one span; a number of them can be taken to belong to another; its products or theirs can be taken to belong to a third span. Each span has its own distinctive temporal, spatial, and causal beginnings and endings, but none provides the essential measure for the length of other spans.

What happens in one span is bounded off from what is in others, but it and they may still be included within some larger span. Both the smaller and the larger spans may be governed by a common purposiveness that none envisages. That purposiveness can never do more than promote a tendency to realize it. It is not the purpose of an oak to produce acorns, nor the purpose of acorns to produce oaks. Whether the two be taken to occur in different spans or to be members of the same span, they may or may not promote a common purposiveness—should there be one.

A span may come to a sudden end, brought to a close by the acts of what is in an intersecting span. The result will be a scene of help and hindrance, with not altogether predictable results. One could take the interinvolved spans to be occurrences within a larger span; indeed, one could, if one wished, treat all of nature as though it were the locus of conflicts and resolutions as long as one did not overlook the distinctive natures of the interinvolved spans. There need be no conflict between the recognition of distinctive kinds of natural beings in distinctive spans and the acknowledgement that their spans may intersect. It is because what happens in one span is distinct from what happens in another that their intersection could jeopardize the continuance of one, a number or all.

Some natural beings quickly change, while a larger number continue more or less as they had. Sometimes there is a change in the nature of a group, signalized by the appearances of new species, new territory, and new ways of acting. Sometimes a quick, large change may occur in all the members of a span, although the span may change but little. Spans, too, may make a great or only a small difference to what occurs within their limits. There is no *a priori* way to deduce the degree of difference a possible grand purposiveness might make to a span, particularly since a purposiveness may not have more than a minimal efficacy. We can never be sure whether or not such a purposiveness is operative, or what degree or kind of influence it may have.

A purposiveness does not act backwards from the future, nor does it provide a terminus that enables a number of occurrences to be and function so that its realization is promoted. Indeed, we can never be sure

that it is present or that it makes a difference to what occurs in any particular span. In effect, it is just the terminus of a possible, large-scale tendency. A reference to it would be futile were it not for the fact that it does make sense to speak of an acorn as the predecessor of an oak that defines the way the acorn is likely to develop.

Purposes provide guides for what is to realize them; a purposiveness can do no more than encourage an activity to proceed in a particular direction. Humans sometimes commit themselves to realize purposed ends; natural beings so act that a not yet reached termination of a span may be made more likely. Some suppose that all of nature is moving toward a final close; their supposition is no more warranted than are others that refer to some supposed initial event of such propulsive power that everything thereafter could be nothing more than a dispersed version of it.

Some take a God to provide a final, glorious outcome that will allow whatever occurs to be more or less distant from an unsurpassable excellence. For others, there is one grand, all-inclusive span whose end the purposed acts of humans may help promote. Why the outcome should be, how it could be known, how it might operate, is not evident. No one really knows whether or not there is some such grand end, if there is such a God, or whether or not finite beings, even if they worked together, could ever make a difference to the realization of the supposed splendid outcome. Nor is it clear whether or not there is a guiding end for what occurs in the humanized world, in nature, in both, or for all the occurrences in all the domains.

The idea of a God may promote an interest in what exists outside all domains, and in the connections among these. The idea is not indispensable, for the knowledge is obtainable if one begins in any domain and uses the instantiated ultimates there as evidences of them as they exist apart from those instantiations. Our tentative characterizations of what occurs in domains into which we cannot enter can be corrected and supplemented by a knowledge of what holds always and everywhere. The instantiation of those ultimates requires for its understanding no reference to a design, to an all-encompassing purposiveness, or to a control of what occurs in any span. Apart from these, it enables us to understand what occurs in nature by coming to it from the humanized world or from ourselves as persons.

One of the basic questions evolutionists have to face is whether there is one overall span within which all others occur, or a span that begins and ends an epoch, to be followed by another, and so on, perhaps endlessly, or whether there are just spans into which various kinds of natural objects fit, perhaps followed by others in which more complex living beings occur, even beings that might have abilities men do not have. We need answers,

too, to the question whether or not space and causality divide into large-scale spans within which there are more limited ones. Conceivably, there could be a single span within which all natural beings exist. No reference need then be made to a purposiveness, particularly since this has no power, controls nothing, never does more than provide a likely terminus that might be reached were a certain sequence of events to occur. Conceivably, there could be a distinct purposiveness for each span, matched by tendencies that make its realization likely. We have no warrant in fact or need in theory to suppose that there is any such purposiveness; though there may be no harm in making the supposition, there also is nothing gained. We have no reason to believe that there is a prospective oak luring acorns to become oaks, nor any reason to believe that there are prospective acorns luring oaks to produce acorns. If there were, many acorns would be uselessly produced, or perhaps produced mainly to feed small animals or to rot, and some oaks produced to provide some shade or places where birds might build their nests.

Oaks and squirrels are apparently caught up in different spans over which they have no control and which end at what may be followed by spans encompassing neither acorns nor oaks. Rot may invade the oaks; squirrels might eat the acorns. If we supposed that the rot and the squirrels were in a larger span, together with the oaks and acorns, we would then begin a process that might not stop until vast regions of time, space, and causation were covered. Unless there were a span that allowed for no intersections or interactions with others, spans must be recognized to be able to be of various magnitudes and to be vulnerable to perturbations due to acts originating elsewhere. Different spans may be quite distinct in nature and operation. The span in which there are acorns, the span in which there are oaks, and the span that encompasses both have quite different lengths and rhythms. But then it must also be said that smaller spans may be nested inside these.

Chance, as Peirce maintained, is operative everywhere. There seems to be no warrant, though, for his supposition that it is a distinct power and could be habituated, and that, as a consequence, nature, or the totality of actualities, is becoming more and more routinized, rigidified, reduced to inert matter. Humans carry out purposes within the compass of a humanized time, space, or causation that differs from the time, space, or causation in other domains. Their purposes are indeterminate, self-set prospects, prompting preparations to realize them. Were humans also subject to a purposiveness, they would be part of a trend of which they might not be aware, with a future that might be so remote that it could be reached only after there were no longer any humans.

We do not know whether or not any natural occurrence fits within some closed-off, purposively governed span. We do not know whether or not there is a single purposiveness within which every other purposiveness occurs. The supposition that there is such purposiveness does not help us to understand what occurs in nature better than we otherwise could. What we now can be sure of is only that nature is a domain in which Voluminosity plays a dominant role. That claim does not stand in the way of the knowledge that naturalists have acquired over the centuries. Our health and our economy owe them a tremendous debt.

We inescapably add humanizations to what we observe, record, or report; it is no less true that what natural beings do can be recorded by instruments functioning mechanically. The machines, of course, are made by humans and the recordings are interpreted by men in the humanized world, but unless we deal with nature as subject to conditions over which we have no control, we cannot know what occurs there, no matter how apparently impersonal our observations and recordings are. Although we cannot avoid humanizing any designated span, that will still allow for an under standing of it as subject to conditions that everything—even human observations and interpretations—instantiates. Once that fact is recognized, it will be possible to free the reports of naturalists from overriding humanized suppositions and additions. Nature will then be understood in terms of preconditions that are instantiated in all domains. In the absence of that knowledge, we must depend on effective mediators to bring our personal and humanized ideas to bear on what is in nature, for acceptance or rejection by it. What does this, and how, could never be known if we did not already know them as already instantiated. In the absence of that knowledge we would be left with conjectures about nature, whose merits we could not determine. Because and so far as we know that Voluminosity has a primary role in the constitution of what is in nature, we know that it is instantiated in spans.

When interest in prospects is lost, those prospects cease to play a governing role. Where a purposiveness awaits no one's interest in it, a purpose presents an objective having the power to direct and constrain. Desires, hopes, fears and other personal insistencies are to be distinguished from what is done to realize them, as well as from what occurs in spans. Purposes guide humans, and control more and more what they deliberately do.

'Stretch' is perhaps as good a term as any to mark off an individed extension in the humanized world from one in nature, and 'interest' is perhaps as good a one to mark off what occurs in persons from what occurs in either the humanized world or nature. Inside each domain

distinctive distancings occur. How odd it would be to measure the time of a family discussion or meal by a stop watch, unless this were done in order to achieve a special effect or result. It is odd, too, to take a span encompassing rabbits to be interchangeable with one encompassing acorns, oaks, or acorns and oaks.

When measures are used without regard for the existence of undivided spans, one cuts across a plurality of different extensions, each singularly pertinent to the activities of a limited number of beings. Use is made of such measures when some single, minimal unit of extension is used to subdivide a span. Though the measures may be supposed to cut across, they will not make a difference to any span. Were they supposed to characterize what is in nature, they would still continue to be apart from and be applicable only to humanized or personalized versions of actual spans. One will thereupon risk breaking up nature into a multiplicity of equal unit spans. The risk is avoided by recognizing that Voluminosity is a single, irreducible precondition instantiated by actualities and the relations these have to one another in nature.

Should it not be said that every item and occurrence in nature has a distinctive span, requiring a distinctive measure? In one sense the answer must be, 'of course'; in another, 'of course not'. Each span is indifferent to the length and nature of other spans, but is also together with them in a common nature. But then it would seem that spans must expand or contract, depending on what might impinge on or intrude into them. A flower's growth cannot be cut off from the flower's relation to the sun, the rain, the soil, and insects, unless these be understood only in terms of their presence within the compass of their own distinctive spans.

The recognition that there could not only be a span encompassing acorns, another encompassing oaks, and still another encompassing acorns and oaks, and that each could be taken to expand and contract, to intersect and to interplay with others, makes evident the need for a discipline occupied with understanding the nature of different spans. Sooner or later, it would acknowledge the presence of a power keeping spans together, despite their differences in pace and length.

A classical way of dealing with this issue would divide natural beings into kinds or groups, deal with these severally, and take their interinvolvements to provide occasions in which their continuance is enhanced or diminished. Particular members could then be treated as falling within some class. There could be spans of oaks but none of acorns, or of acorns and squirrels. These presumably would be taken to be instances of interplays of different kinds of realities, instances of what enables squirrels to continue to live, or instances exhibiting the fecundity

of oaks. What in fact happens, the particular interinvolvements of distinctive kinds of realities, each in its own span, would be subsumed under some such general idea as a struggle for survival. Is that not what should be said if we cannot personally enter nature and must either have our suppositions about it transformed into what is there accommodated, or be content to understand nature to be a domain in which a distinctive ultimate—Voluminosity—has a primary role?

We cannot write the biographies of all those who are involved in a great war. A history of the war will be punctuated here and there with references to some leader, hero, or small group. Yet each participant lives through it in a distinctive way. None is just a punctuation mark in a single occurrence, the war. There is a war; it may take years before it comes to an end. It surely is no less true that there are multitudes who live in distinctive ways during the period of the war, doing things that have little or no bearing on its course or outcome. One comes close to avoiding extremes by trying to envisage a position between an emphasis on the war and an emphasis on some individuals in it, as Homer does. His account, though, depends on the recognition that the opponents were realities of the same kind—warriors, ready to die for objectives that concerned only a few. It would be ridiculous to deal with squirrels eating acorns as though they imitated, even at considerable remove, the war between the Greeks and the Trojans. Acorns have no passions, virtues, vices, anger, hatred, or fear. Trojans remain Trojans and Greeks remain Greeks throughout the war; both constitute and are altered by the war. The fact prompts the suggestion that interacting spanned realities can retain their identities even when they are interinvolved with one another. All the while that acorns and squirrels remain in their different spans, they jointly constitute a common arena to which both contribute, and through which they affect one another.

It is tautologous to say that the fittest always survive, if by that one means that what does not survive was not able to do so. Greater justice would be done to the acknowledged facts if some spans were taken to be nested inside, qualifying and being qualified by others. The temporal dimensions of a span will, in any case, be affected by the spatial and causal in shifting ways and degrees. The outcome could be well understood only after the fact, as a result of adjustments made by what is in the spans.

Each span is at once temporal, spatial, and causal. Sometimes the spatial is most evident—the oceans and continents, the arctic and antarctic, the deserts and the cities. Sometimes the causal is most evident—in preparations, attacks, and defenses. Sometimes the temporal is most evident, particularly in living beings. Vegetation is affected by and

is acceptive of the land in which it occurs, both making a difference to the time passed through and the process carried out. These different dimensions of a span affect one another in different ways and degrees, while continuing to be independent and to function independently.

It is desirable, these observations indicate, to acknowledge not only limited spans occupied by particular realities, and others embracing distinctive kinds in a sequence, but a multiplicity of spans caught up in a single ecological setting—a desert, lake, river, ocean, or a forest. No one of these can be sharply bounded off from other areas. At the very least, they are cut across by the wind and affected by the sun. Still, the envisagement of a single ecological span, within which a plurality of smaller spans can be distinguished as more or less independent of one another, will provide a fairly steady setting within which one can understand what natural beings are and do. But one must remain alert to the need to identify, to vary, and finally to bracket the humanizations we introduce. We should recognize that whatever occurs in nature is primarily subject to an ultimate Voluminosity, and that whatever we claim to know of nature can terminate in it, only if subjected to a Dunamic-Rational mediation.

Since we cannot enter nature, and since even the most detached and careful observations that we carry out are inescapably humanized, the characterizations of what does and can occur there will depend on our ability to understand what has been freed from all humanizations. This can be done in three ways: our own contributions to the humanized product can be identified and varied, and note taken of what remains constant; we can understand the distinctive character of combinations of instantiations of the ultimates and we can come to understand the outcome of a subjection of what is in the mind to transformations ending in what is to be known. Since each independently tests what we claim to know, no one can safely dispense with any of them.

The space, time, and causality that are definitory of spans in nature are not to be identified with the space, time, and causality characteristic of other domains. It is easier to accept that claim today, since physicists have convinced most that extensions in the cosmos are quite unlike those in the humanized world. It is also dangerous. A scientifically sustained cosmology tells us what the scientific community of the day justifiably maintains. Unless their speculations have now achieved a final form—a supposition that no one aware of the history of science, or the ways in which scientists work, would entertain—we should expect that modifications and perhaps radical changes will be insisted on in the scientifically acceptable cosmologies that will follow the one now favored.

Good references to nature and the cosmos, as existing apart from all

humans, require the use of impersonal and preferably technical, special languages. Were a language favored by a community, it would enable the members of it to fit well together in a part of the humanized world, but it would not necessarily enable any one to speak accurately about what occurs elsewhere. Biologists and chemists try to provide languages that will enable them to speak clearly about what occurs in nature. They would end with inert formulae, abstractions, and variables, did they not change their languages in practice to make them be appropriate to what is nowhere else but in nature. Were the languages only forms of what was used in the humanized world, they would be no more than codes, awaiting decipherment.

Logicians and analysts have tried to construct precise, technical languages that will enable them to express what they take to be real, whether or not there were any humans. Contrary to their hopes, programs, and claims, such a language would be 'metaphysical' in the very sense they abhor, since it would refer neutrally to what could occur in any domain. Nothing is gained by following Wittgenstein and trying to replace such a supposedly neutral language by one that refers only to what is in some one domain, for, at the very least, five distinct languages would then be needed—one for each of the four domains, and one more for the intelligible vitalizations that refer to the connections of the different domains with one another. If we wish to continue to use the terms of daily language to refer to what is not in the humanized world, we have to give those terms new meanings and accompany them with distinctive attitudes. The practice is familiar to poets, those who are alert to the fact that what is confined to a domain presupposes factors that not only could be ordered in other ways, but have a reality and a status apart from all instantiations. Once an ecological threefold span is identified, and humanizations subjected to transformations that end within the compass of that span, smaller spans can be dealt with as more or less distinguishable.

We are able to know what is free from us and all humanizations just so far as we terminate in what more or less accommodates or rejects what is presented. We enter nature only so far as nature permits us, and then only within limits it provides. What then occurs has counterparts. To know anything in persons, the humanized world, or the cosmos, we end with what is more or less acceptive of what we make available and may insist on. To know anything is to end at what more or less accommodates what we had initially accepted. We are enriched, not then, but when, beginning with the separately maintained, accommodated content, we transform it into what we accommodate in our own way. We become acquainted with what is in nature by finding it to be more or less independently accommodated by what subjects it to spannings, and we learn what had done this

when the outcome is used adumbratively to penetrate into what is accepting it.

3. Natural Coexistents

Both what we have in mind and what is humanized are accommodated in various degrees and ways by that at which they end. The easier and more complete the accommodation, the more ready are we to speak as though we had come to know what things are as apart from us and all humanizations. What may then be added to the result and used by us, separately or as in the humanized world, may then be bracketed unreflectingly, all the while that it in fact is making a difference. It is, though, because the knowledge was made a part of one's person, or has a place in the humanized world, that it affects the memory, desires, and expectations of a person, and the plans and acts that are carried out in that world. Only at the end of an accommodation can one be said to have entered into another domain, and then only as that which had been adopted by a mediator that, in its own way, presents it for accommodation by that at which that mediator ends. One is most in accord with what is in nature when what it accepts is accepted by us in a return from a passage to it. The fact is taken for granted by naturalists. Any adumbration of what is in nature carries forward the insistence of one who provided the mediated content.

When a horse and a rider suddenly confront a snake, they do so in different ways. The snake and horse are together in nature. The rider and horse, as well as the rider and snake, are in the humanized world, so far as an emphasis is placed on the rider. They are both in nature from the position of the snake. Rider and horse attend to the snake differently, the one coming to it from a position in the humanized world, the other from one in nature. The rider attends to the horse and snake as humanized realities, but the horse attends to the snake as in nature. Since no one hurls his thoughts outward into an external world, the rider should not be taken to be one who is trying to exteriorize or to transmogrify what is in his mind, so that it becomes an occurrence in nature. Although rider and horse might react to the snake at the same time, and could be said to see that it is ready to strike, their 'seeings' and 'endings' are different; what exists in one domain for the rider exists in a different domain for the horse. The horse reacts to the snake, the rider tries to control and protect the horse. The snake is in nature, so are some of the encompassed parts of the rider's and horse's bodies. Both rider and horse had been subjected to humanizations, but the rider will also be in a domain of persons, while the horse will also be in nature. Just as a human is threefold—at once a

natural organism, a humanized being, and the two together—so a horse is three-fold: at once a natural organism, a humanized being, and the two together. The snake is humanized by the rider, while the horse and snake remain together in nature.

The snake, horse, and rider are contemporaries in the humanized world, horse and snake are contemporaries in nature; and rider and snake are contemporaries in the humanized world for the one, and contemporaries in nature for the other. Rider and snake are contemporaries because of the horse, as that which is only in the humanized world or in nature. Evidently, contemporaries can be in different domains, provided there is that which unites contributions from both. Such realities are individuals within a common Habitat.

The contemporaneity that is measured by a breadthless line can be nothing more than a contemporaneity of points, not of realities. It will, therefore, be something imagined or conceived, not something real. If one thought of persons or humanized realities as existing in spans, they would be spans quite different from those occupied by natural beings. The first would be qualified by assessments, the second by affiliations. More justice would be done to the facts, therefore, if different meanings of contemporaneity were distinguished when dealing with what occurs in different domains. Similar observations are to be made in dealing with measurements.

The acceptance of some unit of measure, perhaps the quick pulsation of a small object, provides both an opportunity for and a barrier in the way of an understanding of a multiplicity of different kinds of natural occurrences. When, as is sometimes done today, an attempt is made to speak as though all spans had the same minimal lengths, larger spans have to be understood to be aggregations of these. One would then have to ignore the singularity of long-range experiments, astronomical systems, forests, and oceans. Indeed, one would not be able to acknowledge the existence of any item that lasted for more than a moment. As a consequence, one would be led to say that a bird existed only moment after moment and that it uttered a sequence of sounds heard by momentarily existing listeners. No song would ever have been produced by it or heard by anyone.

Some measures are chosen because they make for ready communication and calibration; others because they take account of the interinvolvement of termini. Nature knows nothing of such decisions. No calibration or interconnection of what is in diverse spans is there possible unless one can relate an occurrence in one span to what occurs in another, without having to abstract from their different tendencies. This could not be done by what lasts for just a moment or that could not, while remaining in its own domain, be related to what is in another by what is distinct from both.

We mark the seasons with the help of a calendar, but major shifts in nature's course rarely match the designated dates. Nature contains a multiplicity of kinds of occurrences, occupying spans of different lengths and having different rhythms, without regard for us or our desires.

Though a flower and a bee exist in distinctive spans, there is only one nature within which they occur and where they could affect one another. What is in one span may interplay with what is in another, without losing a place and role within its own. Since what occurs in some other span may be intruded upon, helped, or hindered, one can envisage an ecosystem made up of a number of spans intersecting, supplementing, and blocking one another, again and again. Those spans will continue to differ in membership, space, and spread, forming an aggregate of spans with different rhythms and boundaries. It would be arbitrary to take any one of them to produce a measure for the others. Were this done, what fell short of the termini of the measure would have to be taken to be an abstraction, and what extended beyond those termini would have to be treated as having distinct segments.

There are many different spans in nature whose termini do not coincide. They could be properly dealt with disjunctively. The relations between spans, even those encompassed within one as broad and as long as nature itself, would have to distend or contract depending on what was being matched. The ultimate Voluminosity, evidently, would not only be instantiated in spans of different magnitudes, but would remain distinct from all of them. Contractions and expansions make different spans contemporaneous, even when they are related as past and future or as larger and smaller. Since some spans exist when others are no longer, and when there are still others to come, it must be said that only those spans are contemporary that overlap to some extent.

This view of contemporaneity is so novel, odd, and dim that one is driven to look for alternatives. What is now evident is that no view of contemporaneity that is expressible as a line joining points could do justice to the concurrence of distinct spans, while a denial that there is any contemporaneity connecting spans would end with a pulverization of nature into disconnected islands. There is a kind of contemporaneity expressed in references to 'species', since this allows for a multiplicity of units to be considered together. Were 'species' more than a general term, it would encompass a plurality of realities that may not exist at the same time. Either 'species' is an abstract class name, or it is a factor encompassing and possessed by a multiplicity of realities that exist in different spans. Since the fact that some members of a species exist before others does not compromise the acknowledgment of their copresence in the species, the air of paradox involved in speaking of different realities in nature as

contemporaries could be dispelled by speaking of them as existent in copresent species. That, though, would require one to refer to contemporaneity as an abstract or formal characterization. Whatever the resolution of the issue, there should be no denial of the integrity of a span with endpoints both distanced from and together with one another, and which, though divisible in thought or in fact, exists undivided.

If what affects a natural being were due to acts occurring long ago and far away, or even to acts that occurred recently and nearby, any such being might at any moment be completely alone or larger or smaller than any other. The realities that had once been, in any case, are not in a past somehow trailing behind whatever is in the present, but are part of what is present. The idea was dealt with in a brilliant, original way by Whitehead. He thought, though, that the present was the same everywhere, existing only as long as it was necessary to adopt the past and accept a prospect provided by God. There is a beautiful simplicity to the view, but it is bought at the price of taking the present to be of the same unit magnitude everywhere. Presents differ in magnitude, just as surely as spatial regions and causal events do. Were there no intermediary that contracted and expanded to make different temporal spans be contemporaries, we would be driven to accept something like Whitehead's view and deny the reality of beings existing in spans of different lengths, acting in ways no Whiteheadean beings could. If all existents exist only in single moments of the same magnitude and only as long as it takes them to become, there would be no existent humans with plans, commitments, and carrying out tasks that take much time to bring to fruition. Nor would there be diverse humanized beings existing for different periods.

Whitehead was right to reject the idea that there is a past that has somehow been left behind, a frozen ghost of what it once was. The idea, though, does not require the supposition that all presents are of equal length in the humanized world or in nature, or that they have nothing to do with one another. His insight can be accommodated, freed from its difficulties, if one defines as copresent whatever adds determinations to whatever is present with it.

Each natural being is affected by all its contemporaries, in the guise of determinations limiting what it will separately do, and by having its prospect qualified by these in still another way. Something similar must be said about the ways that persons, humanized beings, and cosmic units act on their contemporaries. In a domain of persons, the qualifications will all be subject to assessments, in the humanized world to affiliations, and in the cosmos to coordinations.

In each occurrence in nature, various acts and changes are completed in different ways over different spans. All the while, each carries out

distinctive acts that contribute to the constitution of the past and future of all others. "The flower in the crannied wall" incorporates, in the form of a usable past and a relevant future, all that then exists in nature. Every other being there affects and is affected by the flower, enabling one to know 'all.' Monists insist on the fact, but too vigorously, forgetting that the flower continues to be inside a distinctive span.

Aristotle treated both efficient and final causes as effective components confined to distinct realities or groups of them. He overemphasized the final and minimized the efficient causes. Most moderns, instead, acknowledge the efficient and reject the final altogether. Although Aristotle made no provision for an objective time or for a space that was more than a place within some container, he did not, as some later thinkers do, suppose that all realities are of the same type or that copresents could not affect one another. He did, though, suppose that there was a hierarchy of living beings with humans at the top. Though he recognized that they lived in societies and states, he never made evident that humans were not in nature. An Aristotelian today would perhaps remark that humans could, like subhumans, live in groups without ceasing to be in nature, but there is a radical difference between the types of groups they occupy and the role that ideals and commitments have in human affairs.

There is a kernel of truth in astrology; living beings contain what originated in the cosmos. Account, though, should also be taken of the difference that the cosmic bodies, in turn, make to their encompassing bodies. There is also a kernel of truth in palmistry, since it takes note of the fact that humans have characters expressed in and through their bodies, but a reference should also be made by its practitioners to the difference made to the parts by what contains them. Both astrology and palmistry, however, get in their own way, hiding what is legitimate in their claims by unwarrantedly maintaining that their procedures are 'scientific', exact, meeting rigid demands for evidence, proof, and prediction.

Living beings may have arisen many times over the course of nature's existence, but some have not been able to continue for long, or may not have left any traces behind. The first living beings need not have been single-celled. Nor need they have given way to more complex living beings without first having made many false starts. All may have been, but none need be, on a single line of growing bodily complexity. They may have been unduly subject to limitations due to others. While occurring in distinctive spans, they made use of and interplayed with other differently spanned natural beings. Once any came to be, they could continue to be members of groups, each of which had its own temporalized, spatialized, and causal spans. It need not be assumed that the groups themselves have

the ability to make the beings they encompass promote the group's continuance.

No human could 'create' life in nature. The most one could do would be to produce humanized beings within which there were natural and cosmic ones. This would be no small accomplishment, though in principle it would not be different from making ice give way to flowing water, and this to steam. Should a time come when a living being was produced in a laboratory, as water can now be produced there by subjecting two gasses to various conditions, experimenters could justifiably credit themselves only with having provided an opportunity for life to be. Should a multitude of such experiments fail, a search might be made for some hidden or unnoted obstacles or missing items.

The difference between the living and non-living is not expressed in some not yet discovered 'unit of life', but in the arrival of what exists within a new distinctive span. We now know that this, at some later date, is encompassed within larger spans occupied by more complex living beings. The fact that life originates in nature does not preclude its production in a laboratory, any more than the natural growth of trees precludes them from being planted and cultivated. Since the planning and cultivation is due to humans, the trees will inevitably be qualified by what the humans introduce. The result cannot be properly credited solely to nature or to man.

Laboratory results are, in principle, no harder to obtain than are others involving radical changes in natural beings. That, unfortunately, does not mean that the needed experiments are within our power to produce. We also do not know how to change quite disparate living beings into one another. Here, too, there is no known, insuperable obstacle in the way. Presumably, much more could be achieved. What this may be we do not now know, mainly because we do not yet know exactly how the needed transformers qualify and are qualified by the realities that provide them with termini. Living beings are produced in nature. We know that their existence occurs in spans operating in new ways, but we know almost nothing about how and why they do so. That still allows us to recognize that some natural beings are not alive, that they could give way to living ones within new spans, and that there might be some that are very different from any existing today.

Nature, conceivably, might always have been. Its members would, even then, contain cosmic bodies which act there in ways they could not when in the cosmos. The wind blows with equal force against whatever is in its way. The rising sun is seen by chimpanzees. The list can be extended indefinitely, but it will still fall short of dealing with individuals with characters, persons, and possessed bodies, and the effect on them of an

ultimate stratifying Assessor. The kinds of germs that invade human bodies also invade the bodies of subhumans. All the while, humans will be more than just bodies, as their families and sometimes their physicians, insurers, and the police well know. Those writers of science fiction who are content to imagine odd kinds of living beings are too timid, in good part because they do little more than play variations on what is well known. The limitation is emphasized when their creations do no more than think and act in conventionalized, humanized ways. Greater imagination would be shown did the writers try to think of some condition that did not play some role in nature, humans, the humanized world, or the cosmos, and then exploit the difference.

Inquiry begins by taking note of what occurs in the humanized world, and particularly in its familiar, but ill-defined commonsense part. The community to which most disciplined investigators belong requires them to make use of a distinctive language, to follow distinctive procedures, and to make distinctive assumptions. The three are modified over the course of history. Changes occur in all, sometimes gradually and occasionally dramatically, with many of them and the procedures leading to their acknowledgment, accepted by disciplined investigators. Too often, it will be tacitly supposed that all humanizations had been compensated for and that the latest reports of disciplined investigators express what is unaffected by humans and their values.

The fact that living beings originate in nature, which may have existed well before anything there was alive, compels one to acknowledge the presence of a constant, dominant Voluminosity that characterizes the realities in ways not appropriate to what exists in other domains. But, just as we cannot justifiably set any natural being on a footing with humans without overlooking the fact that our knowledge of it is achieved outside nature, so we cannot reduce any living beings to a variant of some non-living one, without overlooking the fact that natural beings exist in distinctive spatio-temporal-causal spans.

Two opposite criticisms can now legitimately be made about what is here being said about nature: too much and too little is being maintained about what occurs in nature—too much, since nature has been said to be a domain into which we cannot enter, except with the help of mediators whose presence and nature has not yet been made evident; too little when we face what is here said with the vast amount of certified knowledge about natural occurences that has been provided over the centuries by geologists, biologists, horticulturists, naturalists, chemists, and trained observers.

Although we cannot enter nature as it is unaffected by our humanizations, we can still have what is in our persons or in the

humanized world brought to bear on what is in nature, and have it not only be more or less accommodated, but have it used as a move back to ourselves, as able to accept or reject the result in any number of ways and degrees. Indeed, this is what naturalists do. What is here noted are generic features of the specific determinations that interest them. Any of us can move from our persons or from what is in the humanized world to nature and back again.

We know that there is more than one domain—one containing persons and another containing humanized beings, and that we can pass back and forth between them. The recognition that, in addition, there is a domain of nature, and that one can pass back and forth between it and either ourselves as persons or what is in the humanized world, leads to the expansion of the idea that there are two distinct domains with their own types of members and kinds of activities, each subject to the same ultimates but in different orders. What seems to be useless knowledge from the position of some domains turns out to be no more than the knowledge that can be obtained in understanding what is distinctive in a particular domain, and what occurs when a condition that is recessive there becomes dominant.

It is also true that we do have much more knowledge of what occurs than is here provided. A philosophic account goes not much further than to point up what is essential to a comprehensive understanding of realities, their warrant, and interconnections. Just as one does not need to know the laws of logic in order to be able to infer correctly, so it is not necessary to know what is being presupposed by those who engage in inquiries occupied with knowing what in fact is occurring inside some domain. Even theories that make possible the understanding of a vast number of phenomena in some domain are too limited to make evident what is always presupposed.

A philosophic account of what is true of a domain is right or wrong—or somewhat askew. Other types of inquiry can do no more than provide data to be understood as fitting into a comprehensive account that has a place for whatever is and could be known. An inquiry that is interested in knowing what is presupposed by each and every occurrence in every domain is enriched by a knowledge of their essential features and what trained investigators accept as certified fact. One of the serious blunders that even the greatest of philosophers makes is to accept some commonly accepted paradigm of some inquiry as definitory of the nature of persons, humanized beings, natural ones, or cosmic units. No biologist, physicist, or mathematician today allows himself to be confined within an Aristotelian or Kantian world. None should allow himself to be confined inside some other domain.

If those interested in knowing what occurs in a particular domain are to benefit from a philosophic study, this must at the very least show that it knows the difference between what occurs in that domain and in others. No philosophic pluralism, of course, could ever provide a final answer, if for no other reason than that it must explain why there are just so many domains, why they exist, and what they contain. That issue will be best faced after we have attended to one more domain—the cosmos. We will then be in a good position to make evident that an otherwise recessive Coordinator plays a dominant role in a distinctive domain, and that there are two other ultimates—the Rational and the Dunamis—that, while dominated in every domain, are dominant in the evidencing of all the ultimates and in the connections of the members of different domains with one another. We will then be in a good position to make evident, not only what is outside all domains, but why there are any domains, and the ways in which they are related to one another.

4

The Cosmos

1. Cosmology

It is hard to escape the feeling that it is absurd for anyone but a trained, knowledgeable scientist to say anything that is both clear and true about what occurs in the cosmos. There have been too many spectacular, checkable studies of parts of it by men of genius, confirmed by experiments, and opening up new areas of inquiry and practice, to make it plausible to hold that anyone other than trained inquirers could contribute anything to our knowledge of what occurs there. Daring, comprehensive accounts, confirmed in crucial observations and experiments, have been accepted by those who know their physics, astronomy, and mathematics. As Kuhn has noted, it is these that the scientific community accepts as it carries out its more limited studies, often enough with considerable success. Explanations of apparently inexplicable or unexpected events, daring new views of the nature of time, space, causation, and bodies have required the discrediting of what had long been taken to be central and even unquestionable truths.

Even a Whitehead, with his knowledge of mathematics, physics, logic, the history of science, and philosophy, held views that did not deviate far from what the scientists of his day endorsed, though he did not, as current philosophical cosmologists do, tailor his views so that they repeated, in other terms, the accounts then widely accepted. Whitehead tried to take supposed cosmological general truths to be specialized by everything, and to give fresh interpretations of the ways unit realities functioned and how they were related. Whitehead did not, though, hold that they were confined in some domain, contrasting with others that were constituted and acted in other ways in other domains. So far as he ignored the

accepted presuppositions and took every occurrence to be cosmological, he stood more or less alone, occasionally stimulating some physicists, but mainly providing a few younger philosophers with an account that seemed to be more viable than any others, no matter what some scientists maintained or what different philosophical schools took to be basic or true. He deviated, too, and rightly, from those who were content to understand cosmological occurrences in ways that made no provision for the inheritance of the past by the present. He also thought that a cosmology would be incomplete if it did not acknowledge a God who was impersonally and implacably involved in the momentary, unit acts that were definitory of the nature and reality of every actuality. God is very kind to trapped philosophers. There He is, filling out the empty spaces, solving their unsolvable problems, taking up the slack. He assured Descartes and Leibniz that clear and distinct ideas were true; he helped Whitehead to get from one moment to another.

There is a way of understanding all occurrences to exemplify the same general principles, no matter what the domain. The recognition that every actuality is confined by and possesses the same set of instantiated ultimates is one instance; it does not require or justify the neglect of occurrences in different domains. One can understand what actualities are, how they can have futures, and what they do, without looking to an all-powerful concerned Being for help. Sooner or later, however, one will have to acknowledge the existence of a necessary Being. This is not an object of worship or the terminus and satisfaction of a faith; it is what is presupposed by all the ultimates, and necessarily does what it does.

Whitehead wanted to take account of what was essential to the reality of every existent. That desire alone distinguished him from his contemporaries. He never did, though, make evident what kind of reality, if any, those essentials had apart from their instantiations. That was a strange Aristotelian omission by a professed Platonist. All actualities instantiate the same ultimates; these have insistencies that must be countered by others if they are to be effective.

Cosmic and other realities usually exist for more than single moments. The understanding of that fact requires the recognition of the presence of persistent factors, and the fact that they can come together for extended periods. The members of the cosmos, like the members of other domains, are products of joinings of ultimates. Those joinings have no antecedently prescribed duration. The ultimates are essential components in every occurrence, prescribing to, limiting, and governing. So far, they are more than constants accompanying or exhibited by what is transient.

Nothing is so dated as a philosophical cosmology that is content to treat the views of contemporary scientists as a warrant for a supposedly

comprehensive, final account of what occurred. Whitehead escaped that criticism, but then failed to account for the essential components of every item, or show how they qualify and are qualified by one another. Although the members of the cosmos are unit bodies, each instantiates all the ultimates. The instantiations are possessed by what is distinct from them. It has already been noted that persons, humanized beings, and the spanned objects in nature are such possessors. Cosmic beings, in a domain of their own, are like them. As will become more and more evident, there are still other possessors that express themselves in, through, and apart from what is confined to one domain.

While scientists agree that a final account of reality, even as present and interconnected in one or more domains, is still in the future, too many speak of the current views of scientists as though they were clear, certain, and beyond the reach of questioning or criticism. At best, a philosophical account of the cosmos can offer scientists only a set of place holders, to be filled out by them in their own ways and on their own terms. Other place holders are needed for other domains, and warrants provided for filling them out in one way rather than another. Those who are content to accept or re-express what the scientists of the day affirm close their books too soon.

If, as Peirce maintained, science is the concern of a community of disciplined inquirers, there are few philosophers who are qualified to do more than dot some *i*'s and cross some *t*'s. I doubt that I could ever do more than that. At the very least, a number of more or less independent subdivisions of reality must be distinguished, if one is to do justice to the distinctive kinds of suppositions, practices, and discoveries by those who are trained to understand them. At the very least, the distinctive procedures and achievements of botanists, chemists, and geologists are to be distinguished from one another, and from the procedures and achievements of physicists and astronomers. The so-called scientific method that is enshrined in texts, and that both positivists and pragmatists take all scientists to use, is a myth. Were the supposed method ever followed, it would be cross-grained with so many dubieties, backtracks, unexamined assumptions, surmises and hopes, that it would be almost unrecognizable. An encapsulation of the method in a formula rigidifies and thereby mocks what serious inquirers do.

Sharing a common overall aim to know what is true of bodies, the different outcomes obtained in different branches of science cannot be well-meshed by any of them. One must either look to one who knows what is done and achieved by all, or be content to know quite general truths that different investigators specialize in their own ways. It is those general truths that awaken the interest of the philosopher; their fillings and details

are usually beyond his power to know or to utilize. In any case, all—the trained and the untrained—do their work as distinct persons and as members of the humanized world. None can enter the cosmos or nature. Science is more multifaceted than is affirmed even by those who work in it.

The cosmos existed before there were men who could think about it. Those who now concern themselves with it are conscious and sensitive, with characters, persons, and emotions, able to initiate and carry out activities no cosmic or natural being could. Able to deal with the cosmos in the same spirit that is exhibited when dealing with what is in other domains, what a philosophy may come to acknowledge to be true about what is in the cosmos will not replace or even correct or refine what is known of it in other ways. The procedures, tests, and certified references in a comprehensive philosophic account are different from those pertinent to what is in some one domain, or even in all of them. What is in one domain is differently constituted from what is in another and, of course, from what is outside all. What a philosophy says about the cosmos can never do more than make evident what it essentially is and what this presupposes.

As we have already seen, the Affiliator, Assessor, and Voluminosity are characteristically dominant in three distinct domains. There are, in addition, three other ultimates—the Coordinator that is dominant in cosmic bodies, and the Rational and Dunamis that are recessive in every domain. Occasionally, we come to know the latter two by noting the effects they have on the ultimates that dominate them. We may also be alerted to them in the course of an investigation into creative activities. Usually, though, it is when we are interested in knowing how to pass from one domain to another, or when we are interested in evidencing all the ultimates as not yet instantiated, that we take any note of them. Though all the ultimates are instantiated together in each domain, the Rational and the Dunamis play dominant roles only when their instantiations are not confined to any domain.

No domain, not even the cosmos, need have been. Were there no domains, however, there would not be nothing at all, since the ultimates as not yet instantiated would still be, as would the Being that those ultimates presuppose as their source. The unit bodies in the cosmos are constituted by the very ultimates that can constitute the members of other domains, but in a different order.

The Dunamic-Rational, i.e., the Rational and the Dunamis together, conceivably could have been the dominant ultimates in some domain. If they were, there would be no connecting of that domain with others, nor any way of getting from what is in any one domain to what is in any other.

Conceivably, there might be someone who was able to identify one or more ultimates, not here acknowledged, that could relate what is in different domains. If there were, he would reveal the present account to be part of a larger one. But now, despite the contingent existence of the four domains acknowledged here, we can do no more than acknowledge that in each of them there is one dominant ultimate, and that the domains can be connected by what is dominant in no one of them.

There would be no relating of domains unless there were ultimates connecting them. One can imagine a God who assumed the role of such a connector. Unless He were also a subdued note in every actuality, He would be alien, remote, imposed on what was, entirely different from Himself. The Dunamic-Rational acts unlike such a God, not on what is entirely different from it, but on what has it in a recessive position. Were there some grand power that imposed the Dunamic-Rational on what did not contain them, the act would be brute, yoking different realities by means that were entirely alien to them. A relation for which no units are germane has nothing to relate.

Once we know the way some actuality is constituted by all the ultimates, we are in a position to imagine what would result if now this and then that subordinated ultimate were to become dominant. One would then not only be able to understand the Dunamic-Rational as able to connect domains, but know the kinds of actualities that could exist in different domains. He could, thereupon, provide checks on accounts that, beginning with what is outside some domain, seek to know what is there. The observation was here partly anticipated when it was remarked that a living human body is not only in the humanized world and is possessed by a person, but is also a reality in which the two are merged. Consciousness and the emotions express that fact in a personalized way; a 'living body' expresses it more objectively. There is a similar merged reality between a humanized and a natural body, and still another between a natural and a cosmic body. The fact cannot be well understood until account is taken of what could possess and use such bodies, a matter to be dealt with in the last section of this chapter. A reference to it now serves to point up the fact that what is in nature and in the cosmos can be bridged by the Dunamic-Rational as concretized in a complex natural body containing cosmic units.

The knowledge of a member of a domain adumbratively moves into what possesses and uses it, but it does not enable one to know that possessor and user as having the power to act in these ways. To know a body to be a member of the cosmos is at best to do so from an angle. One does not yet know what it is that can be so approached. A cosmology, like Plato's, Aristotle's, Spinoza's, or Whitehead's, has the merit of refusing to

understand cosmic units as though they fitted perfectly inside a domain, but it does not make evident what possessively owns and can use them. Like the rest of us, their defenders never do or could enter the cosmos. They did know, though, that it is possible to understand what occurs there, and that this is possessed and used by what is then never more than partially manifested. That is a great deal to know, but it is still not enough.

Beyond the members in a domain are their owners who express themselves in and through what is in adjacent domains, and in what exists between those domains. The members of a domain evidently, are always doubly possessed—by what is confined by the ultimates that are so jointly instantiated that the Dunamis and the Rational are in a subordinated position, and by what exists beyond what is so confined. The latter are individuals, complexes, and singulars, subdivisions of a common Habitat. They will be dealt with in the last section of this chapter. Their reality now needs to be remarked only to make evident that the most complete cosmology must take account, not only of the effective presence of what is confined by an ordered juncture of instantiated ultimates, but of singulars that possessively own and can use both what is in the cosmos and also what exists alongside it.

The knowledge of what occurs in the cosmos, or in any other domain, needs supplementatation by a knowledge of realities that exist outside all domains. Presumably, it is an awareness of such a power, expressed in and through what exists in more than one domain, that has led many to suppose that there is an all-comprehensive conservation of energy, an all-engulfing evolution, a primary process, or a nisus toward some last stage in which everything is bathed in a final glory. 'Chance' has begun to find a place alongside these and, for some, even to replace them.

2. Chance

At a time when a rigid, universal determinism was the dominant, scientific view, Peirce insisted that chance was an unavoidable, operative presence, accounting both for the ways in which actualities happen to be distributed and for observable aberrations in the supposed expression of tight, universal laws. His was a refinement of older views; it needs still other refinements, in part because it is not altogether clear whether or not Peirce took chance to be a cosmologically pervasive factor, supposed that it occurred everywhere, or thought that it did no more than emphasize the fact that there are no rigid laws to which everything conformed. Whatever alternative best expresses his intent, his view does provide a warrant for introducing into formalistic presentations references to vibrancies, the nondeducible, the unpredictable, and the vague, as so many exhibitions

of the Dunamis. This is present everywhere, with varying degrees of efficacy; it occurs in every domain, as well as in the evidencing of the ultimates, in transitions from one domain to another, and in every act. It is doubtful that we could ever isolate it, any more than we could isolate the purely Rational, or any other ultimate.

'Chance' can be taken to refer to the unpredictable expression of the Dunamis as operative within the compass of the Rational, or, alternatively, as a sheer vibrancy more or less structured by the Rational. The two affect one another, both when other ultimates are subordinated to them, and conversely. In the absence of the Dunamic-Rational, there would be no accounting for the interplays of intelligibly joined items, no explanation of how these affect one another, no recognition of the effectiveness of what is rational, and of course no recognition of the difference that both the Dunamis and the Rational make to anything. The Dunamis enables necessarily related items to be distanced from one another and to suffer unanticipatable divisions, beyond the power of a formalism to anticipate or understand. The Rational adds a fixity to what the Dunamis does. Since the two always operate together, both the deducible and the aberrational, the fixed and the elusive, are everywhere copresent.

Formalists make use of the Dunamis to enable them to focus on and make use of the Rational; the practical and productive make use of the Rational as a guide, control, and a test. A logical law is predominantly rational; an inference is predominantly dunamic. Were the two assumed to be radically opposed, there would be no guiding of inferences and no discoveries of logical laws. There is usually little point in attending to the one or the other when it has only a minimal role. Kept apart, they would be both rigidly and variably joined; joined, each makes its distinctive nature and power evident. A Nietzschean Dionysiac or Schopenhauerian will or a Bergsonian *élan vital* are never fully cut off from fixities. The two together are subject to other determinants, and these in turn are subject to the two of them. It is desirable to distinguish the Dunamis and the Rational from one another and from all other conditions, but the distinction will itself involve the use of both.

If 'chance' is identified with the Dunamis and set in contradistinction to the Rational, it will still affect and be affected by this. Indeed, all the ultimates are instantiated together and thereupon qualify one another. In each domain, the Dunamis and the Rational are subordinated to the other four ultimates, while being interinvolved with one another in an endless number of degrees for indefinite times. When we deal with any member of a domain as intelligible or as vibrant, we rarely identify the Rational and Dunamis that are present there, and will consequently be inclined to exaggerate the role that the Rational or the Dunamis actually has. The

exaggerations make it deceptively easy to treat all actualities, no matter what the domain, as though they were caught up in purely rational or dynamic wholes.

If, as Peirce seemed to hold, 'chance' is identifiable with mind, one should expect each mind to act solely in chance-like ways. There is no reason for believing that it does, any more than there is for believing that it acts solely in necessitated ways. The mind that is identifiable with 'chance', in any case, is not the mind of any man. Mental acts have characteristic natures and are worked through then and there within the compass of a person in whom the mind is but one dimension. Despite his generous acknowledgments of indebtedness, Dewey's views differ quite sharply from Peirce's on this and other crucial issues. Dewey's primary emphasis is on the idea that acts begin with what is primarily indeterminate and end as primarily determinate, without ever being exclusively the one or the other. Despite multiple references to Nature and an acceptance of a supposed scientific method, Dewey refers only to what is within his person or at most within the humanized world. It is not clear whether or not he thought that the components in a supposedly primary experience were dunamically qualified, or were items in a dunamic act in which indeterminates were converted into a final determinate outcome. He knew that the 'scientific method' makes use of no fixed set of moves, nor applies to what passively awaits adoption, but he did not seem to allow that the method is imposed on what is distinct from it, or that the method is both intelligibly and dunamically qualified from beginning to end. An intelligible and vitalizing use of what is intelligible and vitalized does not require that the latter be continuous with the former. What is prominent in their connection may be recessive in the connected, and often manifested in the resistance offered to what connects them.

The Dunamis is constrained by the Rational, and the Rational by the Dunamis. What occurs always has the two interinvolved. The fact is not always evident. I, in any case, have sometimes misconstrued it. Neither the Rational nor the Dunamis, or even both together, plays a primary role inside any domain. Rationalists and Vitalists are closet metaphysicians, primarily interested in what operates between or outside all domains, but keeping quiet about the fact. In the West, the role of the Dunamis is usually minimized and even precluded; it took the violence of a Nietzsche to make many moderns aware of it. In some of the speculations of the East, it is the Rational instead that is denigrated. Those who favor the one or the other agree on one point: all other ultimates are to be minimized or ignored. As a consequence, neither can account for what is distinctive about the occurrences in any particular domain—and therefore of themselves as persons or as humanized.

A universally operative, unchecked Dunamis is 'chance' run wild; a universally operative Rational is a rigidity no one can utilize. Where the most flexible of rationalists is inclined to take the Dunamis to be a confused version of the Rational, mystics are inclined to take the Rational to be a frozen version of the Dunamis. Their interpretations are matched by those who suppose that the Affiliator, Assessor, Voluminosity, or the Coordinator alone have essential roles, with the other ultimates, at best, taken to be odd variants of the one that is preferred.

It is sometimes said that philosophy is carried out in schools that are at war with one another, but since they rarely attend to one another or really know what those others maintain, the war is never really fought. Instead it is defined by each to be over, with the others no longer providing any opposition, apparently as a result of suicides inevitably produced by gorging themselves on errors. Wrong-headed theories and the failures of supposed alternatives do deserve to be exposed and eliminated, but little is gained if this is done by what has serious flaws of its own. A comprehensive view allows one to see the merits in the criticisms levelled by each. It does more justice to all the contenders than they do to one another, since it does acknowledge their merits when they are properly limited and thereupon dealt with as only partial, incomplete, not adequate.

The most devastating criticism to make of all limited philosophical views is that they are well-defined, all the while that they remain vague, slack, making assumptions backed by promissory notes. Such notes are worthless, since they do not tell us when or how they will be redeemed. If there is some discipline, some fact, some perplexity that cannot even in principle be dealt with in some account, this must be understood not only to be part of a larger whole but to be unable to do more than point up areas that may have been neglected or dealt with inadequately. Different schools are to be taken as places where important truths are protected, polished, and used, with their criticisms of others limited to noting what others minimize or neglect. In the end, the truths that each defends or hurls at all the others must be acknowledged and placed alongside one another. Better still, one should approach all from a single position which they presuppose, and understand what they severally maintain to be biased instantiations of more general and tenable truths. These can be known only if one refuses to be kept within arbitrarily prescribed bounds. A first big step is taken when the existence of a plurality of domains is acknowledged. A second is taken when the Dunamic-Rational's power to escape the limitations of every domain is recognized. The two allow for the knowledge that the cosmos is but one of a number of domains at which we can terminate, beginning at any other by carrying

out a structured process that is itself well understood.

The accidental, the fortuitious, the coincidental, and the unexpected express junctures of the Dunamis and the Rational, with the first unexpectedly in a dominant position. Chance, i.e., the Dunamis as dominating the Rational, is a large or small part of every occurrence, precluding the existence of the completely rigid, the invariable, and the monotonous. It varies in its degree of effectiveness at different places and at different times. Its presence may be safely ignored when the degree is minimal. There would be nothing amiss with a formalism or a vitalism, did they not identify a minimal variability with its nonexistence or suppose that other ultimates play no role whatsoever in cosmic bodies.

Randomness refers to an opportunity for distributions to conform to the laws of probability 'in the long run.' It is not to be identified either with chance or the Dunamis, since it does no more than mark the fact that nothing is done to affect the ways in which distinct occurrences follow one another. That does not mean that all pertinent possibilities will be realized. There is nothing amiss in a good coin, thrown at random, coming down heads every time. All that one can justifiably affirm is that if a coin is perfect, if there are no undue influences, and if the run is not brought to an arbitrary close, one series of throws is as probable as another. Even the rejection of the presence of the Dunamis will not justify one in holding that a randomized throwing of a tested, balanced coin will ever exhibit an even number of heads and tails. There is no particular time at which an equal distribution of heads and tails has to occur. Indeed, there is nothing amiss if only heads come up, for an endless sequence of heads is no less probable than any other endless sequence. There are many conceivable sequences in which there are an even number of heads and tails, but no one of these sequences is more or less likely than another in which there are only heads, only tails, only ten heads followed by one tail, and so on.

'Chance', as used by Peirce, if identified with the Dunamis as separated from the Rational, could be supposed to have alone occurred at some remote time. Its imagined separation from the Rational requires the break-up of a fluctuating interinvolvement of the two. The idea enables one to point up the limitations of a purely formal account, by pointing up the presence of what is not structured. Even when it is supplemented by the Rational, the Dunamis will fall short of accounting for what is predominantly coordinated—or affiliated, assessed, or spanned. Were it identified with 'chance', it would not only have no formalizable, stable structure, but would be present in each domain, in the relations between them, and in the process of evidencing all the ultimates. In no domains, and

therefore also not in the cosmos, could it ever be more than a minor factor.

Were 'chance' used to express the operative presence of the Dunamis, it should be said to play some role in every domain. Always joined to the Rational and, with it, both qualified by and qualifying the other ultimates everywhere, it has been frequently recognized to be operative in the humanized world, though usually as though it were just an inexplicable source of what is unexpected, coincidental, inchoate, inexpressible, or ominous. Sometimes it is taken to be manifested in insight, impulse, and the sudden. To understand its contribution to what occurs in the cosmos, it must be recognized to be subject to the Coordinator that is dominant there. Since in each domain, the Dunamis is differently qualified, there could be no 'chance' that was operative in the same way in every domain.

Personalized accounts of what occurs abstract from variations due to the Dunamis in the occurrence, as well as from it as present in what is affirmed. The neglect of its role in cosmic bodies, as well as in their interplay, is perhaps what has led to the supposition that well-formulated theories about the cosmos are more reliable than those bearing on what occurs in other domains. It may also account for the shock produced when quantum theory was first presented.

Coincidents, inexplicable occurrences, so readily dismissed as due to 'chance', may sometimes be understood to be the inevitable outcome of a crossing that requires for its understanding a knowledge of the intersecting courses. There is no 'chance' involved in my meeting a friend at a time and place agreed upon; if I meet him unexpectedly, a reference to our 'chance' meeting restates the fact that I did not expect to meet him then and there. Still, there will be a chance-like dunamic component in our several acts, and in the meeting as well, even if we did precisely what we said we would and not at such and such a place and at such and such a time.

When the Rational and the Universal are identified, and actualities are treated as punctuation points, deviations from what is supposedly necessitated are readily attributed to faulty recordings. In effect, the Dunamis will have been excluded, and actualities taken to be no more than loci of a plurality of rational connections. Joined to the Dunamis, the Rational helps make evident that there is nothing entirely fluid or fixed. There is some degree of randomness and order in all occurrences. Since neither the Rational nor the Dunamis is dominant in any domain, the most that an account of them as in the cosmos could do would be to note the qualifications to which they are primarily subject, as well as those they themselves introduce. Since nothing could occur in a domain where the

Dunamis has no role, and nothing would be intelligible were the Rational absent, the two must be recognized to have some roles in every domain and every act.

Although cosmic bodies existed before there was anyone who could know them, and although no one of us exists there, we can know how members of the cosmos are constituted and related by identifying what, like the Rational and the Dunamis, are recessive in the other domains and that, unlike those, could be definitory of what is in just one domain. It is not easy to know just what this is. I could be mistaken in taking it to be the Coordinator. If I am, the Coordinator is not a subordinated ultimate in the other domains, or it does not have a dominant role in the cosmos. If the first, I would have no warrant for supposing that it was dominant in the cosmos; if the second, no warrant for saying that it was recessive in other domains or that what was so recessive always has a dominant role elsewhere. The Rational and the Dunamis, which are dominant in all passages between domains and in all evidencings, are recessive in all; the Coordinator is dominant in one domain and recessive in all the others.

3. The Known and Knowable Cosmos

We can know what is in the cosmos in no less than four ways:

1. We can note the differences that cosmic units make in the bodies of actualities in which they are contained. Bodies would fall at the same rate in a vacuum, or were they no more than aggregates of unit bodies, provided of course that the bodies in which they are contained made no difference to them. When we run, we help determine where the bodies contained within the one we use will be. The latter is no summation of what a number of contained unit bodies do. It does not idly overlay an aggregate of unit, cosmic bodies. Indeed, as will become evident, it is because the bodies I contain are subject to my single body that it is correct to say that the weight I have when thin or fat can be expressed as an aggregate of equal, unit bodies.

2. A knowledge of cosmic bodies requires an understanding of the differences these make to the bodies that encompass them. The striking of a blow may be backed and directed by a desire, intent, fear, or anger; for the act to be carried out, muscles, tendons, blood, and other bodily composites must be brought into play as more than combinations of units. That 2 is an even number cannot be known by knowing that 1 is an odd number and that it could be added to another 1. Even when a man falls in his sleep, unknown to anyone, the unit bodies in him will move in a direction they did not prescribe.

3. Unlike a philosophic atomism, a scientific one takes a sure and

steady knowledge of unit bodies to be an objective that is to be eventually achieved. Today, it takes 'atom' to refer to what is a quite complex body, encompassing a number of others different from it in nature and act. What it now accepts as the smallest known units may eventually be understood to be aggregations of still smaller ones, or more likely, to be linked sets of them. Whatever it be that may finally be said about unit cosmic bodies, they are primarily subject to the Coordinator, in somewhat the way in which living humanized bodies are subject to an ultimate Affiliator, and natural bodies are subject to an ultimate Voluminosity.

Because the Dunamis is always present in every connection between actual entities, the equality sign that is used to express the fact that there are the same number of units within a number of different larger bodies should be replaced by oppositely directed arrows. Whatever is terminated at will be more or less affected by that with which one begins and, conversely, that with which one begins will be more or less affected by on that at which one terminates.

4. Even if we knew the natures of cosmic units as well as aggregations of them, it would still be necessary to recognize that there are other kinds of actualities in other domains. At the very least, we would have to take some account of what was in the humanized world, since it is there that we use a common language, communicate with one another, and experiment. Some account, too, must be taken of ourselves as persons, for it is as persons that we decide, plan, know, assume responsibilities, and commit ourselves.

We come to know what is in the cosmos because while outside it, we are enabled to terminate at what more or less accommodates what infringes on it. The passage is made possible by the Dunamic-Rational as a mediator, charged with our insistence and expressed in an adumbration which takes us beyond the appearance we would otherwise end at. In the last section of this chapter, account will be taken of the brute claim that it is not possible for men to enter into nature or the cosmos. What will remain constant is the fact that if transformations occurred only in a mind, we could never get further than to have an idea of what an outcome might be. To arrive at what exists apart from us, the gap between the beginning and end must be bridged by what more or less accepts what we make available, and is more or less accommodated by that at which it ends. The bridging will need a grounding at two ends, one of which will provide it with a beginning and the other of which will provide it with an end. The termini of transitions all require sustainings. Usually we are prompted to move from a position because we encounter a resistance or feel an emptiness and, making use of what could take one from there, we move to what provided the resistance or could fill out the emptiness. If the

transition occurred in a circle, the beginning begun at will be the same point as the end. Though that point has no size, it will still be distinguishable as that at which one had begun and as that at which one ended.

The unit bodies, which one might have initially acknowledged to be in humanized beings, could not be used as beginnings for a move to the cosmos unless those beings could be freed from whatever qualifications the encompassing body had imposed on them. If the body that had accepted them as components of a single state could transform them into an aggregate existing in the cosmos, it could be said to terminate at the cosmos, where what is ended with was accommodated by cosmic unit bodies. One could then be properly said to have arrived at, but would still not yet have entered into, what is in the cosmos.

Confirmable theories about cosmic units are more than suppositions entertained by individual persons or by members of the humanized world. Such suppositions could never do more than terminate at what may accept or reject them. Although it is possible to imagine or to believe that there is a cosmos, there is no knowing that there is one, or any arriving at anything in it, unless this more or less accommodated or rejected what terminated at it. So far as we stress the rational component of a transformative passage from one domain to another, we can do no more than think about what might be there. If it is the Dunamis that is stressed, we will be able to arrive at what is there but will so far not understand it.

To know what is in the cosmos, we must overcome the qualifications to which unit bodies are subject when they are part of humanized bodies. That knowledge can be acquired by anyone, not only by those who carry out scientific investigations. Scientific accounts of the cosmos express, in intelligible ways, what a limited number of humans infer from experiences with the large and the little in the humanized world. It is never enough for them or anyone else to have what they have in mind matched by outcomes. Cheating may enable one to end at a desirable outcome, but one will not then satisfy the requirement that the result be both what is predicted and in fact reachable by the members of a community of disciplined inquirers. Building on what had been found to be acceptable in the past, and ready to reject any part of it that does not comport with what else is known, as well as with what is to be finally concluded, the result would still be no more than a human product did it not terminate at what is able to accept or reject it on its own terms. If the passage from what we had in mind to what we terminate at is charged with a concern, we will not stop at what we terminate at, but will press beyond this in an adumbrative or discerning move. We do not, though, seem able to do this when we arrive at cosmic beings. No one knows how to deal with them,

unless only in depth, as able to accomodate or reject our insistence on penetrating beyond the point where a mediator terminates.

Scientific accounts today have not yet faced the truth that the Dunamis adds an effective indeterminacy to what is rational. The neglect is due in good part to the fact that the scientific community is not fully aware that a set of equations cannot do justice to what occurs, since it abstracts from the dominant role of the Coordinator, as well as from the less insistent qualifications that are due to the other ultimates. The scientific community is not mainly concerned with solving problems within the embrace of a commitment to arrive at a final, settled truth, but instead tries to obtain the best possible answer that it can at one time. Whatever the answer, it has to be transformed if we are to know what happens in another domain. Other conditions there replace those that are definitory of what occurs in the cosmos.

It is possible to observe much by using only the unaided eye. In order to observe the very minute, what is of great magnitude, or what is at a great distance, special instruments are needed. These make available much that would otherwise not be noted. They also set limits to what could be observed. New discoveries are made within the range that the instruments make available, theory guides the construction of the instruments, and these in turn make possible what could be observed by those who are well-trained to look for them. Those who are not properly prepared do not often look through a microscope or telescope; when they do, they rarely see what trained observers can.

In theory, if not in fact, unit bodies can be separated out from the larger bodies in which they play a role, limiting and being limited by that in which they are contained. No one has yet reached the point where this can be done cleanly and completely. A number of members of the scientific community apparently have dedicated themselves to getting it done. No defeats will persuade them that the venture is foolish; their work is sustained by the conviction that, at the very least, some large errors and grave misconceptions in their own and other views will be discovered and overcome. There is no reason to agree with Peirce that the scientific community will some day arrive at a final answer to all its major questions. The prospect of having such an answer may, of course, encourage and inspire. But better and better is not good enough, though it is of course to be preferred to a replacement of one imagined cosmology by another, even if the other seems to be more plausible or is more congenial. Good theories are guides, pointing to what is to be investigated; they are not necessarily pointed toward a final answer. The members of the scientific community know this, while often and for long periods they remain

content to work within the frame of some theory that, at the time, is accepted by most.

There is a place for a philosophic cosmology in which principles with a universal application are shown to have specialized meanings in the cosmos. Such a cosmology might be acceptable to the scientists of the day, and could be used to express in qualified form what holds in other domains. But the cosmos should not be treated as though it were the only, the most basic, or the model for dealing with what is in other domains. The others are no more faint or blurred versions of it than it is of them. Nor is a supposedly distinctive scientific method any more appropriate for dealing with humanized objects or persons than studies of these are appropriate for dealing with what occurs in nature or the cosmos.

Theories are formulated by persons, and experiments are carried out in the humanized world. There they provide beginnings for Dunamic-Rational moves that terminate at what presumably will be primarily subject to the Coordinator. Whatever the beginning and end, there will be distinctive preconditions singularly appropriate to each, and common presuppositions that can be known only by escaping from the limitations to which the members of a domain are subject. The escape, as will become more and more evident, takes one beyond the members of domains to their preconditions, or to what is expressed through these. The one leads to a study of the ultimates and the Being that is their source; the other leads to individuals, complexes, and singulars, as expressing themselves in and through what confines them. The methods appropriate to what occurs in a domain are not appropriate to either.

Competing philosophies are mainly occupied with some limited truth or approach, and in denying or ignoring those of interest to others. They rightly point up the limitations of their competitors, but wrongly suppose that they do not themselves have similar limitations, perhaps no less serious than those they rightly note as present in the others. A philosophy developed in a true philosophic spirit competes with none of them, contenting itself with making evident what is always presupposed, and exposing the limits within which the partial views of the competing schools operate. Sometimes, with their help, it notes what they neglect or distort. Because it approaches issues from a more comprehensive position, it can find limited places for all of them. The work of finite beings, it is surely flawed; its flaws will be sought for, not hidden or ignored, and corrections, details, and qualifications welcomed. Those anxious to imitate the practices of the scientific community should not carry its distinctive procedures, suppositions, and conclusions into philosophy, but instead should treat a comprehensive account as a paradigmatic comprehensive view that is offered, not to a community of current

thinkers, but to anyone concerned with knowing what holds always, and in explaining why what need not have been, is in fact. Instead of shunning criticism, it would invite and encourage it, since what it seeks is a truth that lies behind all other truths—and errors as well.

No philosophic study, honestly and thoughtfully carried out, is just plain false, but none is adequate if it can see no merit in any other, for these surely do take account of what is important, no matter how this is then exaggerated and defended. Just what strengths and weaknesses characterize each of them is only partly revealed in the most careful study of its affirmations and rejections. One must see each from a position in which it is well placed in relation to the others; that, though, will presuppose that one had already arrived at a position where the opposing claims and denials can be dealt with from a position outside all of them.

Today, major opposing philosophies allow for nothing but what is in persons, the humanized world, or an imagined cosmos. An earlier religious emphasis on the primacy of the person, and a later emphasis on nature, have been rejected today for little more than cultural reasons. More justice can be done to all by attending to them in the same spirit that one exhibits when independently trying to understand a comprehensive, diversified whole whose nature and contents are not antecedently prescribed.

The Rational and the Dunamis are as irreducible as any other ultimates. They are not nobler or more powerful than any of the others. Both are subject to the other ultimates in every domain. When the two are dominant, they, like the others, confine what insists on itself in and through them.

What occurs in the cosmos can help one obtain a knowledge of what holds in other domains, and conversely. This can be done in a number of ways, depending in good part on the degree that the Rational or the Dunamis play a major role in the combination, and on the effect the result has on the other ultimates. There could be many differences among those who accept the same initial data and proceed with the same care, particularly since they will not all usually attend to what they presuppose or have a good understanding of their distinctive objectives. Too often, the presence or effectiveness of subordinated conditions and contained realities will be neglected. Sometimes they will be minimized or exaggerated. We fall primarily as aggregates of unit bodies; we run primarily as living bodies. At both times, recessive factors and subordinated parts make a difference. The striking of a blow may be backed and directed by desire, intent, fear, or anger, and a good understanding of how it was carried out will show how muscles, tendons, blood, and other complex bodily parts functioned. Within these there are other bodies that had natural or cosmic

origins. Over the centuries, we have come to know more and more about such contained bodies, leading some to think that there will come a time when collections of the smallest alone will need to be acknowledged. They say nothing about how these could be known, how they could be related in other than aggregatinal ways, or who could know them.

For the time being, but conceivably always, we must be content to say that, whatever the nature of cosmic units, they are constituted by all the ultimates in a distinctive order, they are primarily subject to the Coordinator, are present in, qualify, and are qualified by what contains them, and severally and together they are all contingent existents, they need not have been. We can, of course, imagine a cosmos in which there are no unit bodies, or in which these are not coordinated. We can also imagine a nature in which horses ate cats, a humanized world in which there were no families, friends, or traditions, as well as a domain of persons who never formed habits, never had beliefs, and never possessed or used their bodies. The conceived versions are limited only by our ingenuity. Even if every item were an adventitious juncture of 'accidents,' features that need not have been, they would still provide occasions for all the ultimates to be instantiated.

What the present domains contain are not possibilities that happen to be realized; they are possessed unities of instantiations of all the ultimates. A coming together of possibilities could leave these unrealized, empty combinations of empty 'maybe's' that were as airy as their components. Were there only a cosmos, its members would all presuppose ultimates that were jointly instantiated and possessed by whatever those instantiated ultimates confined. Like those of the cosmos, the members of other domains have integrities of their own; they, too, are confined by and possess instantiations of all the ultimates.

The existence of a plurality of domains, with their distinctive members, depends on the instantiation of differently ordered ultimates. Those ultimates continue to be apart from all their instantiations. The fact raises a question that must eventually be faced: why should they ever be instantiated? Since there is no necessity that there be a cosmos or any other domain, the question points up the fact that there not only are contingent existences in each domain, but that the acts of the ultimates are also contingent. Since the ultimates could conceivably have been fewer or greater in number, their number as well as their acts will have to be accounted for. Evidently, we must eventually come to acknowledge that which is necessary in and of itself, which necessarily produces what might have been other than it is and need not act as it does. The issue is best faced once we have learned that all the ultimates are instantiated in every domain, that there are a number of ways in which these could be

connected, and that what is confined by them has a power to resist and to express itself in and through them. We now know that there are no less than two domains, because we know that we are not only persons but humanized beings as well. Since what connects a person and a humanized being is different from both, we know that there can be no less than three distinct sets of ultimates. In one the Assessor, in the second the Affiliator, and in the third the Dunamic-Rational has a dominant role. We initially come to a recognition of two more—Voluminosity and the Coordinator—by first taking account of the contributions of natural and cosmic beings to living human bodies as primarily subject to the Affiliator.

The cosmos, with its unit bodies, could and presumably did exist before there were any other domains with their differently constituted members. In their absence, it would still be true that the ultimates that are instantiated in the cosmos could be ordered in a different way. In the absence of all other domains, the cosmos would still be but one domain among a plurality of possible others. Even if it were necessitated, it would be that which could be supplemented by others that need not be. It could not be necessitated, though, in any other sense than being the outcome of the contingent instantiation of all the ultimates in an order in which the Coordinator had a dominant role.

References have already been made to the possessors of the instantiated ultimates in each domain. Persons, humanized beings, spanned natural objects, and cosmic units all have instantiated and confining ultimates joined to insistent possessors that express themselves in and through those ultimates. These possessors and what they possess are owned by what express themselves in and through them. These owners are individuals, though just what these are and how they function is still a matter of controversy. And it always will be, until it can be shown how an individual differs from a person, a humanized body, and a living body in which these two are merged. In the next section, the individual will be shown to be one of the major subdivisions of the Habitat, that which owns and expresses itself in and through the Dunamic-Rational, thereby making possible a passage from one domain to another.

The cosmos, with its unit bodies, could and presumably did exist before there were any other domains. The fact that the ultimates instantiated there could have been ordered differently, or might confine and could be possessed and used differently, not only makes evident that the cosmos, even in the absence of all other domains, is but one among a plurality of possible others, but also that it could not be the 'best of all possible worlds'. A Leibnizian would claim that there was a God who realized one universe in which all possibilities were realized, but since the chosen world realized all possibilities, there really was no plurality of

worlds among which this God could have chosen it. Since worlds alternative to the chosen one could be no more than parts of it, 'the best of all possible worlds' could be the only world, within which all others could be no more than subsections. They could be said to be possible only in the sense that they could be conceivably distinguished as parts of it, while it could not be a possible world since it is not one among them.

A possible cosmos or set of domains other than the one there now is could not be better or worse than what now is except in terms of an ideal Good outside all of them, by of which they could be severally and jointly measured. We could, though, use the Assessor that is dominant in each of our persons to judge what is in every domain as better or worse on the basis of an ideal good, defined as the common terminus of all the ultimates together, to be realized in each domain in a distinctive way. The different domains could then be credited with an involvement in a common good whose realization would maximally enhance the members of each domain by themselves and in relation to one another. But not until we knew what each domain would be at its best, and what was the best possible relation it could have with every other, would we be in a position to do this.

The domains that now are might not have been. There might not have been any; others might have existed instead. Whatever actualities exist, like the components that constitute them, exist contingently. No instantiations of the ultimates need have occurred. No philosophy is complete until it has shown why they did and do. The demand is not to be identified with asking why there is something rather than nothing, since the latter could end simply with the acknowledgment of what necessarily is, but the former asks why, even if there were such a necessary Being, are there others that exist contingently. That question will be faced, but what is now to be emphasized is that none of the ultimates might be instantiated, and therefore that there might be no actualities, individuals, complexes, or singulars.

The unit bodies in the cosmos could conceivably have different magnitudes and still continue to be coordinate. No set of formally operating 'or's' or 'and's' could express how they differed, since their differences depend on the way the Coordinator subordinates and is affected by the other ultimates that are then also instantiated. There is as yet no established language enabling us to express what all the members of a domain are, as both separate and together. So far as we are concerned with expressing our claims in formulae, many of which are provided by mathematicians pursuing their own agenda, we can do little more than thin out some borrowings and fatten others, after they have been detached from their formal settings.

The classical philosophical atomists had a good understanding of the

coordinate status of their unit atoms. They spoiled their accounts, however, by supposing that those bodies were separated by 'nothing,' for that implied that the atoms melded into a single global atom. They also failed to recognize that a number of instantiated ultimates were subordinated constituents in each atom. The supposition and omission left these daring thinkers with no way to account for their own existence, or for the natural and humanized beings in which the atoms also exist. The atomists themselves not only had bodies that allowed a place for the atoms, but they thought about and spoke about the atoms. Their practice of exempting themselves and their views from inclusion in their supposed all-encompassing atomism is today imitated by Heideggerians, existentialists, deconstructionists, and pragmatists in their wholesale rejections of other views. A sound philosophy must, at the very least, allow for a person who can affirm it, for those who do not accept it, for a means by which it can be referred to what is beyond affirmation or rejection, and for what could accommodate or reject the reference. It is hard to find many views that even try to meet these conditions.

Alike in being constituted by the same ultimates in the same order of dominance, each unit body in the cosmos varies in its degree of involvement with all the ultimates. The members of a domain and therefore unit cosmic bodies as well may be more or less alike, on the average, by and large. Similar observations are to be made about the relations of those units to one another. In the end, even the most detailed, specialized, cosmological account will end with what is somewhat like a statistical report, smoothed out and generalized. What is true of it is also true of accounts of what occurs in other domains. The fact needs to be emphasized in order to counter the widespread assumption that the units and relations in any domain are open to fixed and precise formulations. Did one look to statistics to provide the appropriate way for dealing with a variety of occurrences, still one would presuppose the existence and activity of single realities.

It is with what is essential that a philosophy is concerned; it is not primarily occupied with knowing what is to be expected to occur, but with the essential natures of the realities involved, and what these presuppose. Its words, like its thoughts, will fall short of that to which they are referred. If we are to arrive at what exists, we must do more than speak or think. If we could, as we do with humans and humanized beings, at least move adumbratively from what we terminate at, we could make some contact with whatever sets of instantiated ultimates confine and what in turn own them. I don't think we can, but it is surely not impossible.

It has already been noted that there are persons, humanized beings, spanned occurrences in domains other than the cosmos, and that these

possess confining instantiated ultimates. What is still to be understood is what it is that owns and might use a member of a domain. Even a cosmic body possesses the ultimates that confine it and it is in turn owned by a singular being outside the cosmos or any other domain. The members of domains are realities, with their own instantiated ultimates and possessive, confined beings into which it is possible to move adumbratively to some extent. The result is owned by what exists outside all domains.

Our persons are real; so are our organic and living bodies. Both are the outcome of confinements by ultimates and ownership by individuals. So is their merger outside adjacent domains. What is true of individuals is true, too, of the complexes that own what is in nature and the humanized world, and of the singulars that own what is in nature.

It is tempting to identify individuals with persons or humanized bodies, complexes with humanized bodies or natural beings, and singulars with natural bodies or cosmic units, for they all have an obduracy and an integrity, and seem able to account for whatever is known. But we also know that we can adumbratively move beyond what we confront, and that the deeper we get into a reality, the more evident it is that it is an individual. It is the recognition of the individual's possessive ownership of the person that usually alerts us to the fact that we are never just persons or just bodies, but realities that, while allowing those to act in characteristic ways, continue to own them. Since what is true of us is true of other beings, the most detailed and complete knowledge we are able to obtain about what is in nature or the cosmos will leave us faced with insistences originating with what is outside every domain.

It is a person who thinks, believes, or fears. These are acts charged with assessments. All the while, an individual will be expressed through that person, an individual who is able to express himself in a constant way even while the person shifts in interest, stress, and act. We have no such ready access to the complexes and singulars that possess and express themselves through actualities in other domains, but what we know about human individuals should alert us to the presence and activities of those individuals and the Habitat in which they are subdivisions.

Once the existence of individuals, complexes, and singulars is noted, it becomes possible to recognize that there are actualities that exist between as well as in domains. I am an individual who not only owns and expresses himself through his person and his humanized organism, but also through my living body that is a merger of the person and the organism. I feel pains and soothings in my living body. That body is also a body among others in the humanized world, able to be helped and hurt there. Were my living body not owned by me as an individual, it would either exist apart from the other two, or not exist at all. Instead, it most unambiguously enables

me to express myself as an individual, apart from other persons or humanized beings. Related observations are pertinent to complexes and singulars.

An individual impresses himself on and through his person, the humanized body, and the living body. The first is the locus of feelings of pain and pleasure; the second is in the humanized world. I would be divided in two were it not that both are owned by me, at the same time that I own the two of them as merged and jointly constituting a living body. It is because all three are possessed by the same human individual that it would not be amiss to say that there is one living body having roles in two other distinct domains. Related observations apply to other kinds of humans but then more surely than ever we should never be content to speak of the members of domains as though they were the most basic realities.

A refusal to acknowledge individuals will leave one with a plurality of domains, but no connections between them. Those individuals own and express themselves through adjacent domains and in mergers of what is in these. If we are to be able to pass from one domain to any other, though, a reality as basic as individuals, but never expressed in and through some domain, will have to be acknowledged. This is the Habitat; it enables the Dunamic-Rational to relate what is in any domain to what is in any other.

4. The Habitat

Because the Dunamis and the Rational alone are recessive in the members of all domains, they alone can be the primary factors in every transition from one domain to any other. The fact is most evident when we begin with an idea, intent, hope, or desire and seek to end at what more or less accommodates it in some other domain, existing independently of it and us. Its neglect has left epistemologists entertaining ideas, hypotheses, theories, and then ingenuously adding various suppositions to these as though these new personally produced items could get them out of their enclosures. If we begin with what is in our persons and seek to arrive at what exists apart from them, we must take account of what can enable us to pass to and be more or less accommodated by what exists apart from them. Because they exist apart from us, we must depend on something other than us or them to enable what we have in mind to be made available for acceptance or rejection by it. Only the Dunamic-Rational is sufficiently free from the limitations to which particular entities are subject to be able to do this. It could not be instantiated, and therefore available, though, were it not countered by what had an equally wide range.

The Dunamic-Rational is recessive in the members of every domain,

and is dominant in the relation connecting the members of any domain with any other, because and so far as it confines and is owned by what is relevant to it alone. This is the Habitat; its major subdivisions are individuals, complexes, and singulars, each the possessor of what exists in separate domains, adjacent domains, and in which the contributions from adjacent domains are merged.

The Habitat and its subdivisions are not something postulated, imagined, things in themselves any more than they are receptacles or passive matters, an incomprehensible ongoing, or an inexplicable support. Although it is not easy to focus on or to characterize, aspects of the Habitat have caught the attention of those who recognize that what is in the humanized world is owned by a more basic reality.

Both Nietzsche and some of the more daring scientific views about the way a dynamism might be interlocked with a pure intelligibility have made many alert to the fact that the Rational and the Dunamis jointly escape all confinement within domains. Unfortunately, insufficient attention is paid to the fact that the pair, like all other instantiated ultimates, need a backing, and then by what exists outside all domains. A great advance is made when the Rational and the Dunamis are recognized to have a dominant role that is not restricted to any domain, but one will stop too soon if is not also realized that the Dunamic-Rational, like all other instantiated ultimates needs what can own and express itself through the Dunamic-Rational as a single instantiated ultimate.

Each of us is a person in a distinctive domain. Each of us also has an organism in the humanized world. Each, too, owns a living body which exists between these adjacent domains. That living body is different from both the organism and the person. None of us is divided in two; we are living bodies, at once personalized and subject to qualifications by members of the humanized world. Nor are we divided into three parts, for the three are owned by a subdivision of the Habitat, an individual. We are able to discern this to some extent when we move intensively, not from the body as personalized or as humanized, but from it as lived between the two.

To know that a body is hurt, one must attend to it as an organism. To know who is in pain, it is necessary to refer to a person distinct from that body. To know that there is someone who is at once pained and hurt, it is necessary to attend to a body that is at once personalized and organic, a living body existing between the two. There would be three distinct bodies, were it not that all are owned by an individual who continues to hold on to the other two when emphasizing an expression in and through the living organism. Similar observations are to be made about natural and cosmic beings, complexes and singulars. Each owns and is expressed in

and through what is in adjacent domains, as well as in and through what has these merged.

Individuals are subdivisions of the Habitat. They both own and express themselves through what is in adjacent domains, as well as in what is between them. Some individuals only incidentally express themselves through what merges contributions from adjacent domains, wobbling back and forth between them. They are in constant tension, never able to be full individuals. Singulars, in contrast with both individuals and complexes, can do little more than define the points where contributions from unit bodies as in nature and as in the cosmos are balanced.

Individuals can lose their distinctiveness and no longer be able to express themselves in and through what is in adjacent domains or in what exists between them. The Habitat would nevertheless continue, since its confinement by and ownership of the Dunamic-Rational would not be affected. What is in separate domains would then have no other connection but that provided by the Dunamic-Rational. Since this could not be instantiated unless interinvolved with the Habitat, this too would continue to be. The Dunamic-Rational, of course, no more than the other ultimates needs to be instantiated. Since there is no Habitat that is not confined or that owns nothing, this too need not have been. It now is; it could cease to be.

No ultimates need ever be instantiated, there need never have been and there might not be anything possessed or owned. That would leave over the ultimates as able to be instantiated, as well as what the ultimates presuppose. Sooner or later one would be faced with the questions, why are there members of domains, why is there a Habitat and its subdivisions? That issue must and will be faced, but it needs, for its full mastery, a knowledge of the Dunamic-Rational as having a dominant role over all the other ultimates. This it has, at two times—when it confines and is owned by the Habitat, and when operative in a process of evidencing the ultimates that are instantiated in every actuality. We will not be in a position to deal satisfactorily with the issue until we attend to the fact that the Dunamic-Rational confines and is owned by the Habitat, while dominating over all the other ultimates.

Individuals, complexes, and singulars, like the Habitat in which they are, are not subject to the corrosive influence of time and causation. They nevertheless can come and go because the Dunamic-Rational can but need not be instantiated. If it is not, however, no other ultimates could ever achieve a dominant position over it.

The living body in which a person and a humanized body are merged is a body that is pained by an injury and satisfied by what other bodies provide. Conceivably, there could be a body to which members from

three or more domains could have contributed. Whatever occurs between domains awaits the existence of actualities in separate domains, and a merging of their contributions. The merging exhibits a contraction of the Dunamic-Rational at some position, all the while that the Dunamic-Rational continues to range over all domains. Since it is recessive in each domain, the Dunamic-Rational, while acting independently of what is in any domain, will not be completely alien to that over which it ranges.

A living body vanishes with the cessation of an individual, all the while that the person and the living body may continue to exist in their respective domains and depend on the Dunamic-Rational to join them. A person could exist and could affect the body; the body could exist and could affect the person. There may be nothing in between the two but an instantiated Dunamic-Rational, owned by the Habitat. Instead of a living body, there would then just be a Dunamic-Rational connection between actualities in distinct domains. There would be a personalizing of a body related to an organism, but no living body between the two that was individually owned. There could be a burnt finger and a searing pain, but there would be no individually owned, painful, burnt finger.

When the Dunamic-Rational is emphasized by an individual, what is in a domain continues to be primarily subject to some other ultimate. A person is always primarily subject to the Assessor, with the fact more or less hidden when its possession by the individual is focussed on. When the possessive ownership by the individual is stressed, the Assessor dominant in a person is hidden behind what is both Dunamic and Rational. The very opposite therefore of what is contended by both the 'Apollonian' and the 'Dionysiac' must be affirmed: instead of replacing what is assessive, affiliated, extensionalized, or coordinated, the Dunamic-Rational never does more than overlay them, and then only when dealt with from the position of the Habitat.

No one is just a person, a person expressing itself in and through a living body, or a person affected by what occurs in this. Each of us is also humanized, with a body affiliated with other humanized bodies. In all, humanizations play smaller, larger, or just different roles from those we personally introduce. No one of us is two or three distinct beings, nor even two interacting ones. Each of us individually owns his person, organism, and living body, and a living body in which contributions from the other two are joined. The last is not only able to mediate the others, but itself is a limited concretionalization of the Dunamis and the Rational. Though it exists only when and as its constituents exist in adjacent domains, it is to it that reference has to be made to find the roots of the language that is personally used in one way and utilized in another in a part of the humanized world.

Were one content to pass from his person to his humanized body, or conversely, view the body as existing between them, there would be no need to take account of just the Dunamis and the Rational to enable one to pass from what is in the person to what is in some organism. The living body carries out the task extremely well. The so-called mind-body problem, where 'mind' stands for the person or a subdivision of this, is a problem only for those who have forgotten that they in fact quickly solve it from the side of the person when they are emotional, quickly solve it from the side of the organism when they use its channels and accept its guidance, and solve it splendidly by owning and acting in and through the living body. I not only think, but can act thoughtfully; I not only speak, but can mean what I say; I not only express myself in and through a living body, but own it, a body that is more than that in and through which I express my person, and more than that which is in the humanized world.

Individuals, and the Habitat in which they are, are never themselves encountered. We become aware of them as expressed in and through what we encounter. It gives this an insistence and opens a depth into which we can penetrate more or less. When we encounter bodies in the humanized world, we may also become aware of individuals as there insisting on themselves from a position inside the Habitat. It is easy to confound individuals with persons, with single bodies or coordinated ones. No matter how accurate and complete our knowledge of what is in a domain or between domains, it will be incomplete if no account is taken of the individuals that express their ownership of them in insistent acts. When we make use of the Dunamic-Rational to terminate at what is in nature, the humanized world, or the cosmos, we are faced with what we expect will accommodate what terminates at them, on terms set by what these are in depth in the Habitat.

All appearances, however known, are appearances of what occurs in some domain or in mergers of what is in adjacent domains. All of them allow for adumbrative, and sometimes discerning, moves into what is encountered. If we have 'insight', we move toward the individuals in the Habitat. Since we do not directly attend to anything in nature or the cosmos, our insights into what is expressed in them will be inescapable parts of our passages into nature and the cosmos. There they terminate at what is more or less acceptive of them in the Habitat.

When the reality of the members of the different domains is recognized to involve all the ultimates as both instantiated in and confining what posseses them in a particular domain, account must be taken of the Habitat. No reference, though, will have to be made to individuals of the Habitat in which these are. What is in a domain depends on the instantiation of all the ultimates, with the Dunamis and the Rational always

in recessive position. What is in no domain is sustained by the Habitat. There is no domain, not even the cosmos, except when the Habitat is confined by and owns the instantiated Dunamic-Rational. Otherwise, there could be no other domain than the cosmos. When and as the cosmos exists, the Habitat must, thereby making it possible for there to be individual owners of cosmic bodies as well as of natural ones and what exists between the two. No account of the cosmos, no matter how exhaustive, could tell us of the singulars that own there, of what is in an adjacent domain, and of what is constituted by contributions from each. The last, like the actualities that are between natural and humanized bodies, and like those that are between persons and humanized bodies, are directly owned by subdivisions of the Habitat.

Subhuman individuals own bodies that are both in the humanized world and in nature, as well as what is between them, or they own and possess what is in nature and what is in the cosmos, as well as what is between these. As between adjacent domains, the bodies are evidently bodily limited forms of the Dunamic-Rational but, unlike this, are not able to relate either of the adjacent actualities to what is in some other domain. We have the most direct access to a subdivision of the Habitat when we move toward it from the position of the living body that is between the members of adjacent domains. In the absence of ownership, one would be left with a merely imagined reality that was neutrally between the members of adjacent domains and that, unlike them, was owned by no one.

Formalists, with their uninstantiated ideas, and Taoists, with their unexpressible all-absorptive reality, need one another. So do materialists with their unintelligible realities and contextualists with their relations that have nothing to terminate at. The Rational cherished by the first is interinvolved with the Dunamis acknowledged by the second, while the units of the third and fourth need the interinvolvements and the units acknowledged by each other. Detached from its correlative, each is incomplete. If the exclusiveness of these views could be overcome and their excesses eliminated, we could approximate the position where the ultimates were both jointly instantiated in multiple ways and confined what could use them. The result would be one not only able to penetrate beyond the instantiated ultimates to what they confine, but to subdivisions in the Habitat that own what is in domains, and also what is between adjacent ones. No individual is compelled to express itself in only one domain.

Because the Platonic Receptacle and the Aristotelian Prime Matter are passive, they could not avoid being overwhelmed or swept away by what they were supposed to support or supplement. The Habitat and the

individuals in it, like the actualities that are confined by the instantiated ultimates in the different domains, can never be sundered from what confines them. Cut off from these, they would be mysterious things-in-themselves not owning anything.

What still awaits explanation is why and how there are confined beings, that do not necessarily exist. Conceivably, there might not be any instantiated ultimates that could confine anything or that might be owned. Were there no Habitat that was confined by and that possessively owned the instantiated Dunamic-Rational, this would not be instantiated as dominant over all the other ultimates. There would then be no means by which one could get from one domain to any other. It would also be impossible to evidence all the ultimates as not yet instantiated, since that evidencing requires a primary use of both the Dunamis and the Rational. Any system that fell short of the acknowledgment of the Habitat and would end with the Dunamis and the Rational always subordinated to other ultimates, or with them as mere fulgurations, vain nonterminating expressions of some primal source. One consequence: no actuality would be either intelligible or vitalized.

Because Hegel could never see how the stages in his dialectic could exist apart from their presumed source in a final Absolute Spirit, he confessedly never could get to an actual 'this'. Nor could he get to know that there was a Habitat. The stages in his dialectic were no more than rests in a process of inhalations of what had never been more than unnecessary incomplete exhalations, or self-divestings by a perfect reality. No such Absolute could produce a 'this' unless it could set a limited form of itself behind a barrier that that Absolute also provided. Since it is perfect, it would presumably do this only because its perfection required it. If that truth be admitted, one will come close to an acknowledgment of the Habitat and its subdivisions as confined by and owning the Dunamic-Rational. One would, though, still be confronted with the fact that, even if domains came into existence one after the other, what is in them will depend for their reality on a meeting of instantiated ultimates and confined realities.

The opposing views dominant in the East and the West about the existence of individuals after death are not as radically opposed as their dogmas seem to imply. Both take the dead no longer to be possessive owners of their persons and humanized bodies, able to express themselves in and through both, and in and through that in which contributions from both are merged. On death, individuals sink without apparent trace within the common Habitat, no longer able to possessively own and express themselves in and through persons, humanized bodies, and what has the two of them merged. The two views have little interest in the other

subdivisions of the Habitat, though there is more inclination in the East to understand complexes and singulars in ways similar to those followed when dealing with human individuals.

Although we cannot in fact enter into nature or the cosmos, the understanding of the Habitat does allow us to envisage owners of what is in them, functioning in somewhat the ways that individuals do. Since the ultimates need never have been instantiated, there might never have been a Habitat or, of course, any of its subdivisions, or any cosmos, nature, humanized world, or persons. That would not mean that there would then be nothing at all, for not only the ultimates as not yet instantiated would continue to be, but also what they presupposed. Being itself would necessarily be.

No individual exists forever, though the Habitat and its correlative Dunamic-Rational may. Again it must be asked, might there never have been any instantiated ultimates, nothing that they confined and that might possess or own them? Since Being—that which necessarily exists and necessarily does what it does—must somehow be arrived at from the contingently existing realities that now exist, the answer to the question can be dealt with satisfactorily only after we have understood what exists apart from that Being, and how it is possible to arrive at it from them.

The Dunamis and Rational, as already instantiated and interlocked with the Habitat, must be freed from it if the two are to enable us to evidence all the ultimates, and therefore themselves as well, as they are apart from all instantiations. To do that one would have to begin with them as already instantiated, and free them from their involvement with the Habitat or with what dominates the two in each domain.

Although there is no instantiated Dunamic-Rational in the absence of the Habitat, it does have a distinctive nature and way of functioning that this does not disturb. It is that fact that perhaps has led so many to neglect the Habitat, or to take it to be wholly passive. What is overlooked is that the Dunamic-Rational and the Habitat have insistencies of their own. Both insist on themselves with less and less effectiveness the more they are involved with one another, all the while that they continue to be distinct and to function in characteristic ways. The more deeply we penetrate either, the more it takes over.

Our thoughts, theories, suppositions, hopes, and fears have an intensity that is not fully conveyed when they are expressed, though they then contribute to another distinctive intensity, to which that at which they terminate also contributes a cross-graining. A desire has an insistence that is countered by the insistence of the object desired. To pass from one to the other, account must be taken of their distinctive natures and powers. Neglect of the fact has led some to suppose that universals are airy

abstractions. As Platonists have always affirmed, they are insistent. They are also countered and limited by that which enables them to be present in limited forms.

It is an instantiated Dunamic-Rational, as countered by the Habitat, that is used when we pass from one domain to another, transforming that with which it begins into what is more or less accommodated or rejected by that at which it ends. Related observations are to be made about the functioning of the individuals. What is owned by the Habitat and the individuals continues to have a nature and power of its own. It is therefore never completely accurate to say that an individual is this or that. What is done, is expressed through what is owned. Instead of saying 'I did that', it would therefore be more correct to say 'I did that intentionally', 'I did that with my right arm', and sometimes 'I did that intentionally, using my right arm'. It is careless to say 'I thought so and so by using my brain' when what one intends to remark is that one thought so and so by using one's mind.

The Dunamis and the Rational are distinct ultimates, and have their own distinctive specialized forms. References to them as equally contributive to a singular correlative Habitat do not preclude a reference to their primary specializations. If they did, there would be nothing like a logical necessitation or an inference, with the one overwhelmingly rational, and the other overwhelmingly dunamic. In these, and in other specializations, the Dunamic and the Rational function as relations with distinct termini. Both are confronted with what is distinct from them, thereby enabling the relations to have something from which they can begin and at which they can end.

While sustained by the Habitat, the Dunamic-Rational functions as a relation between the members of different domains. The Dunamic-Rational has more specialized uses when it connects other kinds of things. Thinking, perceiving, adumbrating, walking, making, conforming, loving, hating, even cooking and breeding, exhibit limited instances of them in the form of relations making possible a transition from what is in one place or position to what is in another. What enables such connections to be instantiated will qualify them, but not alter their natures. One may continue to walk, though the road is rougher here than there.

The acknowledgment of the Habitat and the individuals in it makes evident that relations have termini that are more or less accommodated by what is distinct from them. In the absence of such accommodations, the termini would cease to be where relations do terminate. The fact has astonishing consequences. This will become most evident after those relations that conspicuously function as mediators have been dealt with.

5
Mediators

1. A Primary Set of Connections

Over the course of the histories of both thinking and practice, a number of thinkers have tried to understand how one could arrive at some one position, having started at some other. Some concentrated on the idea of causality as a productive force, others on the fact that time passes, that there is a primary coming to be and passing away, that ideas have references, and that acts have consequences. Some have held that there are excellent rules and prescriptions which enable one to end at what is sought or, at least, at that which blocks one's way or disappoints. Signs and language are supposed by others to provide satisfactory ways of joining relevant but still independent, disparate items.

The problem that these confronted can today be easily traced back to Descartes with his isolated 'I', to Fichte's attempt to get from the ego to the non-ego, or to a more recent effort by Wittgenstein to see himself and all else as being inside a common language. Hegel faced the problem boldly, and offered an answer in his account of the power of the negative to connect what is apart, and of a power of synthesis by which new stages in a relentless move to an Absolute Mind were supposedly achieved. The problem was already present in both Plato's and Aristotle's theories of knowledge; their failure to solve it has left epistemology frustrated and defeated ever since their time.

Whatever the specifics of the different views and the answers offered, all are faced with the same fact: three distinct items must be distinguished and somehow brought together—a relation, that *at* which this begins, and that *at* which it ends. The latter two are to be distinguished from the termini of the relation, that *with* which it begins and that *with* which it

ends. Anything affected by time, space, causation, work, making, action, or any one of an apparently endless number of ways of connecting entities that are distinct from the termini of the connections, must not only have beings of their own and distinctive powers, but must begin and end at the entities as existing apart from them. Sooner or later one is faced with the question of how a connection is connected with the items it connects. No answer will do, if it requires one to ask how the connection is connected to the original connection and terms, for this will begin an endless chain of questions asking how each connection is connected to its terms. Terms and relations are connected, but not as just terms in a new relation. The terms in a relation are also involved with what is outside the relation.

Today, absolute idealists, pragmatists, and Heideggerians are content to say that all terms are interinvolved but are unable to say anything about what is available for the interinvolvements. If there is nothing that can ground the terms of a relation in what is outside the relation, the relation will pull those terms into itself and, in effect, act as a black hole about which nothing can be said. Contextualists have nothing to relate, matching the atomists who have nothing that relates.

An actual passing time requires realities to provide it with beginnings and endings, moment after moment. A time that had neither a beginning nor an end would be only an aeon—a single, undivided directionality.

In the absence of realities outside time, there would be no past, present, or future that were distinct from one another, able to be related temporally. Something similar to what holds of time holds too of space and causality, of every surmise, acknowledgment, reference, belief, theory, hope, and fear. When we assure a child 'there is nothing to fear', we are trying to point up the fact that there is nothing in fact that accommodates what the child imagines. We are not trying to say 'there is nothing, therefore do not fear', but 'what there is does not accommodate what you fearfully terminate with'. The fear is not thereupon extinguished; too often, it is insisted on, with the child unknowingly trying to end at what is in fact fearful.

Every connection has a nature and reality of its own; it functions as a relation only if it has termini and these are more or less accommodated or rejected by what is outside them. Although the termini of a relation and that which may accommodate or—even—reject them are distinct, there are no relations connecting the termini to the relation. We must not, though, say that there is just an interinvolvement without anything that awaits and sustains this, or that there is just a multiplicity of disjoined items with nothing between them. To be a relation, effectively to mediate, to pass from one item to another, there must not only be termini but also what more or less accommodates or rejects them.

In the absence of realities which can begin and end, there would be no past, present, or future distinct from one another, but just a single relating of what, despite its dating and ordering, would have all its parts together 'at the same time'. What is at one moment provides a beginning or ending for a passing time, but only because what the time begins and ends *with* is different from what it begins and ends *at*. Otherwise, time would be no more than a sequence of positions occupied by nothing. Any one of those supposed positions could be arbitrarily identified as a past, present, or future moment, there being no discernible differences among them. If a temporal relation had terminations, but these were indifferent to what was outside them, there would be nothing for the time to relate. If, though, nothing occurred for a while, there would still be a difference between where and with what the 'while' begins and where and with what it ends.

Denied any power of its own, a connection could be no more than an aspect of a mediating act. What is begun and ended at enables the relation to have distanced termini that are continuous with it, as connected with what is outside it.

Space, causality, speech, and custom, no less than time, have distinctive natures, roles, and powers. All are subject to qualifications by that at which they begin and that at which they end. If they are operative in some one domain, they operate under the dominance of a mediating ultimate that plays a major role in whatever occurs there. In nature, where Voluminosity is the dominant ultimate, time is never wholly freed from space and causality. These, though, have their own termini and are more or less accommodated by what exists independently of them. Formalisms and categoreal systems are all defeated by the fact that they need but cannot account for realities existing apart from the formulae and categories. A satisfactory, complete philosophic system is one whose pivotal claims are accommodated by primary kinds of reality.

Since, so far as can now be determined, there are six instantiated ultimates and only four domains, two of the ultimates must be unrealized or always be subordinated to the others. It is these two alone that can provide a neutral way of connecting what is in different domains. Like the ultimates that are dominant in the different domains, they will also not only have termini, but will always have these accommodated by what is independent of those termini. None of the ultimates may affect that at which it begins or at which it ends; these, though, will qualify the ultimates that enable them to be connected. When I know x, I and x continue to be what we were, while enabling a knowing to begin at me with what I conceive, and to end at x with what is being referred to x.

Formalists concentrate on rules, and learn how consequences are entailed by antecedents. Others concentrate on practice, and try to master

the skills needed in order to obtain desired outcomes or in order to conform to prescriptions and commands. What is distinct from the chosen agency is needed to provide it with a beginning and an ending.

Some relations are clearly directional in nature, with one of their termini distinguished as an origin and the other as a closure. Symmetrical relations combine two such relations, with what terminates one of them at one end providing a beginning for what is at the other end. One can, therefore, take all relations to be either simple or to be compound, asymmetrically ordered connections between terms that are provided by, and terms more or less accommodated by, what will always be outside them, as connected. Were the relations instantiations of ultimates, they would have power enough to make it possible that a qualification of what is accommodated at one end be available for what might accommodate it at the other. I will use 'mediator' to refer to what connects separate items with one another. Since 'mediator' tends to overstress the nature of the connection between beginnings and endings, it will sometimes be desirable to use 'transformer' and 'transition' instead, either to emphasize a difference between what is begun and ended at, or to emphasize the fact that a passage is being made from one to the other. 'Relation' and 'connection' refer indifferently to any of them.

If we are to understand how we infer, perceive, know or otherwise arrive at what is other than what we entertain, we must identify what not only has power enough but to utilize what is provided by what is outside it, but to bring this to bear on what may or may not accommodate it. If we are to attend to a relation, we have to reach it at the end of a different relating act. We would be on the verge of needing an infinite number of relations, were there not one—the Dunamic-Rational—that is able to connect all the others.

The mediator that is primarily operative in the humanized world is the Affiliator. This gives the other instantiated ultimates there a distinctive subordinated role. A passage in that domain qualifies those other ultimates in a distinctive way. The Assessor, Voluminosity, and the Coordinator have roles in other domains comparable to the role that the Affiliator has in the humanized world. Only the Dunamis and the Rational, since they are not dominant in any domain, could connect actualities in different domains— as well as what is evidenced in one domain—to all the ultimates as not yet instantiated.

The six ultimates are instantiated in every connection and in everything that is connected. A primary set of mediators can, consequently, be marked out by attending to the different ways that the six ultimates could begin and end at one another. There would then be $6 \times 6 \times 6$ —or, if we distinguish space, time, and causality, $8 \times 8 \times 8$ —cases, exhibiting the

primary ways by which it is possible to pass from any one of six types of beginning to any one of six types of ending. This large number of cases, fortunately, can be reduced to a manageable set by distinguishing items to be related rationally, relating the result to what can be related dunamically, and then seeing how the two pairs could be related to one another. An examination of the nature of a justified inference not only makes this evident, but can provide a guide in terms of which a multitude of other situations can be well understood.

2. Justified Inferences

A formal expression, where an antecedent *A* necessitates a consequent *B*, has the two distinguished, but not spatially, temporally, or causally distanced from one another. *A* is rationally related to *B*, not simply as one item joined to another by what is different from both, but as what the Rational begins at or ends with. The *A* and *B* must, of course, be maintained apart from the joiner of them.

It is not enough to pass from *C* to *D* along a path matching that which connects *A* and *B*. *C* must be warranted by *A*, or by its representative, and *D* must be endorsed by *B*, or by its representative. Were *C* not warranted by *A*, or by its representative, it would not provide a beginning for an inference to be carried out under the aegis of *AB*. Were *D* not endorsed by *B*, or by *B*'s representative, the inference from *C* to *D* would not have an appropriate end.

An act of reasoning begins with a premiss *C*, sanctioned by the antecedent *A*. The sanction does not suffice to show that *C* is acceptable, but only that it provides an appropriate premiss. Other kinds of acts can be understood in similar ways. Were one to begin to run a hundred yards, one would not have begun to run a race unless the starting point *C* had been sanctioned directly or indirectly by *A*. Nor would one have properly ended that race if *B*, or a representative of it, did not endorse the *D* at which one had ended. In an unofficial race, begun at the spur of the moment by friends, there is a tacit acknowledgment by them of a rule *AB*, under which the race *CD* will be run. In an officially-governed race, the rule *AB* will be more explicitly stated, though there will be much left undetermined—what is to be done if sudden obstacles are placed in the way of some of the racers? if there are threats, or if there are misdirections traceable to officials? and so on, through an unknown number of possibly unidentified disturbances. In an informal race, the difference these make will be taken into account in a commonsense way when deciding who the winner is. The running of a race, of course, is quite different from the

drawing of an inference, but its beginning and ending do need similar backings by what is functioning as an A, definitory of a starting point and what evaluates an arrival at the end.

A syllogism or other logical rule has neither a beginning at *C* nor an ending at *D*. It does no more than formally relate an antecedent *A* to a consequent *B*. So far, nothing is proved. A proof requires at the very least that a beginning *C* be sanctioned by the antecedent *A*, and that the consequent *B* endorse the conclusion *D*.

If a formal necessity depended on a proof, a logical necessity would depend on an inference. Demonstrations of necessities are heuristic, educative, doing no more than to re-express the fact that an antecedent *A* and a consequent *B* are necessarily joined. Projects such as the *Principia Mathematica* whose purport was to derive a multiplicity of logical necessities from a few (and, after Nicod, from just one formally stated, necessary truth) are fatally flawed, since all that one could possibly do is to provide an orderly way of presenting a limited number of *A*'s and *B*'s that were momentarily being treated as *C*'s and *D*'s. All necessities are on a footing, though some may and some may not be tested in others. Gödel's demonstration that the *Principia Mathematica* is flawed is, incidentally, itself flawed, since it depends on the supposition that arithmetic is self-consistent—one of the outcomes that the *Principia Mathematica* intended to demonstrate.

'X implies Y, and Y implies Z', (A), necessitates 'X implies Z', (B), without anything being done to the antecedent. Conceivably, one might take the joining of A to B to involve the elimination of the intermediate Y. If it did, there would be no need to carry out an inference in which such an elimination was a part. A necessitates B without the need or help of any intermediation other than that provided by a rational necessitation.

An antecedent *A* is necessarily related to a consequent *B*. It may also be related to a premiss *C* that can function as the beginning of an inference. The connection between *A* and *C* expresses an act of sanctioning of *C* by *A*. The *C* has a status distinct from the *A*. In fact it is but one of many *C*'s that could serve as a premiss in an inference, carried out along the route marked out by the rational connection that *A* has to *B*. Were *A* a reality, it could conceivably produce a sanctioned *C* that begins some act, but *A*, as just an antecedent in a formal connection to *B*, could do no more than endorse a *C* that acts as a premiss apart from *A*.

The antecedent *A* in a formal rule is sterile. It cannot produce a sanctioned premiss *C*. Only if a sanctioning of *C* is provided will *C* be an approved premiss to be used when *A* has the role of an antecedent for *B*. Were the antecedent *A* 'All men . . .', it would be questionable whether

either Elijah or Buddha would be acceptable as a *C*. There would be no doubt, though, that one could not take 'This tomato . . .' to be a premiss that could here be properly used as *C*, under the aegis of that *A*.

Antecedent and consequent *A* and *B* may be expressed by preceding the one with an 'if' and the other with a 'then' to yield 'if *A* then *B*'. *A* and *B* are here joined by a necessitation. In the absence of the 'if' and the 'then', *A* would not be acknowledged to be an antecedent, nor *B* to be a consequent in an entailment. Some formal logicians would be inclined to reject this account as compromising the fact that *A* is in fact necessarily related to *B*, whether this be acknowledged or not. The two views are not in conflict. *A* necessitates *B*, no matter whether this be known or not, but when we formulate a rule, we begin with a supposed *A*, and use the Rational to show that it necessarily terminates at *B*. Perhaps the authors of the *Principia Mathematica* wanted to do nothing more.

To acknowledge the fact that a logical rule has an antecedent *A* rationally and necessarily joined to a consequent *B* is not yet to provide all that is necessary for a proof. This requires the use of a beginning *C* in an act that comes to rest at an end *D* over a course that is in consonance with the relation that *A* has to *B*. There could be many different *D*'s, all satisfactory, that a premiss *C* could terminate at in justified ways. The connection of an antecedent *A* to a consequent *B*, e.g. 'Fish are living beings', allows for any number of premisses *C* from which one could begin any number of moves to some *D*. Those moves would all be legitimate, just so far as their *C*'s were sanctioned by *A*, the inferential move from *C* to *D* was kept in some accord with the relation that *A* has to *B*, and *D* was endorsed by *B*. One may jump ahead, backtrack, and wander and still make a proper inferential move from *C* to *D*. If one happens to guess the right answer, one may get to it as a *D* well before another who arrives at it, in accord with *AB*, after making a number of false moves. Only the latter will have carried out an inference.

Formal logicians tend to neglect the act of inferring, readily accepting any *D* if it is sanctioned by *B*. They are partly matched by those pragmatists who are primarily occupied with getting to *D* from *C* and using *AB* as a useful guide and nothing more. Each ignores the importance of what the other focusses on, and therefore its need for that other. Rules are effete; actions need guidance. One reasons well only when *AB* and *CD* are in accord, the one prescribing, the other performing.

Even in an immediate inference, *D* always follows *C* in time, but *A* and *B* are non-temporally and forever joined by necessity, no matter how long it may take one who had acknowledged *A* to identify *B*. A warrant by *A* is needed if there is to be an acceptance of *C*, the premiss, as that which provides a proper beginning for an inference arriving at a *D* and in

consonance with the necessity that begins at *A* and ends at *B*. Since a *D* arrived at from a *C* by happenstance falls short of what is wanted, there evidently is an ethics hidden in the pairing of *AB* and *CD*.

A rule *AB* may be quite arbitrary. What the antecedent *A* authorizes might not be desirable. The passage from a beginning *C* to an end *D* might be tortuous and slow. The endorsement of an end *D* by *B* might be regrettable. The passage from *C* to *D* has its own distinctive nature and is carried out outside the provenance of *AB*, even when this is used as a controlling guide. Where *A* is related to *B* primarily by the Rational, *C* is related to *D* primarily by the Dunamis, and where *A* and *B* are always connected, the inference from *C* to *D* leaves *C* behind.

Though a *B* necessitated by *A* may in fact be the last in a sequence of a number of necessitations, all of them will begin at *A* at the same time. Each *D* brings a process of inference to an end, no matter what member of a sequence of consequents of *A* certifies it. *D* might never be arrived at, since one might just stop a process of inferring. It might also be arrived at in many different ways, and over many different paths. No matter how many backtracks, asides, delays, and mistakes are made along the way, one might carry out as successful and legitimate an inference as did one who reached a warranted *D* straight away, provided only that an attempt was made to keep in accord with the relation that *A* has to *B*. Slow reasoners may be as good reasoners as fast ones; those whose minds wander may still infer as legitimately and as accurately as those who are well-focussed.

A proper beginning at *C* is sanctioned by *A*, and ends at a *D* warranted by *B*. Either *A* itself authorizes *C*, or some representative of *A* does, somewhat as an official is authorized by an organization to begin a race, or a police officer is authorized by the state to make an arrest. Good practical judgment, the usual way of referring to the warranted adoption of a beginning at *C*, conveys the idea quite well.

The three Kantian *Critiques* attend to judgment in brilliant ways, but nevertheless obscure the fact that the three are but a small number of equally legitimate ways of providing *C*'s that are warranted by *A*'s. Even a purely subjectified *A*, i.e., an idea or belief that was intelligibly joined to another item in one's mind, could provide a warrant for an effective *C*, e.g., a decision or a hope, through an act of self-expression or by a decision to act. Were *C* not authorized by *A*, either directly or through some representative, there would be no warrant for beginning with *C* in an inference carried out in accord with the necessity linking *A* and *B*. Were the inference not aimed at a *D* that *B* would endorse, it would not be an appropriate inference. If *D* is not to be arrived at through guess or accident, it should be reached from *C* under the guidance of the relation that *A* has to *B*. The inferential move from *C* to *D* might be slow or quick;

D could be arrived at after a number of backtrackings and deviations from a straight path. Nevertheless, it will be a legitimate inference if it is guided by an intent to end at a *D* that *B* will sanction.

An inference supplements a primarily rational necessitation with what is primarily a dunamic act. The result of an act that does not meet that requirement may still be much desired, produced perhaps as a result of so-called creative thinking. To think is to infer. When an inference is carried out within the compass of logical laws in which *A* is necessarily related to *B*, thinking is occupied with reaching endorsed *D*'s from accepted *C*'s. When neither an *A* nor a *B* is acknowledged, a passage from *C* to *D* may nevertheless be accepted as legitimate and may even be said to be brilliant should one end with what no one else had and no one had ever formally certified.

Most inferences are carried out by those who are unacquainted with the necessitations that could certify them. Practical men, scientists, and mathematicians often enough take some *D* to be a prospect to be arrived at from a *C* without knowing or caring about the rules or laws *AB* that might sanction the move. They seek to get to *D* from *C* without delay or difficulty, being content to accept *D* if this allows them to solve a problem. Usually, they proceed inductively, arriving at their conclusion along lines that had already been followed with some success. They will, so far, think in consonance with a connection between *A* and *B* that falls short of a necessity, but which nevertheless provides them with a good guide for their inferences. In fact, it is not often that anyone uses a necessarily linked *A* and *B* to govern his inferences. Formal logicians who think that this should be done are constantly astonished to hear that mathematicians who are not interested in practical outcomes nevertheless, like men of a practical bent, are not even aware of any rules *AB* that supposedly do or should guide their inferences.

Reference is here being made to *A* and its linkage to *B* apart from any inference in order to make evident that a warrant for an inference is distinct from it, and can be understood apart from any use. A sound inference, even when not guided by any explicitly acknowledged *AB,* can be justified by a reference to one. Fermat carried out a bold inference from *C* to *D,* leaving it to later mathematicians to find a justifying *AB.*

Just as an endorsement of an end *D* by a rationally warranted consequent *B* might be regrettable, so a rule *AB* might be produced by one who is not reasonable; the *C* that an *A* authorizes may not be desirable; and the passage from a beginning *C* to an end *D* may be tortuous or slow. An *A* and *B* could be joined by edict, express an expectation, or exhibit a rule of a language. Evidently *AB* may be definitory of the legitimacy of different *CD*'s.

Some practices do not require that *A* and *B* be necessarily joined. Some, too, are to be understood, not by relating *C* to *D,* but instead by relating *D* to *C.* Perception is one of them.

The rational joining of an antecedent *A* to a consequent *B* exists when and as *A* and *B* do. The rational connection they have, even when understood to involve a transformation of *A*'s truth-value into *B*'s, though it takes no time, begins at *A* and ends at *B.* Whether *A* and *B* were first apart and then were joined by the rational, or had always been necessarily joined, we must, in trying to understand them as necessarily related, recognize that *A* and *B* also exist outside the relation, otherwise there would be nothing to relate, but only a relation and its termini. In a rational relation, *AB* presupposes an *A* and a *B* as not yet related. There is no sequence here; when and as *A* and *B* are distinct from one another, they are also rationally and necessarily joined.

Formal logic treats anything other than a necessitation connecting antecedent *A* and consequent *B* as an irrelevancy. For it, an antecedent and a consequent are the end-points of an eternal articulation of the Rational. It also inescapably presupposes that *A* and *B* are not just termini. Indeed, they could not be termini unless they were enabled by realities distinct from them to stand apart from the relation. Since logic offers but one instance of the problem of acknowledging what enables the termini of relations to exist apart from the relation, a more comprehensive examination of that problem is best deferred until other uses of the square *ABCD* have been examined.

3. Perception

When examinations of a brain are supposed to report what occurs there, it is tacitly supposed that one had become acquainted with that brain. So far, not only would no thoughts be arrived at, but the supposed observer of another's brain would presumably be simply undergoing changes in his own brain and, consequently, would not be observing another's brain. Brains do not know one another. For anything to be known, it must be reached through an act that arrives at it as existing apart from what provided a beginning of the act, and apart, as well, from the ending of the act. At the very least, it will be necessary to distinguish a perceived brain, a perceiver of it, and the brain that is being perceived. This could be taken to be an antecedent *A* making *C*—the perceived brain—available to *D*— the perceiver.

A perceived brain *C* is sanctioned by a real brain *A;* it is also the correlate of a perceiver *D,* itself warranted by a *B* rationally joined to *A.* The real brain *A* has an intelligible relation to *B* that expresses itself as *D,* a

perceiver of *C*. Did *B* not provide a *D*, there would be no perceiver of *C*; *C* would then, at best, be an appearing of *A* that had not reached the stage of being something perceived.

Perceivers, *D*'s, express realities, *B*'s, in limited ways. It is only because there is a living being, a *B*, that there is someone who can perceive. What is perceived at *C* could not be a perception of a reality, e.g. the sun *A*, did *A* not make the perceived *C* available for a perception by what is at *D*. It is because realities, *A*'s, make themselves perceivable that there are *C*'s to be perceived by the *D*'s that are due to *B*'s. A real being *B* rationally joined to *A* (a man, let us say, related to the sun by the laws of nature) provides a *D* able to perceive the *C* that *A* provides. The real sun *A* and the real man *B*, though located at different places and given different dates, are intelligibly together. There is no passage of time from one to the other. There is, though, a passage of time from *A* to *C* and from *B* to *D*. When one forgets that fact, it is reasonable for him to assume that there is a passage of time involved in the connecting of *D*, a perceiver, and *C*, the perceived. But *C* and *D* are no less coexistent than *A* and *B* are. It is, therefore, a mistake to attribute the time that is involved in passing from *A* to *C*, and from *B* to *D*, either to *AB* or to *CD*.

When cosmological physicists speak of a time separating *A* and *B*, they refer to a rational connection that holds always. There could be many different *B*'s that were rationally joined to that *A*, as well as to one another. None of those *B*'s can perceive *A*. A perceiver is a *D* produced by a *B*; what is perceived by *D* is a *C*, not *A*. The real sun *A* is rationally joined to a reality *B* that might provide a perceiver *D* of a *C* that the reality *A* makes available for a perception. The *A* and *B*, and the perceiver *D* and the perceived *C*, are here termini. The *A* and *B* are rationally joined; the *D* and *C* are dunamically joined. Neither occurs in a passing time. What any of the four is when it is outside the relation that it has to the others may not be known.

The real sun *A* is related to a real being *B* who might be able to provide a perceiver *D* who perceives *C*. *B* is at a position distinct from *A*. Though it may take a passing time before *C* is available for a perceiving because there is not yet a *D* that has the status of a perceiver, when and as *C* is perceived, *D* perceives it. Conversely, when and as *D* has the status of a perceiver, *C* has the status of what is perceived by *D*.

The sun *A* that is perceived as *C* coexists with the *B* that provides *D*, the perceiver of *C*. Passing time is involved only in the relatings of *A* to *C* and *B* to *D*, not in those of *A* to *B* or *D* to *C*. *B* may be dated as later than *A* in a world in which there is a fixed before and after. That will not affect the fact that when *B* provides a *D*, a perceiver, this will be coexistent with a perceived *C* that *A* provides. If we take *B* to be later than *A*, it will be in a

time that does not pass. If we take *C* and *D* to be in a passing time, they will be there together. *A* and *B* coexist, so do *C* and *D,* but the one is in a time that does not pass, while the other is in a time that does.

When references are made to photons traversing space, to the transmission of messages, and the like, one passes outside the bounds of epistemology to deal with what presumably relates realities *A* and *B.* There are no photons that travel from *A* to *B,* but at most a series of fixed spatial positions at which different photons could be located. Did photons, when at the eyes, provoke a seeing, the eyes and the photons would constitute a *B* that provided a *D* able to perceive a *C.* Did the photons, when at or in the eyes, provoke one to see, they would not themselves be *D*'s, or parts of them, but *A*'s or *B*'s, or parts of them. Seeing is not the act of a reality *A* or *B.* It is, though, dependent on *A* for a terminus *C,* and dependent on *B* for a *D,* a perceiver coexisting with *C,* the perceived.

Did photons, when at the eyes, provoke one to see, they would not necessarily have anything more to do. Nor would they enable one to know where they presumably had begun a journey. They carry no return addresses, that could indicate to those on whose eyes they are presumed to act where they presumably originated. Arranged in a sequence, they are coexistent with positions between *A* and *B.* If they are involved in a seeing, it will be as parts of *B,* but the seeing will be by *D,* a perceiver. If in the absence of photons nothing was seen, it would still be true that it is *B* that provides a perceiver *D.* Even if the presence of photons were a precondition for *B*'s production of a *D,* there would be no knowing the *A* where those photons or their predecessors presumably originated. If photons are realities, they are in *A*'s or *B*'s, outside the reach of perceptions. If they prompt a *B* to provide a *D* that perceives, it will be as parts of that *B,* as involved in the production of *D*'s. Photons are not *B*'s, able to produce *D*'s who perceive the reality *A;* they are or are in *A*'s or *B*'s, positioned in a time that does not pass.

Let it be supposed, instead, that photons are realities that move from a source *A* to a being *B* that is able to produce a perceiver. Presumably, they would do this in the cosmos. They could not then have an effect on what is in other domains, unless they could be brought to bear on these by the Dunamic-Rational. This presumably would have a series of stages that could be identified as a sequence of moments. Those moments, evidently, would be different from those that might be distinguished inside the cosmos or any other domain. If the cosmos existed before there were any other domains, the 'before' marks a position in a non-temporal Dunamic-Rational. If it could be in such a position, time, like the Dunamic-Rational, would not only be a component in a dominant Voluminosity, but would mediate both what is in one domain and what is in another. There would

then, at the very least, have to be five different times—one each for the four domains, and a fifth that was distinct from all of these and able to connect them dunamically and rationally. The time that connects the cosmos with other domains, that exist after it does, is different from the time that is dominant in nature; otherwise there would not be a nature that came to be after the cosmos alone had existed for a while.

Could photons tell us where they had started on their presumed journeys, even though they are indistinguishable from one another? Could they somehow enable us, just by our opening our eyes, to see a multitude of stars and planets existing at different times, perhaps by hitting our eyes at slightly different angles? Could a multitude of men in the same area, looking at the sky, presumably being affected by different photons or waves, all see the same sources of those different photons or waves? No matter what the answers, we will be faced with a number of questions: Is what we see only in our minds? Is it projected back into a past where it arrives at what may have long ago passed away?

Must we not hold that perceiver and perceived, D and $C,$ are correlates, existing apart from one another because they are not separable from realities B and A that exist outside a passing time? If so, must we not recognize that there is no perceptum C awaiting a perceiver D to perceive it? A and B are correlatives. So are C and $D.$ The A and B are intelligibly joined, though in an order of first and second. C and D are also correlatives, but contemporaries, dunamically joined.

Any number of B's can be related to the same A whose C is perceived by different D's at different distances from that $C.$ The sun A is related to various of other realities B at different positions in a single intelligible whole. Those different B's can provide distinct D's at different distances from $C,$ all able to perceive it. A can also produce a number of C's, each of which could be correlative with different D's. Those different D's could all be due to the same $B.$

Since a perceiver is not a reality but the outcome of an act by a reality $B,$ it would be most exact to speak, not of a D perceiving a $C,$ but of B providing one or more perceivers for C's that A makes available for perceptions.

A stone might be warmed by the sun. So might a living body. The warmth might be the occasion for a perception of the sun, but it will not cause the perceiving of the sun. A perception occurs only when there is something perceived, $C,$ not when something at B or D is trying to project something into a possibly nonexistent world. It is when and as the sun A is related to some other reality $B,$ intelligibly distanced from $A,$ that it is possible for C and D to be correlatives.

Since a number of D's may perceive the same C from many different

positions, there evidently can be many perceivers terminating at the same
C. We can therefore speak of hearing, smelling, tasting, touching, and
seeing as expressing different *D*'s, all authorized by the same *B*. In every
case, perceived and perceiver will be contemporaries, no matter how far
apart they are.

We perceive *C*'s, not *A*'s. Perceivers are *D*'s, not *B*'s. A perceived *C* is
due, not just to an *A, B,* or *D,* but to all three, the one making it available,
the second intelligibly related to the first, and the third related to the
second and acting as a correlative of *C* in a perceptual situation. It may
take time for *A* to manifest itself as *C,* and it may take time for *B* to provide
a *D,* but not until *C* and *D* are both produced will there be anything
perceived, or anything able to perceive it.

Epistemological realists hold that there are *C*'s awaiting *D*'s to attend
to them; epistemological subjectivists suppose that there are perceivers
D's of *C*'s that are unrelated to any *A*'s. The one supposes that there are
unknown *A*'s that provide *C*'s, perhaps only in the form of 'impressions',
the other supposes that there are unknown *B*'s that are identical with or
provide the *D*'s that perceive. A perceiver is not a closed-off mind. What is
perceived is not something in such a mind. Perceiver and perceived, *D*
and *C,* are distinct from one another; both are products of realities.

Nothing is changed in principle if, instead of the sun, one spoke of a
chair across the room. This, too, is seen as *C* by what is copresent with it at
D. A and *B,* the chair and someone able to perceive, are distanced in an
intelligible extension; the perceived chair *C* is distanced from a perceiver
D in a passing present moment. An account that spoke of someone
perceiving the chair as in the past would provide a partial counterpart of
H.G. Wells' 'time machine' that supposedly carried one back into a past
that somehow had not passed away. The account would differ from Wells',
primarily in allowing one to get to the past and to return to the present
instantaneously.

Many questions hover on the edge of these compressed claims. Some
have already been noted; others need to be brought forward. Dealing with
them together makes it possible to see how they back one another. Good
answers to the questions should yield a set of mutually-supporting claims
and lead us to what is presupposed by all occurrences. Here are some such
questions.

Q: Doesn't it take time for light and sound waves to cover distances?
A: Yes.
Q: Can we not put a mirror at a distance, send out a signal, and
successfully predict the time at which it will be received?
A: Yes.
Q: Do light waves not travel faster than sound waves?

A: Yes.

Q: Must it not then be concluded that what we see had occurred in the past?

A: No. What we see, hear, smell, or feel is copresent with us as perceivers.

Q: Do we not undergo perturbations in the brain?

A: I accept the reports that there are such perturbations.

Q: Do not those who undergo those perturbations in the brain project something into the external world, to end with what is perceived or encountered there?

A: No. A projection is a continuation of that with which one begins. If it is begun in one's privacy, it ends in one's privacy; if it is begun in the brain, it remains in that part of the body. A brain, as an A, could provide perceivable occurrences of itself; it could not produce a perceiver. If you identify the brain A with what is perceived of it C, you would still have to refer the C back to the brain as a reality that was not perceived. A living being B or a part of it, if an active brain, produced a D. It would do this only on certain occasions, or as long as one was alive. For a being B or a part of it, a brain, to provide a D, a perceiver of C, it would have to act apart from A to produce that D. The D awaits a B to express itself.

Like A, B is not only a term in a rational relation, but a source of expressions. One of these is a perceiver D correlative with an expression C due to A. A and B are not only related to one another; each separately expresses itself, the one as what is perceived C, the other as a perceiver D. It is a real being A that is perceived as C and a real being B who perceives a D. The realities A and B are correlatives. Perceiver and perceived D and C are expressions of B and A that are correlative with one another.

Whether one took the brain to be a part of a real complex body, or a specialized source of a perceiver, it would not perceive anything. A perceiver is an outcome, just as the perceived is; once either exists, so does the other. As long as there is no perceiver D, C would be indistinguishable from the appearing of A. As long as there was nothing to perceive C, D would be no more than a reality B, readied to be a perceiver.

Q: Do you not assume a kind of pre-established harmony? Why should the sun be perceived only when some other reality, perhaps one quite remote in space and a non-passing time, produces a perceiver?

A: There is no need to refer to a pre-established harmony. Both C and D are two-faced. Both are readied by A and B, acting independently of one another. Conceivably, A might produce a C that never was related to a D; conceivably, B could produce a D unrelated to any C. C does not fully express A; B may fail to produce D. There might never have been anything

perceived or anything that could perceive. The center of the earth is not perceived; shoes do not perceive.

Q: Cut out this or that part of the brain, would you not then deprive one of the ability to hear, see, touch, remember, and so on?

A: Yes. I do not deny that the brain is used when one carries out such acts. To be used, though, there must be someone who can use it. He may use it as an *A* in the course of an act in which he provides a perceivable brain, *C,* or he may use it as a *B* that is enabling a perceiver *D* to be present. You are, I think, referring to the latter.

Q: Don't those who are closer to an occurrence perceive it before those who are at a great distance?

A: Yes.

Q: Well, then, if we put together that admission with what we know about the speed of light and sound, and add in the time it takes to carry a message from the eye to the brain, and for the brain to process it, one evidently cannot perceive what is present.

A: I deny that. What you claim to know of the brain and its activities is based on what you now perceive to be occurring in that brain. You surely cannot take refuge in a reference to a present, observable brain if it takes time before what occurs to be perceived.

Q: The interval is very short, is it not?

A: You have no way of measuring the distance between the past and the present. Every measure is exhaustively used in the present.

Q: How can you set yourself against the acceptances of most, and perhaps even all scientists, and other reflective, able, and honored thinkers?

A: It has been done before, and with good results. The history of scientific and philosophic thought is strewn with discarded views.

Q: But the claim that we perceive only after there has been a passage of time between the beginning and the reception of a transmission of light and sound waves or particles is both well-authenticated and has been received without question.

A: Is it more strongly grounded than were phlogiston, Ptolemaic or Newtonian physics, or the fixity of species?

Q: Are you dismissing present acknowledgments by reputable thinkers because mistakes were made by others at other times?

A: No, I am in no position to reject what scientists maintain today about scientific matters.

Q: Yet you seem to deny that a brain is observable. Instead of stopping with what can be observed of it, you retreat to supposed realities, to a user of the brain or a perceiver of it. Neither of these is observable. The more

we study the brain, the more we learn about the ways a human thinks, perceives, and knows.

A: We, as *B*'s, learn about a real man, an *A,* by attending to what he expresses about what he has in mind, intends, believes, fears, and so on, and by utilizing his expressions in intensive ways to learn about him as a member of a domain, as between adjacent domains, and as owned by an individual.

Q: Do we, can we, know a real man? Does he not exist, if at all, outside the reach of any appearance or phenomenon that is available to us? You turn Kant upside down. He, too, said that there was a difference in degree between the surface and depth of a thing, but he said it was a difference between the more and the less, the full and the empty.

A: He overlooked the fact that sympathy, love, even hatred and fear, insight, adumbration, and discernment pass from surface to depth, the thin to the thick, the porous to the self-maintained, the encountered to the insistent.

Q: How do you know that these are not just imagined by you?

A: They are manifested in the speech, and acts of some, and in the appearances of most. What is at the root of these can be reached toward as more and more insistent, and in so far as more and more resistant to our penetrative moves. Sometimes even those limits are breached. Ecstasy and inexplicable, passionate interinvolvements are some of the results.

Q: Aren't you taking refuge in a reference to a mysterious reality beyond the reach of your experience?

A: It is not mysterious. It is an individual or what it owns, toward which we can move intensively from *A, B, C,* and *D* together, beyond any pre-assignable degree. This makes its presence known by the way it uses the mind and the body for ends that neither can cancel. Neither creative acts nor perceptions can be well-known by those who allow only for what is on the surface, or is only intended or encountered.

Q: Nothing empirical can be excluded from scientific study.

A: I do not deny that. All I now deny is that such a study could tell us what is perceived, or how.

Q: You deny that the earth goes round the sun?

A: No. I take the claim to be but one of a number of alternative tenable ways of understanding astronomical occurrences. It is no less legitimate to hold that the sun goes round the earth, that the two go round one another, that either is fixed, or that both go round something else. It is mainly a matter of ease of explanation, a simplification in calculations, or a coherence with what has been well-established that determines which of these different formulations will be accepted by scientists. It is for them to decide which accounts are most promising at some stage of their inquiry.

Q: That seems to be a judicious remark. Still, I can't get over the fact, known even to those who have no acquaintance with the sciences, that those nearby see a lightning flash and hear thunder before others at a greater distance from a clash of clouds can and do.

A: I don't deny that. All I claim is that what is perceived is copresent with the perceiver of it. When those who perceive what I do are at different positions from where I am, they, no less than I, are D's copresent with what they perceive at C.

Q: Could a perception occur before there had been a traversal of light and sound waves at determinable rates?

A: Perhaps not, but that would show only that it may take a while before one is in a position to perceive a contemporary occurrence at C. C is not the reality A; it is what a D justified by B, confronts.

Q: Your view still seems to be at such variance with what everyone else holds that it is hard to avoid supposing that it is riddled with serious errors. It deserves to be faced with further related questions:

In what domain does the sun exist? Astronomers speak of it as though it were in the cosmos. Animals, birds, and flowers seem to react to it as together with them in nature. Humans know it through perceptions carried out in the humanized world. Subhumans react to it as in the same domain in which they are. If they are pets, do they dehumanize what had already been humanized?

A: The sun, as having roles in different domains, is qualified in different ways by the ultimates that are operative in it. What is in one of the domains can only arbitrarily be taken to be *the* real sun. In the preceding illustrations, it was identified with a reality A that was objectively and rationally joined to other realities. In all domains, A is objective and real, rationally joined to B's. In some, the A's are productive of C's that are connected with D's warranted by B's. Although there are no perceivers in the cosmos, and many nonperceivers in nature and in the humanized world, whatever D's there are will be contemporaries of C's warranted by A's. Perception is but one of many ways in which contemporaries, C's and D's are related.

Q: Could a perception provide a means for knowing what is in a domain other than the one where the perceiver is?

A: It could not. The seen sun is in the humanized world or in nature. It is quite different from an aggregate of cosmic bodies, or from what one might privately think about. To know what is in the cosmos, a C that was perceived in the humanized world would have to be so subjected to a mediator that it was able to be presented to what may accommodate it in the cosmos, perhaps in a radically altered form.

Q: Does a person B join two positions, one in which he is related to the

sun *A* as another reality and another in which he acts as a perceiver *D* of what the sun makes available at *C* for him?

A: Yes. There never is just a perceiver *D*. A person *B* who is intelligibly and dunamically related to other realities is needed to provide a *D* that perceives a *C* due to *A*.

Q: Is there not a difference between what is perceived and what is real? Do we not perceive appearances that are deceptive? Do we not see the sun long after it has disappeared behind the horizon? If it takes time before a perceptual form of the sun is copresent with us, how could this be credited to that sun? Is it not, therefore, more correct to say that we can find no warrant, no sustained reality for the seen sun *C*? Isn't the real sun a thing-in-itself that could not possibly be known?

A: A thing-in-itself is a supposed reality, dependent on the supposition that we can know only percepts or appearances; we remain confident that there is something else. No advance is made when, with phenomenology, one stops with appearances or just 'phenomena'. An 'intentionality' that is stopped by nothing never arrives at anything. If it is held that there is something that adds determinations to what one has in mind, one will not yet know that there is such a provider of those determinations. To know an appearance is to know an appearance-of-a-reality. That appearance is to be distinguished from the appearing of the reality *A* as well as from what is perceived *C*. Unlike them, an appearance is oriented toward the reality *A*. To reach *A* from this, one must reverse the process which began at *A*.

Q: Do we not use binoculars and telescopes, television, and other devices to enable us to see what in fact occurred some time ago?

A: Yes. Men have landed on the moon. They have done so by attending to the teachings of astronomers and engineers. The moon, like other realities, was perceived by others from many other positions. The moon's resistance to the step of an astronaut was perceived by many. None of those perceivers, though, passed intensively into the resistant moon as the astronaut did when he walked on it. None of them perceived exactly what the astronaut did. It took a while, moreover, before others were able to be *D*'s who were correlate with the perceived *C*'s of the astronaut's walk. As *B*'s, they were all at intelligible distances from the moon at *A*. Once, though, that the *B*'s provided *D*'s, there were *C*'s that they perceived.

Q: How could we ever know any reality if we were acquainted only with perceived *C*'s?

A: We carry out intensive moves, taking us from *C*'s toward *A*'s, realities.

Q: Could this be done if what is perceived is at a great distance? If we now see what occurs at a place or time different from where and when the

reality is, if the seen sun is present for us, but the real sun no longer exists, how could an intensive move take us from what is perceived to what is real? If it did, would it not take us to an *A* that might be quite different from the *C* that we perceive?

A: We cannot give up the idea of an intensive acquaintance with realities. We move from surface to depth, from what is confronted to what makes itself evident, without having to deny that we know any realities, and all the while we tacitly acknowledge that we are real, without having to give up the idea that we can perceive. Either what we now perceive is all there is, or we can penetrate beyond the *C*'s we perceive to what is real behind those appearances, to *A*'s. Each *A* is intelligibly related to other realities, of which oneself as a *B* is one. If a mediator is to enable one to reach something to be known, it cannot be cut off from that which enables it to begin. The fact reveals touch to be a more metaphysical sense than sight, for while sight allows for intensive moves, touch does so more insistently. The fact is particularly evident when what is touched is alive.

What is perceived is at the end of a perceiving mediation ending at a perceived *C*, warranted by *A*. There is here no first, cut off from a second. *C* is both at the end of a transformation of *A* and has the status of a correlate of *D*. We find ourselves less and less able to make sense of that fact when we try to understand how what is quite low on the organic scale could perceive, but it is not impossible, as an occasional poet makes evident. Wallace Stevens is a good, modern guide. The English Romantic poets helped others, a century earlier, to become aware of the fact.

4. Diverse Perceptual Deliverances

It bears repeating: nothing travels over vast stretches of space and time to report what happened some time ago. Neither photons nor waves are messenger boys moving over incredible distances with tales about what had happened at the moment they set out on their journeys, and which we understand after our brains had been set awhirling and thereupon had produced images instantly projected back into the environment or to the beginning of these journeys. None of these arrives at one's eye with an address on it. From the eye's position, the angle at which one photon or wave enters may be slightly different from that at which another does. To obtain a report of its origin, the slight difference in the angles would have to carry all the needed information about their supposed origins. This would then have to be translated by the brain, and the result somehow presented as a report of what may have passed away a long time ago. Even if we are deceived by echoes, shimmering rain-like roads on a hot day,

mimicry, and other illusions, these would not require us to deny that they exhibit realities, though in misleading ways, just as surely as other perceptual objects do, but more reliably.

We hear lightning and later hear thunder. We see an axe strike wood and hear the sound of the striking some time later. We see a broken oar in the water and feel it to be straight. In daily life, touch and hearing yield reports that are sometimes jeopardized by what is seen, and what we report of the seen is sometimes jeopardized by what we learn from experiments.

An Aristotelian reference to a 'common sense', though valuable in enabling one to relate what is heard to what is seen, felt, or tasted, does not tell us if any sense is to be favored, but only that we should also attend to what is different from what they severally provide. That is good advice, but it does not require one to suppose that the 'common sense' is able to transform what is sensed into a knowledge of what is real.

It is now time to test the general view, already dealt with in specialized forms appropriate to the study of inference and perception, by confronting it with other, apparently more difficult cases. One of the most familiar has to do with conflicting perceptions obtained through the use of different senses.

We are confident of many of our adumbrative and discerning moves because they are both accommodated and enriched by that at which they are directed. Most of our other moves end at what is not as inviting, leaving us with little more than an awareness that we have arrived at a reality. The depth contacts we sometimes make with some beings are not compromised by the fact that, most of the time, we find it hard to say what has been reached unless we resort to metaphors or charge our expressions with sympathy or fear.

An oar A may provide C's that have different perceptual natures in different circumstances. The oar may be seen while it is being felt, and it may be seen from a position different from that where it is felt. It cannot, though, be a straight and a broken oar, two different A's, at the same time. A felt oar and a seen oar-in-the-water are different perceptual objects, different C's. The one is perceived as straight, the other as broken. The problem of reconciling them requires for its solution the acknowledgment of the real oar A as not identifiable with either, but mediating both.

Both C, a perceived broken oar in the water, as well as C', a perceived straight oar outside the water, can be understood to be due to the same real oar A by taking account of the different ways B, one who could perceive, is related to different D's, each a correlate of a different C. None of these D's is in the mind or in a language. The same oar A may be both seen and felt, felt but not seen, seen and not felt, or neither felt nor seen. If

it is perceived in any way, it will be as a *C* correlate with a *D*. It is the oar *A*, not the perceiver *D* of the oar perceived *C*, that provides the means for reconciling the different *C*'s.

Were one to take the oar, or some other reality *A*, to be in nature or in the cosmos and not in the humanized world, one would be allied with those who take an axe cutting wood to be properly expressed only as an interchange of mass and energy, presumably in the cosmos. Were they right, there would be no *D*'s seeing a broken oar, feeling a straight oar, seeing a striking axe, or hearing the axe hitting the wood. There would just be a number of different *C*'s that were not only detached from a common *A*, but which were derived from a single *C* attributed to that *A*. We would not perceive that *C*, nor would we know that it had its source in *A*. An *A* would just be a construct credited with being the source of those *C*'s. But no one rows with a construct, an unknown support is not known to provide a support.

The prisoners *D*'s, in Plato's cave watching passing shadows on a wall, perceived *C*'s due to *A*'s. If they did not know better, they presumably would suppose that the *C*'s were idle projections from themselves both as *B*'s, having no status apart from themselves. The prisoners would, therefore, not know that they were seeing anything. If they knew that they were seeing, they would also know that they were *B*'s, acting through *D*'s, perceiving *C*'s. For a prisoner to act as a perceiver *D*, he would have had to be a *B* who, together with other *B*'s and their different *D*'s, could perceive the same *C*. They might not know the source *A* for the *C* they saw, but they could know that they were themselves *B*'s acting as *D*'s. Released from the cave, they would see, not realities *A*'s but *C*'s that were different from the *C*'s they saw in the cave. A perceived shadow of a man is a *C*, as surely as a perceived man is.

With fellow men, the wall, their chains, and the ground on which they sat, the prisoners were realities, *B*s, that provided *D*'s for *C*'s. They might not know the sources of what they perceived, but they could know that what they perceived had a status distinct from themselves both as *D*'s, perceivers, and as *B*'s, realities able to take on the role of perceivers. Released from the cave, they would see, not *A*'s, realities, but other *C*'s. No change in position gets one from the state of being a perceiver *D* to the state of being a reality *B* able to perceive.

Were the chained men in the cave nothing more than perceivers, they would not be able to go outside the cave. They could do that only if they were realities *B*'s who were both related to *A*'s and were productive of *D*'s. As realities, both when they are inside and when they are outside the cave, they perceive what other realities make available. The prisoners did not become realities *B*'s simply by going outside the cave. They were just as

real when they were in the cave as they were when outside it. Chaining them did not make them unreal, nor did freeing them from their chains or taking them into the sunlight make them real. Chained or unchained, in the cave or outside it, they were *B*'s, who acted as perceivers, *D*'s, related to *C*'s of different kinds. The fact that what was seen in the sunlight, *C*'s, was matched by other *C*'s, shadows in the cave, does not show that they were anything more than the kinds of *C*'s that could be seen outside the cave.

The prisoners never looked at the sun *A*, nor did they ever see anything other than *C*'s, both when they were inside and when they were outside the cave. Though they saw things outside the cave that they did not see in the cave, and conversely, all they ever could see were *C*'s at both times. If they had looked at the sun, they would have seen, not a reality *A* but a *C* different from the *C*'s that they saw inside and outside the cave. Plato surely knew that, but he chose a poor illustration to make the point that what one sees in daily life is not identifiable with what is real.

Why was nothing said about one who was in a position to release those prisoners? Either he had been freed by someone else who was freed by another, and so on; or he had somehow escaped and had come back to help the others, or he had never been chained. Whatever the explanation, the one who released the prisoners would have had a privileged status, but how or why is not evident. A better introduction to Platonism would have been provided had Plato not spoken of men in a cave but, instead, of those who came to know that the light in which objects were bathed was due to a sun *A* at which one could look safely only when its light was dimmed. That, though, would still fall short of showing how one could ever know the sun *A* fully.

All that the released prisoners apparently saw were *C*'s, different from but just as 'unreal' as the shadows they saw on the wall of the cave. The prisoners themselves were real beings, *B*'s who as *D*'s, saw a wall that presumably was a *C* where other *C*'s were located. What was seen in the cave, and outside it as well, were never more than perceived *C*'s, not realities, not *A*'s that enabled the *C*'s to be available for correlative perceivers, *D*'s. One who sees remains self-same is a reality *B*, whether he squints, opens his eyes, sees shadows or what is shadowed, or looks directly at the sun. No matter what one sees, one ends at a *C*, and needs to adumbrate or discern if he is to move toward the *A* that provided that *C*.

Plato did not want one to attend to what was illuminated by the sun, but to a final reality that makes everything intelligible. If he had wanted those in the cave to see the sun itself, his freed prisoners would have had to look at it. If he had wanted them, instead, to attend to what was in the sunlight, he would have had to show them how to know the source of

shadows as well. This would be an *A* not a *C* seen in the sunlight, no more than it is a *C* seen in the cave.

The friends of Plato will undoubtedly protest that I have left out stages in Plato's account, and that I am misconstruing a metaphor intended to show only that one might be preoccupied with effects and should see things in another light, shining on what is real, an *A*. The sun, they would say, is not to be understood as though it were a reality in the same world as what is seen inside or outside the cave. The main point of the story, they might claim, was to show that when one first attends to anything one does not realize that *A*'s are presupposed. Perhaps.

A variant of Plato's myth was offered by Eddington some years ago, though he apparently was unaware of the fact. Eddington held that there were two tables, not one. He claimed that one of them, the perceived table *C*, though obdurate and observable, was not real. The other, *A*, he apparently thought was made up of a plurality of cosmic units, separated from one another in an empty space. Ignoring the fact that he was leaning on the table that he perceived, that it blocked his way, was property, and could burn, he assumed that he not only knew it to be unreal, but that he also knew a different, supposedly real table *A* without making use of any intermediates. He apparently thought that the perceived table *C* was in his mind, but he then could not have pointed to it as in the room with him and his listener. What Eddington saw was not identical with what he leaned on, though both were *C*'s related to the same reality *A*. That *A* was not a congeries of cosmic units, but a table in the humanized world. It was not identical with his 'real' table, for that apparently was an *A* existing in the cosmos. Did he want to know that, he would have had to recognize that it provided a *C* that could be perceived in the humanized world. He leaned against neither the table *C* that he saw in the room, nor the real *A* that presumably was in the cosmos, but against a table *A* that was a reality in the humanized world. It was this that was perceived by him as a *C* and was thought to encompass the cosmic units in which he was interested. Rightly remarking that the perceived table *C* was not the real table *A*, he overlooked the fact that the latter enabled the former to be available to him as a perceiver *D*.

5. Some Familiar Transformations

HUMANIZED TRANSFORMATIONS

The humanized world is the world of daily life writ large, freed from the control of individual persons, natural beings, and cosmic units. Were the humanized world alone taken to exist, it would not be possible to give a

satisfactory account of creative work in the arts or mathematics or of persons with their characters, privacies, commitments, their doubts, fears, pains, and hopes. Nor would we know how to pass from what is in the humanized world, where experiments are performed and the results noted and assayed, to nature and the cosmos to which those results presumably refer.

One kind of transformation, familiar to many, starts with water as a fluid and ends with it as steam or ice, or conversely. Such a transformation could occur outside the humanized world, but not while it is caught up in an experiment, for this is carried out in the humanized world. A more striking experiment, now made familiar to the young, involves a transformation of water into gases, and conversely.

Water is not H_2O if, by using that formula, one means to affirm that water continues to contain the gases that were replaced by water. H_2O refers to the proportion of the unit parts of the gases that are needed if water is to be produced when they are properly joined. It does not refer to the gases themselves. It surely does not refer to what is contained in the water, since the amounts of oxygen and hydrogen in water are minuscule. Moreover, when in nature those gases and the water as well have their contained unit bodies subject to what exists in spans and, so far, are not identifiable with the water and gases that are in the humanized world.

To know water and gases as they are in nature, one must free them from the human contributions that qualify them when they are the objects of experimentation. That will require knowledge of how to transform what they are in the humanized world into what they are in nature. The water and gases used in experiments are affiliated members of the humanized world. What is known of them with the help of experiments may be reported in formulae and equations, but not without abstracting from the actual water and gases.

Since every item in the humanized world is affiliated with others, should it not then be possible in theory if not in fact to start with any one of them and produce any other? Must it not be possible for a mountain to be transformed into a mouse, and for a mouse to be transformed into a mountain, for a pet cat to be changed into a pet dog, a table into an orange, hats into blinding snow, and buildings into children? Yes, but the acts require a multiplicity of highly specialized versions of the transformations that do occur, and a possible multitude of not yet known intermediaries. Even then, no matter how many intermediaries we might provide, they might not suffice to get us in fact from one to the other. We now know how to pass in principle from one element in Mendeleev's periodic table of the elements to any of the others, but we cannot do so in fact.

What has to be learned is what and how many transformations have to

be carried out before what is sought can in fact be achieved, or its achievement understood. For those who take all occurrences to be reducible to collections of unit bodies, every transformation, no matter how odd, would just make evident that the same units could be clustered and separated in countless ways. Transformations that change one cluster of unit bodies into others, however, are possible only in the cosmos or in what is abstracted from what exists in other domains.

MIND-BODY

Although some theorists have been paralyzed by the truth, none—not even they—have much difficulty in relating their own minds or other subdivisions of their persons to their bodies. A cut finger is an injured finger, the injuring and injury may be painfully undergone. We can examine the finger as closely as we and all our technology and skills permit, but we will never detect the pain. We may misconstrue just where the bodily injury is to be publicly located, but wherever it is and whatever its nature, it cannot be identified with the pain.

A pain is privately undergone, an injured finger is part of a publicly knowable organism. A pain in an injured finger is a privately undergone experience of an injury in a living body. Anger puts a greater stress on the private side; a reference to a felt organic injury puts the stress on the body as lived; the injury itself is in the organism. We do not feel the pain as an injury, but as a pain; the organism undergoes it as an injury, not as a pain.

As joined by individuals possessing both persons and organisms, a pain is an emotion. This may vary in its emphasis on the personal or on the organic side. Sometimes it is more accurate to say that our hearts beat faster because we are frightened, and sometimes that we are frightened because our hearts beat faster. The beating of the heart is here not simply the beating that some machine might record, but the beating of a heart in a person who is frightened.

A person is always joined to an organism, without either of them ceasing to have a distinctive nature and be able to carry out distinctive acts. One's character is always operative, and thereupon habituated. There is no moving of the person into the organism, but at most a passage that begins at the one and ends at the other, or conversely. The emotions are expressed, in passages from one to the other, doubly qualified, limited shifting forms of a consciousness expressing the way one's character joins a person and a humanized organism. It is the two as so joined that is definitory of a living body existing between adjacent domains.

What is privately undergone by a person is not converted by an organism. The person is already joined to the organism. When we are

angry, we charge our bodies in a way we otherwise would not; when our organisms are strongly affected by other organisms, our persons change in tone. To maintain or to recover something like a balance, we must make individual efforts, transmitted through the character. It is more appropriate to credit the 'will', not to a person, but to the use of the character by the individual.

An assessment of my person and my organism is most evidently expressed as a consciousness when this is charged with emotions, reflecting a stress on one or the other. When I suffer, my person is emphasized; when I am hurt, my bodily organism, instead, plays a major role. The two are joined by my character, expressed as a consciousness that is emotionally charged, varying in emphasis and tonality from moment to moment. Sometimes I make use of my person or my organism at the beginning of a passage from the one to the other. My consciousness or an emotion then acts as a transformer. An emphasis on a subdivision of my person, e.g. my sensitivity, sensibility, or mind, is thereupon made to give way to an emphasis on my possessed organism, or conversely. My emotions are the outcome of the way in which my character is individually used to join my person and my organic body.

Both a good and a bad character may be either strong or weak. Its goodness or badness is determined by the nature and degree of one's commitment to realize an objective; its degree of strength, instead, is a result of habituating uses that provide opportunities for the Assessor to be effective in determining a relation of better or worse of the person and the organism relative to one another. There need be no deliberation or self-reflection involved in the act. A character is more or less fixated and more or less good to the degree that it persistently enables a private act to qualify the organism and its bodily termination as more or less good, or conversely.

Where emotions subordinate the contributions of both the person and the organism, character makes it possible for an individual to begin with either and end at the other. One of the ways by which most of us judge the worth of others is by treating their emotions as revelatory of their characters.

NATURAL TRANSFORMATIONS

Each reality in nature exists in a span. We can take acorns to occur in one span and oaks in another; we can also take the two spans to be encompassed within a larger span, different in kind. Water may be changed from fluid to steam or ice and back again, or from and to gases, not only in experiments conducted in the humanized world but in nature

as well. In the latter, the changes are subject to distinctive limitations, due to the spans in which they occur. The changes may be taken to be quite similar to what occurs in the humanized world, but since the Affiliator there plays a primary role, while it is extended spans that do so in nature, what occurs in the one cannot be equated with what occurs in the other. Water as a fluid is in a span that also embraces water as ice and as steam. The first may change into the others, and conversely. Whether the changes occur or not, the water will exist over a stretch of indefinite length within which it can pass from one phase to another. It may also exist as a subdivision of a still larger span in which it had not previously been, or in which it can pass from one phase to another. It may also exist in a subdivision of a still larger span in which it had not previously been, or in which it may not subsequently be.

The beginning or end of long-range spans within whose compass a multiplicity of many diverse spans occur may define a position where one period or epoch gives way to another. We come to know that there had been such endings and beginnings by taking account of the spans that precede or succeed them. Within those spans, other spans may occur, with ones longer providing mediators that make it possible to pass from one of the shorter spans to another.

A longer span is more than a sequence of smaller ones. It affects and is affected by the shorter ones that it connects. Were there a single span connecting an acorn and an oak, and another span connecting the oak and other acorns, a span connecting the earlier acorns or oaks to later ones would connect them directly, with the oaks or acorns respectively acting as transformers for the others.

Aristotelian accidents, adventitious irrelevancies, and idle riders are quite different from what results when realities so interplay that a new one is produced and the contributions made are altered in nature and role. Long before literary deconstructionists tried to pry off social, linguistic, or political overlays to find a supposed pure nuclear reality, other reductionists supposed that the only truth about actualities was to be expressed exclusively in personal, epistemological, biological, or cosmic terms. All the while, all tacitly supposed that they themselves were somehow absolved from all such reductions. Gadamer is one of the few who has been acutely aware of the fact, though he has not himself clearly answered the question whether or not he fully understands what he himself is doing. It is not enough to remark that one must begin with prejudgments. If one knows that, one must know something not pre-judged, or must be at the beginning of an infinite regress. Sooner or later, every account comes to the point where something is known to be more than a removable cloak beneath which are an endless number of others. It

is strange and sad that these revisionists do not think of subjecting themselves to the demands they impose on all the rest. They have no inalienable philosophical right to do to the work of others what they will not do to their own. They, too, use transformers that lay hold of that with which they begin and that with which they end.

Northrop's and Kuhn's view that a hypothesis can be falsified but never fully certified tacitly assumes that there are things distinct from the hypotheses. It is those things that can be known to reject the hypotheses. The rejections, no less than acceptances, presuppose that what was entertained has been brought to bear on what is able to oppose it.

If used by a disciplined inquirer, a hypothesis will rarely be bluntly accepted or rejected by what is enabled to terminate at it. If it is rejected, it may then be subject to a transformation that ends with a modification of the hypothesis. To claim that a hypothesis is falsified is but to say that it was accommodated by that to which it is addressed. Were the reverse transformation not also carried out, the hypothesis would not be known to have been falsified; it would have been merely blocked by what exists apart from where the hypothesis is offered for accommodation.

We risk adding irrelevancies when we accept a transformer that supposedly operates independently of us. Yet such a transformer is needed when we use a hypothesis, entertain a supposition, and the like. Beginning with the terminus of the transformer as qualified by what had rejected it, we can more or less accommodate it as ending at us. That, of course, would not be possible did the transformer not have a nature and power of its own, and therefore were it not able to adopt qualifications of it by what is external to it. It is accommodated by us as terminating a move back from the external reality that failed to accommodate what was being credited to it.

Were a hypothesis that was rejected by a reality not transformed into a rejection of the hypothesis by us, it would not be a known, falsified hypothesis. All we could then say would be that it had not been accommodated by what, so far, is not known. A falsified hypothesis, like every other that is entertained, is not simply rejected by that at which a transformer ends. A rejection expresses the fact that a transformer's outcome is denied.

To have an idea is not yet to know anything. If there is anything existing apart from an idea, able to accept or reject what a mediator made available of the idea, that existent would continue to be what it is. It would of course not be known until it was confronted by what was conveyed of the idea, all the while that the idea continued to be possessed by one who entertained it. If so, the Aristotelian view must be reversed. We do not

know by separating a form from an object in which it is embedded—how could we ever have found it?—but by learning that what we entertain is in fact accommodated by what already exists apart from us.

Until what we entertain is conveyed by a mediator to what exists apart both from us and that mediator, there is nothing that accepts or rejects it. Although the idea may itself have been elicited by a mediator that had begun at some external reality, the idea will not be true or false unless it is an elicited idea of something, an idea at which a mediator, starting at an object, terminated. The Aristotelian view could, therefore, be retrieved if one took his separated forms to refer only to ideas that were true. Aristotle would then be a proto-Cartesian.

What is needed is an actual transformation of an idea into what is presented for accommodation by what exists apart from the idea. What does this may not be noted or known, but if there be a knower and something known, it will not only relate these, but will enable what is available at one end and have it confronted at the other end by what exists apart from both the idea and the mediator.

Some claim to have certain ideas, beliefs, expectations, or projective powers that end at objects, without anything else being required. They are kin to those who hold that there is in fact some distinctive way one can start in oneself with an 'intentionality', a faith, an insight, and the like, and arrive at something existing apart from themselves. Unless use were made of mediators that in fact arrive at what can accommodate what those mediators end with, one would just continue to project what had been begun with.

Conceivably, when one ended his projection, he might find that what he had begun with possessed determinations had not been provided. Since those determinations would have been provided by what is not known, they could be said to be due to a God, to the mediator, to oneself in another mood, to what is entirely different from the determinations—indeed to anything whatsoever. Phenomenologists would do nothing but phantasize if they did not actually encounter anything. The religious are clearer; they simply assume that there is a real God who justifies their faith, by accepting the faith offered but on His terms. God, for them, is not an unknown source of determinations in what they project, but a reality encountered, more or less accepting what they offer to Him. Whether or not there is a God who does this is another question.

Did we not have an independent knowledge of those mediators, we would have to learn about them when they function in particular situations, without understanding how they could do so. It is because mediators are ultimates that we can know them as they are apart from any

act of mediation, and can understand how they could have made it possible for there to be passages to and from different kinds of entities. We not only have ideas, but have them accommodated by the mediators that adopt them, and which bring them to bear on what may be more or less, and perhaps even not at all, accommodative of that with which those mediators end. Mediators make contact with what is distinct from them, as made evident by the fact that there is that from which they begin and at which they end.

It is because what we have in mind is brought to bear on what is acceptive or rejective of it that we can have knowledge of what is not in our minds. Because what is terminated at by a mediator affects what the mediator conveys, there can be something that is known; because what is known is qualified by a mediator ending at us, as apart from what is known, we can come to know that what we had in mind is true or false. We could never know anything unless our ideas were brought to bear on what is distinct from them.

We can know what exists apart from us because and so far as what we have in mind is countered by what is not in our mind. We could therefore take what is in our minds to be a more or a less intensive form of what is not in our minds. Idealists prefer to take it to be more, empiricists prefer to take it to be less. Once it is recognized that what is in and what is not in our minds are distinct realities, with their own natures and ways of acting, constituted in different ways by instantiated ultimates, it becomes evident that these identifications arbitrarily take what is at one end to be a variant of what is at the other.

Antecedents may be used to check on ends, ends on antecedents, beginnings on consequents, consequents on beginnings. Theory is checked by practice, and practice by theory, authorizations by certifications, and certifications by authorizations. For particular purposes, one or the other check may be preferred. It would be a mistake to take these alone to be the only permissible or useful ones. Indeed, any outcome could be used as an occasion for the provision of new definitions, meanings, or actions.

Transforming mediators act on their own, but they are qualified both at their beginnings and their endings. Since what occurs in nature or the cosmos is in a domain in which we are not a part, we can know what is in them only if we are enabled to pass from what we conceive of what is in one of those domains to what more or less accommodates what is terminated at.

We know how to bring lives to an end, but we do not know how to reverse the process. Nor do we know how life first arose, or how to

produce it in the laboratory. We can formally state the reverse of the process by which the living become non-living, but we have no knowledge of how the transformation operates, nor do we know exactly what that transformation is like, how many intermediates there are, or the nature of the span in which the transformation might occur in nature. All that we can be sure of is that spans, within which the living and non-living are, can conceivably be traversed in either direction. The observation verges on a tautology: If we are to understand the origin of life, the difference between the non-living and the living has to be bridged by a transformation that begins at the one and ends at the other. The so-called law of conservation of energy would also express a tautology if we abstracted from the difference between the beginning and ending of a transaction in which energy is expended, but then we should say that any account of changes in any domain also verges on a tautology. If we did, we would then be likely to overlook the fact that something different is finally arrived at.

COSMIC TRANSFORMATIONS

The microscope and telescope have enabled us to see what could not have been seen before. Various scientific instruments have made it reasonable to take many occurrences that had seemed to be singular and indivisible to depend on the activities of multitudes of smaller occurrences, all acting more or less independently of the larger occurences and of one another. We have accustomed ourselves in the use of aids enabling us to see and hear what otherwise would be missed, but that is no reason for our not making use of other, more powerful aids as well.

Nothing new in principle is involved when we use telescopes rather than eyeglasses. Before there were eyeglasses, men squinted. When they looked to the right, they saw what had not been seen at the left. Try as we may, we cannot perceive what is in persons, nature, or the cosmos. Scientific explanations of illusions provide neat, certifiable explanations of when, why, and how misleading perceptions occur. They are to be replaced, not by reports of what is in the cosmos or the brain, but with accounts of the ways we should expect and speak in the humanized world in order to remain in good accord with what is known to occur in the cosmos. We can come to know what is there because a combination of the Dunamis and Rational enables what we have in mind, or what is known of the humanized world, to become more and more subject to what is in the cosmos.

In this century, we have been alerted by Einstein to the interrelations of mass, energy, and light, presumably expressible in terms referring to

cosmic unit bodies. The formula in which the interrelation was so neatly presented offers a brilliant yet simple way of showing how the numerical value of one of the three can be matched by the paired values of the other two. The dominant presence of the Coordinator as cosmically operative is here acknowledged in the use of an equals sign to relate the cosmic units located in mass, energy, and light. Einstein did not claim that the mass, energy, and light noted in his formula referred to what is dealt with in experiments conducted in the humanized world. These supposedly referred to cosmic unit bodies. To know any of these, one would have to find a way to pass from the humanized world to what is in the cosmos. It is not yet evident whether or not quantum theory is pointing up the presence of some unknown specialization of a transforming Coordinator, able to arrive at a terminus that is altered by what accommodates that terminus.

Instead of remaining in the humanized world and trying to make contact with what is in the cosmos, one might, with Whitehead, begin with unit beings whose existence is exhausted in their coming to be, but whose natures are nevertheless preserved both by God and whatever unit beings follow them. Whitehead's God is credited with two natures, but nothing is said about what connects them. The view, unlike most others, does recognize, though, that if there is a passage from one cosmic unit to another, it will be due to what is able to bridge the gap between them. His was a philosopher's God, the locus of his unsolvable problems, in fact indistinguishable from the Coordinator as able to qualify and be qualified by what it connects in the cosmos. That Coordinator is not intrinsically superior to the other ultimates; with them, it presupposes a single reality—Being—impersonal, necessary in itself, and necessarily doing what it does. It is not a plug to stuff up a hole in an inadequate account, but a reality that not only presupposes nothing, but is the source of all else. It is because we know that there are ultimates, constitutive of all actualities and relations and of the Habitat and its subdivisions, that we are able to understand how any item could be transformed, at least theoretically, into any other.

MEANING

Quite early in his career, Peirce tried to determine the highest degree of 'apprehension' that was possible. He said that one should "Consider what effects, that might conceivably have practical bearings, we conceive the object of our conceptions to have. Then, our conception of those effects is the whole of our conception of the object." When he later referred to this maxim, he remarked on his deliberate use of the terms 'conceive' and

'conception.' Beginning at *A* with a concept or idea, and making no reference to a *B* or *C*, Peirce terminated at a *D* that was a specialized form of *A*. Although the maxim is usually taken to provide a beginning for pragmatism—the view that what occurs or is done is the measure, test or meaning of what is entertained—Peirce's account reveals that the maxim, for him, was different from one that focusses on actual consequences.

D, for Peirce, is a conceived *D*, not something occurring apart from *A*, nor something into which *A*, what one is entertaining, is transformed. The followers of James and Dewey are right to note that these two found the meaning of *A* in a *D* that exists apart from the *A*, and therefore in what could be reached from *A* only through a non-rational, but not irrational, transformative act. The nature of this was never made very clear, though Dewey did devote a great deal of attention to it. Again and again, his references to 'transactions' pointed to transformations that changed that with which one begins into that with which one ends. For his transactions to make possible a needed passage from what is entertained to what is encountered, however, the two have to be distinguished from one another as an *A* and a *D*, something entertained or in mind from what occurs apart from this. One could then take account of what makes it possible to pass directly from the one to the other.

There is no arriving at a *D* as existing apart from *A* unless there is a mediator distinct from both, able to adopt *A* and terminate at *D*. In the square with *A* and *B* at the top corners and *C* and *D* at the bottom ones, 'meaning' is expressed in the diagonal that starts at *A* and ends at *D*. Involving as this does a passage from one domain to another, an individual person's mind and an occurrence elsewhere, meaning is here being expressed as a combination of the Rational and the Dunamis, the one provided by *B*, the other by *C*. A reverse passage from some matter of fact *D* to an idea, hypothesis, or some other intelligible beginning at *A* would also involve both *B* and *C* as constitutive of the move. A comprehensive theory of meaning will deal with two different beginnings, *A* and *D*, and, with the help of *B* and *C*, ends at their diagonal opposites *D* and *A*.

SIGNS

Closely allied with the study of meaning is the study of signs, another enterprise Peirce focussed on with such effectiveness in his brilliant, heartbreaking career. He took meaning to be primarily a matter of the relation of a sign to an object for an interpretant. That interpretant could be understood to be midway between *A* and *D*, representing *D* for *A*, and *A* for *D*. Most likely, Peirce intended to take *A* to be the interpretant for *D*. If he did, he would have to have two squares sharing a common point, a *DA'*

where the D is for A, the user of the sign, and the A' is of D', the object to which the sign refers.

A sign is directly related to A, its user, and to D', its object. As midway between these, D' has two roles: it is relative to A, its user, and an A' for an object D', thus it is a DA, mediating the user and object.

Peirce thought that signs are to be distinguished primarily as being like, interplaying with, or being intelligibly related to their objects, all for the sake of their interpretants, A's. He should have taken account of the different effects a sign DA' might have on its user A, and of the effects that an object D' of a sign might have on the sign DA'.

We should distinguish:

1. A user of a sign, A.
2. What can be used as a sign by A. This is D.
3. The sign as related to its object. The sign here has the role of an A' for an object D'.
4. The sign DA' as between its user A and its object D'.

If A, the user of a sign, be termed its interpretant, the interpretant requires a sign to be both an object D for it and an A' for an object D'. A sign is evidently two-faced, a DA' a mediator between A and D'. Its status as an object D for A is of something to be used; its status as an A' for D' is that of something used. A thermometer is no less an object than the weather is, but its status as an object D for A becomes subordinated to its status as a referent A' when it functions as a sign of D'. The reading of a thermometer is a process of passing from a D for A to A' as related to D', the weather.

Since a reality such as a living body, existing between adjacent domains, enables what is in one of them, e.g. a person, to be related to what is in the other—a humanized body—and conversely, enables what is in the humanized world to be related to the person—it can be understood to be a sign operating in two directions at the same time. It can be said both to be used by a person to enable it to take account of the organism as in the humanized world, and for the organism, as in the humanized world, to alert the person. A pain leads one to look for an injury to the organism being; a threat expressed in the humanized world may be intended to arouse a fear.

If one were to take a sign to be an object, D for A, one would not yet have a sign of anything. If the sign, instead, were taken just to be of an object D', it would function as an A', but would not itself be an object D for a user A'. One would then have a sign that was not used by anyone, and therefore not truly a sign. A sign is a mediator DA', itself produced with the help of BC and terminating at D', with the help of $B'C'$.

The definition of a sign as that which is of the object D' for an interpretant A skips over the fact that the object A' of a sign had to have been reached before there could be a sign, a DA', of the object D'. A sign is both for A and of D', used by A as that which terminates at D'. It is a mediator between and existing in contradistinction with both A and D'. Without an A and a D', user and object, there would be no sign.

Semioticians today are acutely aware of how a sign functions, how a user is related to it, and by what means it is related to the object signified. It is not enough, though, to say how signs are related to users and objects; one should ask how they function. That is what is done when a sign is identified as at once a D relative to a user A, and an A' relative to an object D'.

A thermometer can be bought, calibrated, and read; words are expressed and heard. Both are signs, DA's, because they are for A's and are of D's. Each sign acts as a mediator between an object D' and a user A. Usually, each is already related to its object D' before it has the role of a sign DA' for an A. Although a man makes a thermometer, he calibrates it with reference to an object D', the weather, before he makes use of it as a sign. The process is sometimes reversed. Darkening clouds, D's, may be treated by men, A's, as signs (A')'s of a storm D' to come. There is no functioning sign, in any case, until there is an A and a D' mediated by the sign as a DA'. A theory of signs should also take account of the different effects a sign, as DA', has on its user A, as well as of the major kinds of relations that the sign, as A', has to an object D'.

The same sign DA' of D' could be a sign for a number of A's. It is not restricted to use by those who respond to it in the same way. When a thermometer DA' represents a particular degree of cold D', it may be for one who is shivering, for another who is ready to turn up the heat, for a third who has a muffler in hand, and so on. Each is an A, confronting a D that is acting as an A', terminating at D', the weather. Each user A reacts in a distinctive way to the D' at which the used sign DA' terminates.

Instead of thinking of a sign as a unit DA', existing between an A and D', user and object, it would be more precise to view it as a mediator that begins at A and ends at D'. Although a thermometer is one object A among many, when it functions as a sign it does so as a DA' mediating A and D'. As a sign of weather, the thermometer does not hang on the wall; it is and acts as a mediator DA' that begins at A and ends at D'. It is used to register the weather, D'—that is why it was bought. A sign A' of the weather D', it is to be used in place of an experience of this. Peirce's division of signs should, therefore, at the very least, be expanded to take account of the distinctive roles that a sign has with reference to different kinds of users, A's, as well

as of the different kinds of objects, D's that are able to provide beginnings for signs, DA's, mediating those objects, D's, and the users, A's, of those signs.

RECONSTRUCTIONS

Instead of attending to A as the antecedent of an entailment or implication, one can take it to be at the beginning of an action, e.g., as enabled by B and C to end at an occurrence or object D. One could also begin a reverse move, using B and C to enable one to begin at D and end at A. This move is familiar to those engaged in historical studies. Beginning with what is available—records, reports, and the like—the import of a D' will be determined by an A' arrived at with the help of $B'C'$. The move mirrors one made by a strong pragmatism when this passes, with the help of BC, from what is entertained at A to what is at D.

Although we inevitably begin in ourselves, we often pass, almost unknowingly, to what is in some other domain. Most often, we do this when we start with A, what we have in mind, and end at a D, occurring in the humanized world. That is one reason why it was most reasonable to begin this work, not with an examination of ourselves as outside the humanized world, but with us as existing there. Were we, though, to forget that we could not have begun in the humanized world without first having moved from ourselves as persons in that world, each an A transformed to a D we would become unreflectingly receptive to behavioristic, linguistic, and sociological accounts of what we know, lost in a world that is outside our persons, unable to know this world. .

ACCOUNTABILITY AND RESPONSIBILITY

Accountability is attributed to someone by what is external to him; responsibility is assumed by someone who initiates an act. The attribution of accountability may not end at one who is responsible. It suffices if the accountability is determined by an impartial use of established ways of determining who should be rewarded or penalized. One assumes responsibility whether or not one knows that one does so. One can also be accountable for that for which one is not responsible. A general may be dismissed if his army loses, even though he might not have been at fault; he may also be responsible for beginning a chain of desperate moves, and never be held accountable for any of them. One who is responsible is comparable to a user A of a sign; one who is held accountable, instead, is comparable to the outcome of the determination of the import of a sign, DA', by an object of the sign D'.

To initiate an act is to become accountable for it, just so far as the act is

identifiable as beginning a public *C;* if the act is authorized, it will be because *B* determined the public import of what is done. Public reference to an 'intent' is to an *A,* a supposed source of an act, reference to public evidence is to a *D,* an ascertainable source of an act.

The distinction between responsibility and accountability points up a radical difference between what occurs in a member of a domain of individual persons and what it is to which references in the humanized world terminate at. It leaves over the question whether one who is responsible may not also be accountable, and conversely, whether one who is accountable may not also be responsible. To know if someone is both responsible and accountable, responsible but not accountable, not responsible but accountable, or neither responsible nor accountable, one has to focus on a privately initiated public act and compare it with authorized and unauthorized ones. Bureaucrats have accountabilities; sentimentalists have responsibilities. A reasonable man leavens his acknowledgment of the one by the other.

6. Other Major Uses of the Dunamic-Rational

Epistemology, when it begins with mind-possessed items, futilely struggles with the problem of getting from these to what supposedly occurs in the humanized world, and sometimes to what supposedly occurs in nature and the cosmos. But if no provision is made for the Dunamic-Rational, it is not possible to get outside the mind where the act of knowing begins. Sometimes an appeal is made to language, logic, or laws. None of these will suffice, for what is needed is an actual transformative passage from what is in the mind to what is in the humanized world. Knowledge of what occurs in that world is affected by the knower, by a specialized version of the Dunamic-Rational, and by what is arrived at.

To pass from what is in one domain to what is in another domain is possible only when the Dunamis and the Rational act together. More than one speculation has fallen short. Peirce is an example. He spoke of abduction as a means by which one is able to obtain viable hypotheses about matters of fact. The idea can be understood in two ways: In one, a start is supposedly made with some occurrence *D* and a hypothesis *A* is arrived at about it. Such a move presupposes that a *D* distinct from oneself, an *A,* had been arrived at, that a return had been made to *A,* where the move had been initiated, and that a hypothesis is then formulated at that *A,* enabling one to reach an external occurrence *D.* The supposed simple procedure, not only takes off from some idea *A* and ends with a *D* that exists apart from it, but makes use of a mediator of which nothing is said. In the second way, it is supposed that one initially passes from oneself *A*

with the help of a mediator, a combination of *B* and *C*, to end at a *D* from which a reverse move can be made to oneself as the *A* who formulated and uses the hypothesis. To forge a plausible hypothesis based on what one has come to know about some matter of fact, one proceeds from *D* to *A*, with the help of *C* and *B*, though not necessarily taking note of that help. To pass to and from one domain and another, one must instead depend on the operation of *BC*, which is distinct both from that with which one begins *A* and that at which one ends *D*.

Only the Dunamis and the Rational together—the Dunamic-Rational—makes it possible to pass from what is in one domain to what is in another or to evidence themselves and all the other ultimates as not yet instantiated. From the position of that at which the Dunamic-Rational begins, this enables one to end at what has an insistence and an import not accounted for. It will, therefore, be tempting to take the Dunamis to be the primary reason why the end of a passage from one domain to another, or to the ultimates themselves, differs from the beginning, its nature and course cannot be captured in rational formulations. One would, though, not yet be able to know what it was at which one began and what brought the move to an end. Still, there are times when the effectiveness of the joint action of the Dunamis and the Rational is so dominated by the latter that it would not be amiss to speak of a Rational-Dunamis rather than a Dunamic-Rational. A reasonable insistence offers one instance. Since the role of the Dunamis is neglected or minimized in our tradition, one remains in better accord with the facts by referring most of the time to the Dunamic-Rational rather than to the Rational-Dunamis—as long as one remembers that the Dunamis plays a more significant role than the Rational in all becomings and in perhaps all but the most mechanical of actions. The safest generalization to make is to the two as always inter-involved in varying degrees at different times and on different occasions.

When account is taken of the fact that the Dunamic-Rational can be qualified by that with which it begins in one domain, as well as by that at which it ends in another, twelve kinds of outcome can be distinguished. In all, the Dunamic-Rational is affected by the other ultimates in various degrees and has its end-points affected by contributions from that at which a beginning is made and that at which it ends. In all, there are midpoints in which the contribution at the beginning and the end have a more or less equal effect.

1. When we begin with ourselves as persons and pass with the help of the Dunamic-Rational to what is in the humanized world, we arrive at the affiliated members there as affected both by that at which the move began and that at which it ends. If the contribution made at the beginning dominates, its contribution will be emphasized; if what is insisted on by

that which brings it to an end is prominent, the humanized contribution will be seen to have made a difference to the result. The two together constitute *conventions*. A language, with its namings and classifications, is one of the more familiar of these. When the contribution of that from which the move is begun is emphasized, there will be *deviations* from the established ways. When the humanized contribution instead is emphasized, the outcome will be *traditionalized*. *Conventions* more or less balance the two.

2. When the Dunamic-Rational enables one to arrive at what is in nature, one's personal contribution may be emphasized. If it is, one will end with what is *experienced*. When, instead, the outcome in nature is taken to affect the Dunamic-Rational that terminates in it, one ends at what is *appreciated*. When the two are more or less in balance, one ends with an *acceptance* of what is in nature. At no time do we enter nature; all we could do is qualify and share in the Dunamic-Rational that has its termination in and is affected by what is arrived at. By replacing an experience with an appreciation, the Romantics made no real advance over the clods they condemned. They did, though, make an advance when they took beauty or a benign power to be expressed in nature. It would have been still better if they had moved beyond the distinctive stresses of both sides to accept what the Dunamic-Rational had made available.

3. When, beginning with ourselves as persons, we are enabled to terminate in the cosmos by means of the Dunamic-Rational, we end with a *submission* to what is there. If the cosmic contribution is greater than our own, we end with a *confirmation*. Theories and hypotheses about cosmic occurrences are privately formulated and entertained; they would continue to remain in our minds if they did not qualify the Dunamic-Rational and did this not carry them forward into the cosmos, where they are affected by what accommodates them. A *sustained judgment* about the cosmos combines a submission and an accommodation to what is there.

The next three cases replace a beginning in a person with a beginning in the humanized world. We could with warrant have begun with these three, since it is in the humanized world that we spend our days. There is no praxis, experiencing, or experimenting that is unaffected by the persons who engage in them, although a machine or a robot might act without supervision, it is still one whose moves were initially ordered by humans.

4. When a beginning is made in the humanized world, the Dunamic-Rational makes possible a termination in oneself as a person. The beginning will, of course, have been made by a person who had already arrived in the humanized world and who is making use of the converse of the Dunamic-Rational move that had enabled him to arrive there. If the

contribution made by what is in the humanized world is emphasized, one will be *involved* with it. If instead the personal contribution is dominant, the result will be expressed as an *interest*. *Self-consciousness* combines the two, expressing an interest in oneself as one who is involved in what occurs in the humanized world.

We can speak to, and not just at, other humans; we can sympathize, empathize, reach toward them as individual persons. Sometimes an attempt is made to evade all discerning by others, but the attempt may well provoke and promote it, with the attempted evasion evoking a greater interest in the other as existing apart from the rest. Not only what is said, but facial expressions, bodily moves, and inadvertencies often arouse the interest of those who are involved with others and thereupon prompt sharp discernments of them. A failure to recognize the role of the Dunamic-Rational, connecting what is in the humanized world and in a person, makes it impossible to acknowledge what occurs every day and what is known to occur by almost everyone.

Learning from experience presupposes a prior transformational move from ourselves into what is independent of us, and a submission to a Dunamic-Rational beginning somewhere near that with which we had ended. An infant must first confront what is in the humanized world before he can learn from it. To do this, he must carry out the converse of the transformation that had initially accommodated what the infant had entertained. This may have been nothing more than an odd feeling. Nor will the return be exactly to the initial point, though it will usually be to some place in the person.

5. When with the help of the Dunamic-Rational we begin in the humanized world and seek to understand what is in nature, versions of the involvement, interest, and discernment that characterize passages from humanized occurrences to persons become evident. A *focussing* by us, or an *insistence* by an object, may then be prominent. The two play more or less equal roles in an *adumbration*. (Decades ago, when I first referred to depth movement, into realities, I made no distinction between adumbration and discernment, and therefore blurred the difference between a move into natural beings and one that could end in a person.) We can discern what is in ourselves as apart from all others. Sometimes we discern other persons, but we apparently cannot do more than adumbrate what is in a subhuman. That claim will be rejected by many who have pets, but they, too, will usually grant that we cannot do more than adumbrate other natural beings even though they are encountered as having been subject to humanizations just as the pets are. The failure to take account of the role of adumbration keeps one confined to phenomena, surfaces, and sense data, all afloat and possessed by no reality. A discernment is carried out in

a single move; an adumbration needs to be insisted on against a stronger and stronger resistance and adoption by what is confronted.

6. The Dunamic-Rational enables one to begin in the humanized world and to terminate at what is in the cosmos. The history of science makes evident that this is best done by specializing the Dunamic-Rational in experiments carried out in the humanized world, and then trying to capture their import in *theories* amenable to testing. An emphasis on the humanized contributions reduces the theories to viable cosmic *hypotheses.* The opposite stress on what is in the cosmos ends in *certifications.*

Although the move from the humanized world to the cosmos is what interests great numbers of thinkers today, it has not yet been well understood. The hypotheses forged by trained inquirers reflect the results of many encounters and are not to be confused with idle fancies about a world never encountered. But then what has to be shown is how such encounters are possible. To know that, one must acknowledge a prior move from oneself as apart from or in the humanized world to the cosmos. It will thereupon become evident that a hypothesis about what is in the cosmos was achieved by first moving from oneself to what is in the humanized world, and then back to oneself as occupied with providing a beginning for a transformation of what is privately entertained into what is in the cosmos.

7. If a beginning is made, not with a person or with what is in the humanized world, but with what had been dunamically and rationally reached in nature, the Dunamic-Rational may be so qualified that one arrives at oneself as having made a distinctive contribution to it. One could then be credited with a *purpose,* in contrast with a *purposiveness* that was credited to what occurs in nature. If the two are more or less in balance, the result will be a *design* in which the Dunamic-Rational is begun in a purposive nature and related intelligibly and vitally to humans with purposes. The design requires no divine backing; nothing more is needed than a natural purposiveness qualifying a Dunamic-Rational passage ending in humans with purposes. A strong evolutionary theory that seeks to do justice to the continuity and difference between subhuman and human persons keeps alert to the fact.

8. If a beginning is made with what is arrived at in nature in order to end in the humanized world, a stress on the contributions of that world to what the Dunamic-Rational terminates at yields a *stabilization.* An opposite stress on the contribution made by nature to the mediating Dunamic-Rational allows for a distinction of *kinds.* Stabilized kinds occupy *periods* in the humanized world. When we speak of our ancestors as humans existing at remote times in a humanized world, we refer to them from a

position we had already reached in nature and then had dunamically and rationally moved away from into the humanized world. An Aristotelianism, if it attends to such distinctions, can be reconciled with the Darwinism with which it has usually been set in opposition.

9. If a beginning is made with what is arrived at in nature in order to end at what is in the cosmos through the use of a mediating Dunamic-Rational, an emphasis on the outcome will end with the cosmos being accepted as existing over a series of *eras*. When, instead, the emphasis is on the contribution that the cosmos makes to nature, the outcome will end in what satisfies objective *laws*. A balancing of the one with the other allows for a characterization of the cosmos as having distinctive *layers*, reflecting the differences the laws of nature make to the cosmos in an era.

10. Having arrived at the cosmos through a joint use of the Dunamis and the Rational, a reverse move will take us to ourselves as so many persons. When the cosmic contribution to the Dunamic-Rational is emphasized, a person will be arrived at as *unduplicable*. A reverse emphasis on a personal contribution will end with its *irreducibility*. Persons are different from combinations of cosmic units and aggregates, no matter how tightly these are joined. From the position of the cosmos, their *singularity* requires for its acknowledgment the recognition that they are unduplicable and irreducible individuals that, unlike human individuals, cannot repress themselves in and through persons or living bodies.

11. One can begin with what is known of the cosmos through the use of the Dunamic-Rational and then use this to end in nature. If the contribution of the cosmos to the Dunamic-Rational is stressed, there will be an emphasis on *constancy*, if nature's contribution is emphasized, the result will be a plurality of *epochs*. The two together allow for a characterization of nature as *regulated*. These distinctions will be of interest mainly to those who seek a cosmic beginning for references in nature, itself able to affect the termination of the Dunamic-Rational in it.

12. If, finally, we begin with the cosmos and pass to the humanized world by means of the Dunamic-Rational, the outcome will be divided into *clusters*. If the cosmic contribution is greater than that from the humanized world, the result will be *arenas*. If the Dunamis and the Rational are more or less in balance, they will yield *arrangements*. Today, the move from the cosmos to the humanized world is of particular interest to those who seek to show that computers think in publicly ascertainable ways, or that knowing can be understood to be an interinvolvement among different parts of the brain, themselves to be understood as cosmological units existing in the humanized world.

Although some of the designations offered here reflect fairly common

usages, others do not. A careful exploration of the different cases will make evident whether or not other designations would be preferable. In any case, in every one of them a beginning is made in one domain, and a Dunamic-Rational move is made into another, with its beginning and ending more or less affected by what provides them.

The characteristically dominant ultimate in a domain makes it possible to start at one item and end at another there. The Dunamic-Rational in that domain has only a minor role. When, then, we wish to make use of logic or mathematics to get us from one item to another, we must abstract from what is in fact occurring in the domain. Dewey and Wittgenstein were acutely aware of the fact that the logic that is appropriate to what occurs in the humanized world is identifiable neither with a logic that supposedly holds in every domain, nor with a logic governing connections between them. Insufficient attention, though, was paid by them to the fact that, no matter what logic is applicable, it must have power enough to accept what is available and be able to end at what may not wholly accommodate it. Laws—logical, natural, and political—have a power traceable to the ultimates as existing apart from all actualities.

Language, custom, and traditional practices most evidently connect occurrences in the humanized world. In this, as in other domains, what is at the beginning and what is at the end of a transformation make a difference to the outcome. Although greetings are often casually exchanged, they may express an acknowledgment of others as persons who qualify what the greeting transmits. Conventional expressions of sympathy and concern may be charged with emphases and thereupon convey more than what is ostensibly said.

Honest questions as well as a sophisticated use of them in a dialogue reveal an acceptance of another as so far equal to oneself, but they give a new weight to what terminates at them. Even in a rigid, socially ordered part of the humanized world, questions and their answers often cut past differences at both ends. The abject, forced confession wrung from someone after intolerable beatings exhibits him as adding personal notes—as his oppressors also do—to the humanized situation in which the confession is expressed. Both qualify the common language that connects them, revealing them to be involved with a mediation having its own nature and power.

7. Relations, Terms, and Realities.

The present examination of mediators began with the recognition that actualities would be isolated were there nothing powerful enough to connect them. It was then noted that if we start with a mediator, there had

to be entities apart from it, able to qualify and be qualified by it. Yet, if we attend to a mediator, what it is to connect seems to be unreachable.

The problem has sometimes been stated as: are relations external to their terms? If they are external, the relations would have to be related to the terms, and we would have begun an endless search for relations to relate relations to their terms. Yet, in the absence of anything outside a relation and what it begins and terminates with, the relation would have nothing to relate. The termini of a relation are inseparable from it; could they not also be maintained apart from the relation, they would be pulled into the relation, turning this into a black hole where nothing can be distinguished. The independence of a relation and of entities distinct from it is a precondition for there being termini of relations. There are a number of ways the fact can be understood.

1. Each of the corners of the diagram *A, B, C, D* discussed previously has a nature maintained in contradistinction to the others. That is why it can be related to them. The antecedent *A*, e.g., could have consequents other than *B*, warrant other premises than *C*, and be related to other occurrences than *D*. The consequent *B* could have antecedents different from *A*, justify consequents other than *D*, and allow for premises other than *C*. The premiss *C* could have served other antecedents besides *A*, had other conclusions besides *D*, and yielded consequents that were not acceptable to *B*. The conclusion *D* could have followed from other premises than *C*, and is achieved under rules other than those that begin with *A* or end with *B*. It is not enough to identify the four as just being the corners of a square; they must be there in contradistinction both to the relations and to the other positions if they are to play a role in the sequare.

The diagram *A, B, C, D* is properly exhibited in a space, not because this is needed in order to enable the corners to be distinguished from one another, but to make the fact evident. No matter what the terms, they must both be and be distinct if they are to be related to one another. It is not space that distinguishes them; it is they that justify the use of a spatial configuration, making evident that they are distinct from one another. It makes no difference, therefore, whether the space of the diagram be large or small; it suffices if it is able to be as distinct from what they are as related to one another.

Abstract as much as we like, thin out whatever there be or treat everything as part of a context, we cannot escape from the fact that what is part of a context is distinct from itself as able to be such a part. Our square is not a flat surface; it is pulled down at the corners by what is not in the square. We evidently speak with remarkable precision when we say that a line ends *at* a point, and not *in* a point, if what we intend to say is that the point brings the line to an end.

There would not be anything at the corners unless it were able to be there. Nevertheless, if we are to avoid endowing what is at the corners with an inwardness of its own—substantializing it, as it were—we must go further than to remark that what is at the corners has realities expressed as pulls at the corners.

2. Each of the corners of the square exists between two others. A is between B and C; B is between A and D, C is between A and D, and D is between B and C. The pair A and D evidently terminate at B and at C, while the pair B and C similarly terminate at A and at D. A terminates and is terminated at by B and C. As that which terminates at A, each of these must have a status of its own. As that which is terminated at, A must also ground the outcome of acts by B and C. What is said here of A is also to be said of B, C, and D.

Whether, then, we begin with what is at A, or instead account for it as a product of pairs of others, it is presupposed that it is distinct, as are the pairs that end with it. We have no more reason for taking A to be the product of some pair than we have for taking it to be their common source. An antecedent is no more basic than a consequent, a premiss, or a conclusion.

Although we have here begun with A, terminated at a consequence B, taken it to provide a premiss C, and arrived at a conclusion D, all four are coordinate terms and, so far, are equally involved with one another, all the while that they exist apart from that interinvolvement. Whether it is explicated by the others, or is constituted by them, each remains apart from its interinvolvement with them. Although we can understand it to be the outcome of the acts of the others, it must be recognized to have a reality at which the others jointly end.

3. The foregoing allows for an understanding of one position from the standpoint of a pair of others, with both it and the pair credited with a distinct status and power. A more basic and illuminating way of understanding what is at the corners of the square $ABCD$ is to recognize that they break up into paired outcomes AB, AC, CD, and BD, with each pair being understood to depend on a distinctive common source. A and B, e.g., are terminal points in a rational connection, an entailment, depending on the presence of distinct A and B. Here the emphasis is on the connection that exists when and as A and B do, grounding both. This it could do only if it had a reality in which A and B were merged and was explicated by the terms as related in the square.

A and B are merged in a proto-rational AB; A and C are merged in a proto-affiliation AC; C and D are merged in a proto-dynamism CD; and B and D are merged in a proto-evaluation BD. Here the emphasis is on the merger, not on the articulation of it. There is something for relations to

relate because they and their terms are expressions of them as merged. Pairs of terms and the relations between paired items are enabled to be because they are at the preference of themselves as initially merged in a richer union.

Distinguished items are not irrelevant to one another; they are joined because they have something in common. *A* and *C*, antecedent and premiss, in limited ways articulate an interplay in a common past including them and a host of other antecedents and premisses—or, more broadly stated, in which intelligibilities, *A*'s, and occurrences, *C*'s, are interrelated with a multitude of other other *A*'s intertwined with *C*'s. A particular pair of terms *A* and *C* offer a limited articulation of what had been. The antecedent *A* and the premiss *C* are limited, specialized items carved out of the past and brought together as relevant. There is, so far, no need to refer to the reality of *A* and *C* in contradistinction to one another. They are grounded in what had been and are there together with others, able to be subsequently distinguished and interrelated as a pair. Before they had the status of antecedent *A* and premiss *C*, they were together with a host of other items, not yet able to have the status of an antecedent and a premiss.

Just as *A* and *C* articulate an indefinite past, so *B* and *D* articulate an indefinite prospective future. *A* and *B* articulate an indefinite intelligibility, and *C* and *D* an indefinite ongoing. Each of the positions on the square, *A*, *B*, *C*, and *D*, exists apart from the square because and so far as it is a merged factor in an *AC*, *AB*, *CD*, or *BD*. Where before, *A*, *B*, *C*, and *D* were seen to be able to exist apart from their relations to two of the others—so far as they continued into more intensive beings or because they were paired off in contrastive ways—they are here seen to exist apart from the square just so far as they are inseparable from themselves as merged.

4. We have now arrived, in a search for what is not pulled into a relation, at four different mergers. The four are together in two ways. They are alongside one another, and they belong together. Were they not alongside, they would not provide equally satisfactory groundings for the pairs *AB*, *AC*, *CD*, and *BC*, did these not belong together, equal groundings would not be coordinate. As will become evident, a primal One, Being, alone provides what is needed, but only so far as it is inseparable from a plurality of basic items. It is possible to acknowledge a plurality of situations in which terms in relations have a status apart from the relations because that plurality exists as the counterpart of a primal unity. It will become evident in the next chapter that the attempt to determine how terms could have a reality distinct from the relation that joins them is a version of the problem of how there can be a plurality of

realities distinct from a primal Being to which they are inescapably subject.

If we start with relations and seek what exists outside them as able to make those relations not only have termini, but have something to connect, we reach the same final outcome we could have reached had we started, not with relations such as those illustrated in the square with corners *A, B, C, D,* but with realities, and then tried to understand how there could be relations distinct from but able to relate them. "Tom loves Mary" offers as good an illustration as any. Both Tom and Mary are realities, here joined by the relation 'loves'. Tom and Mary continue to be Tom and Mary apart from that relation. Neither alone could produce the relation. Although Tom could love Mary even if she knew nothing about the fact, they would still be related to one another in two ways. In the one, Tom and Mary would be in a relation having the intelligible nature of love, in the other, they could be interinvolved in an activity of loving. Just as they had to be apart from the relation 'love' in order to be related in this way, so they have to be apart from that relation in order for the relation to have them as related.

Tom, as related to Mary by 'loves,' exists apart from this; he usually discovers quite soon that Mary also exists apart from that love. Whether or not she was aware of him, or of his love, she exists. He, too, though he may be unable to escape from loving Mary, continues to be apart from the relation. He lives, eats, walks, sleeps, thinks about other things, even while apparently unable to do so. He exists as a separate reality, living at a pace and in a way that often has little or no relevance to his loving. Tom is Tom and Mary is Mary, apart from the loving that relates him to her. No matter how many relations connect them, Tom and Mary continue to be not only apart from one another but from every other relation that might connect them. They are not only distinct from one another in the humanized world, but they have their own centers as realities. Only relations that could reach to and subject them to demands could possibly connect them. This is what the ultimates do. Because these have powers of their own, they are able so to counter the independent realities of Tom and Mary with a power that enables Tom and Mary to be related. Because and so far as relations function as mediators, there can be relations not only able to have terminations, but to be in fact affected and qualified by realities existing apart from those relations. Not only must we recognize that there are realities that are more than termini of relations, but also that there are relations that are more than connectives with termini. Relations impose demands on what they relate, and thereupon reveal themselves to have beings of their own.

Realities need something that relates them, thereupon revealing them-

selves as termini. Idealism and other forms of contextualism meet the first requirement; empiricism and other disjunctive accounts meet the second. They need one another. Since there must, at the very least, be some relations with termini that encroach on what exists apart from those relations, and also realities that are related by what has some reality as well as termini of its own. The neglect of ultimates, with their power to begin at realities existing apart from them and to end at other realities that can accommodate or reject them, ends either with a primary relation that has nothing to relate, or with a plurality of units that cannot be related.

Starting with relations, we finally arrive at what all presuppose: a reality that necessarily produces what divides into a contingent number of ultimates that may or may not thereupon act to confine members of various domains, as well as the Habitat with its subdivisions. If the ultimates do so act, they will finally be faced by what owns them. These— the members of the domains, the Habitat, and its subdivisions—are Being itself in confined forms. They would add to the totality of Being, and thereby make Being be less than what cannot be added to or subtracted from, were they anything other than what Being itself provides when the ultimates are instantiated together.

Confessedly, these observations awaken demands for clarification, and for a removal of perplexities and doubts. Some sharp questions and answers may help dissipate these, preliminary to the presentation of a final, justified move from actualities to the ultimates, from these to what they presuppose—Being itself—and a return from this to the ultimates and finally to the actualities with which we began. If, and so far as, it can be shown how a justified move to Being is matched by a move from this to the ultimates, and from these to the members of domains and to the Habitat and its subdivisions, a comprehensive, integrated account of the nature of realities will have been brought to a satisfactory close. Some preliminary questions and answers:

Q: Are you saying that every relation needs what is distinct from it if this is to provide the relation with terminations?

A: Yes. Otherwise, there would be nothing but the relations and their endings, endings that have no end.

Q: Yet those endings cannot be entirely cut off from realities existing apart from the endings?

A: Yes, were there no realities to which the endings of relations are connected, the endings would not be able to be terms for the relation.

Q: You are talking about relations whose termini are not fictions?

A: Yes, but what is being said applies to the latter as well. There could not be an imagined war between the Greek Gods if these were not more

than imagined terminal points in the supposed war. Imagined to be at war, they must incidentally be imagined to be distinct from the war.

Q: Aren't you caught up in an infinite regress no matter what status you take the realities outside relations to have. The terms of your relations have to be related to what exists outside the relations.

A: What is outside a relation is a term in it, but intensified, able to do other things as well. What is a term in a relation is continuous with what is outside the relation; there, it has a nature, power, and ways of acting otherwise.

Q: Does this not mean that in any relation xRy the x and the y have two roles, one in which they are parts of a single relation, and another in which they exist apart from this? Must they not also have a reality between the two, be it that which is both in some relation and also not in it?

A: Yes, but that existing apart is of many different kinds. There is an existing apart as at a position—what I have treated as the corners of the square $ABCD$ bent away from themselves as not related there.

Q: But you are not satisfied with that answer?

A: I am not, because that standing away is relative to the interrelated $ABCD$.

Q: You therefore hold that the pairs AC, AB, CD, and DB are the outcome of common sources, different from them?

A: Yes—but that answer needs to be completed by asking how the sources are related.

Q: There never is a term in a relation unless it also is interinvolved with what is not in that relation?

A: Yes. But it must not be supposed that what is between the two is just a product or a source of them. It is both at once, explicable by and explanatory of the two.

Q: Would it not be more accurate, then, to say that every entity has three roles or natures?

A: Yes, but we must then avoid supposing that there are other realities between pairs of them.

Q: How could that be avoided?

A: By recognizing that what is between a pair is a particularized version of what mediates them.

Q: A as not separated from B or from C is richer than one that is separated from them?

A: Yes and no. A as in a relation to B or C is a thinner version of A as merged with the one in a primal intelligibility and with the other in a common past. A, e.g, is rationally related to B. The two avoid being absorbed within a rational connection only because and so far as they are

merged in a more basic rationality. They are distinguishable in this as that which itself needs to be unified. What is true of *A* and *B* is true of *A* and *C,* and of *B* and *D.* Each of these pairs has the members interinvolved but still distinguishable. We get to a final answer only when the unities characteristic of the different pairs are joined, at the same time that the pairs are alongside one another.

Q: This is incredibly obscure!

A: Yes, for it's largely anticipatory of what will be discussed next. A final unity, Being, will be shown to be presupposed by everything else. When it is here said that *A* and *B,* in order to be distinguishable from themselves as mere terms in a relation, need to be brought together in what has the two merged while they continue to be distinct, and that there is a unity on which they depend, and conversely, the final answer is foreshadowed. We cannot get to know how related terms could also have the status of realities apart from the relation without sooner or later acknowledging the terms to be distinct entities, inseparable from a more basic unity.

Q: Doesn't one end with interinvolvements disconnected from one another?

A: Not unless we refuse to take the further step and show how the different interinvolvements are both together as distinct and subject to a single final unitary Being. We come to an end with Being and what is distinguished from it. If we were to stop with Being, it would be with what makes itself be a term. If we were to start with what is distinct from Being, it would be with a term that is an irreducible reality. Neither claim can be well understood without the other.

Q: You seem to answer a question everyone answers every day by moving to a consideration of issues that are strange and perhaps untenable. We all know that it is Tom, as not involved with Mary, who is able to love Mary and who is also outside that relation.

A: Tom and Mary are outside the relation in many ways. Neither Tom nor Mary, nor the relations between them, are inexplicable. All three remain distinct and are interconnected. The fact becomes most evident when the relation functions as a mediator taking us from a beginning at Tom to Mary as accommodating or rejecting the love terminating at her.

Q: You have yourself remarked on the fact that we can intensively move beyond what we confront, say a Tom and a Mary, and even a cat, and perhaps a thing, as outside all relations. Why is it not enough to say that there is a Tom and a Mary who can be discerned or adumbrated, and a love that relates them?

A: It would be enough if all we wanted to know is how to join them. What is now being shown is that if we start with a Tom and Mary, we start

with what is able to be adumbrated or discerned, and that if, instead, we start with what is already joined, we have to account for what could be available for such joinings, and adumbrations or discernments as well. Once entities are known to be outside all relations, references to relations will be needed to show how they could be together. This particular examination was begun by viewing a pair of items and trying to find out how they were able to be related, and therefore what kind of reality they had apart from the relation. It ends at distinct beings and Being. The solution is like that which can be reached by considering a single item, a mere 'this'. If, as Hegel supposed, we can get no further than to a 'thisness', a universal rather than an unduplicable obstinacy, we will be left with nothing to do but interrelate the primary 'thisnesses' in a final all-encompassing reality. Each 'this', though, has its own insistence; it is differentiated from 'thats'; it can be together with such 'thats' in many ways; and is always dynamically joined to them. It could be with others in different ways only because it not only exists apart from all other 'thises' but from all relations, the ultimates, and the Being those ultimates presuppose.

Q: This is not very clear. Let it be granted that you have somehow shown that all terms and relations, and even a radical singular such as 'this' or Being must exist in these various ways. You still must show that a 'this' at least exists apart from all else and that it is related to a Being. Otherwise you will end with your despised contextualism, in which every designated entity is no more than a termination in a single whole, apart from which there is nothing, not even those who are defending the view or those whom they are trying to convince. Is there something that is to be contextualized? Could it be known without it thereby becoming contextualized? Aren't your supposed irreducible Being and individuals, or the Habitat in which these are distinguishable subdivisions, all interinvolved? Don't you end with a context from which nothing can be separated out? Hasn't your pluralism turned out to be no more than a multiplicity of stresses in a single whole in which you, too, are absorbed, and whose nature could not possibly be known?

A: That is a frightening prospect. I know that none of the current and favored views can escape it. You are asking me, I think, to show you that it is possible to affirm that there are realities outside all contexts.

Q: Yes, but also that you can account for the reality of each of us, without contextualizing any. Can you do that?

A: Y-E-S; I think I can.

6

Being, the Ultimates and Actualities

1. Evidencing the Ultimates

There are a number of distinct kinds of finite entities—the members of domains, what is constituted by a merging of contributions from adjacent domains, and the Habitat with its subdivisions. All are confined by and own a combination of all the ultimates in a distinctive order. The members of each domain instantiate the same ultimate in a dominant position, with the other ultimates subordinated to it in various ways and degrees. A pair of ultimates, the Dunamis and the Rational, are dominant in what exists between adjacent domains, as well as in what confines and is owned by the Habitat. The other ultimates, the Affiliator, Assessor, Voluminosity, and Coordinator, are dominant in humanized actualities, persons, natural occurrences, and cosmic bodies, respectively.

Were the Rational or the Dunamis dominant in all actualities, these would be in one domain, but were the two dominant in some one domain, they would so far not enable the members there to be distinguished from the members of other domains. There would be no ultimates able to mediate what is in one domain and what is in any other. Nor would there be a Habitat or individuals, able to own what is in an adjacent domain or to own what joins contributions from these. There could then be persons, organisms, and humanized beings, but there would be nothing that owned and might use these and what they jointly constituted.

The Dunamis and the Rational are primarily mediators, making it possible to pass from what is in one domain to any other. They also provide evidences of themselves and all the other ultimates as not yet instantiated.

None of the ultimates is necessarily instantiated. Nor need there have been any actualities, a Habitat, or its subdivisions. All of these exist contingently. Although they now exist, they might not have. All might cease to be.

To account for the existence of actualities the Habitat, and its subdivisions, reference must be made to their sources. If those sources were other contingent realities that had preceded them, we would be driven back and back in time, never arriving at an answer. To understand why this or that contingently existing reality is, we must acknowledge a source, different in nature and act from all of them. If that source does not itself necessarily exist, it too would have to be accounted for, but in a different way from that attempted by one who tries to account for present actualities by referring to others that had preceded them. A 'big bang' or some other version of a first occurrence to which all others can be traced in time arbitrarily acknowledges some one initial contingent occurrence. Were it accepted, one would be faced with the same question that now faces us: why did that initial event occur, though it conceivably might not have?

To account for present contingently existing realities, it is not enough to take them to be the remote effects of an act that conceivably need not have occurred. Kant made the fact evident in his first Antinomy. He then examined what he took to be its antithesis, "The world has no beginning, and no limits in space; it is infinite as regards both time and space." He thought this to be the counterpart of the other and concluded that there was no way of resolving the problem. The antithesis he should have examined is whether 'the world', i.e. all contingent existences—even a Habitat and its subdivisions—could be accounted for. Their source must be other than something subject to the difficulties to which these are subject. One must take account, not of some contingently existing 'first' occurrence, but of what any and every occurrence presupposes. This could be—indeed, it will be seen, it in fact is—what might have been otherwise in nature and could act in ways it need not. Itself contingently existing and able to act in contingent ways to constitute contingently existing actualities, the Habitat, and its subdivisions, it will, though, itself be subject, not to what necessarily precedes it in time, but to what exists when and as these do.

A move from contingently existing, confined realities to the sources of the ultimates that confine them is a move to what itself contingently exists. This move differs in nature and kind from a move to a temporal antecedent that is subject to the same conditions as that with which one began. To get to the source of confining, instantiated ultimates, use must be made of the Dunamic-Rational. This enables one to evidence all the ultimates—and

therefore the Dunamis and the Rational as well—as not yet instantiated, not yet confining, not yet possessed or owned.

There have been monisms which have acknowledged the Rational, and others that have acknowledged the Dunamis as the ultimate that alone governs and interrelates all actualities. Four other monisms can be envisaged. In one, the Assessor would constitute and relate all realities; in another, the Affiliator would do this; in a third, Voluminosity would relate all as so many natural beings; in a fourth, the Coordinator would relate all as unit, cosmic bodies. Each monism would treat what occurs in any domains in terms appropriate only to the one in which its chosen ultimate had a dominant role.

Each monism is both superior and inferior to one that supposes either the Rational or the Dunamis to be dominant in every actuality and relation—superior since it takes account of what occurs only in some domain, and inferior since it cannot apply equally well to every actuality, or allow for a passage from one kind of actuality to any other. Formalisms and materialisms, as well as the two together, provide relatively better accounts than these other monisms because the Rational acknowledged by the one and the Dunamis acknowledged by the other are dominant factors in no member of any domain. They could, therefore, both relate the members of all the domains, making it possible to evidence all the ultimates. When the ultimates are jointly instantiated, they provide evidences of themselves. Those evidences can be used to reach the ultimates as they exist apart from those instantiations. The Dunamis and the Rational are alone in the position of being able to begin in any domain and reach all the ultimates, themselves included, as yet not instantiated.

All the ultimates jointly constitute actualities, whether we know of the fact or not. We can come to know those ultimates as being presupposed by every actuality only after we know them as instantiated in some domain. To learn about them, as existing apart from their instantiations, we must begin at some actuality and, through an evidencing act, finally arrive at them as uninstantiated. All of us are familiar with this process, though we engage in it deliberately only occasionally and carry it out only casually and incompletely. When we pass to 'Tom is *a* man' from '*This* man, Tom' we move from an instantiated 'man' to 'man' as able to be instantiated. It is the latter that Tom and others possess, because and as each is a 'this-man'. Only an extreme nominalism rejects that claim, all the while that it holds that the 'nominalism' has a universal application differing from every instantiation of it. Unlike the universal 'man', the ultimates have powers of their own. They are confronted, not by an effete 'matter', but by actualities having power enough to own them as instantiated.

Were there no instantiated ultimates that were constitutive of every

actuality, as well as of the Habitat and its subdivisions, and were those instantiated ultimates not owned by the Habitat or its subdivisions, there would be nothing that was necessarily common to a multiplicity of actualities, or to a multiplicity of individuals. We must join the opponents of the nominalists, but unlike most of those opponents, without supposing that there is something inert that nevertheless enables the ultimates to be instantiated. Such suppositions allow for nothing that could be both confined by and able to make use of those ultimates. It surely is an error to suppose that the ultimates are all-powerful, controlling, and golden, and also that they are somehow supported and localized by what is passive and irrelevant. Agreeing with the opponents of nominalism that what is instantiated presupposes what is being instantiated, one must still evidence the ultimates as having the power to come together and be instantiated as the constituents of every distinct reality, confining what in turn possess or owns them.

One readily turns away from an attempt to acknowledge what is common to all actualities as having realities of their own, usually because it seems apparent that actualities are not only irreducible and obstinate, but that what they instantiate is flimsy and feeble. It is true that the weakest of men is stronger than 'man'; there is an obstinacy to a dead leaf that 'leafness' lacks. The further we move from actualities, the more we seem to be caught up in fantasies.

The power that the ultimates have is not greater than that characteristic of universals. It is exhibited in their act of jointly confining what express itself in and through them. Instantiated ultimates have an insistence and a use that no universals do. To know them as they are apart from their instantiations is to know what has power enough to confine what can make use of them.

Not idle universals they, like these, are present in any number of distinct, finite occurrences. Like the medieval transcendents, they are pertinent to every actuality, no matter what the domain, 'species', or 'genera.' Unlike those transcendents, but somewhat like medieval 'angels', they act in distinctive ways. Unlike these, though, the ultimates have neither wills nor ambitions.

It has here been maintained that there are six ultimates. I may be mistaken about their numbers and kinds. It now seems clear, though, that there are a number of domains, and we know that the members of them are similarly confined and possess and make use of them. Equally evident is the fact that the Dunamis and the Rational alone enable us to pass in intelligible, effective ways from one domain to another, as well as from instantiated ultimates to them as apart from their instantiations. The fact that the members of one domain are differently constituted from those in

another does not affect the Dunamic-Rational evidencing of all the ultimates nor the Dunamic-Rational's passages from one domain to any other.

The ultimates could conceivably be joined in many ways. Any one of them could conceivably be dominant over all the other ultimates, and so far justify a monism in which actualities would differ from one another in the degree to which subordinated ultimates affected a single dominant one. It is also possible to envisage a monism in which all actualities were constituted primarily by the Rational, or by the Dunamis, differing only in the way they affected or were affected by it. One might also envisage other monisms in which other ultimates, separately or jointly, were dominant. One would then have to find an explanation for the existence of one of those monisms rather than any of the others—or end with a mystery.

No one ultimate or combination of them is necessarily dominant over all the others. Nor is any one necessarily subordinated to every other. If there are any ultimates that are recessive in all actualities, they would be intrinsically inferior to the rest—unless they could dominate over these in some other ways. Both the Rational and the Dunamis meet those demands.

Each monism is one of a possible number, whose selection is still to be accounted for. All stand in contrast with a pluralism of domains, for none is more than a 'possible world'. They are in fact not possible at all, if by 'possible' one means actualizable. An actual world does not allow any other to be possible, though it does allow for possibilities that could be realized in place of whatever actualities there are in fact. What is possible is not an alternative to what exists; it is what is able to be realized with the help of what does exist.

Both a monism and a pluralism require references to agencies connecting different cases, the one joining what could be or could have been apart, the other acknowledging the distinctiveness of basic kinds of realities. A One that concerns the first is not possible without a Many that concerns the second. A pluralism does not preclude its acknowledgment of a One, but indeed it insists on it as a precondition for whatever else there is. The Many—ultimates—that must be allow for other manys, particularly the members of different domains.

The contingent natures and existence of the members of domains, what exists between adjacent domains, and the Habitat and its subdivisions, make evident the fact that the ultimates need not have had the natures they do or acted in the ways they have. It does not follow, though, from the fact that the natures and number of the ultimates might have been otherwise, that the ultimates might never have been or that they could ever cease to be. All depend for their existence on a necessary act by what they all presuppose. That act, it will soon be evident, necessarily ends

with the production of ultimates that, on their own, subdivide and may then act in ways they alone determine. One must acknowledge the ultimates, not in order to patch up an Aristotelian scheme in which there is no way of referring to all the 'genera', but because the ultimates are constitutive of every actuality, play a part in all evidencing, and are presupposed by every finite being. They are instantiated, confine, and are possessed and owned. They are owned by what they jointly confine.

A refusal to acknowledge any ultimates leaves one facing a number of them as instantiated together in such weakened forms that they could not enable one to pass from one item to another even inside a particular domain. All of the ultimates have effective mediating roles, though only the Rational and the Dunamis together are able to take one from what is in one domain to what is in any other, or to all the ultimates and therefore to themselves as well, as presupposed by all actualities and relations. Only these two are recessive in the members of every domain.

Bergson's *élan vital* offers one version of a dominant Dunamis. Logic offers one version of a dominant Rational. References to responsibility are to limited expressions of the Assessor. Naturalists make primary use of Voluminosity. The Coordinator has a primary role in the cosmos. All should be acknowledged since all play some role in every actuality and relation and in the evidencing of the ultimates as not yet instantiated. When their separate contributions are fixated, the Rational will be favored; when the two are taken to be in a changing relationship, the Dunamis will be more evident. A pure and frozen form, and a sheer reified ongoing one are abstractions from them; the two are always together.

The process of evidencing the ultimates is not well controlled. Beginning with what is not fully understood; at its best, it comes to a final resting place at what is freed from the contributions that had been made by what the ultimates jointly confined. Through the process of evidencing the ultimates, one comes closer and closer to them as they exist apart from all their instantiations. We gain from that act, for the ultimates as not instantiated have a range and a power greater than they have as instantiated, and that they have for us as possessors, owners, and users of those instantiations. We can and we do act in ways those ultimates do not; we can and we do produce what they cannot; we change, build, and destroy what they do not and cannot. The facts should not be permitted to stand in the way of the truth that it is the ultimates that are instantiated, that it is these that confine, and that it is these that relate and mediate.

In a process from what is in one domain to what is in another, one begins with one kind of actuality and ends at another. In a process of evidencing the ultimates, one comes closer and closer to what exists apart from all actualities and their interconnections. Neither move can be

reduced to the use of hypotheses, theories, suppositions, intentions, plans, or posits, since none of these provides a means for arriving at anything that exists anywhere but where it is entertained. When references are made to tests or to confirmations, a move is made to something distinct from, and which may not accommodate well what was initially entertained.

A Peircean abduction tries to take one to what is supposedly relevant both to that with which one begins and that at which one ends. It is not evident what this could be, other than what has power enough to use what is in one domain as a beginning for an act ending in what is elsewhere. To end with what might or might not be instanced elsewhere is not yet to have what is needed if what is entertained is to be carried forward to what may or may not accommodate it. Abductions, to be useful, must bridge the gap between where one begins and that which brings an act to an end. They must, therefore, be no more than mediators shrunk to a point, with their connections to their beginnings and endings ignored. A mediator stretches between its own terms, as affected by realities distinct from those terms. What alone could mediate a supposition and an occurrence, that will accept or reject it, has a reality and a power enabling one to begin with what can be brought to bear on what exists apart from it and on what had been supposed.

It is possible to begin at one place and end at another with the help of what adopts whatever is available at one place and awaits accommodation or rejection by what is at another. One would not, though, yet be in a position to say that what one had entertained was true, but only that what one had entertained had been brought to an end by something. To know that what had been entertained is true, that one's hypothesis is confirmed, one must begin with what had accommodated a mediator and, with the help of another mediation, arrive at oneself as receptive of what is included in it. Only then will the hypothesis that one had entertained be ended at as altogether, or as more or less true or false. The more practical the man, the less likely he is to have an interest in knowing what he had supposed is true, since he will be content with seeing if what he had entertained is in fact accommodated by that at which a mediating act ends. Were he interested in arriving at the ultimates, he would contentedly end at them. Had he preceded his move from the ultimates by some instantiation of them, he would end at the third of three mediations—one taking an idea of his to the ultimates, a second in which the idea was accepted by them, and a third in which they ended at some actuality.

Usually, we make what we entertain available to a mediator and await its arrival at what more or less accommodates it, and then treat the outcome as the beginning of a move to oneself, as having provided a

beginning for the mediator. It may take a considerable time to arrive at the ultimates, not because these are at supposed spatial or temporal distances from their instantiations, or because we seek to overcome difficulties and dangers, but because we begin with what is not entirely clear or detailed.

We are usually receptive of some mediator while attentive to its termination as a prospect needing accommodation. A knock on the door makes us alert to the door as that which our walking will enable us to reach. Instead of entertaining a hypothesis or submitting to a mediator, we are prompted by a knock on the door to accept a mediated walk which ends with our being at the door. If one wishes to speak of entertaining a hypothesis about a knock, a door, or someone at the door, it would have to be added that the hypothesis is the outcome of a mediation carried out from the door to us, we who must then engage in the distinctive mediated act of walking to the door.

One may take considerable time to arrive at the ultimates, not because these are at a spatial or temporal distance from their instantiations—intensive moves reach what is already present, but in richer and more powerful forms—but because the move begins with what is partly qualified by what possesses the instantiated ultimates, and ends with the qualifications eliminated.

Evidencing passes from the constituents of an actuality to these as not instantiated; it does not take one from appearances to what appears. Such a move would end at an actuality. The evidencing of ultimates leaves behind that at which it begins, to end at what is presupposed. I am able to evidence only six ultimates. Conceivably, there could have been fewer or more of them. Why then are there just so many? Spinoza boldly answered: there are in fact an infinite number that together exhaustively express Being's—he usually says 'God's'—essence, nature, meaning, or reality. It is not evident, though, just how the infinite number of these 'attributes' supposedly expressing Being's essence, exhaustively differ from the Being they severally and apparently fully express. If they could not act independently of that Being, there apparently would be nothing but that Being. Nor, is it evident how there could be any 'modes', contingent existences, or subdivision of the attributes of God.

Those who call Spinoza a 'pantheist' or 'God-intoxicated' suppose that the attributes of his God have no independent ways of acting, and that the 'modes' of those attributes are subdivisions of them. The first book of Spinoza's *Ethics* provides a good warrant for these claims, but the rest of the work requires the acknowledgment of humans who are able to be and to act in contradistinction to any of the attributes and to the Being that subtends these.

Spinoza thought that we know only two of the infinite number of

attributes, but he did not tell us why we do not or could not know more. Nothing in principle would have had to be changed for him to have acknowledged a greater number than two. Had Spinoza also not tacitly begun with the supposition that there was a final Being that had an eternal essence from which its existence supposedly followed necessarily, he could never have known of its supposedly self-caused infinitude. It is an odd rationalism that claims to know that something has an infinitude of equally revelatory and basic attributes, and then claims that we can know only two of these. If any one of the attributes expressed God's essence perfectly, moreover, there should have been no need to know any others. Since Spinoza acknowledged only a 'mind' and an 'extension' (i.e., the Rational and Voluminosity), he left no place for vitalizations, values, coordinations, or affiliations, though again and again he refers to what instantiates these.

We can know that there are no less than six ultimates, because we not only can distinguish their instantiations in actualities but can evidence all of them. Since six is but one number among many, and though it is a 'perfect number', there is no contradiction involved in supposing that there could have been more or less than six ultimates. Nor would it be amiss to suppose that any or all the six might have had natures other than those that they now have. Were there no more than the four that were dominant in the different domains of which we now have knowledge, there would, of course, be no way in which we could pass from one domain to another, or could evidence all the ultimates as sources of the constituents of whatever actualities there be, since there would then be no neutral Rational and Dunamis bridging the gap.

Were there in fact more than six ultimates, we might at some time learn about them, either by carrying out another analysis of actualities, or by carrying out a better evidencing. In any event, we are now faced with the question: why are there the six we can now distinguish and evidence, when there could have been more or fewer, and ones with natures different from those now known? The full answer to that question awaits the discussion in the last section of this chapter. An anticipation: every actuality presupposes all the ultimates. Since these could conceivably have been different in number and kind, their present number and kind are evidently contingent outcomes, what need not have been. Also, since ultimates might not have done anything, and might not have acted in the ways they have and do, they evidently have acted and do act in ways they need not have.

If what the ultimates themselves presupposed had a nature and way of acting that might have been otherwise, we would be forced back from this until we came to what is necessary in itself and necessarily does what it

does. If then we are to account for what might have been otherwise, we must, sooner or later, not only acknowledge what necessarily is and necessarily does what it does, but also show why and how it necessarily produces what might have been otherwise.

2. Necessity and Contingency

In his brilliant examination of the relation of master and slave, Hegel recognized that the slave has to act on his own in order to provide what the master demands. Hegel thought that the slave thereupon put himself on a footing with the master, since he, like the master, subjected what he acted on to his own determinations. Though there surely is a sense in which a slave's acts give him a status that he did not have as someone subject to the whims of his master, he still continues to be a slave, commanded, limited by, and subject to the decisions of another. Hegel did not take note of the fact that, even if the slave did what was beyond the capacity of the master to control, he still remained a slave. Even if his virtues, skills, and accomplishments reveal him to be superior to his master, he still is his slave. Even when he does what the master decrees, he does what the master cannot prevent. Yet were the slave tied up hand and foot, or had every move controlled, he would still be able to blink, breathe, and engage in a multitude of acts in distinctive ways. Beaten into submission, yoked to a plow, made to move in this direction or that at a pace dictated by the master, he would still act on his own. Like the master, he engages in some acts that are not decreed; at the very least, he carries them out in demanded acts in ways that are then and there determined by himself. No one can be completely enslaved. The most subjugated of agents still remains one who is a reality existing and acting in contradistinction to every other.

Every agent has some degree of independence from his principal. Were a slave completely cowed, did he do nothing but follow orders slavishly, he would still be one who was different in being from the master, and would inescapably express that fact at least in his breathing and his heartbeat, his fear, resentment, and dismay. Even when he did exactly what the master demanded, he would qualify it in ways that reflect the fact that he is other than his master, expressing himself in a distinctive way.

The most perfect agent is an independent being, differing from all others not only in doing what is decreed but in continuing to benefit the principal, even when acting independently, doing what was not demanded. No human is that perfect. Since a human principal may demand what would be to his disadvantage, his agent, to benefit the principal maximally, may have to do some things the principal did not prescribe,

and sometimes even do what was forbidden. Generals under a dictator are faced with this problem again and again. Those who act to benefit the dictator by going counter to what he demands depend on brilliant successes to justify their bravado.

In Hegel's system, 'contingency' is a category, just as 'necessity' is. Like this, it is a necessitated and necessitating part of a set of positions produced by a final, absolute power. Neither that category nor any other in the system exists at any other place than where it must be, or does anything other than what it must do. His system might prescribe a place for it, but the occupation of that place and functioning there require actions that are not in that system of necessarily linked items. A category that did not exist in contradistinction to the place it had in the whole would be no more than a punctuation point in that whole. If there were no contingent occurrences distinct from the category, the category would have no application and could not exist in contradistinction to the whole. A system such as Hegel's allows neither for a genuinely distinct category of contingency, nor for contingent occurrences.

Hegel emphasized the power of the 'negative', but seemed to give one end of it a greater power than he gave the other, or, at least, took it to be privileged over the other until this one independently achieved an equal status, preparatory to its being melded with its correlate other. While recognizing that enslavement depended on acts by both, the master imposing it in place of killing, and the slave accepting it so that he could continue to live—evidently a paradigmatic case—Hegel seemed to think that the slave escaped the burden of his enslavement by separately involving himself with what he had to do.

In Hegel's system, there had to be slavery, and it had to occur at a particular position in a supposed inescapable progression toward an Absolute Mind, but we know that slavery occurred before and after he assigned a place to it. There are, moreover, prostitutes who never achieve an equality with their masters by carrying out their required work. Never completely controlled, acting in their own ways, they continue to be enslaved. But, like more benign connections between principals and agents, their enslavement still allows for some contributions by them that their principals could not preclude. Each carries out her prescribed work in her own way, but without ever becoming the equal of those who command her. Because she is not a perfect agent, she will do more or less or other than what is demanded. Only Being could have a perfect agent.

Since the category 'contingency' is no less clear, elegant, limited, or required than the category 'necessity', it provides as respectable a means for classifying occurrences as this does. It could characterize every occurrence, no matter what the domain. If it provided a stopping point in

a necessary progression to an Absolute Mind or Being, it would still provide a place for what need not have been. Contingent occurrences might themselves be necessarily linked, their contingency expressed in their place within the linkage. They may be expressed as well in details and insistencies, in acts that might have been elicited and limited by what else occurs, without losing their distinctiveness.

'Contingency' refers to what need not have occurred. It is inescapable if there are agents of any kind. Even if a principal acted necessarily and was in firm control of its agent, the control could never be so complete that the agent could not do what need not be done. The greatest of realities might—indeed, it must—do only what could not be otherwise, while the lowliest of realities is always able to do what it need not do. Caught in a necessitation, this will still be what could be so caught and will be able, so far, to exhibit itself as not yet necessitated. Only what is less than perfect is able to do what need not be done.

The ultimates are not categories, but realities, able to join one another, and to be instantiated together. Were they necessary in themselves, they would necessarily do what they do, but since they might not have constituted any actualities, and since they might constitute others than those they do constitute they evidently do not necessarily do what they do. Since, too, there could have been a greater or lesser number of them than there now are, with natures different from those they now have, they are evidently contingent in number as well as in kind. Why do they have the natures and numbers they now have when they could have had others? Why are there any ultimates? If the answers to these questions were provided by what was subject to the same questions, we would be on our way over an infinite regress of explanations. If, though, there were a final necessary Being that was the source of the ultimates and could not have been otherwise or have acted in any other way than it does, it would have had to produce whatever ultimates there are, even though these have natures and are of a number that could have been otherwise.

The ultimates might have been different in nature and number than they are. The actualities they have constituted might not have been. Unless we can pass beyond the ultimates to what is necessary in itself and necessarily acts as it does, we will not be able to account for whatever ultimates there are, for their contingent natures and numbers, or for the existence of any actualities.

The ultimates are perfect agents. Being produces them to do what it needs to have done. Being makes the ultimates exist. In addition to doing what Being demands, the ultimates exist and act in ways Being does not prescribe. When they do what they must, they are oriented toward Being; when they do something else, they are turned away from it, existing and

acting as separate realities, able to join one another and constitute actualities and fields. They not only produce what might not have been, but do so in such a way that the expression of their independence from Being will be matched by their service to Being.

The ultimates are Being's eternal and perfect agents, necessarily doing what Being demands, but always benefitting it even when they act in other, not prescribed ways. Perfect agents, they do what they must. They may, but need not, do anything more. If they do, it will be by acting in contingent ways that will be what Being demands to be done. All other agents also act on their own, but unlike the ultimates may produce what is not acceptable to their principals.

To account for actualities and fields, we must refer to the ultimates as acting together. They need not have done so. Whether they do or not, they will themselves have been produced by Being to do what it requires, while still able to do something else. If they do something else, they will produce what need not have been. If what they did, did not also serve Being, there could be occurrences in addition to Being that might limit or oppose it. That is impossible. Nothing could limit or oppose what is necessary in and of itself. Though the ultimates can act independently of it, they inevitably carry Being forward within what they jointly constitute and, thereupon, provide for what compensates for the freedom that those ultimates had exhibited. When instantiated together, the ultimates convey and confine Being, within their limits as individuals. These are Being itself, owning the ultimates to the degree that those ultimates had acted independently of Being.

No actuality is necessary in and of itself, if for no other reason than that it is finite and, so far, limited. What is necessary in and of itself cannot be limited by anything, unless it demands that it be limited. It will then produce what can do this. That in fact is what occurs, for in order to be possible Being produces that which enables its possibility to be effectively referred to Being.

Conceivably, there might be just one actuality. No matter what its magnitude or dignity, it will be finite. Whatever its nature, and no matter what it does, it will be a contingent reality, what need not have been. Nor is any ultimate or any number of them necessary in and of itself, for, though whatever ones there are necessarily are, being the outcome of a necessitating act by a necessary Being, they still could have been otherwise and could have acted in ways other than they have, in addition to any that Being necessitates. Being could not necessitate every act by the ultimates without denying them the status of agents required to be and do what it prescribes and to serve Being.

The necessary and the contingent are distinct, each with its own nature and power. Only the contingent could be credited with freedom, the ability to do what it need not. Since Being cannot do anything other than it does, it evidently is not an absolutized form of ourselves. When Being lets the ultimates be and act independently of it, it still precludes them from doing what does not benefit it. It does not impose restraints on them, but by supervening over them it is able to possess and use what the ultimates independently produce. The ultimates join and act in ways Being does not demand, but whatever they do will provide a means by which what the ultimates themselves do will be matched by Being's possession of the result.

Being allows the ultimates no other status but that of perfect agents. It makes them function on its behalf, enabling it to be possible and to possess and use whatever else the ultimates might produce. The constituting of actualities need not have occurred, but once it occurs, Being is provided with the opportunity to match the independence that the ultimates exhibited by a possession of the result. When the ultimates constitute actualities and fields, they provide limiting confinements for the Being that enabled them to act apart from it. It does, though, seem odd that Being, what is necessary in and of itself and necessarily does what it does, could be limited in any way. The apparent oddity is due to the fact that one had overlooked the truth that what is necessary in and of itself necessarily produces what necessarily does what it (Being) requires and, therefore, must exist apart from it, and be able to act in other ways as well.

Were there no ultimates that did what Being prescribed, there would be nothing that enabled the possibility *of* Being to be a possibility *for* Being; instead, the possibility *of* Being would just dangle from it. Being necessitates that there be what separately exists and acts, in order that Being's possibility be a possibility *for* Being. Being necessarily produces what enables the possibility of it to be maintained apart from and be referred to it.

What is necessitated is necessarily linked to what necessitates it; what is contingent exhibits some independence from its source. Evidently, necessitarian schemes are too tight, not allowing even their defenders to think, express themselves, and confront their opponents. Those who, instead, speak of a primal, pervasive flux, of becoming, or of chance are too loose, unable to prove anything.

If, from a beginning at actualities, we are to reach the ultimates as not yet instantiated, we must carry out a structured process of evidencings. If we are to get to what those ultimates presuppose, we must follow the directed insistence that they express on behalf of Being's possibility. If,

instead, we begin with Being, we must acknowledge that it is possible, and that its possibility must be provided by it. As just due to it, the possibility would be *of* it, dangle from it, not be a possibility *for* it. To be a possibility *for* Being, the possibility must be distinct from and be referred to it. That requires Being's possibility to be insisted on by what exists and acts in contradistinction to Being. Being must, when and as it is, produce what can refer Being's possibility to Being.

No possibility could be referred to Being were there nothing with power enough to refer the possibility to Being. Since Being is the direct or indirect source of whatever there be, Being must not only provide the possibility that is to be referred to it, but also what can refer that possibility to Being. It must produce the ultimates when and as it is, in order for it to be possible when and as it is. Since the ultimates must be produced by Being as having a status and an insistence enabling Being's possibility to be a possibility *for* it, Being must produce what exists and acts in contradistinction to it. When and as Being is, Being produces an agent, carrying out the inescapable task of enabling Being to be possible.

Hegel's criticism of Schelling, that he reached his final reality 'like a shot out of a pistol', misfires. Not only does Hegel himself take a finite number of steps to get to his Absolute, thereby substituting some other finite number for Schelling's 'one', but he fails to find a beginning in something that existed in contradistinction to his Absolute. 'Thisness', Hegel's accepted starting point in his brilliant *Phenomenology,* is an abstract universal, having no reality apart from the end that is to be reached. There was no occasion for any shot to be fired, for on his view nothing existed except the target. The ultimates, and the possibility that they refer to Being, as well as what those ultimates might jointly constitute, all exist in contradistinction to the Being on which they depend for their existence.

A philosophy can begin nowhere else than in the humanized world. It can never properly end with what precludes such a beginning. A privately initiated evidencing enables one to move to the ultimates as existing apart from that evidence. As so apart, they are contingent in nature, number, and act. The attempt to understand why they are contingent in these ways leads one to Being as that which they presuppose. When and as Being is— always—the ultimates are; they are necessarily made to be by Being, so that they can act on Being's behalf.

Were there no ultimates, there would be no actualities or any coming to be or passing away of any of them. Since the ultimates are produced by Being, when and as this is possible, the ultimates must always be. Indeed, though they have natures and are of a number that could have been

otherwise, and though they act on their own, when and as Being is, they must be and must do what Being requires them to do—act on its behalf. The ultimates are perfect agents. As agents, they necessarily act on their own; as perfect, they will act only in ways that benefit Being.

Contingent realities are sometimes thought to be defective in some way, since what is necessary in itself has a finality to it that not only leaves one content, but seems to offer justifications and explanations that are apparently both clarifying and completive. Yet if there be anything that acts in contingent ways, producing what need not have been produced, it must have an ability distinct from what Being has. While falling short of what is necessary in itself, the ultimates can do what need not be done, and not do what they could. Although they are not necessary in themselves, and depend for their existence on what is necessary in itself and necessarily does what it does, the ultimates, nevertheless, must have distinctive, independent natures and abilities. Their number and natures express the degree and kind of independence from Being that Being necessarily enables them to have. They could not have those numbers and natures determined by Being, without thereby being denied their independence and, therefore, their ability to enable Being's possibility to be referred to Being.

No matter to what degree the ultimates are determined by Being, they will act as it requires—enable Being's possibility to be a possibility *for* Being—and to do that, they must exist apart from Being. The ultimates are perfect agents *for* Being, acting on their own, but doing exactly what Being needs to have done. As agents *for* Being, the ultimates act on its behalf; as perfect agents, they do exactly what Being needs to have done. Since Being needs to possess whatever the ultimates produce on their own, or be faced with what is alien to it, the ultimates will necessarily convey limited versions of beings, each affecting the ultimates to the very extent that these ultimates act independently of Being. Being, in producing the ultimates, produces what has a degree of freedom from Being. Producing only a perfect agent, Being nevertheless produces what, while acting on its own, does what Being needs to have done.

The ultimates are produced in order that Being's possibility can be insisted on. They are than able also to convey Being in the form of owners of themselves as instantiated. This is done to the degree to which those ultimates act independently of Being. The degree of independence from Being that the ultimates exhibited when they were jointly instantiated is matched by the ultimates' conveyance of Being within the limits those ultimates' jointly produce. As a result, what Being gave up when the ultimates act in ways additional to their referring of Being's possibility to

it, Being recovers in the guise of owner of those instantiated ultimates. Consequently, there is, so far, nothing more than Being, with delimited parts of it referring back to Being as their source.

Since there is no necessity that there be any actualities and, therefore, no joint instantiatings of the ultimates, there could conceivably be nothing, in addition to Being, other than the ultimates insisting on Being's possibility. The ultimates would then have a freedom from Being that they did not exercise, but that would be enough to leave Being faced with what is independent of it the ultimates as subdivided and able to be instantiated together. When and as Being produces the ultimates, it gives them the status of perfect agents, limiting their independent activity to the conveyance of Being within the limits that those ultimates jointly provide, and therefore to a repossession of the ultimates to the degree to which those ultimates acted independently of Being.

Did the ultimates do no more than jointly constitute actualities, the ultimates would not confine anything. Instead, they would together constitute appearances of nothing—what are sometimes called 'phenomena', or powerless presences. The ultimates do more, as agents of Being, they convey Being, as well as they can, beyond themselves, within the limits those ultimates jointly determine. They are able to be related to Being through the agency of the very ultimates that had conveyed Being within the limits that those ultimates jointly produced. Since actualities use their confining ultimates as means by which they can act on one another, those ultimates will preclude the actualities from being no more than related to Being itself.

There must be a direct orientation of actualities toward Being itself, in addition to their involvement with their confining ultimates. Being, independently of its conveyance by the ultimates, must be present at the very place where it is conveyed by the ultimates, holding on to this as its own. When, then, Being in a limited form is conveyed by the ultimates, it will fill out the place that Being had already identified as its own. As a consequence, what the ultimates jointly convey will not only be Being, as oriented toward the confining ultimates, but will also be beings directly related to Being. An actuality, as a consequence, will be doubly oriented toward Being, once via the ultimates that confine it, and once via the position that Being had made its own.

Were an actuality no more than Being in a conveyed form, it would always be involved with its confining ultimates; were it no more than a filling out of the position that Being adopts, an actuality would be involved only with Being. It exists in contradistinction both to the confining ultimates and to Being as a presence, because it is both at once, countering

the claims of the one by the claims of the other. Each actuality exists midway between confining ultimates and an encompassing Being, avoiding a complete involvement with only one because it is also involved with the other.

Actualities are relatively, while the ultimates are absolutely, contingent. Though the one need not occur, the other must. Each actuality may be understood to be the outcome of a necessitation originating at some antecedent that is traceable to the ways in which ultimates happen to act, but the antecedents of those necessitations need not have been.

It is not possible for there not to be ultimates. They exist when and as Being, what cannot not be, does. Neither the numbers nor the natures or actions of those ultimates had to be. The neglect of the differences between these two types of contingency, one characteristic of actualities that need not have been at all, and the other characteristic of the ultimates that had to be, has long stood in the way of the understanding of the distinctive nature, existence, and actions of the ultimates.

The ultimates depend for their existence on Being. It necessarily produces them; if it did not, they either would not exist, or Being itself would produce them contingently and would, so far, itself do what it need not do. That would leave over the question why it did so act when it need not have. Did the ultimates not exist in contradistinction to Being, with natures and powers of their own, they would, at best, be just effulgences, exhalations of Being that never left it, akin to Hegel's categories and stages in an inescapable progress into a final Absolute, from which they had not really departed. Whatever the ultimates do, they do as realities that were necessarily produced by Being to act on its behalf but in their own way.

Being necessarily produces its own agents; these must, in order to be able to serve it, act on their own. Since the number of ultimates could have been greater or smaller than it is, and they always have their own natures and ways of acting, Being, in necessarily producing the ultimates as its agents, necessarily makes them able to have natures to subdivide, and to be able to act in ways it does not determine. It necessarily produces what exists apart from Being, which must be contingent in nature, number, and activity.

The ultimates necessarily enable the possibility *of* Being to be a possibility *for* Being. This they could do only so far as they were made to be when Being is, enabling it to be possible. They are made by Being to exist and act in contradistinction to Being. It is as so necessarily existing in contradistinction to Being that they are able to act together to constitute and confine whatever they are able to convey of Being. Acting, as they need not, they still are Being's perfect agents. Acting independently of it,

they do so for its benefit. As perfect agents for Being, they compensate for their independence of it by conveying Being beyond themselves within the confining limits that they provide when they jointly act.

The independent constituting of actualities by the ultimates is insepar able from the enabling of Being, in limited forms, to own the ultimates. What Being had to let go in order for there to be a possibility for it, maintained apart from and directed to it, is a perfect agent for it, able both to act on its own, and as Being requires. Sustaining and insisting on the possibility *of* Being, and thereby make this a possibility *for* Being as well, and also compensate for their own free activity by conveying and confining Being beyond themselves as jointly instantiated. The independence that the ultimates enjoy in order to be able to act as agents for Being, and which enables them to make the possibility *of* Being that Being itself provides become the possibility *for* Being, is compensated for by the ultimates expressing their independence from Being by their conveyance of Being within limited confines.

The ultimates are let go by Being in order to be agents for it. Because they are perfect agents, they not only provide an insistence enabling the possibility *of* Being that Being provides, to become the possibility *for* Being, but they also enable Being to repossess and own what the ultimates produce when they continue to act as its perfect agents. Being, evidently, must necessarily provide not only for its own possibility but for the ultimates as enabling that possibility to be maintained apart from and referred to Being.

Necessitated by Being to be so that the possibility *of* Being can be a possibility *for* Being, the ultimates are in a position to act independently of Being. They could exhibit their independence from Being simply by subdividing and being positioned to be instantiated together. We know that they have done more. They constitute finite beings. These are the owners of jointly instantiated ultimates. What possesses and uses the confining ultimates is Being itself in limited forms, matching the degree of freedom that the ultimates express when they constitute individual beings and the Habitat. The ultimates that Being necessarily produces are able to be and act independently of Being. Indeed, that is why they were produced.

Being alone, directly or indirectly, finally accounts for the existence of what is able to act in non-necessitated ways. Had Being not produced something, it would never produce it, for it necessarily does what it does and necessarily does not do what it does not do. It is not only unable to act otherwise than it does, but there are no resistances that it must overcome. The supposition that Being has potentialities or abilities, even in an absolute or glorified form, belittles it. It acts necessarily in a way that is

different in nature, power, dignity, and outcome from what is possible to any other reality, no matter how freely this might act, how powerful this is, or how splendid its achievements.

That humans have persons, possessed and used bodies, and characters that are strong, weak, good or bad, that they commit themselves and may create provides no warrant for the supposition that Being, too, has these abilities in an absolute, heightened form. Being is not a human infinitized. The noblest achievements or features of man do not have perfected forms in what necessarily exists; this has a different nature and power from what any other reality could have. Nor are the excellencies that a human may have minor versions of those which are characteristic of another kind of reality. To be greater than a human is not to have human powers magnified; to be less than a human is not to have human powers in a diminished form. Each human is able to be and act as Being and subhumans do not and cannot.

If there be a God behind Being, we could know of His powers and acts only if He enabled us to do so. Since that God would not have a faith, what some take to be an expression of man at his best must be denied to Him. Different kinds of realities, even if ordered as superior and inferior, have different kinds of powers. A God who was beyond the reach of knowledge may be credited with any number of abilities of which we have no inkling, but we would then have as much warrant for making entirely different claims.

The world's religions remain strongly and sometimes bitterly opposed to one another, each supremely confident of the truth of its claims about God's nature, intent, powers, plans, and rewards. Most credit their God with heightened forms of human powers. A better understanding of the nature of Being would promote an understanding of the kind of nature and power that might plausibly be credited to Him as a reality beyond Being, presumably to be characterized in terms not appropriate to this. What Aristotle, Descartes, Spinoza, Leibniz, Kant, and Whitehead, and their followers, call 'God' differs considerably from what concerns the pious. I once thoughtlessly followed the lead of those distinguished thinkers and referred to 'God' as though He were philosophically available. Sometimes one is badly misled by those whom one most admires.

The supposition that Being possesses infinitized versions of the powers that humans have does not flatter it. There are no resistances that Being must overcome, requiring the exercise of such powers. Its nature and action are of a different kind, not possible to any other reality, no matter how this might act or how splendid its objectives. That humans have persons, characters, and bodies, that they possess and possibly use what the ultimates jointly constitute, can commit themselves, and may create,

provides no warrant for the supposition that the ultimates, Being, or a God beyond this, have these abilities too, perhaps in an absolutized form. As beyond the reach of knowledge, a God may be credited with any number and kinds of powers, but there would be as much warrant for crediting Him with some but not others, as there would be for making a different claim. A messenger or a prophet might conceivably tell us what his God is or does, but we do not know that he really heard the Divine voice, or that what was supposedly heard is true.

Human freedom exhibits the fact that responses to what compels need not be reactive. Being (or a God) has no need of such freedom, for it is not subject to unwanted determinations and, therefore, need not call upon hidden reserves in order to surmount them. Were Being not necessarily what it is, or did it not necessarily do what it does, contingency would be intrinsic to it, leaving its existence and acts inescapably inexplicable.

Were the ultimates universals, they would depend for their realization on the acts of actualities. Though these could be understood to have been the outcome of previous realizations of universals, these in turn would have to be accounted for. If they were not the product of convergences by the ultimates at some common point, the universals would be inexplicables, or be the outcome of acts by other powers. Universals do not have the ultimates' power to constitute and confine and are unable to refer Being's possibility to Being.

'Man' is a universal. It could be before and after there were any actual humans, but it would then not be an airy, floating indeterminate, detached or detachable from all actualities. Nor is any human or other reality compacted of universals, for each of them has a power of acting that no universal has. Universals are terminations of relations beginning in the present or future, and terminating in the future or present, respectively. As the first, they are prospects; as the second, directives, with one or the other playing a primary role at different times. However they be understood, they cannot be substituted for the ultimates, lacking as they do the productive power these have, and their independence from actualities. Unlike universals, the ultimates could be were there no actualities— unless, like Platonic Ideas, the universals were identified with ultimates, but as unable to constitute, confine, or be owned.

It would be foolish to try to account for the ultimates by referring to some reality that acted in contingent ways, for what is contingent must finally be understood by showing that it is necessitated by what is not contingent. The supposition that contingencies are necessarily linked in time or a causal process, or that they are subject to immutable laws, leave not only the time, the causality, and the laws unaccounted for, but also what is subject to these. It is eminently desirable to know the prevailing

scientifically justified and the legally sanctioned laws, but these might have been otherwise. In any case, they do not fully account for what occurs, and therefore that to which they apply.

What is subject to gravity is never identifiable with it or its laws. Nor is what is subject to legal demands ever identifiable with these. The most comprehensive, rigid frame awaits the existence of that which it is to encompass. Did we not begin our inquiries with some obdurate matter of fact, we would never have had any reason to look for laws, to evidence the ultimates, and finally to arrive at Being, preparatory to a return back to where we had begun. Beginning with what is present and not necessary, we are compelled to acknowledge, first the ultimates, and then Being. We must acknowledge the ultimates again as what is necessarily produced by Being, so as to enable Being's possibility to be referred to Being. This, the ultimates could not do unless Being made them be and act in contradistinction to Being, independently of Being, even when acting as Being's perfect agents.

3. The Way Up and the Way Down

Every study, and surely every philosophy, properly begins with actualities, limited realities existing in a domain. It is these, not sense data, ideas, hypotheses, categories, intuitions with which we are initially acquainted. We start with some knowledge of humanized beings as well as of our persons, expressed through what effectively confines us. We are vaguely aware that we are individuals, who own our persons, organic bodies, and what has the two of them joined. Most of us, and everyone most of the time, attend to what seems to be relevant to the promotion of our interests, or at least allows us to live more or less undisturbed or effectively. Some try to attend to what seems to provide satisfaction for not well understood desires and needs. Others, interested in achieving a greater mastery or a better understanding, will try to understand what had been or will be by taking note of the ways actualities are interconnected, or what might be ended at did we take account of the primary ways in which actualities are related. A few seek to know what is presupposed and governs what occurs in some domain. A systematic philosopher, instead, tries to understand what all finite beings presuppose. Beginning with what he daily knows, he tries to learn what it is that is presupposed. Some hold that he will eventually arrive at intelligible forms, a primordial outgoing, persons, individuals, natural objects or cosmic bodies. Some look for an exhaustive set of categories; others look for a God to ground all Being and to provide a final justification for all claims.

The first half of this work tried to make evident that there are

distinctive kinds of realities in four different domains, all constituted by the same set of ultimates, but in a different orders, and also that there is a pair of ultimates, the Dunamic and the Rational, that alone makes it possible to pass from one domain to any other, and from any being to what is presupposed by every one. It was there noted that, through a process of evidencing, one can begin at one's person or what is in the humanized world, and end at what these presuppose—the ultimates. Those ultimates are instantiated, in different orderings, in nature and the cosmos. No resolute thinker could be content to rest with the presupposed ultimates, for they are of a number and have natures that could have been otherwise. Once, though, that they have been reached in a process of evidencing, they confront one with a number of questions. Why do they exist? Why do they have the natures they do? Why are they of such and such a number when they conceivably could have been more or fewer? Must they be instantiated? What do they all presuppose? Why should what is finally presupposed have produced them? This question starts us on the way down, from the Being we had arrived at in a search for a presupposition that presupposes nothing, to the ultimates, and then to the actualities with and at which we had begun the upward move.

Leading thinkers have explored the upward move, a few claiming that it involved but one step from actualities to Being itself. Most have ignored the downward move, or have been content to refer to it as a creation, a fall, or a gift. The proper match for these would be a Kierkegaardian leap into—no one knows where or what. The downward move from Being to the ultimates, and finally to what is in the different domains, to the Habitat, and what is in this, would be as warranted as any upward move from confined realities to what confines them, and from this to what necessarily is. The discussion in the preceding section pointed up much that is germane to the two moves. It is time to focus on what is central and crucial for each.

It seems that we can do little more, in carrying out the upward move, than start with what is less than Being—some actuality or other, ourselves, some idea, and the like, and then deduce Being from it. If so, we would apparently repeat or imitate the infamous ontological argument in an odd form, since, like this, we would begin with what is less than Being, and inescapably derive it. There would then be something amiss in our account. Since it does claim to move from actualities to the ultimates, from these to the Being that necessarily is, it begins with what is less than Being and tries to get to it the source of all the ultimates and what these jointly confine. To get to Being one must in fact arrive at it. This the ontological argument cannot do. At its best, it is seriously flawed; it cannot be more than a wrongly detached part of another, more basic, inescapable

process that in fact ends at Being, and then only because Being enabled it to do so.

There could not have been an upward move to Being, did Being not invite it. There could not have been a downward move from Being, did not Being necessitate it. Being is presupposed by all else. Nothing alien could compel it. What is different from it must be due to it, and directly or indirectly be referred to it as a self-sufficient ground. Were the source that is Being supposed to be uncharacterizable, we would be left with a Parmenidean 'One', but with no place for Parmenides to say that much, or to begin to arrive at it.

The ontological argument has usually been presented in the form of a 'proof' that God necessarily exists. Anselm, who first referred to it, thought that it helped bolster a faith. In its modern form, it has been taken to provide a convincing argument that presupposes no faith and, presumably, could convince even atheists that Being, the source of all else, necessarily exists. Faith does not need its help, but whether it did or not, the argument does not do what it is purported to do.

Given the alternatives: it is possible that a necessary reality exists, or it is possible that it does not exist, one readily supposes that there are two possibilities, each a precondition for a distinctive outcome. The first, though, does no more than express the idea that a necessarily existing Being is not self-contradictory, while the second says there might not be such a Being. The first is implicitly accepted when the idea of a necessary Being is entertained; the second connects a possibility to what is not a necessary reality. Nothing logically follows from either alternative—or, indeed, from any possibility—unless it be some other possibility.

Beginning with the acknowledgment of a possibility, the ontological argument claims to deduce the existence of a necessary Being from this. But it is impossible to derive a reality from a possibility, no matter how feeble the one or how grand the other. However far down the scale of realities any actuality be, no matter how weak it is, it still has a being greater than any possibility has. Enlarge the possibility as much as one likes, identify it with some ideal such as the good or the beautiful, it still has less reality than the feeblest actuality has.

Could one arrive at God by beginning with a possibility, it should be child's play to arrive at much lesser realities by beginning with that possibility. Anyone able to derive God, or any other reality, by envisaging a possibility appropriate to it has enough power to produce a world in which hatred and folly have no place.

The possibility with which the ontological argument professes to begin is provided with no grounding. How or where it is, how it could be started with, is not stated. It is also made to do double duty—once as an

Being, the Ultimates, and Actualities

antecedent joined to a formally necessary existent as a consequent, and then as a premiss in an inference which leaves this behind to end at a conclusion. If one accepted the first, one would still have to provide the second. That would require one to replace the idea of a possibility with the possibility itself, and then use this as the beginning of a passage to the conclusion.

A connection between an antecedent and consequent has them necessarily joined; a connection between premiss and conclusion requires that the first be left behind before the second is affirmed. Nothing is ever proved if no proving is carried out. Even if one accepted a formal relation connecting possibility with a reality—which is all that the ontological argument does—one would still have to find a possibility that was subsumed under that antecedent and could provide for a beginning of a passage that ended at a conclusion endorsed by the consequent. The ontological argument does no more than present one with a supposed necessity connecting a possibility with a reality. Not only does it then neglect to provide a premiss from which a conclusion is arrived at, but the antecedent it provides, a possibility, could not entail any reality, and surely not a necessarily existing one.

Kant's famous criticism of the ontological argument is dependent, in part, on his supposition that it is restricted to a proof of God's existence and, in part, on Kant's supposition that an object of reason is devoid of content. Had he asked himself about the ability of a possibility to function as a premiss, he undoubtedly would have noted that it could do so only if it were endowed with a power by the reality for which it was a possibility. The possibility that allows one to end at Being is unlike any other, not because of its distinctive content, but because it depends on Being itself to produce what enables the possibility to be referred to Being.

A possibility can be *for* Being only if it exists apart from this. Yet no matter how glorious the possibility, it could never necessitate that, even the most feeble of realities exist. Nothing could necessitate that there be an eternal reality—unless this produced that possibility as well as what could insist on it, thereby making the produced possibility be, not only *of* its source, but also be insistent, directed at, be *for* this. When and as Being is, i.e, always, it produces what insistently turn the possibility that Being provides into a possibility *for* Being, a possibility insisted on.

The ontological argument begins with an effete possibility. Could the possibility be for Being, it would have to be backed by enough power to enable it to terminate at Being. Being alone could never do more than express itself by providing a possibility. That possibility is an impotent expression of Being. It does not have reality or power enough to be

insistently referred to Being. For it to be referred to Being, it must be provided with an insistence, turned around to make it refer to Being.

The argument speaks of a possibility for whose presence it provides no explanation. Though it supposes that Being, or what it calls 'God' is perfect, the source of all else, it nevertheless somehow finds a possibility from which Being, that which necessarily exists in and of itself, is a necessated outcome.

The only possibility that could entail a necessity is one that this not only produced, but provided with an effective backing, enabling the possibility both to be apart from Being and to be so empowered that it refers to Being. There would be no temporal lapse here. When and as there is a necessary Being, i.e., always, there is a possibility that is both produced by and enabled to terminate at Being. Both that possibility and the empowerment of it are provided by Being. The empowering is due to Being, but the exercise of the power, the actual referring of Being's possibility to Being, is due to the ultimates. They must be produced when and as the possibility of Being is, i.e., when and as Being is, and must then and there refer the possibility to Being, make the possibility that was *of* Being become a possibility *for* Being. This they can do only if they exist when and as the possibility of Being is, making it be *for* Being. Being, to be possible, necessarily produces the ultimates to make Being's possibility be more than an attenuation of Being and, instead, be a possibility *for* Being. When and as Being is, it is possible; when and as Being is possible, it has its possibility referred to it; when and as its possibility is referred to it, there must be that which can do this; when and as there is a possibility *of* Being, Being had to produce what enables that possibility to have the status of a possibility *for* Being.

The possibility *for* Being with which the ontological argument begins is a possibility *of* Being that is insisted on and directed at Being by what Being itself produces. The insistence is not Being's, but depends on that which exists apart from Being.

The kindest thing to say about the ontological argument is that it presents a half of an argument, accepting a possibility for which it cannot account, and supposing that this could be directed at Being without anything enabling it to do so. The most glorious of possibilities remains a possibility as feeble as any other. If it entails anything, this too would be no more than a possibility. If it is referred to anything, it would have to make use of a power provided by what is distinct from it. It is that power that the ultimates provide. They do this when and as Being is, for Being always makes its possibility be insisted on by what is distinct from the possibility.

We arrive at Being by beginning at actualities, tracing their confining constituents back to the ultimates, and then attending to their insistent reference of Being's possibility to Being. That ascent is matched by a passage from Being to that which both sustains the possibility *of* Being and makes it function as the possibility *for* Being. The way up to Being via the ultimates is matched by a way down to actualities via those same ultimates. On the way up, the ultimates function as a concerted many, a many acting in consonance, referring Being's possibility to Being. On the way down, they provide the possibility of Being with a locus, expressing their independence of Being by subdividing into a plurality, and may act together to convey and confine what they can of Being.

A Cartesian might claim that, if we had a clear and distinct idea of a possibility, the reality would necessarily exist. To back that claim, he would, sooner or later, have to depend on a real God who guarantees that what is clear and distinct is true. Defenders of the ontological argument disdain such help. They think that by logic alone they can not only end at what is real, but at what is the greatest reality of all. Not even God could do that. If He began with nothing more than a possibility, He would know what it entailed, but He would not be able to produce that conclusion just by entertaining the possibility. If He could, He would also be able to deduce Himself from His own possibility. The possibility that allows for an arrival at a final Being that is necessary in and of itself is provided by that Being. Being enables its possibility to be referred to itself by producing what necessarily refers the possibility of Being to Being.

Only Being necessarily provides for its own possibility and what refers that possibility to it. It is not first possible, and then necessary. It is necessarily possible when and as it necessarily is. It cannot not be, cannot not be possible, and cannot avoid having its possibility referred to it by what is distinct both from the Being and the possibility. When and as Being provides a possibility of itself, it provides what enables this to be referred to Being. It does not carry out a sequence of acts; what it does, it does once and forever. Though the referring of Being's possibility to Being depends on the ultimates existing in contradistinction to Being, those ultimates are the permanent result of Being's necessary act of enabling itself to be possible.

Being does not first exist and then become possible. Nor does Being first become possible and then actual. When it is, it is possible; when it is possible, it is. Since Being is and is possible always, the ultimates, that are needed in order to enable Being's possibility to be a possibility for Being, must be when and as Being is—always.

The number and kinds of ultimates that there are express the degree of independence achieved when and as Being produces them. They have to

have some degree of independence from Being in order for them to do for Being what Being requires. What that degree is, is determined by the ultimates, when and as they are produced. Being can do no more than enable the ultimates to be able to function on its behalf; it cannot do what it needs to have done by them—refer its possiblity to it. It must produce them as independently acting realities, but it cannot determine the degree of independence or the manner in which the independence will be exercised. It makes them be so that it can be possible, and thereupon makes them able to act on their own.

Were there an omnipotent Leibnizian God that was able to create the best of all possible worlds, that world would have to exist apart from Him and would, therefore, also be able to do what was not decreed. If the world could not act independently of that God, it would not exist in contradistinction to Him. Dictated to, subject to a divinely imposed necessity, that world must be apart from God, and therefore able to do something else as well.

What Being produces never limits it. Instead, it is enabled to be independent of Being, so as to be able to act on Being's behalf. But, so far as it is independent of Being, it will also be able to do what Being does not prescribe, though never what could disadvantage it or reduce its power. When and as Being is, it produces its own possibility, and whatever else there must be in order that this possibility be referred to Being. Neither could be necessary in itself without compelling Being to face what has an equal and opposite force.

The ultimates are Being's perfect agents, necessarily doing what Being requires and able to do something else as well. The degree of independence that those ultimates have from Being is not and cannot be prescribed. The ultimates determine the degree when they are produced, and express the fact in a division into some number and kinds. Being cannot dictate what that number or those kinds will be, since it necessarily makes the ultimates be independent of it, an independence that those ultimates express in their subdivision and in any actions that they must express, as well as any others that they may carry out.

Were the ultimates not Being's perfect agents, they would fail to do what Being needs them to do. Since they are its agents, they are able to do things on their own, but because they are its perfect agents, what they do on their own is what Being needs to have done. They cannot avoid referring Being's possibility to Being; that is why Being produced them. They can do that because they exist and act in contradistinction to Being.

As so able to exist and act, the ultimates would be able to do what Being does not need them to do, or what Being might even not want to be done, were it not that they are Being's perfect agents, able, as agents, to act

on their own and, as perfect, doing only what benefits Being. Their subdivision and interinvolvement are part of their act of becoming agents of Being. Being does not do more than enable them to act on its behalf, but that means that Being enables them to be so that they can function independently of it, a state that they express in never doing what does not benefit Being.

As undivided, the ultimates provide a single needed insistence that enables the possibility *of* Being to be more than a dangling continuation of Being. When providing that insistence, they act for, but in contradistinction to the Being that produces them. As able so to act, they exist independently of Being, able to do other things as well. They could have had a different degree of independence than they do; they could divide into a greater or fewer number of ultimates that could have been different in nature from what they in fact are. They need not produce anything.

We now know, as a matter of fact, that the ultimates did unite with one another, since there now are actualities that the ultimates constitute and confine. We also know that there is no necessity that there be just six ultimates, or that they have the natures they have. Being produced them only in order to have its possibility be a possibility for it. Yet to do that, it had to make them be independent of it. Just by requiring them to act as one, in order to have its possibility referred to it, Being still requires this to be distinct from it. That distinctiveness is expressed in their existence in contradistinction to Being, as well as to the possibility they accept and direct to Being. The ultimates make that evident by their subdivision into a number of separate, interinvolved ultimates. The six different kinds of ultimates already identified reflect the degree and kind of independence they maintain in contradistinction to Being. If there were only one, this would be no less a contingent outcome, since it could have been otherwise.

The ultimates are Being's agents, and therefore can act independently of it. They express the degree of their independence in their subdivision into a number and in kinds that could have been otherwise, without compromising their joint ability to refer Being's possibility to Being. They might do nothing more than refer Being's possibility to it, but since this requires them to exist and act in contradistinction to Being, they can also act in other ways as well.

Did the ultimates do nothing more than insist on Being's possibility, they would have the status of agents for Being, and so far would be possessed by Being as subject to it. If and when the ultimates constitute actualities, Being, as having supervised them and as existing in contradistinction to itself, will be conveyed by the ultimates beyond what they constitute. The ultimates, though they acted independently of Being,

would still have acted on behalf of it. Being would then be both confined by and possess or own the ultimates that had acted independently of it.

When the ultimates act independently of Being, they still enable Being to own the result. Unlike the imperfect agents that serve other realities, the ultimates never do what does not benefit the principal on behalf of which they act. Not only do they enable Being's possibility to be referred to it, but when they jointly constitute and confine actualities, they convey Being itself within the limits they provide. Balancing the independence from Being that they exhibit in their becoming instantiated independently of Being, they convey Being within the confines that they constitute. Perfect agents, the ultimates express their independence from Being, not only by subdividing, but by enabling Being to exist within the limits they jointly provide. They need not have been instantiated.

Being enables the ultimates to be independent of it in order that they be able to provide a needed insistence for its possibility. Not having lost all hold of them, it requires them to convey it beyond what they jointly constitute. Actualities, and the members of the Habitat that own these, are Being itself, matching the independent activity of the ultimates with a possession and ownership. That does not mean that Being and the ultimates are correlatives. If they were, Being would be no more than one of a pair of realities, limited, not that which is the primary source of all else. Being is not limited by anything alien. Whatever limits it, it provides.

The other of the ultimates is not Being itself, but Being-as-an-other. When and as Being produces the ultimates, it also produces an other of itself. This matches the possibility of Being that those ultimates insist on. Being-as-an-other and the ultimates as insisting on Being's possibility constitute a correlative pair. The possibility for Being arrives at Being only because it is intermediated by Being-as-an-other. Being is never the correlate of anything; if it were, it would not be in itself, but only for or with something else.

Although the number and kinds of ultimates could have been different, the ones that now are, are necessarily what they are, since the degree of independence that they achieve occurs when and as Being produces what it must, in order that it be possible. What insists on Being's possibility might not have subdivided, or it could have subdivided in a different way; the ultimates could have so joined one another that they produced something quite different from what they have, but whatever they do will express the degree of independence from Being that they achieve when and as they are produced by Being. If they do nothing more than refer Being's possibility to Being, they will still exist apart from Being. Although the number and nature of the ultimates could have been otherwise, they are, forever, determined when and as Being produces them. Were there

only one ultimate, it would have the ability to subdivide. Whether it did so or not, its ability to do this is distinct from its insistent reference of Being's possibility to Being via Being-as-an-other.

When they insistently sustain the possibility *for* Being, the ultimates do exactly what Being requires them to do, since they then enable Being's possibility to be a possibility for it. Since the ultimates, to do this, must act independently *of* Being, the ultimates must be able to do other things as well. If and when they do, since they are Being's perfect agents, they will make good the independence that Being enabled them to have, by conveying Being beyond themselves, to the very degree that they had expressed their independence from Being.

Because the ultimates exist and act in contradistinction to Being, they are able to convert the possibility of Being into an insistent possibility that terminates at Being. That is why, when and as Being necessarily is, the ultimates also are, and why they can do more than provide power enough to turn the possibility that Being provides, the possibility *of* Being, into a possibility *for* Being that is both distinct from and referred to Being. Since Being is always in itself, not in a relation to something acting apart from it, its possibility can be *for* it only because and so far as it is mediated by Being-as-an-other for what else there be.

Were a creating God identified with Being, He would have had to create His own possibility, as well as what referred this to Him, while necessarily leaving that agent free to do other things as well. He would not do more than that one eternal act; producing what must do what He decrees. Contingency is not characteristic of anything that such a final God is or does. If it were, one would self-contradictorily, have to suppose that a necessarily existing reality, subject to nothing and the presumed source of all else, might be confronted with what limits it.

A God who did nothing but confront some indeterminate prospect and then acted to realize this would, for a while, be faced with an indeterminacy that He presumably had created, and would subsequently act to realize it. He would be a God in time, presupposing rather than accounting for it. Were He no more than what necessarily is and necessarily does what it does, He would be indistinguishable from Being itself, grounding a Being-as-an-other and a correlative, insisted on possibility. If there be a faith that in fact reaches beyond this to end in a God as He is in Himself, it would be a faith that passes beyond all understanding. What this is, of course, no understanding can grasp.

Were a creating God identical with Being, He would have had to create His own possibility, as well as what referred this to Him, while necessarily leaving this free to do other things as well. There would be no need for Him to engage in more than one act of creation, since if He were a

necessary Being, He would have acted only once, necessarily doing at onc time what had to be done. His act would accomplish what He decrees. This, while able to act in other ways, would still be subject to Him. A God who listens to prayers, supervises the coming to be of each individual, or passes judgment on what men freely do, is outside the reach of a resolute inquirer, He is neither to be accepted or rejected by one who seeks to affirm only what he must. A breaching of faith and reason compromises both the man and the God.

Being, at any rate, is not to be credited with a will or an ability to create, but only with the necessary production of whatever enables it to be possible. This may act in other ways as well, a matter to be decided by it, and not by Being. Produced by Being, the ultimates are its agent. Since Being is hindered by nothing, that agent will be perfect, doing only what benefits Being.

The contingent natures and number of ultimates is determined once and for all when Being provides for its possibility to be referred to it. Being does not determine whether and how those ultimates will join to constitute actualities. There might not have been any actualities, and the actualities could have been other than they are, since the ultimates need not be instantiated and could have been instantiated together in other ways than they have. What the ultimates might or might not do, in addition to enabling Being to be possible, no study of them reveals, though as perfect agents they will never do anything that does not benefit Being. When they are jointly instantiated, they act independently of Being, but at the same time convey Being within the confines they jointly achieve. As a consequence, Being is enabled to compensate for the independence that the ultimates had exhibited in their joint instantiation.

The number and kinds of ultimates is determined. What is not then determined is if and how the ultimates might join one another to constitute actualities. These could have been otherwise than they are. Also, the ultimates could have joined one another in different ways than they now do. They might not have joined one another. They need not do anything more than provide the possibility of Being with the insistence it needs in order that it be referred to Being, via Being-as-an-other. Still, since they exist in contradistinction to Being-as-an-other, they are able to do things on their own, though never what does not benefit Being. Did they not necessarily benefit Being, Being would have necessarily produced what is irrelevant to or opposes it. This would make Being be less than it is, faced with what it does not need or cannot accept. That is impossible.

The Habitat, and its divisions, presupposes the independent existence and action of the ultimates. These exist because Being needs them. Since Being cannot be compelled by anything, it must do what it does on its

own, and do it once and for all. Although it necessitates that there be what acts apart from it, it does not determine whether or not this will do anything more than insistently present Being's possibility to it.

The ultimates must be, but they cannot do anything more than what Being enables that they do. Though they act as realities existing in contradistinction to Being, and though their acts are their own, what they do must benefit Being. That is why Being produced them. The benefit will have two forms: the ultimates necessarily enable Being to be possible, and they necessarily convey Being within whatever limits they produce when they act together.

Different from Being, able to act independently of it, the ultimates are not realities that, if added to Being, would constitute a totality of realities of which Being is but one. The fact is picturesquely but still only partially expressed in the idea that God is not only the creator of all else, but a creator of angels who exist when and as He does and are able to act in ways He does not decree. The ultimates, though not things, are not spirits. They neither obey nor disobey decrees.

Necessitated by what is necessary, required to serve Being, they enable the possibility of itself, that Being provides, to function in a needed way. Since, to do this, they must exist in contradistinction to Being, Being must produce them when and as it is. If they then did what Being did not require them to do, they would not be perfect agents for it. They do produce what Being itself does not, but this is never more than what they must. Their necessitated acts—one enabling Being's possibility to be directed at Being, via Being-as-an-other, and another enabling Being to possess and own what confines it—match the degree of freedom that the ultimates have in contradistinction to Being. Being produces perfect agents for itself. These match their freedom from Being by doing exactly what Being requires of them.

The ultimates, when they enable Being to be possible, continue to be under the supervision of Being. When those ultimates jointly constitute other realities, they compensate for the freedom from Being that they then express by conveying Being beyond what they constitute. They thereupon enable Being, in a limited form, to subject the ultimates to constraints that match the freedom they had expressed in constituting actualities. Conceivably, the ultimates might have been preprogrammed, so that they had to produce what they in fact produce, perhaps at different times. What the ultimates did would then be necessitated.

Yet, if actualities are contingent existences, these could not have been separately produced by the ultimates, but would, at best, be part of a single necessary totality of actualities. That totality would be no less distinct from Being than the ultimates are; though necessitated, they

would not be necessary in themselves. Any period when the actualities did not occur would be one that might be followed by another in which they did exist. If the periods could have been longer or shorter, or need not have been, they would be contingent. To account for them one would sooner or later be at what necessarily is and necessarily does what it does. Were there a programming of the ultimates by Being, we would have to refer to Being to account for what they do, and then would be faced with the question of how and why Being could and did produce ultimates that act in non-necessitated ways.

Being cannot produce another necessary Being. Since it necessarily does what it does, and is presupposed by whatever else there be, it is a necessary reality that necessarily produces what is contingent. As confined by instantiated ultimates, every actuality is Being in a limited guise, turned toward Being as not yet differentiated. Because Being had already supervened over the region where the ultimates convey what they can of Being, what occurs there will be a being existing within the compass of Being. What is within the confines that the ultimates provide also exists in contradistinction to them, because it shares in Being as supervening over every place and, therefore, over where the ultimates are able to convey Being and confine it.

Each individual exists between the ultimates and Being; it is confined by the one and encompassed by the other. None is ever absorbed by Being, since it is confined by the ultimates; none is just confined by the ultimates, since it is an instance of Being. Each balances what it is, as confined, with what it is as encompassed by Being. An emphasis on one at the cost of the other will unavoidably subject an actuality to the task of taking a greater account of that other. When one or the other of these dominates over the other, he is faced with the task of recovering his equilibrium by taking greater account of the other. If he has been overinsistent on himself on and through the ultimates, he must become more submissive to Being as encompassing it; if he has been overly submissive to Being as supervening, he must reverse the emphasis. Always doubly directed, he is always faced with the task of maintaining his equilibrium between the two.

An upward moving dialectic enables one to end at Being. This is more powerful than the ultimates that presuppose it. It is also more intelligible than what a faith could end at. The move takes no more than two steps, from any being to all the ultimates, and from these to Being.

The upward moves are necessitating moves to what is presupposed; the downward move from Being to the ultimates is necessary. When there are ultimates, Being is, and when Being is, there are ultimates. These, though necessitated to be by Being, might not constitute and confine anything. While there is no escaping an ending at Being in the two-step upward

move, there might not have been any further downward step taken than that which arrives at the ultimates.

Beginning with the contingent fact that there are actualities, two necessary steps must be taken to arrive at the Being that is always presupposed. Beginning instead with what necessarily is and necessarily does what it does, one necessarily arrives at the ultimates as what Being must have done, and then allowing for another step in which the ultimates are instantiated, as Being's perfect effective agents. Although the downward move from Being is not completed until two distinct acts have occurred, only one of those acts, from Being to the ultimates, is necessitated. The upward move, in contrast, has both of its steps necessitated, since they take one from actualities to the ultimates as not instantiated, and from those ultimates to Being itself.

The downward move is primarily ontological; the upward, epistemological. The second depends on the first to provide a path over which it could move to what is always presupposed by whatever there be. Both Plato and Hegel slighted the downward move, leaving inexplicable the fact that there are contingently existing realities. They also took the upward move to be both ontological and epistemological in nature. Although that move gets to what is necessary in itself and is presupposed by whatever else there is, it does not produce that necessary Being. The downward move in contrast, passes from what is dependent on nothing to what depends for its reality on this, and from there to what might or might not then be produced. Both steps in the upward move must be taken, but only if one seeks to find out what is presupposed by confined actualities; only one step in the downward move is necessary, since the ultimates might never be jointly instantiated. The ultimates necessarily exist because Being needs them, but they might never do more than enable Being to be possible.

In taking account of both the upward and the downward moves to and from Being, we follow Plotinus at some remove. He thought that the downward move involved three steps, or hypotheses, but never did show why there had to be just three, or why they began and stopped where they did. Nevertheless, he should have alerted subsequent thinkers to the need to give an account of the moves needed to take one from Being to actualities, as well as from these to Being.

One learns nothing from the supposition that Being had contingently carried out an act of creation of the ultimates, the actualities, or both. Since we in fact begin a move to Being by first evidencing the ultimates, and can carry out another by melding into Being as it supervenes over the position that the ultimates confine, we are not only able to get to Being in a two-step process of moving to what is presupposed, but also by a simple

yielding to the presence of Being. Both types of activity could not be carried out together, for when a single move from actualities to Being is made, the actualities continue to be distinct beings confined by the ultimates, and conversely, when actualities are confined by and act on and through the ultimates, they continue to be encompassed by Being.

Such great dialecticians as Plato and Hegel not only thought that they had to take more than two steps to arrive at Being, but apparently could not show why or how Being, at which their dialectic had to end, provided a beginning for a move to actualities. They were able to arrive at Being because they had begun with what existed, apart from this; they could, though, never have arrived at Being unless it was already a reality presupposing nothing, and necessarily benefitting from the acts of what it had produced. Otherwise there would be what defied Being, making it less than perfect.

The upward move to Being requires a start at what is distinct from it. The downward move could have ended before such a starting point was provided. The move to what necessarily is takes two steps from actualities to the ultimates and from these to Being; the move from Being might have taken only one, from Being to the ultimates. When another downward move is taken—as it in fact has been—one arrives at that from which one can move to the ultimates, and then to Being. Did one move from actualities to the Being that supervenes over them, one would, of course, move to Being in a single step but would not then know why the actualities were not then completely absorbed in Being. We come to know Being because we get to it either by tracing what confines to its source, and then terminating at the Being those ultimates make possible, or by yielding to Being as supervening over us. Each precludes the completion of the other, leaving us and all other individuals somewhere in between the two.

What is necessary are Being itself as an othering, Being-as-an-other, and the correlate of this, what else there be. Being enables the correlatives to exist apart from one another, by providing one of them, Being-as-an-other, and enabling the correlate of this, the ultimates, to be on their own, able to act in ways Being does not prescribe. In the absence of Being-as-an-other, Being would have to assume the status of an other for whatever else there is and would, so far, cease to be independent of all else. When and as Being makes itself have the role of an other, it enables the correlative of this to have an independent status. It would not do this, did it not need to have its possibility referred to it. That correlative of Being-as-an-other is both apart from it and necessarily refers to its correlate. Able to act on its own, it continues to be the correlate of Being-as-an-other and, with the help of this to terminate in Being. The nature of the othering that Being intrinsically is, is different from the othering connecting Being-as-an-other

and the ultimates. Its nature and role is not well conveyed in our ordinary uses of the term, 'othering'.

Being in itself is too indeterminate to be subject to the law of excluded middle, too limitless to allow for an inference beginning and ending in it, too general to be subject to the law of contradiction, too inconstant to allow for the use of the law of identity, and too radically unduplicable to allow for the use of a law of substitution. When we speak of it, of course, we submit to those laws, but we must then understand that what they govern converges on what is not subject to them. The fact that Being has a depth, power, and finality that is only partly expressed in what we say of it does not mean that it can be no more than the object of a mystical vision. It means only that the laws governing finite, bounded items do not govern it.

The ultimates provide for a single insistence directed toward Being, whether or not they do anything else. While they could have had different natures and could have been greater or fewer than they are, whatever natures and numbers they do have, they always have, since these are determined when and as they are enabled to be independent realities, acting as Being's agents. What the ultimates do, in addition to enabling Being's possibility to be referred to it, is determined by them in ways that make evident Being's continued presence. Produced by Being to do what it demands, the ultimates express their independence of it by providing the sustainer of Being's possibility with a needed insistence, and by their subdivision into a number that could, but need not, jointly constitute the Habitat and its subdivisions. The ultimates are always agents of Being, necessarily doing what must be done so that Being is possible and always able to do what Being does not decree that they do, but never without yielding what Being accepts—Being in confined individualizations over which Being supervenes.

There can be no agents that do not act on their own. Even a perfect agent doing exactly what its principal requires it to do is still able to do what is not required by its principal. A perfect agent is no less free of its principal than an imperfect one is, but unlike this, does what benefits the principal. The sorcerer's apprentice had to do what the sorcerer demanded that he do. That the apprentice was able to do more, he demonstrated when he began his own experiment. Were he the most obedient of apprentices, he would still be one who was able to show that he was more than a continuation of the sorcerer. If he sneezed or rolled his eyes, chewed his food, or had a thought, he would, while acting as a most obedient agent for the sorcerer, reveal that he could do what the sorcerer had not prescribed. Unlike the sorcerer's apprentice, the ultimates, when they act on their own, always do what is acceptable to their source.

Whether the ultimates act or do not act, the range and power of Being will not be affected. A divine creation that was understood along these lines would take the creation to produce actualities within a divinely charged dominion. Were there no such dominion, there would either be no realities other than the creator, or these would exist in contradistinction to this, and thereupon limit it. The promise of salvation must precede a divine creation of what exists and acts independently of that creator.

Being does not create anything, but, still, like a creator, it provides an area within which all other realities exist. It does this when and as it produces the ultimates, thereby defining these as agents that act within the limits it defines. Though the ultimates can act independently of Being and can confine limited forms of this, Being was already present there as ready to accept whatever the ultimates confine. No individuals have been, but when they are produced, it will be as realities existing within Being's dominion. All individuals are realities that act in contradistinction to Being; all exist because the ultimates convey and confine Being beyond what those ultimates jointly constitute; all, like the ultimates, exist and act where Being supervenes. In theological terms, the promise of salvation precedes the existence of the realities that are to be saved.

Pantheists assume that a divine dominion is at best punctuated by what has no independent reality, and perhaps no contingent existence. They are matched by those who suppose that what is created is able to defy their creator. The one has a counterpart in an idealism that allows for nothing but Being and, therefore, has no position from which the claim could be made. The other has a counterpart in an empiricism that allows for nothing but actualities and, therefore, is unable to account for their existence.

Being does not and could not allow the ultimates to act in ways that make Being less than it is, as though it were just one among many interacting, competing actualities. When the ultimates act independently of Being, they convey Being beyond what they jointly constitute; as so conveyed, Being matches the result of the free action of the ultimates by being able to use what confines it. What Being lets go to act as it would is repossessed by Being as carried forward within the limits that are then produced. That carrying forward was anticipated by Being in its encompassment of positions where individuals could be confined and also own what confines them.

Did the ultimates do nothing more than provide the insistence that is needed in order for Being's possibility to be referred to it, their ability to do something more would still testify to the fact that they were Being's perfect agents, providing Being with limited positions from where it could match the confinings with ownerships, the one by the members of the

different domains, and what is between these, the other by the Habitat and its subdivisions. To the exact degree that the ultimates are jointly instantiated, they convey and confine Being. What is so confined both responds to what confines it and is encompassed by Being as already present at that position. The individuals that the ultimates necessarily confine when the ultimates are jointly instantiated not only match the independence that the ultimates then express but are situated within Being, a single, all-encompassing reality. They would be sundered from Being were they simply confined by the ultimates. They would be unable to own what confines them and would be limited by this, set in contradistinction to Being, did Being not supervene over them. Once again, to use theological terms, individuals cannot be saved as long as they exist apart from Being, and they cannot impose themselves on one another just so far as they are saved.

Being is omnipresent, making its agent do not only what it requires, but what benefits it should the agent do something else as well. Being's agent necessarily enables Being to be possible, and does this when and as Being is. Otherwise, Being might exist and not be possible or, having once not been possible, might subsequently become possible. The first supposition takes Being to be beyond comprehension; the second takes it to be subject to a condition or to express a spontaneity which denies that Being necessarily exists and acts no matter what else occurs.

Doing what Being requires them to do—provide it with a possibility directed at it, a possibility that is for Being—the ultimates are necessarily distinct from Being, able to act in other ways as well. When they do act in other ways, they could do what is irrelevant to or is opposed to what Being requires were it not that they are Being's perfect agents. As such agents, the ultimates, while acting independently of Being, unavoidably convey Being within what those ultimates jointly constitute. Since Being, independently of the ultimates, had already laid claim to the area that the ultimates confine, Being will, when the ultimates are jointly instantiated, occupy that area as both oriented toward what confines them and toward Being as that which supervenes over it. An individual, consequently, is at once a being confined by, and owning the ultimates, and also an intensified, localized version of Being. As in itself, it is between the two; an equilibrium point between itself as confined by the ultimates and encompassed by Being. Were it ever the one alone, it would be cut off from Being itself; were it the other alone, it would not exist in contradistinction to other finite beings.

The Being that is conveyed by the ultimates when they jointly constitute actualities and their connections has three forms. One occurs when, under the dominance of the Dunamic-Rational, the ultimates constitute

individuals and the Habitat; another when they constitute cosmic unit bodies, natural beings, humanized bodies, and persons; and then, when individualizations constitute a conveyed, miniaturized instance of Being—objects, complexes, and individuals in the Habitat. Individuals, in particular, are a vigorous, conveyed instance of Being.

The question 'Why is there something rather than nothing?' is evidently badly stated if it intends to ask 'Why, in addition to what is necessary, does there happen to be something else?' Because Being necessarily is, there could not have been nothing at all. The fact that Being must await the carrying out of contingent acts by the ultimates before it is manifested where those ultimates are jointly instantiated, does no more than point up the truth that necessitated acts may be completed in contingent ways.

Being is present wherever the ultimates are, and in whatever these produce. These serve it when they constitute individuals, since they then convey Being in limited forms within their confines. Unlike the sorcerer's apprentice, they do not and cannot defy, ignore, or oppose their principal. Yet, while acting independently of this, they inescapably serve it. James Stephens had something like that in mind when he imagined God congratulating Satan, at the end of time, for a job well done. Such a view underscores the idea that Satan is an agent who, while acting on his own, independently does what the principal wants to have done. Were one to make the Miltonian view be in greater consonance with what is here being maintained, his God would have to be envisaged as producing angels who were necessarily created, perhaps to sing his praises, but still able to be distinguished from and able to act independently of Him.

Milton's God apparently produced a holy choir celebrating His glory. As existing in contradistinction to Him, it could act independently of Him, but still only within the limits that He set. Milton's Satan and his henchmen provide picturesque ways for referring to what is coeternal with, but able to act independently of their source. His supposed God, with his kindled anger and his punishings, acted in ways He need not have, and therefore was not free from all contingencies. He was inferior to Being, for this never does what it need not. But neither Being nor that God could determine the degree of separation from itself that what it produces could achieve. More prosaically: the ultimates may do nothing more, when they exist in contradistinction to Being, than provide an insistence for Being's possibility.

It is as correct to say that there is just Being and other realities as it is to say that there is nothing but Being in a number of distinguishable, interrelated guises. The former is preferable when a beginning is made with actualities. Once a move from these is completed, the reverse move from Being can be envisaged, finally returning to the actualities as so many

separate, confined versions of it. One would thereupon be in a position to begin again with actualities as distinct realities, existing apart from one another and all else. A philosophic account, of course, since it is carried out by a human, properly begins nowhere else than where a beginning at Being had come to an end. It could not successfully maintain that Being alone is, for the claim is made by one who is distinct from Being. Always confronted with independently existing and vitalizing ultimates, Being necessarily produces an independently maintained correlative of itself as an other, all the while that it remains a primal, necessary othering reality, necessarily providing the possibility of itself and what enables that possibility both to be apart from and be referred to Being—and be able to do other things as well.

These observations have been made within the compass of a new epoch in philosophy, recently well marked off from all others by Robert Neville. It has been preceded by no less than four others. The first is the Greek, itself subdivided into the so-called pre-socratic, and the period encompassing Plato, Aristotle, and their followers. A radical shift in the understanding and role of religion, and the dominance of theological problems and their answers, characterize the second period. New interpretations and great discoveries in astronomy, mathematics, and physics led to the third, 'modern' age. A fourth, a 'post-modern' epoch, now quickly fading, tries to cut away from the categoreal, formalistic, absolutistic, detached nature of what it takes to characterize the other epochs. Nominalistic, rejecting all prescriptions, fixities, and controls supposed to be accepted by others, it is itself unashamedly dogmatic, adopting a position it never justifies. Tacitly assuming that it is so well-grounded that every other position is to be dismissed as untenable, it backs a radical scepticism with an unexamined assumption that it has a strength, and even a universality, that no other position could have.

The present work bypasses rather than reacts to the positions assumed in the fourth epoch, to attend afresh to the presupposition made by all inquiries, descriptions, acknowledgments, and doubts about what is real and what can be known of this. It does not see itself to be either sceptical or dogmatic, to be adding to or negating what others affirm, but, instead, to make use of whatever it can, no matter in what epoch it first became evident, and whether or not it had been previously noted or focussed on. Struggling to think through issues at the base of all others, it has no fixed agenda, no settled method. Claiming neither to report nor to create, it proceeds somewhat like an amateur painter, step by step, gropingly and persistently trying to understand reality in its depth and breadth, as diversified and unified. Accepting the deliverances of commonsense to provide it with a beginning, it takes this to require a clarification that

could be provided only by attending to what is presupposed, not only immediately, but finally and always. Backing surmise with self-criticism, it also uses criticism to help it carry on relentless probings, while it strengthens its defenses and pushes on, step by step. It moves back before it moves forward, and moves forward to what warrants its having arrived at it, never stopping until it is directly or indirectly able to account for all the primary kinds of reality that there are. It would founder in the face of multiple claims made on behalf of the affirmations of particular disciplines, did it not subject itself to checks at every step of the way and move on only when the results both justify its doing so and point to what is next to be done.

Beginning with what is daily known, philosophy in this new epoch ends with an understanding of Being and then reverses its direction to come back to its beginning, at once chastened and emboldened, with a better understanding of what had been initially acknowledged and presupposed. Nothing so distinguishes it as its welcome of questions at every stage and its willingness to face them fully and well. What is sought is an understanding of reality in its depth and breadth, as diversified and unified. Backing surmise with criticism, its procedure, defenses, and conclusions are all freshly forged, even when they do no more than duplicate what had already been established by others.

What is now offered is one example of what can be accomplished at this time. Its claim to answer questions many have asked but to which no satisfactory answers have been given, as well as its opening up of issues that have been slighted or neglected, provide some warrant for studies that had been systematically carried out before, while opening up areas that have never been well explored. Often enough, it is bold where others have been timid, and self-critical where others have been dogmatic. It is no less true that it is obscure where one would like it to be clear, is too little concerned with extracting all the good it can from its predecessors and contemporaries, and ends too soon. As a systematic philosophy, it claims to make evident the nature of reality in its major diverse forms, and to show how they are interrelated. As the epoch of which it is a part unfolds, it will become more and more evident if and how these observations are accurate and warranted.

4. Good Questions

A representative of the preceding epoch stands before us, uninterested in the fact that his rejections and denials rest on an unexamined dogmatic ground. 'What you are maintaining is nonsense,' he declares, 'nothing but idle words, meaninglessness made to sound profound. Either accept the

reports of the sciences, live a religious life, describe what is known, believed, or said, be content to show how every act and thought is historically and politically qualified, or just struggle to get along in this somewhat unknown and perhaps never fully knowable world.'

Since he makes unnoticed use of the Assessor in his dismissals, and is sure both that he understands what is being maintained by others and that his negations are both ahistorical and apolitical, he evidently is a closet dogmatist, surveying and evaluating all else from a position he does not justify or try to understand. At his best, he points up radical, irremediable faults in what he rejects, may provide openings for another, better view, with a warning, pointing out where serious difficulties do, must, or might arise. A goad rather than a critic, an irritant rather than a stimulus, he has value only when one fails to carry out needed self-criticisms at every step. Wholesale rejections are dogmatisms with negative signs. They never manage to attach to anything themselves.

Every philosophy is the outcome of a struggle to deal with pivotal positions and crucial turns. Their defenders are inclined to ignore the struggles, jumping from peak to peak, indifferent to the fact that these exist because there are mountains below them and a ground separating these. Initial positions need to be qualified, expanded, and contracted, not only in order to face up to difficulties encountered, but to search for others. Every surmise is to be subject to remorseless scrutiny in the course of a struggle with difficulties, obscurities, and perplexities, encountered at every crucial point, as well as by those deliberately raised to test the strength and limits of what is maintained.

None of the five epochs of philosophy distinguished is without its cross-currents and borrowings. Each is challenged by what is maintained in other epochs. The fifth will, of course, provide and provoke its own challenges, and many of these might well be found to be restatements of what had been maintained before. Indeed, its recognition of that fact is one of the conspicuous differences between it and most of its predecessors. Plato and Aristotle, though, in sharp contrast with those who followed them, seemed to be challenging themselves again and again, an activity that has found little favor with their disciples—as was to be expected—or with successors who were content to adopt the methods and sometimes the results previously achieved in science, politics, ethics, and logic. What had once been maintained should be neither blindly accepted nor arbitrarily rejected, but should instead be mined for whatever truth or leads it might contain.

Each epoch has had something to contribute, as well as some things that had to be discarded or radically qualified. It is unreasonable to

suppose that this, the fifth epoch, is the last. What will follow we will, of course, not know until the present is at its richest. Only then will it become possible to see clearly what has not yet been mastered, and see what it is which one should attend in order for the mastery to be complete. Claims made in preceding epochs will, in any case, be tested in the course of a true fulfilling of the promise of the fifth epoch.

A number of current thinkers are now systematically resolving issues that had been raised before, but were then not well treated—particularly, the nature of individuals, ideals, preconditions, contingency, privacy, the essential differences among different kinds of actualities, mediators, emotions, and creativity. There is today a new flourishing philosophic society focussed on the nature of sport, and quite a number of able thinkers interested in the problems of technology. Slowly but surely, fresh questions about Being and the means by which it can be reached and studied, what it grounds, and basic issues not often faced, are coming to the fore. Pervaded by a common concern with root topics, it should help promote the mastery of the fifth epoch in a way no single thinker can. Yet, without those who go their own way while sharing in a common resolute attempt to carry out a systematic inquiry, not much will be achieved.

These observations may be dismissed as a form of self-advertisement. They may well be. But they also are no less a way of helping to mark out basic issues that characterize thinking in the fifth epoch. Other thinkers will surely find things to add, qualify, and reject, and they may place emphases elsewhere in the attempt to obtain a better, comprehensive account. There is nothing antecedently prescribed for those who seek to participate, unless it be the resolute pursuit of an inquiry in which every achievement is open to careful examination and serious questionings.

The pragmatists' rejection of the Cartesian doubt as a paper doubt, never more than an idle question mark automatically set behind every claim except the affirmation that there is a God who endorses all clear and distinct ideas, is well warranted. It is to be replaced, though, not by doubts raised only by blockages in the way of a life well lived or of inquiries by a supposed community of scientists, but by doubts raised deliberately, preliminary to the determination of the strength of what is being maintained. Philosophic inquiry in the fifth epoch deliberately raises doubts at every stage in order to determine the strength of what is claimed.

Our imagined sceptic never makes contact with what he supposedly denies. His negations are forms of self-affirmation. What is needed are negations that are attached to actual claims, just as genuine doubts are attached to what in fact is being doubted. The attachings are not modes

of destruction—that would end with the doubts themselves being destroyed—but instead are means for turning that to which they are attached into pointers toward better answers. Between universal sceptics and doubters, and those who question or doubt when they must, are the thinkers in the fifth epoch who voluntarily doubt what they have accepted in order to see how strong this is, and why and how it might have to be rejected, altered, or supplemented.

Philosophy is an ongoing enterprise. Unlike mathematics, which retains what was previously achieved while moving into new regions, unlike the sciences that discard what has been found to be faulty, and make fresh starts again and again; and unlike the arts, which may suddenly abandon one approach and adopt another, philosophy builds on what it can, while beginning and proceeding afresh in ever renewed attempts to master pivotal truths. Every move it makes is newly forged, even when it traverses well-trod ground, and every major step will be tested, usually a number of times, well before it is made known to others. Criticism will always be invited, though it may not be well understood.

Reality, despite thousands of years of resolute inquiry, has not yet been well understood. All that anyone can now hope to do is to make its major divisions, interconnections, and consequences better understood, and make possible a still better treatment by those who carry on the work fearlessly and resolutely. Each inquirer must try to contribute to the achievement of the best comprehensive, systematic account, particularly by those who are aware of the major achievements and weaknesses of those who had previously tried to understand reality in its full breadth and depth. This may have to be done in the face of, or neglect by, others who claim that the needed work has already been carried out, or those who hold that no one should even make the attempt. The first cling to some accepted master, perhaps one fitting well inside some past epoch; the second tacitly assume that they have grasped the essence of all conceivable attempts and know, with a surety that allows for no gainsaying, that nothing worthwhile could ever be produced. Both are historically tempered, the one stopping at some particular time and defining the future as otiose, the other taking themselves to be outside of time and therefore able to see the futility of every effort, tried or untried, in the past, the present, and the future. The blind submission of a disciple is here matched by the miraculous omniscience of a rejector.

At every step of a serious inquiry, one must look behind, in front, to the sides, above, and below. At each position in which difficulties have been well met, others are to be sought out, and what seems sound and satisfactory is to be tested by trying to see where and why it might not hold. The ideal outcome will be unified and pluralized, reinstating what is

at the root of the daily known, and resolutely probing into what no one had yet fully understood.

The recognition that every one of us is unique, is a person, and has a character to be gradually strengthened and redirected again and again, has responsibilities, feels, and knows something about what else exists in a number of domains, as well as what is always presupposed, makes it possible to begin with and move on toward what will be reaffirmed in some form at the end. Each claim is to be coldly examined, and the rough forms it has in daily discourse refined. If one finally closes with that with which one began, this will be with important qualifications that the inquiry made evident. The history of thought has shown that many ideas that had been taken to be central and even widely held cannot be maintained. That should not preclude one from isolating and accepting what is sound in those beliefs.

Ethics, education, politics, leadership, and arts, are to be dealt with on terms different from those appropriate to a scientific understanding of bodies. None will be discovered by examining the heart, blood, nerves, or brain. Radical and daring, checked by a searing caution, what is finally achieved will have to be left to others to correct, supplement, or discard. The entire enterprise must be carried out again and again, with emphases on what had been previously slipped over or slighted, or with corrections made on what had been improperly taken to be central or crucial. Nothing is to be placed beyond the reach of critical examination, but nothing, too, is to be supposed to have vanished just because it had been dismissed by those who could find no place for it in their accounts.

The primary task of a philosopher is to know a reality that is complex and diversified, where values, affiliations, extensions, coordinations, the intelligible and the vitalizing contribute to all outcomes, where what necessarily is, is made evident, and the existence of contingencies accounted for. Alert to difficulties, he is patient and flexible, ready to be quieted but refusing to be silenced. His primary task is to learn what reality is, both in fact and in promise. Our contemporary sceptic does not provide him with much help, in good part because he is little more than a pale version of a more muscular, more persistent, more searching, more sinuous questioner who does deserve to be faced and answered. I have been aware of him throughout this work. Occasionally, he has presented difficulties and acted as a stimulus, passing judgment on the suppositions and claims that had been made, and pointing up the kind of issues that still need to be faced. Unlike the sceptic, with his dogmatic dismissals and his avoidance of all challenges to his position and claims, the persistent questioner encourages further inquiry and provides opportunities for making it possible to see if crucial positions have been secured. Enabling

one to find answers that otherwise might never have been surmised, he may sometimes require that apparently sound views be abandoned, qualified, supplemented, or provided with better warrants.

Each systematic philosophic account has a distinctive nature, pace, divisions, and organization. Each, nevertheless, states much that has been known by others in different guises. Each also attends to what had been previously neglected or distorted, at the risk of introducing the same fault in other places, and perhaps new faults as well. Unexamined essential features of a culture, and the assumptions unreflectingly made in a language used at a particular time, will get in every thinker's way. The closer one comes to the end of a philosophic study, the more evident and insistent the ever-present questioner becomes, making one face issues, the answers to which seem to undermine even apparently well-certified achievements. If that questioner could be satisfied, what has here been maintained will be protected, or at least be clarified. Unfortunately, the questioner is never known in his full majesty until the inquiry is completed. Even if a satisfactory answer were here achieved, and the persistent questioner quieted others would still have to evoke him while going through the entire process on their own. He is always to be looked for and should be met from ever new positions and other angles. What every serious inquirer into serious issues needs most is to recognize that the persistent questioner is the faithful friend of truth, and therefore of anyone who is concerned with what there is, no matter what his antecedent predilections. Unfortunately, one hears him speak in tones and in ways that closely mimic one's own. Alert to that fact, it still is well worth listening to and trying to satisfy him.

Persistent Questioner (PQ). You hardly noticed me when you presented your account of the members of the different domains, and in your study of mediators. You then went on to say hardly graspable things again and again, with not much variation, perhaps achieving little more than the dulling of the wits of those who read you. What you have maintained would surely benefit from a better understanding of the ultimates, Being-as-an-other, Being itself, and the beings that actualities have. What is one of the most fundamental of your contentions offers a good place to begin. You are claiming that not only Being, but Being-as-an-other, and that for which it is an other, necessarily exist?

I: Yes. When Being is, it necessarily is, and necessarily produces its possibility, as well as what grounds and insists on this, i.e., the independently existing ultimates. It also produces the counterpart of this, itself as an other of the locus and user of its possibility.

PQ: Is what Being produces distinguished from Being? If not, is there anything more than Being itself?

I: Being is never not possible, but its possibility must be distinguished from it. Although there are not two or more Beings in themselves, there is also no referring of the possibility of Being to Being unless there is what exists apart from Being. This is a correlative of Being-as-an-other and, like this, acts as Being requires.

PQ: Being, as the terminus of a reference to it, is different from Being-in-itself?

I: Yes. Being-as-an-other and the correlate of this, the ultimates, are produced by Being. The two exist always, when and as Being does. Being-as-an-other has the twofold role of a necessary production by Being, and of a correlative of the ultimates. The ultimates have the threefold role of a necessary production by Being, a correlative of Being-as-an-other, and what can act independently both of Being-in-itself and of Being-as-an-other. Since reference has to be made to Being-as-an-other only to enable one to understand how the possibility for Being can terminate in Being-in-itself, there is no need to take account of Being-as-an-other except when concerned with understanding how the possibility for Being could end in Being. Being in itself is not affected by the fact that Being-as-an-other enables the possibility for Being to end in it.

PQ: Not only is it hard to understand this, but it is hard to find warrant for it in your discussion of Being and the ultimates. Why was it not focussed on?

I: I was trying to point up the fact that the ultimates had to exist in contradistinction to Being in order that they be able to act on its behalf. Now I am trying to make evident what Being is in itself. That requires me to emphasize the fact that the insistent possibility for Being ends in Being-in-itself only with the help of Being-as-an-other. Being is a self-othering that accepts what is transmitted to it, without thereby being relativized. It is not characterizable as possible or as anything else, except from positions that relativize it. Being-as-an-other transforms what is relative to it—the ultimates and the possibility for Being that these insist on—into what is no longer distinguishable in Being. By being transmitted into Being by Being-as-an-other, the possibility for Being becomes an indistinguishable part of Being. In itself, Being is not characterizable as possible or in any other way.

PQ: It is not Being that confronts a possibility for Being, but Being-as-an-other?

I: Yes. Though the possibility for Being is produced by Being in a necessary act, an act that also provides what insists on that possibility, the possibility is a correlate, not of Being as in itself, but of Being-as-an-other. If it were a correlate of Being as in itself, it would relativize this.

PQ: Being-in-itself is not possible?

I: Yes and no. It is, of course, not impossible. Yet whatever is distinct from it cannot be related to it except via a corelative, Being-as-an-other. This enables Being-in-itself to be possible, without making Being cease to be in itself, relative to nothing. In itself, Being allows for no distinct items. Being-as-an-other transforms the possibility for Being into the possibility of Being, a possibility that Being always encompasses as not separated from the rest of Being. The possibility of Being is distinguishable from Being only by the ultimates, which transform it into a possibility for Being, a possibility that Being-as-an-other transforms into a possibility of Being.

Being is possible when and as it is. The possibility, as provided by Being, is no more than a possibility *of* Being, a continuation of it, having no status of its own, no insistence. For there to be a possibility for Being, the possibility of Being must be maintained and insisted on by what Being also provides—the ultimates. The possibility for Being terminates in Being itself, via Being-as-an-other.

Being is the source of its possibility and whatever this requires in order that it become a possibility *for* Being. That possibility can terminate in Being because it is mediated by Being-as-an-other. This, the correlate of the possibility for Being, enables that possibility to terminate in Being itself, become a possibility *of* Being.

PQ: Your answer is not entirely clear. Let's look at the issue from the side of the ultimates, the correlate of Being-as-an-other. Must that correlate not exist in contradistinction to Being itself, and not just to Being in the role of an other?

I: Yes and no. Being-in-itself and Being as the referent of Being's possibility are related as source and terminus. The referent is Being-as-an-other. It and its correlate, the insistent possibility for Being, are when and as Being is—always. Being-as-an-other is dependent on Being itself; so are the ultimates, as insisting on having Being's possibility referred to Being.

PQ: How could the ultimates be both necessitated by Being and be able to act independently of it?

I: They are necessitated to act on Being's behalf. That requires them both to be, and to be able to act independently of Being.

PQ: In itself, Being is faced with its other. Does that not mean that it is in a process of tearing itself asunder?

I: No, and that for two reasons. The self-othering of Being terminates in Being-as-an-other, as well as in what enables Being's possibility to function apart from Being.

PQ: Isn't the possibility for Being a correlate of Being-as-an-other?

I: Only as insisted on and through by the ultimates.

PQ: Does Being not have a reality in contradistinction to all else?

I: Yes.

PQ: Even in contradistinction to the laws of logic?

I: Yes.

PQ: Is it subject to those laws?

I: No, for if it were, it would be limited by what is distinct from it.

PQ: The laws of contradiction, excluded middle, substitution, identity, entailment and inference do not apply to it?

I: They do not.

PQ: How then can it be understood?

I: As that which is at once vague, indeterminate, unique, allowing nothing to be separated, all-acceptive, and not bounded.

PQ: You seem to end where the mystics do, with something you do not and apparently cannot make intelligible.

I: No. I can understand Being as it exists in contrast with Being-as-another, and what insists on referring Being's possibility to Being via that Being-as-an-other.

PQ: Why was this never said before?

I: Is it not perhaps what the Arians and Greek Orthodox theologians claimed to be true of God and the two other persons of the Trinity?

PQ: You are not claiming these as your supporters?

I: No. I am trying to answer your question. I am not here speaking of God or of a Trinity, but only of Being as it is in itself, and as having a pair of correlatives.

PQ: Well, why has it not been said before by other philosophers?

I: I can speak with some confidence only about some of those in the West. Most of their major advances were made relative to what had previously been done.

PQ: Those who do not accept what you maintain have not taken advantage of what your predecessors achieved, or have not properly attended to that to which you refer?

I: Yes. We know what we mean when we mean what we say.

PQ: That sounds clever. Try again.

I: The meaning of what we know is provided by the object of knowledge. Starting where I now am in the humanized world, I have taken account of myself as contributing to this, to what results when I am united to my body, to what I can come to know about what exists in other domains, as well as about what and whatever exists in adjacent domains. All are confined by instantiations of all the ultimates. The evidencing of those ultimates, as not yet instantiated, leads to the acknowledgment of the ultimates as preconditions, and finally of what these presuppose. That upward move ends in Being, via Being-as-an-other, from there, one can

proceed in the reverse direction and show why the ultimates are produced, and what it is that they must do. Eventually, one arrives at the contingent, transient realities from which the initial move to Being had begun. Those realities are Being itself, as conveyed and confined by the ultimates and occurring within Being as superveniently present everywhere.

PQ: What is everywhere, Being-in-itself or Being-as-an-other?

I: Being-in-itself. Being-as-an-other is that Being in the role of a correlate.

PQ: Doesn't Being-in-itself remain in itself, and therefore unable to do more than supervene? How could it be conveyed without being squeezed inside the narrow limits that the ultimates provide?

I: What is conveyed is Being-in-itself, as expressed through Being-as-an-other and the ultimates. When it is said that Being is conveyed by the ultimates within the confines these provide, reference is made to Being-as-an-other, since it is this with which the ultimates are directly involved. When it is said that it is Being itself that is present in a limited form within the confines that the ultimates provide, reference is made to that over which Being directly supervenes.

PQ: What is everywhere, Being-in-itself or Being-as-an-other?

I: Both are wherever the ultimates are, and in whatever they do.

PQ: If Being is everywhere, will it not be multiplied?

I: No. What the ultimates confine is not Being-in-itself, but Being-as-conveyed.

PQ: Do the actualities exist in contradistinction to the ultimates, as well as to Being itself?

I: Yes. As the first, they are owners and users; as the second, they are locatable within Being as supervening over all else.

PQ: So far as they are independent realities?

I: Yes. That is why they are able to make use of the ultimates in ways these do not and could not determine, as a supervening reality.

PQ: Since the ultimates are Being's agents, must they not act independently of it?

I: Yes. But since they confine what exists in positions over which Being already supervenes, what is there is existent in contradistinction to the ultimates that confine them. Since they also act on and through the ultimates that confine them, they resist absorption in Being as supervening over them.

PQ: If individuals are Being in limited forms, existing in contradistinction to Being as it is in itself, there must be more reality than that which Being has. Yet, if there is more reality than Being has, Being must be

limited by what is not Being, and therefore be less than that which necessarily is, that which is limited by nothing.

I: Being produces what is and acts independently of it, but within the controlling limits that Being itself sets.

PQ: Will Being not then be in a continual process of struggle and perhaps dissolution?

I: When and as Being is, it terminates at the correlatives, as others of one another.

PQ: Being-as-an-other and what insists on Being's possibility are termini both for one another and for Being itself?

I: Yes. When and as those correlatives exist, they are related in a distinctive othering relation.

PQ: Being-as-an-other and what insists on Being's possibility are termini both for one another and for Being itself?

I: Yes, but Being does not exhaust itself in that act.

PQ: As not exhausted in the act of providing correlatives in a relation of othering, must not Being be in a continual process of dissolution? I am now asking you about the othering, not as it relates correlatives or about the way it provides the correlatives, but of the othering as due to Being itself.

I: We can know that Being makes itself possible, that it produces itself as an other, as well as that which is the correlative of this.

PQ: That does not tell us what Being is, but only what it does. No matter what it does, it is not something more? If so, what is this?

I: Being is a primal reality.

PQ: Is it as such that it provides a correlative pair of others—Being-as-an-other, and the ultimates as referring Being's possibility for transmission by this?

I: Yes. It ends at the correlative others. That othering is a thicker version of the very othering that connects the correlatives.

PQ: Are Being-as-an-other and its correlative not the termini of two separate kinds of othering.

I: Yes and no. When and as Being produces its other, it produces the correlatives of this.

PQ: You say that Being is not subject to any of the laws of logic. I ask you again: do you not end with the inconceivable?

I: Being is always able to be referred to by expressions that are subject to logical laws, while it continues to be beyond the point those laws reach. These enable one to refer to Being. They are exhibited in its correlatives, and in the relation they have to one another. As accommodated by Being,

the correlatives cease to be distinct; so do the laws of logic, for when and as Being accommodates those laws, it accommodates the correlatives. The accommodations end in the subjugation to Being of what is accommodated. It is that fact I have tried to convey in speaking of Being as not subject to any laws or, alternatively, as that in which all of them are negated. Being is referred to by what terminates at Being; as accommodated by Being, what terminates at it is no longer referable to it.

PQ: You end in the inexpressible?

I: No. Being is always characterizable, always able to be referred to by expressions that are subject to the law of contradiction, excluded middle, and so on, while it continues to exist beyond the point they reach.

PQ: At that point does it not become unintelligible, incommunicable, mysterious?

I: Only if what is a more intensive version of that at which one ends is unintelligible, incommunicable, or mysterious.

PQ: Being itself is an intensive version of what is true of it, but whose nature cannot be expressed except in intensively used terms?

I: Yes. To know it is to end in it.

PQ: Will it not swallow what is known of it?

I: Only if it were not distinct from what is known of it. Only if it were not ended at as receding, while it accommodates whatever refers to it. In itself, Being is an othering without terms, self-differentiating, too dense, too absorptive to be expressible.

PQ: Is there nothing in between Being and Being-as-an-other?

I: No. If there were, there would be a third being connecting the two.

PQ: How could the ultimates be necessitated by Being and still act independently of it?

I: They are necessitated to act on Being's behalf. That requires them both to be and to be able to act apart from it.

PQ: The ultimates might not constitute anything and would, so far, in addition to acting on Being's behalf, exist but not benefit Being?

I: When they do not do anything more than provide the insistence that Being's possibility needs in order to be a possibility for Being, the ultimates continue to be Being's agents, able to do other things. As agents, they are always subject to Being, supervened by this, existing within the compass of Being.

PQ: Would there not then be realities other than Being?

I: Yes. Being, e.g., does not produce me; I am finite and transient, a contingently existing reality. But Being is not limited by me or by anything else, is forever what it is, and acts once and for all.

PQ: Must there then not be more reality than Being itself, or than Being and the correlative others it produces?

I: Yes and no. The ultimates operate as Being's agents. In addition to doing what Being requires them to do, they act on their own, but within limits that Being had already set. Individuals and the Habitat, as so many separate beings that might not have existed, are realities in addition to Being, but they occur within an area already under Being's governance. They can be said to be Being itself, particularized by independently acting ultimates. What the ultimates constitute is produced by them under the aegis of Being; Being supervenes over the ultimates and anything that the ultimates jointly confine. Just as an admiral is definitory of every ship in his fleet and therefore is instantiated in each of every ship's separately produced acts, so Being is already present as a precondition, able to be filled out by what the ultimates jointly produce. Each actuality has its own integrity. Could the ultimates exist in abstraction from Being's governance of the positions which the actualities fill out, there would be more reality after the ultimates jointly act than there had been before. Identified as instantiating the Being that, in its own way, occupies the confining area that the ultimates produce, what was made to be by the ultimates is nothing more than Being as at once confined and omnipresent.

PQ: This is not clear. Somehow you are claiming that there is something more than Being, even contingent realities that Being could never produce, and yet that these are just instantiations, even transient instantiations of Being.

I: Actualities are independently constituted by the ultimates where Being already is; what those ultimates provide is a filling for Being as already present. Treat the filling apart from Being's presence, and you have something more than Being; recognize it to be a coloration of Being, you have what is no more than an aspect of Being. When Being, in a limited form, is conveyed within the confines that the ultimates jointly produce, it is enabled to act in the opposite direction from that which it had when it produced the ultimates. As so conveyed, Being compensates for the freedom that the ultimates expressed when they constituted and confined actualities. But since Being will there be dependent for its presence on their act it will, so far, be the outcome of contingent acts. The paradoxical sound of this is dissipated with the recognition that Being had already occupied the very places into which the ultimates convey Being in a limited guise, able both to be encompassed by Being and to be confined by the instantiated ultimates.

The contingent position and role that Being obtains through the agency of the ultimates compensates only for the independence that the ultimates

express in their joint instantiations. What the ultimates confine is encompassed by Being as already present. From the position of the ultimates, a new reality is produced, owning and able to use them as jointly instantiated. From the position of Being itself, that confined reality is located within Being as supervening there.

PQ: Somehow Being is already present within the limits that the ultimates may, but need not provide? Somehow, also, it is not present, and awaits the contingent acts of the ultimates before it is present within those limits?

I: Being, as already present within the area that the ultimates jointly confine, is Being itself, accommodative of what the ultimates convey of it. For Being to be in itself, it must provide for other realities that exist and act independently of it. These would seriously limit it, did they not do what Being needs to have done—have possibility referred to it, and also have those realities compensate for the independence it grants them.

There are many distinct realities of which Being is but one; all of them together are Being in a pluralized form, each member of which has its own reality and ways of acting. Being encompasses all of them. I, like other actualities, am identifiable with Being in ways that oppose one another, and thereupon enable me to exist apart from Being itself.

PQ: Your account swings back and forth, but never seems to have a fixed position or a midpoint.

I: It does seem as if again and again it wobbles, from speaking of actualities as though they were Being itself conveyed within the limited confines that the ultimates constitute, to speaking of them as though they were positions in Being. Both must be maintained, no matter how awkward the expressions of the double-claim sound. Imagine a beneficent primordial creator who not only produced an area within which salvation occurred, but who then and there produced what fitted into this to some degree, and you would have a good idea of what I think occurs, provided only that you secularize the idea of creation or salvation.

PQ: Now I understand what is meant by those who say that non-believers use God for their own purposes. Individuals, at any rate, have realities of their own?

I: Yes, but that does not compromise Being's ubiquity.

PQ: Can you know any actuality as distinct from all others?

I: Yes, I can discern individuals, and I can adumbrate other kinds, passing beyond what they appear to be to them as expressing themselves in and through their appearances.

PQ: Since the ultimates can act independently of Being, must they not also be adumbratively reachable? Since they always are, but might never

have produced anything, do they not add to the number of beings that forever are, in addition to Being itself?

I: Being is not multiplied when it produces an agent to do what it prescribes.

PQ: But the agent is apart from it and may also do what was not prescribed?

I: Yes. But when Being's agent exists, Being continues to encompass it.

PQ: I still do not have a good understanding of what you are claiming about the reality of actualities or the ultimates. Let us proceed slowly, step by step. You are not Being?

I: I am not. I am finite, transient, a contingent existent, doing things on my own.

PQ: You are real?

I: Yes.

PQ: Being is real and you are real. You do things it does not do; it does things you do not do. There are, then, no less than two realities, one eternal, necessarily doing whatever it does, the other a contingent existent, doing what it need not have done.

I: Yes.

PQ: You set limits to what Being does, and Being sets limits to what you do. But if you set limits to what Being does, you so far take it to be less than that which necessarily does what it does, never subject to any contingency.

I: The limits I set to Being occur within the compass of Being. Those limits express the presence and effectiveness of the ultimates as jointly instantiated. I am Being, as existing within the confines of those limits, and also as occupying a position where Being already is. I differ from Being itself by having a status of one who matches his encompassment by Being, by an involvement with confining ultimates. Could I free myself from Being or the ultimates, I would be completely involved with the other, never able to act in contradistinction to it. I would be no more than a punctuation point in Being, or what the ultimates carry forward, but would not exist apart from either. What the ultimates carry forward within their confines is able to exist in contradistinction to them, because it is given a lodgement within Being. I am able to be distinct from both of them because each precludes full control by the other. I am Being in miniature, facing Being itself from two competing directions.

PQ: You also say that finite Beings are encompassed by Being. Does that not relativize Being, take it to be relevant to whatever the ultimates confine?

I: Yes and no. Being, as supervening over the position occupied by a

finite reality, is not affected by what occurs there. It continues to be in itself, where the actualities may sink if they can free themselves from all confinings.

PQ: Being is not added to when it allows for an agent that can act independently of it? Since the agent acts on its own and produces what it need not, as well as what it must, will it not be sufficiently distinct from its principal to reveal it to be a reality in addition to that principal—Being, its source?

I: Unlike other agents, the ultimates, when acting independently of Being, always serve it.

PQ: Yet they are distinct from Being and are even able to act in ways Being does not decree? They even have natures and are of a number that Being does not determine?

I: Yes, but they have those natures and number because they distinguish themselves from Being, in order to refer its possibility to it.

PQ: When the ultimates constitute actualities, they produce what Being does not determine? Here, at any rate, we have a plurality of realities in addition to Being.

I: Those realities own the independent constituting, and confining ultimates.

PQ: Still, there are many actualities in addition to Being, Being-as-another, insistent ultimates, and what those ultimates jointly constitute. When you begin with a single necessary Being acting in necessary ways, you somehow end with a plurality of realities that did not have to be. Out of a necessary One you extract a non-necessary plurality.

I: I do not think I do that. What I do is to note that, just as there are correlates when and as Being is, so there are ultimates when and as Being is.

PQ: But individuals and the Habitat might never have been? When and as Being is, they need not be?

I: Yes. Individuals are beings compensating for the degree of freedom that Being's agents express when they jointly act.

PQ: When the individuals are produced, are there not beings in addition to Being?

I: No. Just as Being-as-an-other, and the insisted-on possibility for Being do not multiply Being, so the ultimates do not. Nor do they constitute and confine so as to limit Being in any way.

PQ: Yet the individuals and the Habitat are realities. If they were not, the ultimates could not have jointly confined anything real.

I: They are realities, but they could have no more reality than that which Being enabled the ultimates to convey within a place where Being already is. They are distinct from, but not additional to Being.

PQ: You are beginning to repeat yourself. Let me try to get you to answer a different set of questions. There could have been different ultimates than there now are?

I: Their natures and number express the degree to which they are independently able to do what Being requires them to do—make the possibility that Being provides be apart from and yet be addressed to Being.

PQ: Might not the number and kinds of ultimates have been different from what they are?

I: Yes and no. The independence that the ultimates achieve occurs when Being is possible, i.e., always. Its degree is not prescribed, but whatever it be, the ultimates may or may not engage in further acts by which actualities are constituted and confined. Being necessitates that the ultimates be, but for them to be they must exist in contradistinction to Being. Being acts necessarily; the ultimates that it produces necessarily act as a single insistent power referring Being's possibility to it. To do that they must exist and function in contradistinction to Being. They make that fact evident by subdividing in ways they need not have, and thereupon being able to act jointly in other contingent ways. Being necessarily produces what must act as it prescribes and must exist apart from Being, a fact contingently expressed in the natures and numbers.

PQ: When the ultimates act, they exist in contradistinction to Being?

I: Yes and no. They exist apart from Being, even when they do nothing more than 'sustain' and refer Being's possibility to it. Being does not await the contingent moves of the ultimates, nor does it control them. What it does, it does just once, when and as it is. When the ultimates constitute actualities, they do not act under the control of Being, but nevertheless serve it. Being not only necessitates that they insist on referring Being's possibility to it. It accompanies them when they act in other ways and is, thereupon, conveyed by them within the limits they provide.

PQ: Need the ultimates do anything more than provide Being with the possibility that those ultimates necessarily refer to Being?

I: No, but, as a matter of fact, since we exist, we know that the ultimates constitute and confine what owns them.

PQ: Whether we know it or not, Being compensates for the freedom the ultimates exhibit when they jointly constitute and confine individuals and the Habitat?

I: Yes. When Being necessarily produces independently existing, contingently acting ultimates, it continues to be a principal that benefits from whatever those ultimates express by its acceptance of what those ultimates produce. Since Being awaits nothing in order to act, it must

already be present for the ultimates that convey it, and in the place where they convey it. As conveyed, Being is limited, not entirely freed from the confining ultimates. From the position of Being, every actuality is an intensified unit part of it; from the position of the ultimates, acting as Being's perfect agents, every actuality is Being in a confined form.

PQ: If you knew what necessarily does what it does, should you not know everything else about it? Aren't necessities necessarily linked?

I: Logical necessities are necessarily linked. Others need not be.

PQ: What is not necessarily linked must be contingently joined?

I: No. They may be interinvolved, but not distinguished, not necessarily joined in logically definable ways.

PQ: To know what necessarily is, and what does what it necessarily does, is this not to know Being?

I: It is to know it as that which is different in fact from the necessity as understood.

PQ: Do you know the difference?

I: Yes and no. I know there is a difference, for I find that the necessity I understand is an aspect of what I intensively share. Yet, no matter what I know, I know that it continues to have a reality outside my knowledge.

PQ: How then can you know whether or not it is there?

I: Just as I know that what I perceive is more than what I perceive of it, so I know that Being is not reducible to the necessity as comprehended by me. The latter connects distinct terms; the former produces what it connects.

PQ: You know items expressed, but you do not know the realities they express?

I: I can know these through intensive, convergent acts. I do not get them into my mind.

PQ: You end in ignorance after a lifetime of struggle?

I: Yes and no. I have learned many things. It would not be worth it, were the result just a set of arbitrary claims, illuminating nothing. If it overcomes difficulties that sooner or later arise and seriously perplex, and if it removes uncertainties about what one's nature is, what ought to be done, or how excellencies may be realized and then used to promote the achievement of other splendors, and if, in addition, it enables us to deal well with crucial issues, it could help us achieve other goods that may otherwise not be obtainable. If, also, the struggle helps us strengthen and increase the range of what otherwise might have been too narrowly understood, it would surely be worth the effort.

PQ: Brave words by one who has paid little attention to the practices and achievements of the sciences, supposes that there are a number of separate domains, makes references to not commonly recognized proc-

esses such as adumbration, discernment, mediations, evidencing of transcendent ultimates, and ends with a primal 'self-othering'.

I: What's wrong with doing that? What is sought is what enables one to understand reality in a way and to a degree no other inquiry can. Only it enables one to see why and where all other inquiries must end. All others ignore what could set serious limits to what they are able to comprehend. One could suppose that one or more encompassed all that was or could be known, but in the absence of a comprehensive warranted account, there would be no knowing whether or not such a claim was warranted.

I do not bring the reality into my knowing, but I know it as continuing beyond what I articulate and conceptualize. My knowledge of a reality is grounded in it as insisting on itself, thereupon making evident that the necessity, or anything else that is true of it, is at the forefront of it as able to do more than what is known of it could do. To know X is not to yank X into my mind, nor is it to face an unknowable. It is to be more or less accommodated by X itself.

PQ: Might not X alter the knowledge of it?

I: Yes and no. What is known of X is true of X; what is true of X is maintained by X on its own terms. The most X can do for what is known of it is to intensify, enrich it.

PQ: Can you know that what you know of X is true of it, unless you know X as intensifying it?

I: No. There is no known X that is just attached to a real X. To know X is to end a transformational act that begins with an idea, surmise, or supposition, and ends at what accommodates this on its own terms. When I know X, I find that what I know of it is taken over by that which terminates my knowing. I impinge on what is acceptive of what I end at to find that what is primarily intelligible is primarily dunamically possessed.

PQ: Do the ultimates not point in two directions—toward Being and toward whatever they might in fact constitute and confine?

I: Yes. They insist on referring Being's possibility to Being, and they are subdivided independently of this, able to constitute and confine individuals.

PQ: In what ways are Being and individuals alike and different?

I: Both are irreducible, intensively real, but the one is a self-othering, while the other may make use of what constitutes and confines it.

PQ: Are Being and individuals not inverted versions of the ultimates?

I: No. When and as Being is, the ultimates provide it with a necessary counterthrust, a reference to Being through Being-as-an-other. Those ultimates provide for the presence of owners of what they constitute. These are able to act on and through those ultimates. Individuals own and can use what constitutes and confines them.

PQ: Yet the ultimates act independently and constitute actualities that exist apart from Being?

I: Yes, but without ceasing to be related to Being.

PQ: Your individuals seem to be Being Itself somehow delimited. Are they not both encompassed by Being as present everywhere, and identical with Being itself in conveyed, limited forms?

I: Yes, but they differ from Being not just in two but in four ways: in their dependence on a contingent conjunction of instances of all the ultimates, by their confinement by these, by their ability to possess and own their constituting ultimates, and by their coming to be and passing away.

PQ: Were there no actualities—and you admit that there might not have been any—would the universe not be defective in some way? To avoid this, would not a perfect being necessarily see to it that the ultimates necessarily produced individuals?

I: No. Being enables them to produce individuals, but does not dictate that they do. It does not produce anything that contingently exists. The individuals are necessarily produced as what must act in one way and can act in other ways. Though actualities occupy a region of Being, and though they are limited, conveyed beings, they depend for their existence on the acts of the ultimates that are then and there possessed by those individuals. Distinct from the instantiated ultimates, filling out a region of Being, individuals, whether human or subhuman, and the Habitat as well, would vanish did they not own the ultimates that constitute them.

PQ: When you were not, there was Being, the ultimates, and other actualities?

I: Yes, none of them depends on my existence or knowing.

PQ: You know that? I am not confident that this, or most of your other answers have done more than underline unresolved difficulties. Is there any point in going on? Indeed, why should anyone do more than what one ought to enhance one's own life and the lives of others?

I: Knowledge of what is presupposed makes it possible to avoid misconstruing what one is, or the relations one has to whatever else there be. It also makes it possible to know what can be utilized.

PQ: You haven't done that here, have you?

I: It would require another work, perhaps as large as this.

PQ: That may well be, but you should give some indication of how this could be done; otherwise you will end with a promise without shape.

I: Apart from the satisfying of such a promise, or even apart from an indication of how it might be fulfilled, it is good to know what is.

PQ: Few will accept what you maintain, and surely not with just the stresses you introduce. You have admitted that you do not often agree with

leading thinkers in four periods of great and searching thought, stretching well over two thousand years! You have, moreover, focussed on dimensions of reality that have been emphasized in the West, making only occasional references to what is emphasized in the East, and then without backing your acknowledgments with a sure knowledge of what is being maintained. You speak as if you were open to radical questioning, were willing to learn, and were content to open up areas that had not been previously noted or explored. You may have opened a door, but to what, I am not sure.

I: It not only takes a lifetime to know what justifies one's beginning, but one ends with what it would take other lifetimes to develop and use. If what is here said has moved us closer to what holds always, and helps clarify and complete what is known in other ways, then I think that what has been done will have proved worth doing.

PQ: You do claim, do you not, to present a final answer? Not only are there great systematic accounts that, despite considerable battering, have withstood long periods of severe criticism from many sides, but we surely have not yet come to the end of philosophic inquiry. While many thinkers speak as though they had written the last word on a subject, we know that they have not. It is not likely that you have brought the subject to an end. If philosophy has a future as well as a past, what you say will surely be replaced by other accounts, will it not?

I: Yes. Indeed, I hope it will. Philosophy is faced with an unending task. One makes a significant contribution to it if one avoids past errors, opens up new avenues, and solves problems previously neglected or improperly answered. Every one of us is finite, with limited knowledge and insight, blundering, too rigid, naive, and unperceptive at various times. At best, one can offer only what has been honestly faced, vigorously struggled through, hoping that others will venture courageously and cautiously into areas that one's achievements have opened up. A primary enterprise sustains a vigorous inquiry for an indefinite time. No views are to be rejected because they do not fit in with what is now accepted; they should instead make one aware of places where the view may be most vulnerable, or where it requires additional defense and clarification.

PQ: Not every account, no matter how much of a life has been devoted to its pursuit, is worth having. Let it be granted that what you say fits well together, and even that some things that have been left obscure, or have been misconstrued or neglected, have been made more evident and secure. If you are right, should you not be able to understand in a fresh way every kind of reality, even the object of special technically-controlled inquiries by disciplined investigators who take no account of what you are maintaining? If there is to be not just a new and perhaps even inescapable

but limited transient period in the history of thought, but an important fifth epoch in which thinkers open up a new and better way for everyone to know what is, must be, can be known, and ought to be done, you must do more than answer the questions I have put to you, even granted—as I do not—that you have answered them fully and well. Can your account be expanded, can it be applied, can it be filled out, lived with, grow? Can it make a difference to other enterprises, or does it exist apart from all, impinged on and impinging on none? Why don't you test it by seeing if it enables you to make advances in the understanding of education, politics, religion, even of mathematics or science?

I: I agree that these test and are tested by a comprehensive philosophic account. I have dealt with them and other enterprises, in other works. They provide checks on what has been and is now maintained, and are themselves in turn clarified by these in ways they otherwise would not be.

PQ: Since you suppose that you have made an advance on what you or anyone else has done, ought you not go back to see what in your previous accounts needs to be modified, added to, or abandoned—or, alternatively, restate them and incidently clarify and test what you are now maintaining? Here is one challenge: Ethics has occupied itself with problems that concern everyone. What need is there to know anything more than what it can teach us about the best way to spend our lives? Must not your account—and any other supposedly all-embracing philosophy—prove its worth by showing that it is needed if one is to achieve a good, full life?

I: Yes and no. A human exists in a large humanized world, itself inside a more complex diversified totality of realities, each illuminating and providing checks on the others. The more I know of that totality, the more surely am I in a position to check and complete accounts that are primarily occupied with what is of major interest to those who are concerned with living an ethically endorsed life—or who are occupied with the promotion of science, mathematics, politics, art, or other pursuit—important in themselves but not constituting a totality of reality. Philosophy is engaged in by those who are restless and unsatisfied as long as they have serious problems for which they have not been able to find satisfactory resolutions. How odd it is that some suppose that the 'problems of men' do not include perplexities about the nature of knowledge, the understanding of what is always being presupposed, the difference between particulars and universals, the nature of ideals, and the like.

PQ: Think of an exceptionally good person, one who is perhaps wise, sensitive to the needs of others, concerned with doing what should and can be done in the humanized world. What need is there for such a person to consider the nature of Being, the ultimates, the fact that there are a number of domains, and so on? Think of a bigot or a tyrant. Are they evil

because they do not understand the nature of reality? Would they mend their ways if they had a better philosophic grasp of things? Would a Heidegger have been a better philosopher were he a better human being? Is the evil he and some other philosophers endorse or tolerate something outside the limits of a philosophic account or of a philosophic life? You have not fully faced such questions. Can you show that a good grasp of reality will make possible a better understanding of these and other matters of major concern to everyone? Can you show, even if only in outline, how your account makes it possible to deal with such matters in better ways than would otherwise be possible?

I. I must try to show that it does. I grant that I have only a flickering vision of the totality of reality, and even of Being, the ultimates, individuals, and the Habitat. I know that a good deal of what I have maintained quickly slides, almost imperceptibly, into the unfocussed and ungraspable. I am quite confident that I have proceeded in the right way, and that I saw what was next to be faced. I am not that confident that I have clearly reported what I thought I saw. Before I try to indicate how the present account makes evident and contributes to the understanding of such issues as good and evil, I would like to ask you a question. Who are you?

PQ: I thought that was obvious. I am the totality of all reality, facing you in a personalized form.

7

The Unending Task

1. Living Philosophy

There are great men and women with good, strong characters, who inspire and help many. The lives they lead, as well as what they do, set a standard. Their splendid achievements are usually backed by a fine grasp of what humans need and should become. Without thinking of themselves or of benefits they might thereupon obtain, they try to help others. Those who lack the insights, range, and characters of these rare individuals, may be sensitive, generous, and kind, ready to sympathize, sacrifice, and help; they may also enrich the lives of others. They cannot, though, be counted on, for they may act unsteadily, often in unduly limited ways. We may honor and admire them, but we rarely confuse them with the great. The model figures seem to be goodness incarnate, the others, responding well only in special circumstances and for short times, not only fail to promote and produce much that is eminently desirable, but lack vision and long-lasting, effective concerns.

To live a good life, and occasionally to promote the welfare and happiness of others, is perhaps the most that most of us want to or could do. What is achieved will often need correction and supplementation; this will not likely be provided, except by one who also knows what ought to be done in most situations. Reading the lives of great figures, attending to their admonitions, prescriptions, warnings, and promises, while neglecting their times and traditions, are not the best ways to attempt this. Unfortunately, much of what is recorded of the great is either too specific or too general to provide a useful guide. To know what should be done, one ought, at the very least, know what men are in root and in promise, and what they may likely do. Signal successes are not to be expected if one

does not know what humans are as persons, organisms, and between the two, as well as what could and should be realized by, in, and for each.

It is not enough to want others to be fulfilled or to be happy. One should also know whether or not, as well as why and how this could and should be done. Otherwise, one will be radically challenged in situations where gains for others involves serious losses for oneself. Nor do great achievements in the arts and the sciences, remarkable instances of bravery or devotion, need to be bolstered by a demonstration that they brought about great good. They do not need to be justified by showing that they do or even promise to enhance any life. What good would it do to show that there is a necessity governing the distribution of prime numbers? Conceivably, the knowledge might help us learn more about the nature of numbers; this, help us to solve otherwise intractable problems in mathematics; this, help science to progress; this, help us solve technological problems; and finally enable us to be in a position to make life easier and more pleasurable for many. It may not; that will not compromise it or show that it is not worth doing.

A philosopher's autobiography is partly contained in his work. Details about his character offer clues on how to read it perceptively. Though it need not be supposed that the best of thinkers had the best of characters, it must be assumed that they were essentially honest, sensitive, persistent, and self-critical, willing to carry out their studies as well as they could, but without also maintaining a hidden agenda, tempting them to distort the inquiry or its outcome. It should not be a great surprise to find that a Nazi's philosophy is peppered with fraudulent philology, dismissals of positions held by others that in fact anticipate his own, or that he finally abandons his project when he comes to the most crucial questions.

A fine, strong character, and a vigorous intellect, a respectful assessment of what is or has been widely and long accepted, daringly cross-grained by caution and ready doubts, backed by strong self-criticisms, good judgment, decency, and courage are needed if a satisfactory, systematic account is to be achieved. No one really knows or needs to suppose that he fully meets these stringent demands. Each, though, should do what he can do to make a serious, strenuous attempt to do so. A philosopher exists primarily in intent, secondarily in thought, and finally in an outcome in which the two are well-joined. One who is seriously occupied with it has something like the temper of a mountain climber. He knows that each step is an adventure, never entirely separable from the steps taken before and those that are to follow, and that each is to be begun tentatively and then secured. Most important, he knows that he must manage to get down as well as go up.

A living philosophy not only has a more or less clear understanding of the whole of reality as joined to specialized subdivisions, such as ethics, but has the meetings maintained and used by a good, strong character. This joins thought and intent in an insistence that is carried out in and through a living body. The insistence will have any number of degrees of strength and any number of degrees of excellence.

There are some who have good but weak characters, some who have poor and weak characters, some who have poor and strong characters, and still others who have good and strong characters. Sentimentalists have good but weak characters, the mean-spirited have poor and weak ones, tyrants have poor and strong characters, while the noble have good and strong characters. Each type has many degrees, and there are many ways in which it could be used. A character, no matter what degree of strength or excellence it has, does not, of course, carry out any act on its own. An individual thinker in particular so expresses his character that he acts on and through a personalized juncture of his thought and intent. If he is to live properly in the humanized world, he must express that character there.

Each human is a distinct, irreducible, unduplicable reality, confined by and able to act on and through his person, his organism, and both together. Each expresses himself by using his character to live apart from as well as in and through all three.

There would be beings in addition to and limiting Being were individuals not so many confined instances of Being, occupying positions that Being already encompasses. When the ultimates are jointly instantiated, they not only convey Being in a limited form beyond themselves, thereby compensating for the freedom from Being that they exhibited when they acted independently of it, but they convey it in that limited form to a position that Being already pervades. As conveyed by the ultimates, an individual is a limited being that would be opposed to Being, had not Being already been positioned there as able to adopt whatever the ultimates conveyed of it. When and as an individual is enabled to exist within the limits that the ultimates provide, each is accommodated by Being.

No one can free himself from the ultimates that confine him; each is living, limited and qualified. If he so uses what confines him that he hampers others from making full use of what confines them, he does less good than he ought. If the act is deliberate, he is evil; if it is unreflectingly carried out, he is irresponsible. In either way, he is subject to the need to match the harm he does another by an obligation to do for him what had been put beyond that other's power.

All individuals are Being in miniaturized forms, using what confines them. When anyone so acts on others that the burden of the confining ultimates on those others is increased, he subjects those others to limitations in addition to those to which they are initially subject, thereupon requiring them to do more than they must in order to make full use of what constitutes them. Each individual exists between what confines it and Being itself. When any one precludes others from using the ultimates that enable them to exist there, he is obligated to provide what enables the constitutive ultimates to be properly used.

Evil is an affront against the being of others, imposing undesirable additions to the constraints to which they are natively subject. One who is evil subjects others to constraints in addition to those which are due to what constitutes and confines them. Evil cripples rather than enslaves, subjecting one who increases the burdens of others to the obligation to compensate for the undesirable addition. It could do that, though, only if it subjected itself to Being to a degree it need not. One who is evil has the task of compensating for the burden he imposes on others, a burden exhibited in an inescapable submission to Being to a degree otherwise not exercised, skewing him toward Being rather than allowing him to exist midway between it and the confining ultimates. Those who deliberately submit themselves to the supervening Being more than they need to, match those who are evil by sacrificing their self-centeredness in a different direction, failing to counter what confines them with appropriate mastery. Both the evil and the self-denigrating are unbalanced.

The more one limits the use which another actuality can make of its ultimates, the more does one assume the task of providing for that use; to the degree that one reduces another, to that degree is one burdened with the demand that the loss be compensated. As long as that obligation is not met, the perpetrator fails to fit properly into a position over which Being supervenes. No longer centered, he is obligated to make good whatever losses he has produced. Evil exhibits an ontological dislocation, not just an unwarranted injury to other actualities.

If other actualities are to be helped, they must be enabled to make better use of their constitutive ultimates than they otherwise would. If they are injured, debased, or tyrannized, what is lost becomes the object of an obligation by the perpetrator. To live at their best, humans need to exist both apart from and together with one another in ways that maximize them and what they can do, severally and jointly. None, of course, could live and prosper without making use of, consuming, and subordinating some things. Life is inescapably parasitic. The price for human continuance and prosperity is paid by other realities. It could be partly justified if

the outcome made possible an increase in value in the others, provided only that one avoided the utilitarian error of allowing for the sacrifice of some humans or even subhumans in order to benefit the rest. Vegetarians, like meat-eaters, destroy living beings in order to enable themselves to continue. The brute, biting, debasing, horrible acts that are traceable to the vicious—and, too often, to the heedless and the mad—leave these burdened to a degree that cheats them of an effective centeredness that some of them think they have not only achieved, but have enriched.

A poor philosophic account contains confusions and contradictions, inexplicable gaps, and odd irrelevancies. It makes assumptions it does not justify, and fails to account for what it takes to be pivotal. An ideal living philosophy, instead, combines a sound understanding of the nature of reality with an effective self-knowledge, exhibiting how the major types of reality exist separately and together. It knows that each being is self-centered and interrelated, and makes evident that evil skews reality in ways that one should try to understand. To accept the skewing as desirable is to misconstrue who one is, what others are, and how all fit together.

A philosopher who claims to have understood reality in its multiplicity and unity tacitly supposes that he has a comprehensive, clear mind. The more successful he is, the more surely will he become aware of what evil is and how it can be avoided and perhaps even overcome. If he voluntarily serves a tyrant, he will present a philosophy that is radically defective, unless perhaps a philosophy is little more than a series of suppositions, well sealed off from one's character.

A good test of a philosophy is to see if it could be seriously entertained and lived by an honorable man. No one, of course, is perfect; characteristic flaws may be overwhelmed by sudden insights and brilliance, particularly in short forays. Still, it is always a good question to ask why, if one claims to be aware of what things are in fact and promise, one allies oneself with what is corrupt, debasing, and distortive.

The fact that philosophy today is taught in departments does not mean that it can be departmentalized without being distorted. Conceivably, thoughts can be directed at what is abstract, ideal, inert, and may focus on what is dessicated and irrelevant; the result will fall short of a complete and sound philosophy. A philosophy should be lived, the expression of one who is trying to be radically honest, sensitive, appreciative, and comprehensive, looking for defects in himself with the same objectivity that should be exhibited in dealing with his fellowman. It does not follow, of course, that the best of men has the best philosophic vision or abilities. An honorable man may not have the kind of mind that a sound, comprehensive philosophy requires. All we can be sure of is that a dishonorable

man cannot have a sound view, one that can be lived both when alone and when with others, in spirit and in fact.

Those who take their stand with logic, language, semiotics, science, praxis, history, analysis, or what just happens to be, not only have one another to contend with, but other approaches as well. Blunt dismissals of other honest attempts to understand are not only arrogant but unjustified. Each might help one to become alert to the limitations to which other approaches are subject, without freeing it from the criticisms of it that those others raise. The only defensible view carrying out a single program respects diversity within a justifiable whole.

Linguistic-, political-, religious-, and other hyphenated philosophies are evidently one-sided if they intend to indicate that they are grounded in language, politics, etc., or, conversely, if they intend to deal with the language, politics, etc., as the primary instances of a philosophic view. The hyphenations should be read backwards and forwards. Such expressions as 'philosophical linguistics', 'philosophy of politics', or 'philosophy of religion' do not exactly match what the backward readings achieve, for these end, as the forward readings do not, at a philosophy focussed on some major parts. Because each of the views emphasizes its beginning, it should have this matched by a counterthrust begun at the other end, or, at the very least, should take a stand at their common meeting point.

These contentions will undoubtedly be countered in two different ways. There are those who will maintain that some particular mode of thought, belief, or action alone is definitory of what one is to be and do, and there are those who, instead, will claim that we should face each issue afresh, and so struggle toward a way of dealing with it that we will then be in a good position to act with continued success. Neither can be carried out properly unless one knows what in fact is, what should and could be, and how all can be brought together, by more effectively instantiating the very factors that were already operative in limited or distorted ways.

The best and worst of humans differ in degree, but the degree also marks a difference in kind, since the worst implicitly obligate themselves beyond the power of any human, and sometimes even all humans, to satisfy. Through a union of intent and thought, we can forge a single, well-joined philosophy. In principle, we also can so own, and use the ultimates that we can carry out evidencings that arrive at those ultimates as not yet instantiated. A satisfactory philosophy shows the way in which Being and actualities can exist in consonance. Ideally, it will be so pursued and expressed that whatever one knows and does will not only be clarified but make possible a better mastery of all else. It need not be supposed that what is or what is known forms an organic whole. A sound, coherent

account allows for a multiplicity of diverse realities, which remain distinct while they continue to be interinvolved.

2. Ethics and Philosophy

A good understanding of reality requires a meshing of a number of essential positions within a systematically mastered whole. There is no greater justification for ordering them as more or less valuable on the basis of the preparations and time that they require, than there is for doing so on the basis of the benefits they provide. Sometimes the one ordering may be more reasonable than the other. A more permanent and justifiable warrant would be provided were they judged from a position they all presuppose, and conversely. It will then be possible to mimic, in a limited way, the upward and downward moves of a dialectic that takes one from any reality to Being and back again.

If one focusses on conditions and not on realities, a good case could be made for taking logic, language, science, economics, or religion to provide the best measures for determining the legitimacy or importance of the others. Unlike those who are content just to describe, one would then be able to avoid wandering among problems but instead, would accept some as legitimate and others as illegitimate, simply because they do or do not fit in well with what had been anointed as definitive of all else.

Explicitly or implicitly, one always begins with what is prescriptive, determining the legitimacy and range of claims and practices of other ventures, while leaving over the question of how one is to decide which answers are to be preferred. Should all be accepted and bundled together? What is to be done when their demands conflict? May the satisfaction of some preclude opportunities or time enough for the others to be met successfully? The more comprehensive and nuanced the account, the more evident is the fact that the living of a philosophy requires both an awareness of what others are and need, and what one can and should do to make this available. Those whose accounts minimize the fact of evil, or who tacitly endorse it, will end with what compromises the claim that one has a sound philosophy.

To live as we ought, we must become alert to the nature of a multi-faceted, comprehensive whole, where all actualities are both confined by and own the ultimates instanced there. Only then will we be able to exist and act in the ways we should. A satisfactory account will make one aware of what others are and need, and what should be done to make the knowledge available. It should be tested by seeing if it enables one to do what must be done so that all could live well together at their best. The most desirable living of it is exhibited in a readiness to treat others and

oneself as both needing and deserving to be helped to overcome unnecessary limits, and to minimize the restraints that are unnecessarily imposed, to their or one's own disadvantage.

The acknowledgment of cosmic realities brings existentialism, pragmatism, naturalism, and their offshoots, to a sudden halt, just as surely as they make evident that a cosmically oriented view cannot provide a good understanding of what occurs in persons, the humanized world, or nature. Nothing less than a systematic, unified pluralism could do justice to the major types of actualities, and then only if it took account of all the domains in which each of four different ultimates were dominant and of both the Dunamic and the Rational as the dominant ultimates in what confines and is owned by the Habitat.

There are predators, the self-centered, the disinterested, the weak, subhumans, and things. There is a remorseless competition for what is scarce. Some of those who are strong are corrupt; some who are good are confused; many realities are unable to feel, seriously reflect, or decide. Some of us distort or misconstrue and, thereupon, live in disaccord with what would otherwise support or enhance us, and perhaps others as well. The understanding of the major kinds of reality and the ways they are related gives them a new import. To accept the venture and its outcome as an expression of oneself at one's most earnest, at once radically insistent and acceptive, is to be prepared to live in a multifaceted whole in one's own way, while finding proper places in it for others as well.

Each human is confined within limits produced by all the ultimates. There are three sets of these; one in which an instantiation of the Assessor is dominant over the others, another in which the Voluminosity has that role, and a third where the two are joined as dominant. We are at our best when we so use what confines us that we make it possible for others in Affiliated situations to achieve a better use of what confines them than they otherwise could. We are sources of evil, so far as we use and act through our confining ultimates in such a way that we add to the burden that the ultimates impose on others, we are good to the extent that we so use what confines us that others can make better use of what confines them.

Humans, among other things, seek to know whether what is known is useful or not. Theoretical physicists are among those who exemplify that fact in a splendid way. So do other scientists. So do some philosophers. An ethics that seeks to make evident what men ought to do must acknowledge that among the things men ought to satisfy is a desire to know, whether or not what is known promises to yield other benefits. Not every good is good for something, unless it be just the good of having it.

Spontaneity backed by a good will, particularly when this serves the promotion and expression of a strong, good character, will usually be

found to be eminently desirable. While a good character does not guarantee the achievement of what ought to be, yet without it, what ought to be will not often be realized or even promoted. The fact can be known and even endorsed by one who does not possess the needed character. Just as the best of humans might give poor advice, the worst may say much that is wise.

The study of what humans ought to be and do has two parts. If reference is made to what a society endorses or condemns, the study will be focussed on a morality. There are as many moralities as there are societies, with their distinctive histories, traditions, customs, practices, and classifications. All of these contrast with an ethics; this is occupied with knowing what humans are, ought to be, and ought to do, and is mainly concerned with knowing the worth of what is intended and done, independently of what the interests of a society demand.

An ethics, among other things, provides principles for determining the merits of all practices, both those that had been individually initiated, and those that are due to a society. A study of morality, in contrast, is primarily concerned with actual practices. No matter how widely accepted a society's edicts and how reasonable its practices, it is always open to ethical judgment on terms the society does not provide. Like a state, a society determines men's accountabilities for what it credits them with having initiated or supported, but does not guide men's acts by enforcing laws.

It is hard to know how much it encompasses, but no matter what this be, society will always fail to encompass persons, with their distinctive characters, privacies, judgments, evaluations, and intentions. Though the expressions of every one of these are affected by social practices, each has a sufficient degree of independence to preclude it from being an inverted form of what it is socially defined to be. Although what is said of any will be said in a common language, and though what is evaluated will be so on terms provided by the society, the saying and the evaluating will still be individually produced. While a society may condemn decisions and evaluations carried out apart from it, especially when they are expressed as challenges to its practices and decrees, its references to them can never be more than unverifiable suppositions about presumed origins and causes in areas into which it does not enter. No one is so completely socialized but that he has thoughts, fears, hopes, resolves, and expectations of his own devising. The honors or punishments a society may bestow will always fall short of their presumed occasions and backings in individuals. Accountabilities are not to be identified or equated with the responsibilities that humans separately assume.

An ethics is primarily occupied with the question of what humans

ought to be, do, and become. This requires it to recognize projects that may never be carried out, or that may be carried out in unwanted ways. It also takes account of commitments to realize ideals, makes possible objective evaluations of the personal import of social decrees, provides principles for assessing the worth of particular societies and their practices, as well as of the kinds of lives that are and can be lived then and later. One of its major tasks is to make evident what ought to be, what must be done to bring this about, and what a good character is and enables one to do. It also provides warrants for men to occupy themselves with theoretical as well as practical issues.

Ethics is a part of philosophy. It finds its place within it, dealing with its topics primarily in terms of their relevance to men as unduplicable social and political beings. Philosophy, in turn, is a part of ethics, this dealing with philosophy and other subjects on its own terms. The paradox that the two observations seem to promote vanishes with the recognition of the different objects and roles the two subjects have. Ethics focusses on rights and benefits, philosophy on reality and knowledge. Ethics' concern with the one requires it to subject itself to assessments by what it presupposes; philosophy's concern allows for a subdivision of itself to stand apart from it, and to assess it, as well as other enterprises. Similar paradoxes arise when the claims of philosophy and its subdivisions are set in contradistinction to the claims of a religion, society, state, the sciences, or the arts. Each of these is subject to judgment by both philosophy and ethics, as well as by one another. In the fourth epoch of philosophy, the prevailing disposition was to ignore the issue, and be content to describe what one could, bypassing the fact that this might be subject to evaluations by that which the view could not acknowledge. Only one singularly humorless would fail to recognize the absurdity of trying to do no more than criticize and describe, while refusing to allow for a criticism of one's own position and procedures.

Always presupposing a knowledge of and using material from what there is beyond its confines, the place that ethics has in the total range of inquiries and practices is defined by what is distinct from it, whether or not the fact is noted. An ethical justification for an occupation with science, art, education, politics, and other ventures can be provided by showing that these, in addition to what else they achieve, contribute to the promotion of other goods, all the while that they contribute to activities and studies that may do no more than satisfy a curiosity or an aesthetic sense, or help round out or clarify what is already known. Conceivably, they could also help make evident what had been poorly grasped or vaguely surmised, make possible good predictions, and ready one to prepare for them. If good provisions are made for what is essential, if men

322 The Unending Task

are to be enriched, then it may well be asked if it is necessary or desirable to do anything more.

A wide range of activity is encompassed in the claim that what is done is justifiable if it satisfies a persistent and perhaps inextinguishable human desire to be perfected. Effort spent on the improvement of the environment, the strengthening and perfecting of character in oneself and others, and the exercise of the mind and body might find their justification here. A life devoted to mountain climbing, chess, a stamp collection—or philosophy—might also be sanctioned along these lines. Their practioners would then be viewed somewhat as acrobats are, as having an ability to use powers and techniques in ways others do not, and perhaps could not, but who might provide those others with a distinctive pleasure, by showing what a human could do were an unusual ability or predilection backed by dedication and diligence. A devotion to any serious inquiry has a stronger warrant than this, at the very least if it promises to enhance the lives of humans sooner or later. It is questionable, though, whether any philosophy could be fully justified in that way. Too few are interested in its pursuit or achievement; it does not seem to please or benefit many. If it does any good, it is usually after it has been filtered, toned down, and tucked inside other views and activities more evidently pertinent to the production of other satisfactions.

An engagement in a sustained philosophic inquiry needs to be justified, particularly since it involves a neglect of other pursuits, apparently more germane to a satisfaction of primary needs and hopes. Conceivably, somewhat as some scientists look to mathematicians to help them achieve a better understanding of what they had already grasped in limited ways, one might look to philosophy for suggestions, distinctions, and conditions otherwise overlooked, or not well conceived. This has been done. Theologians, over the ages, have dealt with it in this way, looking to it for arguments, distinctions, categories, and terms that could be used to clarify, and perhaps to justify their attempts to back up what had already been accepted as the terminus of a faith. Some political thinkers and economists do something similar to warrant their major distinctives and objectives. The American Founding Fathers are here as one in attitude with the Marxists. Poets and other artists have sometimes been alert to it, and have used what they understood in new ways. Dante, Coleridge, Goethe, Schiller, Dostoevsky, Yeats, Wallace Stevens, Chinese and Japanese painters, Indian sculptors and architects are a few of the more conspicuous instances of those who did this. Although they often accepted philosophic views in a form that is at some remove from the original, and that had been developed without a thought of their possible use by anyone, those views were used to undergird, inspire, or guide their endeavors.

Mathematics has developed in distinctive ways, in part because it tackled questions initially raised in the measurement of land, commercial transactions, gambling, and war. For the most part, though, it dealt and now deals with issues that have at best only a remote connection with what is otherwise known or sought elsewhere. Medicine and religion have raised questions for law and politics, and might conceivably be justified and defended for what they have contributed and what they might reasonably be expected to contribute to and through these, thereby promoting the living of a good life.

It does not, of course, follow that if some discipline is useful, it has no intrinsic worth, or that it may not itself use what uses it, for purposes of its own. Viewed as useful from the standpoint of some particular enterprise, others might still be allowed and perhaps encouraged to carry out their work independently of any use, perhaps in order to make them more useful on other occasions. Were that, though, their only justification, they would in effect be parts of other ventures in which a kind of free play of the imagination, carried out under rules of a distinctive sort, was encouraged in the hope of obtaining goods not otherwise likely or possible.

A stoutly maintained pragmatism might well view mathematics, religions, the arts, and a systematic philosophic study as fine means for honing the wits, in preparation for going on to other, presumably more important work. That justification is neither needed nor satisfying. One dedicated to tracing presuppositions back to their sources, and seeing how what was presupposed clarified what had been accepted, will surely not look for it. No less than a rejection, such a justification should, in any case, be subjected to radical scrutiny, not because it was unwelcome or its verdicts suspect, but because a dedicated inquirer seeks to accept nothing unless there is a very strong warrant for doing so.

The problem of the worth of a philosophic inquiry is bypassed if one shrugs: "I like to think about philosophic issues." Not all likings are worth satisfying. Nor would it be enough to say: "It pleases me, and it does no harm." This is not only to belittle the adventure, placing it on a par with lying on the beach or swimming with little exertion in a pool, but it slips over the fact that a systematic philosophic study is challenging and difficult. It might yield little even after much struggle, while standing in the way of an engagement in other activities more useful and pleasurable. One might enjoy the study of medicine and keep close to a part of the Hippocratic oath, not to do harm; the study though is pursued not for that reason, but to yield eminently desirable goods.

Philosophy has its own tasks, backed by an oath, privately lived with. *Try to understand.* Though the one is a part of philosophy, it asks and answers questions that no other part of philosophy does, and to which the

whole must attend. Some topics are dealt with by both, the one considering them as involved with man's essential needs, desires, objectives, rights, and virtues, while the other examines them in the context of an ethics, with the same detachment with which it carries out other studies, trying to make evident what is being revealed and what is being presupposed. A systematic philosophy tries to show how the problems and answers that an ethics provides fit in with other problems and answers. For it, ethics is no more or less important a topic than is a study of language, logic, science, religion, or technology; all will have different degrees of importance at different times and in different situations. What most of those times and situations require will be known in particular, only when they occur, but that will not preclude a grasp of them in principle.

If sound and comprehensive, a philosophy will protect one from confounding what ethics requires with what the current morality endorses, and will thereby avoid the serious errors made by Plato, Aristotle, Thomas Aquinas, and those who replaced them. No ethics that is oblivious of the indefensibility of slavery, the subjugation of women, or the right to belief or disbeliefs that there is a God, can stand. More than a collection of admonitions, advice, blunt affirmations and rejections, ethics is surely no less important than is a study of semiotics or theology, though it may have less effect on the practices or attitudes of most. As part of a philosophy, it is subject to examinations carried out on terms broad enough to make evident the place it has among other endeavors.

Ethics is also to be distinguished from other enterprises as a limited study, occupied with distinctive problems, primarily those that have a signal bearing on the living of a good life. As part of a philosophy, it is one of a number of studies to be dealt with on terms that fit within a comprehensive system, having its own warrant. As an independent enterprise, it limits its activity to an examination of those pivotal issues and ideas that contribute to a better understanding of its particular topic, without attempting to know, explore, or justify what it presupposes. A comprehensive view takes account of it as one of a number of major topics instantiating well-grounded principles having a bearing on other endeavors as well.

An ethics dealt with as a distinct inquiry takes for granted that the perfecting of humans is an eminently desirable task. It does not grant that other inquiries have an equal and perhaps even a better warrant than it has; instead, it takes itself to be in the singular position of alone being justified to demand credentials from all others. The situation could be reversed; mathematics, science, the arts, and a systematic, speculative study all help determine the merits of an ethics by seeing if it promotes an interest in and contributes to a better mastery of those fields.

2. Ethics and Philosophy

Whatever claims the right to pass judgment on other endeavors needs a sanction of its own, and may even have to look to one or more of the others to provide it. It is one of the oddities in the history of thought that a number of different enterprises have been assumed to be privileged to determine the merits of all others, at the same time that a similar right is denied to any of them. Sceptics, deconstructionists, language philosophers, analysts, and phenomenologists, while rejecting one another's positions as untenable, take no time to show that they alone have the right to pass judgment on all other endeavors, whether these be engaged in making equally bold rejections, or are attempting to understand reality in its multifarious primal forms. It would be wryly amusing to hear them trying to talk to one another.

We use language to speak about language, logic to deal with logic, and are presumably honest when we try to understand what honesty is. The ethics in terms of which we judge the value of philosophy is an instance of this; conversely, the philosophy in terms of which we understand the nature, merits, and role of ethics is an instance of it. The present work, consequently, is to be understood as an instantiation of an as yet unexplored precondition; an ethics that is part of that precondition is that which is properly explored as subject to that precondition.

A systematic philosophy is but one enterprise among others. Unlike them, though, it also—and alone—is occupied with knowing the whole of reality in which the objects of every enterprise, and itself as well, are located. It is not dogmatic; at every step, it rests to see if a move was justified, and if it is possible to return from there to its beginning. Every move forward is countered by a retreat, making evident what it was with which one had begun.

The upward and downward moves of a dialectic are carried out over a series of retreats, interspersing advances. The failure to recognize that fact is one reason that those who move dialectically upward to or downward from a final reality do not know how to do so in the opposite direction, contenting themselves with making an inexplicable leap or with speaking of an inexplicable fall. From Plato on, great dialecticians indicated ways in which they could arrive at what was final, absolute, and perfect, but with the exception of Plotinians here and there, little or nothing was said about the downward moves that made it possible to have begun where they did. Whether the progress upward was carried out step after step, or in a Schellingian or Kierkegaardian leap that left the beginning behind, philosophers could not account for the fact that they had to start somewhere other than where they ended.

A philosophic leap toward what is glorious or forever is not possible if it does not take its start from solid ground and end at that from which a

return to this can be made. Those who claim to take their start with experience, hypotheses, sense data, or language, not only fail to account for these, but do not show that what is finally arrived at allows for a return to that with which they had begun.

A philosopher's official beginning is made at a position that had been arrived at. The very first move that he should make is to look beyond his beginning to see from where he had arrived at it. He began with commonplace objects, already lived with. Only because these are never lost sight of, was it possible for him to move to where they can be returned to but better understood. Empiricists move in one direction and speculative thinkers in another, both starting from the same position and needing to come back to it after they have ended at that from which an effective, clarifying reverse move is to be made. At each step, both need to keep a hold on the familiar world, from which all investigations begin, and to which they must finally return, but better understood. When phenomenologists say that one should abandon one's natural attitude, they are asking one to do what is impossible. No one arrives at what is radically cut off from the daily world. Endings for which there had been no beginnings could never be reached, except by leaps that begin nowhere, to end in that from which there is no return.

Philosophy is a singular pursuit, concerned with acquiring knowledge of a distinctive kind, subtending all others. Concerned with understanding the nature of reality in its primary forms and interconnections and what all knowing presupposes, it sees the concerns and assessments of humans to be part of that larger enterprise. It might not have any practical value, and it might not fit well together with what else is maintained, but not necessarily because it affirms what is false or irrelevant. Somewhat like an occupation with prime number theory, it does not need to be justified as what will perhaps produce some good for men. It does not offer the best opportunity for most to exercise their minds. The distribution of primes is perplexing and has not been well understood; it is assumed to be worth pursuing as an area in which creativity can be displayed, with results to be set alongside those achieved in other creative ventures. Philosophy may never yield results worth setting alongside those of mathematics, science, history, or other grand enterprises, in good part because it always seeks to arrive at a final truth, always tries to get back to what provides a proper beginning, always tries to attend to what it presupposes.

The kind of truth that philosophy seeks could be taken to be a prospect superior to that sought by mathematicians and others; it could be taken to be superior to beauty, glory, or justice, though there seems to be no good reason why it should not be set alongside them. Although it can comprehend them, find a place for them within its spacious whole, it must sooner

or later be content with accepting what these affirm, all the while that it makes evident what they presuppose. Its objective is as indeterminate and may be as attractive as any other, warranting as strong a commitment to carry it out resolutely and well. Whether or not philosophy is a creative enterprise—I think it is not—it is not in a position to determine the worth of others unless it can successfully attend to what they presuppose, make their natures evident, show that and how they are connected, and understand them separately and together in ways otherwise not possible.

Were ethics a creative enterprise or, more plausibly, a distinctive inquiry marking out the essential parts of a creative effort to become and do good, it would not yet be in a position to judge other kinds of inquiry, since it would, at least tacitly, be focussed on other issues. Treated as a subdivision of a systematic philosophy, it could have only a limited range, referring only to part of the scheme of things. Claims about the status of ideals with which ethics is concerned, the nature of the beings to which its demands and claims apply, and the principles it employs, all need to be scrutinized and their warrants made evident. This is obviously true when what it claims disagrees with what the dominant morality maintains, and often, too, when it agrees with this. A satisfactory ethical account will show that it is not sufficient to have a good, strong character, or even to use diverse powers under its aegis so that every one of them is exercised successfully. It will also try to make evident that and how the proper exercise of those powers contributes to the promotion of desirable practice. Even when its own distinctive objectives are to the fore, an ethics will not be able to avoid being a part of a more comprehensive enterprise, dictating to and marking out its limits.

Splendid ethical beings do not necessarily make the best politicians, soldiers, artists, or scientists, though those who are corrupt will usually, sooner or later, get in their own way. Some claim that those who live good lives will be rewarded after death, though it is hard to find any evidence that rewards will then be bestowed, or that there would be anyone there to receive them. Did one know that there was a good beyond what any human could achieve, one could perhaps justify the pursuit of a systematic, self-critical, independent inquiry that was able to provide a satisfying articulation of what had been certified by prophets, preachers, and canonical works, particularly when these are part of a long tradition. Even those who are confident that great benefits will eventually be added to whatever good humans achieve or exemplify, sometimes look to sustained, strong philosophic studies for ways to justify and express what they already firmly believe. The use that is then made of those studies will presuppose that they were carried out freely and freshly, not forced to support what had been antecedently taken to be true.

It is not necessary for a philosophic inquiry to operate within the limits set by any other inquiry, or to support hopes, faith, convictions, or conjectures. Even the use that others seek to make of it presupposes that it is carried out freely and independently. It is turned to by them, precisely because it is concerned with knowing what is irreducibly real, and may therefore be able to show that they are justified in making their claims. To the question "Why carry out a resolute ethical inquiry in which each claim is to be justified and interlocked with all others?" it is appropriate to reply "It is good to know if the good that humans can achieve, as individuals and as members of the humanized world, is all the good there could be." That reply uses 'good', to refer to an ideal, not to what is tailored to meet some particular demand. The latter awaits an appraisal of the nature, roles, and acts of diverse realities, separately and together.

A philosophy needs no sanction from other enterprises. If it is begun because one wants to know what warrants an acceptance or occupation with ethical and any other limited set of issues, it will soon find itself faced with new issues, different in nature and broader in range, dealing with presuppositions, determinations of the limits of other studies, and the problem of how the methods and outcomes of these could be severally and jointly understood.

Conceivably, what is achieved in a philosophy might be no more than an innocuous account of what reality might be in the large and in the little. It could, though, not be known whether or not this were so unless the inquiry were carried out. No one wants to hear a 'likely story'. There could be an endless number of these. What is wanted are reasons for supposing that a thoughtful study about what is real is true.

Faced with eternally produced questions as to why one should carry out a lifelong arduous inquiry into the essential nature, dimensions, relations, and parts of the basic types of reality, a reference must still be made to the need to know it, and how the greatest good that humans could achieve is part of a greater. Whatever the answer, it will be justified, not by its use elsewhere, but by its ability to show what always is and is always presupposed, to clarify what else is known or done, and to make evident why and how what need not be, in fact is. A knowledge of Being, as well as of the ultimates, individuals, the Habitat and its subdivisions, ideals, creativity, mediators, and an understanding of the nature, range, achievements, and limitations of various disciplines, have their own intrinsic value.

Although the most resolutely carried out philosophic account cannot get beyond Being, it cannot show that there could be no reality that could be reached in some other way—by faith, revelation, a change in attitude, perhaps—for which no other warrant is needed or might be found. It is in

fact an inquiry that should be endorsed by all others, as that which alone can make evident the limits of different kinds of knowledge and what it is to which they severally refer. Philosophy is committed to making a resolute, independent self-critical effort to carry out an inquiry into presuppositions and what these clarify. Conceivably, it might end with the recognition that the greatest good for humans may or may not need to be supplemented by other achievements, but that outcome would have to be justified. Ethics, in any case, takes this to be one of its tasks.

The present study has been occupied with understanding Being, the ultimates, individuals, and their interinvolvements. It began with expressions of the third, could not get beyond the first, and acknowledged the second as necessary for the understanding of the contingent existence and constitution of the major kinds of contingent realities that there are, what these presuppose, and what necessarily is and necessarily does what it does. To the direct ethical question 'Why carry out the inquiry?' it answers 'Because what is sought is what alone could justify every other endeavor, and also provide an answer to the questions that are at the root of all others'. To the observation that this has never been done, it adds 'That is why it must be attempted again, and in a somewhat different way.'

Different fields of creative work deserve to be placed on a footing, for the ideals they realize and their required commitments and efforts end in achievements that presuppose what is relevant to everything. A philosophy interested in creative ventures would point up what has to be said about its practitioners' objectives, commitments, efforts, and results, as well as the ways they are related. Resolutely exploring the essential dimensions of reality, and incidentally enabling one to learn whether or not there is or could be greater goods than those that humans could produce, a philosophy makes up in range, clarifications, warrants, and self-criticisms for whatever splendors creators alone could provide. No greater claim, though, need be made to justify a lifelong philosophic inquiry than that it enables one to know the limits of knowledge, and the major kinds of reality, both those that need not have been, and those that necessarily are.

There is no evident warranted way to rank the arts, mathematics, science, leadership, and statesmanship as better or worse, superior or inferior creative enterprises. Were a philosophy creative, it would have to be set alongside these as also being occupied with realizing a distinctive ideal through the use of ultimates and material, all to be joined again and again in novel and related ways. This is not what it does. If we are not to be arbitrary, we must be content to take an Aristotle and an Aristophanes to be engaged in what is worth equal devotion and effort, and to end with what may be of equal value. Yet the first, unlike the second, was not a

creator, nor apparently ever thought he was. Towering over most other thinkers, he is like them in carrying out an endeavor that is more akin to that of an explorer or a cartographer—as J. Brent has also noted—than that of a noble person, a playwright or other artist, an original mathematician, a great leader, or a statesman. Unlike them, he is occupied with learning about already existing realities, not in making something.

There are a number of distinctive, all-consuming activities which end with the production of what seems to satisfy their distinctive practitioners to the same degree, and seem able to benefit others as well. Unless we could provide a scale that warrantedly ordered the best works in different areas, we must be content to set them alongside one another as incommensurable. Were we to take the exercise of a good will to be among the primary virtues, we could then place philosophy alongside other engagements, accepting all of them in a spirit that would be hard to distinguish from indifference. Those who engage in a philosophic quest are, of course, as fully a part of the world as are others, but what they do is different in objective, outcome, and value. While incomparable in some respects, the others are alike in being occupied with limited parts of a whole, dealing with them as a philosophy cannot. What they achieve in specificity and control is matched by what it achieves in completeness and systematization. Interested in knowing what other enterprises necessarily but usually only implicitly suppose, a sound, comprehensive account underwrites their efforts, examines their procedures, marks out their limits, and evaluates their achievements. Instead of being sealed off from all else, it will at the very least try to promote the understanding and appreciation of what they severally do and achieve, and how they fit together.

These ideas need detailed examination if one is to make unmistakably evident that the outcomes of different basic enterprises can be ordered relative to one another, without belittling their intrinsic merits or the different degrees of importance they may have in different settings. At the very least, it will carry forward Peirce's classification of the basic disciplines, freed from his categoreal scheme and, therefore, from the need to place aesthetics above all the others. Only after a philosophic study has marked out the major realities and the essential relations that they have to one another could a classification be known to be useful and sound.

An ethics is one enterprise; a systematic, all-encompassing philosophy is another. A third is a living philosophy. This joins the other two, to yield a vibrant complex in which the parts enrich the whole, and the whole the parts. Whether or not individuals try to understand whatever there be, they will bring to bear their characters, aims, and commitments and try to back what they claim by facing it with remorseless questionings and

probings. It has already been noted that it is doubtful that anyone is so resolute and impersonal that some sly bluntings and evasions do not distort what is stoutly maintained. It is not easy to avoid all sly slips over the course of a life or even over the course of the production of a single comprehensive work. One will be helped in part if one attends, not so much to the results achieved in other enterprises or in recognizing the merits of their procedures, but noting their limits and the need to see how they comport with one another, and looking for openings and difficulties at every turn. It is sad to hear really eminent thinkers claiming that they take logic, language, current science, semiotics, literary criticism, poetry, economics, or politics to be a universal solvent. You cannot get alchemy to work by substituting words for test tubes.

Set down on paper, with its major parts and junctures well-distinguished, a philosophy will soon seem to be as detached, remote, and inert as a mathematical formula is when expressed in words. Its false starts, retreats, advances, hesitations, doubts, sudden insights, defeats, surprises, unexpected openings and closures will usually be slid over; one must take care to see that they are not entirely hidden in the final formulation. One of the major attractions of Platonism is its ability to keep one alert to the fact that a philosophy is carried out over a faintly noticeable road toward a justified and justifying end. It should have returned to where one had begun, but purged and enriched, bounded and clarified in unexpected ways.

No matter how controlling the daily world is, how committed we are to social or political programs, how sure we are that cherished values will be sustained, we must move away from them, if we are to know what in them is free from prejudice. Otherwise we risk being lulled by language, and tempted to favor congenial positions that may be in little accord with what exists or is done. Since what is superior in some respects may be inferior in others, one ordering will need supplementation by others. Since it is necessary to know what the primary realities are, if we are to know whether or not our classifications miss no essential items, and if we are to be in a good position to check the merits of one approach by others, so a complete, satisfactory account will end by locating even its own spacious study of all reality within a limited part of the whole.

Ethics is a subdivision of philosophy, with its own issues that it has to pursue and clarify in a distinctive way. It purports to assess the merits of whatever humans do and, consequently, will inevitably pass judgments on their decisions to attend to other issues. It is right for it to do so. Justification for making any choices presupposes it. It is therefore correct to say that even a complete, systematic philosophy presupposes ethical decisions and, therefore, an ethics that accounts for and evaluates these.

Unless the ethics could provide warrants for its own principles and procedures, it would in turn depend on a more comprehensive philosophic account to determine its limits and warrants. The two are to be brought together in an account that exhibits the spirit an ethics endorses, while grounding its aims and procedures.

A good joining of technology and art is exhibited in techniques. A good meshing of morality and politics makes it possible to avoid purely legalistic and social interpretations of the common law or of a constitution. Signs, it has already been noted, are where users and objects meet. Can every endeavor be similarly joined to any other, and, with these, produce new ones? At first glance, it seems reasonable to suppose that this is not possible. Yet such apparently odd fellows as science and sport have, in modern times, come together in sport medicine; before them, morality and mathematics were combined to create controlled economic systems; and choreography, religion, and politics were seen to be united in native dances. There may well prove to be enterprises that cannot be merged to produce a new subject matter. We will not know exactly what can be done until we have a well-grounded discipline that justifiably distinguishes major from minor pairings. Sooner or later we will need a vocabulary that allows us to speak clearly of midpoints in ways that are not antecedently biased toward one or the other end.

There are no less than three meanings nested in the expression 'living philosophy'. A good account of it will distinguish and relate them. A: Philosophy, as a single comprehensive enterprise, is joined to one or more of its parts, with each combination distinguished from others as a part of a 'living thought'. B: Philosophy, as subject to determinations by one's character, can be identified as a 'living intention'. C: The determination of action by an individual making use of the living thought and intention is a 'comprehensive living philosophy'. All three allow for subdivisions embracing a number of more limited forms.

A. Ideally, a philosophy will make evident how the large and the small, the general and the specific, the eternal and the transitory are so intertwined that a radical separation of them would end in their destruction. A systematic, viable account is to be achieved in a Platonic spirit, but presented by an Aristotelian, the one stressing termini, the other their junctures. Sensitivity to that fact will be reflected in part in an envisagement of all that is, as encompassed within a single, modulated system, and in part in a pluralism in which each essential component is shown to have a distinctive status and role. The account pulsates with the thrusts and counterthrusts of both the whole and its parts. Ideally, a stress on one will be matched by another from the opposite direction. Rarely, though, will the two be perfectly matched. Sometimes one of the contributors will be

so evident that it will be assumed to dominate over the other on all occasions.

When philosophic accounts march under banners, identifying themselves as idealisms, realisms, positivisms, and the like, they express a resolution to overlook counterthrusts or to take them to be just so many weak, partial versions of themselves. What they subject to criticism will usually be antecedently defined or treated as misconstrued parts of what alone is supposed to be legitimate. Were they, instead, credited with an independent existence, this would supposedly be wiped away as soon as it was confronted. If it were not, there would be that which defied the supposedly all-embracing view. The most that could be justifiably claimed is that such a view corrects or clarifies what it confronts. The more complete the victory over all others, the more surely will these be revealed to have been otiose. A living philosophy faces its greatest challenges with respect and some trepidation.

In living thought, a whole and its parts jointly constitute a single activity. If either were irrelevant or were it destroyed by the other, there would be no constraint put on this; it would be alone, and presumably would always have been alone, with its supposed counterpart revealed to be nothing more than a poor image of it. The result would exhibit a form of an objective idealism in which a final all-encompassing reality annihilates all that supposedly contrasts with it. Nothing real, though, no matter how feeble, could be fully pulled into a final reality; otherwise there would be nothing but this, not even one who tried to know or accept it. Opposing positions are interlocked from beginning to end. They are joined in what they jointly constitute, while continuing to exist apart from this. Hegel knew that every midpoint in his system was preserved in his Absolute; it is not evident, though, that he realized that these also continued to exist apart from it.

Each thought has opposing termini and a midpoint where these are merged. Only the last is lived. When a philosophy meshes with its parts, the result has a nature and course different from both. Its joining with this or that part occurs within a single joining of all. We could never know what an all-comprehensive meeting point was until we knew all the parts and the contributions these make to the whole, and knew that that whole is a whole for just those parts. The fact that what is partial can be completed does not mean that that it disappears into what accepts it. This step, this word, this note continues to be distinctive, all the while that it is caught up in a dance, a poem, or a song.

Living thought has at least as many instances as there are junctures of known wholes and parts. The wholes may be enriched in any particular case by their parts to a greater degree than the parts are enriched by it, and

conversely. A perfect match is an ideal that is perhaps never achieved or, if it is, is achieved only for a limited time. Most junctures of wholes and parts fluctuate, with now the one and then the other component making a greater contribution than the other does. Since there are many parts of different kinds in a philosophic whole, the living thought that has the two interlocked will not only vary in its emphasis on parts or the whole, but on what parts make a significant difference at a particular place or time.

The study of the relation of wholes and parts is not new, but I am not aware of one that focussed on its applicability to living thought, and particularly to philosophy and its major subdivisions. It would not surprise me to hear that it has been provided, or that it has been presented in such a form that what is here said is revealed to be nothing more than an instance of it. What is now evident is that living thought involves the meeting of thought about a comprehensive whole with thought about its subdivisions.

A comprehensive philosophy has many distinguishable parts. It is doubtful that anyone knows all of them. If someone did, it would still be questionable whether or not he understood how all the parts interplayed with one another and the whole. In the meantime, there is much to learn from a study of the totality of reality as encompassing a multiplicity of distinct realities. The interplay of a systematic account of this kind with ethics makes possible a more complete and subtler understanding of one's hopes, beliefs, judgments, and projects than would otherwise be possible. In effect, it puts one in a position to live a philosophy.

B. A living philosophy at its best engages one's person with what is well understood of reality as a systematically organized whole, in which pivotal positions function both independently and together. It is not wholly in the mind or caught up in discourse, but permeates and is encompassed by one who knows that he is a distinct reality, always interinvolved with others no less distinct and irreducible.

It has already been remarked that had a philosopher found no fault with a brutal tyranny and its slaughter of innocents, one should begin to wonder if what he claims, no matter how attractive and promising it may seem, could have been well lived by him. No one is so broken up into sealed areas that an acceptance and surely an endorsement of powers, intent on dehumanizing those who did not conform to some gratuitous idea of what it was to be a human, would have no effect on what he thought. He might be as persuasive as an honorable person was, but he could not provide a philosophy that could be well lived in and with.

No philosopher can sanction deceptions and falsehoods without raising questions about his own honesty and decency, and the possible effect these defects have on what he offers as truths. Conceivably, a good

account could be produced by one who had, for a while, freed himself from the corrosive outcomes of a poor character, used to endorse lies and murder. Another with a weak character might have periods in which some enterprise was carried out vigorously and well. In the end, though, nothing more could be produced by either one, excepting fragments obtained during the short periods in which needed abilities and strengths were employed. The ideal result may perhaps never be obtained, but a serious, honest thinker will strain to obtain it.

No one is so virtuous and steady but that flaws and faults will be left untouched and perhaps even insisted on. If one's self-chosen task is to try to provide a complete account of what is real and important, he must strive to make it free from defect beyond any pre-assignable degree. He does, of course, need both the opportunity and the ability to carry the work to a successful completion, but he may not know whether it is a lack of ability or a fault in his character that precludes him from completing the kind of account he had implicitly committed himself to provide.

If there is to be a fine living of a philosophy, one must make use of a good and strong character. One who possesses such a character may accomplish little, while one without either a good or a strong character may have unusual insights. A knowledge of a philosopher's virtues and vices should alert one to the likely presence of serious deficiencies—or value—in his major aims and work. Knowing the virtues, we should be on the alert for defects, and then be ready to return to his achievement with a better sense of the degree of its excellence than one could have had before.

C. Great philosophic works are alive in a double sense: their authors are sensitive to the nature of diverse realities, and they are responsive to the ways these impinge on one another. Produced by fulfilling a commitment to know the primary realities and how they are related, at once singularly individual and aware of the vital currents of the day, those who commit themselves to a desire to know what is presupposed, also commit to a knowledge of how pivotal realities affect one another. Like everyone else, each will be caught up in a common tradition, reflect common hopes, and be alert to common problems. What will be achieved will exhibit in a new context the vitality, the daring, and the caution characteristic of the kind of good life that should be lived by everyone. Were a philosophic account well lived in and with, it would make possible a better understanding of the import of other enterprises. In no position to judge or correct their specific findings, a strong philosophic account assesses the strengths and limitations of other enterprises—and its own. It knows that there is something amiss with any view that allows no place for a study of individuals or speculative thought, that allows for no way of

moving toward and into other realities, that fails to acknowledge what necessarily is and necessarily does what it does, or that does not see that a good character enables one to move toward and into what else there be. At its best, a living philosophy provides a comprehensive, well-ordered whole, and reveals oneself to be an individual being who is enriched by and enriches other realities within a single, diversified whole.

Index of Names

by Constance Rothschild Pitchell

Index of Subjects

by Constance Rothschild Pitchell